Hunting
with a Camera

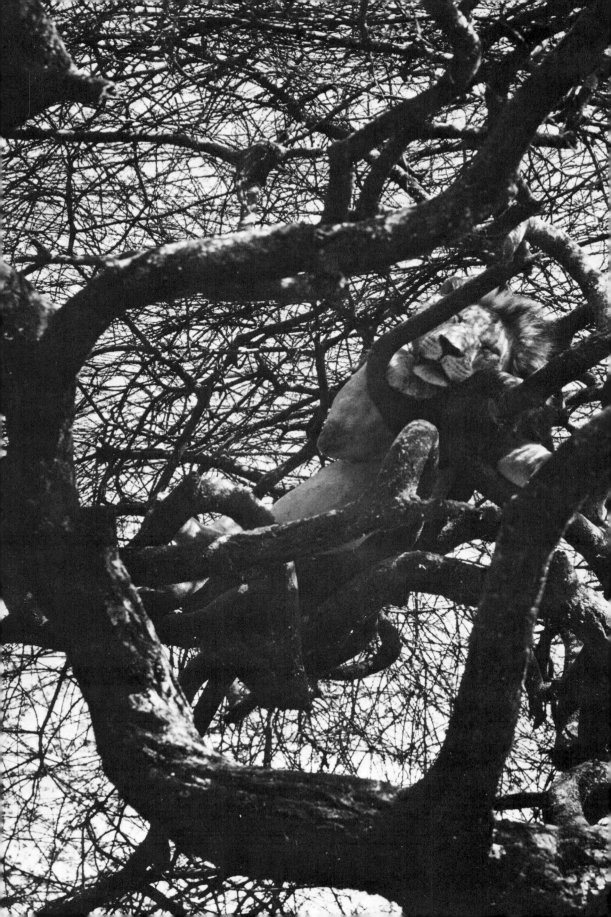

Hunting with a Camera

A World Guide to Wildlife Photography

ERWIN A. BAUER

WINCHESTER PRESS

To Peggy, who can be packed and ready to go anywhere on earth in five minutes time. Or even less.

Library of Congress Catalog Card Number: 74-78698
ISBN: 0-87691-143-2

Published by Winchester Press
460 Park Avenue, New York 10022

Printed in the United States of America
Designed by Angela Foote

Foreword

During the past decade or so, more and more Americans have suddenly become concerned about their environment—and none too soon, because it is now a matter of survival.

In many instances this concern has focused on wildlife because birds and animals offer an unfailing early-warning system for our own human future. When any environment is sufficiently degraded, the wild creatures are the first to disappear. Almost without exception, the quality of human life around the world is highest where the citizens have preserved and cared for their places of natural beauty and have not destroyed their precious wildlife communities.

One effect of the new conservation awareness has been a growing interest in wildlife photography, and that isn't any wonder. Photography itself is an immensely fascinating activity. When the subjects are wild and beautiful, it becomes doubly fascinating and even high adventure. That explains why Americans in steadily increasing numbers are exploring farther and farther just to shoot wildlife trophies on film. Nowadays whole holidays are spent happily just in searching out those lonely, quiet, exquisite places where deer or ducks or doves live. Witness how attendance at U.S. and Canadian national parks has expanded and how our wildernesses are invaded by nature cameramen. Today taking a photo safari to Africa or even beyond no longer raises any eyebrows. Thousands do it annually, and any such trip can be the richest experience of a lifetime.

I have written this book for all wildlife photographers, both

serious and casual, amateurs and professionals, veterans and
beginners. It is meant to be a guide, mostly on the best places to go,
but it was not doggedly compiled through a lot of secondhand
research, and it does not pretend to cover every corner of the
world in exact proportion. My goal is to create enthusiasm as well
as impart information, and I have depended almost entirely on
personal experiences. But it has been my good fortune to pho-
tograph wildlife from the sagebrush flats outside my door to
Alaska, Antarctica, and many points in between, and thus my own
experiences do truly constitute a world guide.

A good portion of my adult life has been spent in lugging
photo equipment all over the outdoors, and I cannot conceive of
any other vocation or avocation which would have been as pleasant
and rewarding. It is a career without dull moments. I hope that will
be evident in the text and photographs of this book.

Erwin A. Bauer
Jackson Hole, Wyoming
May 1974

Contents

Hunting
with a Camera

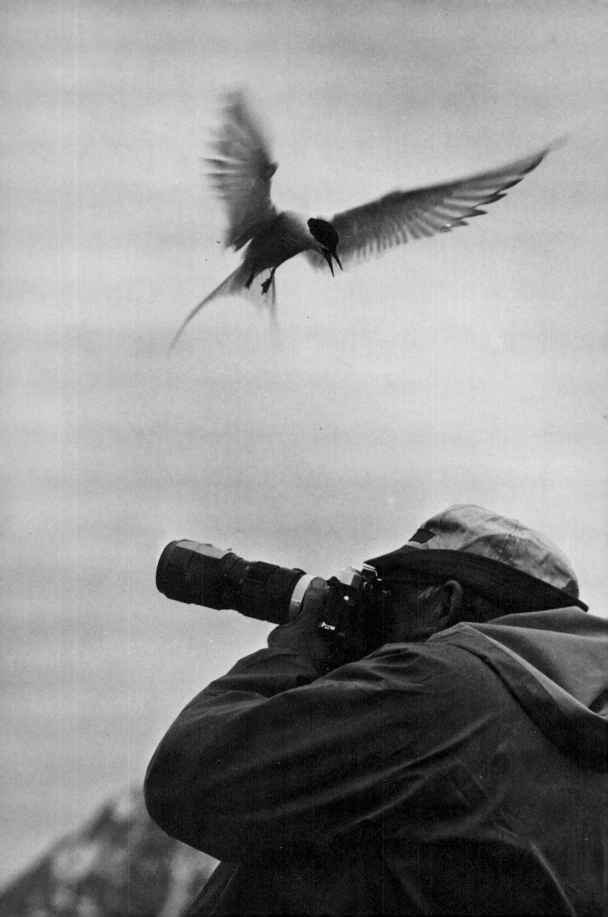

PART I

The Camera Hunter

Effective use of telephoto lens requires considerable practice. Sometimes the subject (here an Arctic tern) does not cooperate and "attacks" instead.

1

Safaris
for Anyone

I was driving homeward—home is in northwestern Wyoming—on a cold and stormy evening toward the tag end of December. Such a heavy snow was falling that visibility ahead was nearly zero. I rounded a bend and the beams of my headlamps suddenly fell on a band of elk crossing the road just ahead, and I jammed on the brakes. Startled, but still in single file, the huge animals plunged ghostlike through the flank-deep snowdrifts on the berm, splashed across the ice-encrusted Gros Ventre River, and evaporated into the gathering darkness.

There were twenty-eight elk in the band, and to see that many so near is always exciting. But *all* of these were massive, mature bulls with heavy antlers, and their passing was very significant. It meant that the annual migration of big-game animals, from their summertime ranges in lush meadows of the Rockies to traditional winter pastures, was just about complete. The biggest males are usually the last to arrive at the National Elk Refuge in Jackson Hole. Now the best wildlife watching in America at any season of the year was about to start there.

By morning the storm front had passed and left a dazzling bright day in its wake. Retracing exactly my route of the evening before, I made what might be one of the shortest camera safaris ever, at least in distance. It covered only seven miles. But that was enough to put my camera in range of several moose, many mule deer, four rare trumpeter swans, a whole steaming pool of Barrow's goldeneyes, and about seven thousand elk!

Some of the pictures I made accompany this chapter. But what

is far more important is that almost anyone who visits this area
from January through March can duplicate them.

The truth is that nowadays anyone can enjoy a wildlife photo
safari. Perhaps "safari" isn't exactly the right word to use; it is
Swahili and means "trip"—or usually "happy trip." Its origin is East
African, and originally a safari was a hunting trip there. But more
and more the word is used to describe hunting trips anywhere,
including wildlife watching and photography expeditions. So "sa-
fari" can well describe my short trip after the elk, and certainly it
can describe the typical North American photography expedition
that follows.

Frank Sanderson had been a lifelong big-game hunter, and his
trophy room attests that he was a successful one. But like a growing
number of Eastern sportsmen he has not been lucky enough to
draw licenses or permits in the annual lotteries held by the big-
game states of the West. Today's demand for permits is much
larger than the harvestable supply of game. But Frank is also a
good amateur photographer, and so he decided to go hunting

*These three trophy elk might have been photographed by anyone with simplest equip-
ment near Gardiner Entrance of Yellowstone Park. Many elk spend winters here
close to the highway.*

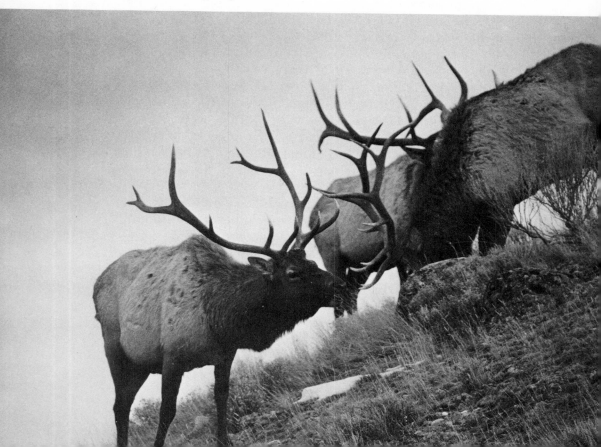

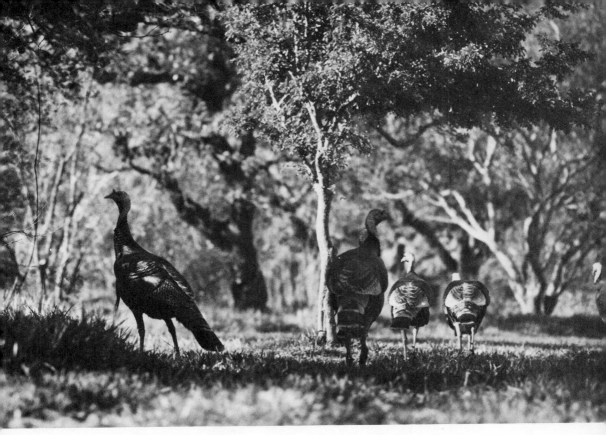

Normally a shy and elusive bird, wild turkeys can be photographed at several wildlife refuges in the South and Southwest, as here in Texas.

with his camera. Specifically he wanted to see just how many species of big game he could "bag" in just one state, Montana, during his three-week vacation—and during the same period he would have been hunting anyway. Towing a small fold-out camp-trailer behind his station wagon, Frank and his wife Jane headed westward in mid-September.

What followed was the greatest holiday the couple ever enjoyed together. Frank was immensely successful in his hunting, and for the first time ever, Jane did some "shooting." Early autumn is normally an exquisite time to be in Montana, and they made the most of a succession of brisk, bright days. Altogether Frank "shot" eight species, or nearly all of Montana's native big game. He got his bull elk, bull moose, and black bear in Yellowstone. He collected mule deer, bison, and antelope on the National Bison Range. The two toughest trophies—the bighorn ram and mountain goat—came last, in Glacier National Park.

Frank's photos indicate that both the ram and the antelope buck would probably have made *Boone & Crockett Records of North*

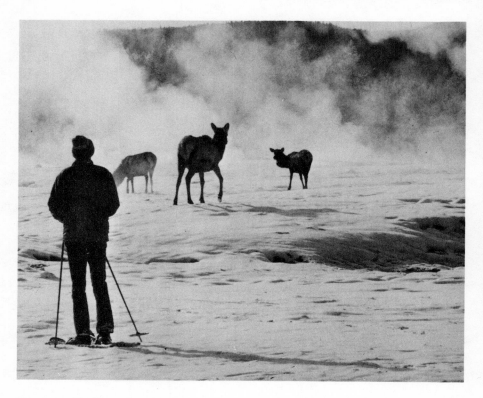

During midwinter photographers can approach herds of elk to very close range on snowshoes or cross country skis. This is near Old Faithful, Yellowstone.

American Big Game. The only Montana natives Sanderson did not shoot were the grizzly and the mountain lion, but a man's chances of seeing (let alone photographing) either of these are virtually nil nowadays south of the Canadian border.

In years past, Frank's hunting trips had been fairly expensive, and the cost increased each season. But this photo safari for two wasn't much more expensive than staying at home. With the camping trailer they were able to use the numerous public campgrounds scattered across the state. A few weeks before, many of these would have been crowded to overflowing, but as September blended into October, most were nearly empty. Some they had entirely to themselves.

Remember also that Sanderson had no licenses or permits to buy, no guide's or outfitter's fees to pay. Nor did he have to worry about drawings, open seasons, bag limits, or protected species. The only costs that the Sandersons would not have incurred at home

were for gasoline and oil to travel halfway across the country—less than $200 at the time—and a few small campground fees. Frank figures they saved enough to think about a trip to Africa next year. A photo safari, of course.

More than 3,000,000 Americans own some sort of recreational vehicle—a trailer, pickup camper, motor home, or whatever—and with any of these can duplicate the Sanderson budget safari. Recreational vehicles can be rented everywhere, too.

Better even than a rec vehicle in many ways is a good roomy tent, which can be pitched in even more places than a trailer or camper can be parked. A number of national-park and national-forest campgrounds are now restricted to camping under canvas alone. What may be the best combination of all is a tent plus a four-wheel-drive Jeep, which is my own favorite. With this my wife Peggy and I have the greatest flexibility. We can enter and live in remote country which is impossible for almost all rec vehicles and even for two-wheel-drive cars.

Also consider backpacking. For an investment of from $50 to $100 for a complete, high quality outfit, a person who is physically capable is equipped to travel into remote wildlife habitats which cannot be reached even on horseback. Besides the filming opportunities, it's the most exhilarating kind of adventure. Or with only a light rucksack, a photographer can headquarter in a public campground and hike out daily into the back country. The latter plan has worked out very well for us on late fall trips when light camping at high altitudes is too uncomfortable or even too risky because of the sudden heavy snowfalls which are possible then.

During one October camp-hiking safari in Grand Teton National Park, Peggy and I had two memorable encounters which are worth describing here. One afternoon we were returning to camp, hurrying downhill in a race with dusk, on a trail which would have been heavily used by many hikers only a month before. But now from the lack of human footprints on a new snow, we knew we had the place to ourselves . . . until a large cow moose crashed out of dark timber ahead of us. Then, unaccountably, with nothing in pursuit, it raced across the face of a rocky slide caused by an old avalanche.

"Wonder what caused that?" Peggy asked.

Obviously we will never know. But we had stopped to watch the retreating moose, and for that reason alone did we happen to notice a huge male mule deer watching us from dense cover nearby. It was the largest, most magnificent buck of the species I've

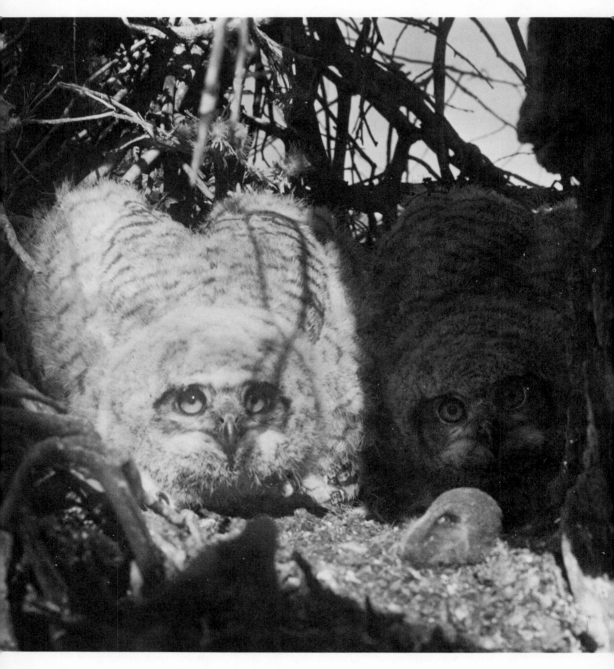

Great horned owls live and nest in ever corner of America. Find a nest in early springtime and pictures of nestlings like these are possible. But watch out for protective parents.

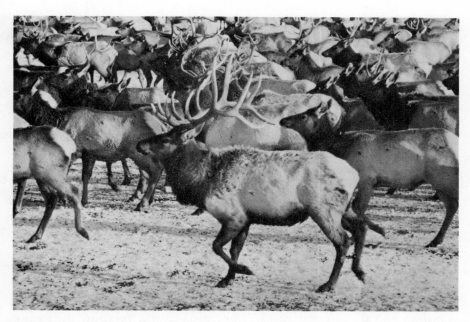

Wildlife photography is always easiest and most rewarding in national parks and wildlife refuges. These wintering elk on the National Elk Refuge were filmed at point-blank range from a horse-drawn sled.

ever seen, and I've seen my share. Its head would also rank high among the finest of *all* big-game trophies I've ever seen. The color slide I shot of that deer is not a very good one, even considering the poor light, but the animal's rack is the kind which hunters (with either gun or camera) dream about . . . and dream only.

The next day was even more remarkable. Returning over another trail in the late afternoon, we heard a violent crashing in a stand of lodgepole pines close by. I knew it was the sound of antlers—of animals fighting—but after stalking closer, wasn't prepared for what I saw. In an open, snowy glade, three—not just two—large bull moose were charging and smashing one another head to head. If I suddenly had five thumbs on each hand while focusing the camera, it wasn't any wonder.

Now maybe hunting "tame" moose in a national park with a camera seems unexciting. If so, read on. Abruptly—as if on signal—the fighting stopped and all three moose turned to stare at me. The time was late and the animals stood in dim light, but still I could clearly see the raised ruffs, the wet muzzles and bloodshot

eyes. Lovesick bull moose, national park or not, are unpredictable during the rut. My knees felt liquid enough to stir with a spoon as I looked about for the closest climbable tree. Then just as suddenly, the moose turned away and began to browse, apparently with no further interest in fighting or in me. Still it was a spooky hike down the remainder of the trail to camp.

But few moose encounters are that nerve-shattering. One I remember is more typical. Beavers also are abundant in lowland portions of Grand Teton National Park, and by damming a small stream have created a necklace of shallow ponds right beside U.S. 187, a highway which is very heavily traveled during the peak of the summer tourist season. Here one hot August day an ungainly cow moose and her equally ungainly calf stood for nearly an hour in the belly-deep water of a beaver pond, browsing on pond lilies. They ignored the tourists who gathered to watch them.

During the time that the show lasted, I counted more than 150 travelers who stopped long enough to photograph the animals. In fact, a traffic jam was created because too many lingered long enough to take several shots. They aimed and focused with every kind of camera from Polaroids and Instamatics to some very sophisticated equipment. If all obviously were not experts, they were having a great time and they were excited.

After the two moose had finished feeding and disappeared into a willow thicket, a man whose pickup camper bore a New Jersey license plate turned to me.

"I've traveled far this summer," he said, "and I've seen spectacular scenery and many showplaces. But filming wildlife like this has given me the most pleasure."

I could easily understand what he meant, because I am a full-time professional photographer of wildlife, nature, and outdoor adventure. The local moose are now familiar old friends, but still I derive great pleasure from filming them over and over. I never tire of it, because wildlife photography has both a challenge and a fascination difficult to match or resist. Anyway, the animals are always doing something different against a different background every time I see them.

There is plenty of opportunity for bird and animal watching in North America. We have not always treasured and cared for our natural resources as we should, but fortunately a great wildlife heritage still remains in our wonderful system of national parks, national wildlife refuges, and other sanctuaries, all of which will be described in detail later. Entrance to these places administered by

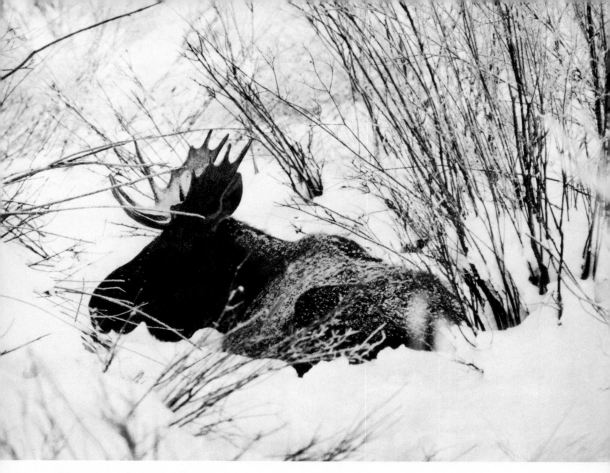

Shiras moose bull takes refuge from storm by bedding down in deep snow. Snow-shoes made such a close approach possible for the author.

the federal government is either free or covered by purchase of an annual Golden Eagle Passport, authorized by Congress, for $10. Citizens over sixty-two can obtain a Golden Age Passport free.

And good reliable photographic equipment is available today in every price bracket. Anyone with an appreciation of the outdoors can enjoy wildlife photography regardless of age, physical condition, experience, or income. It's something an outdoorsman can pursue seriously as an absorbing hobby—even as a career—or casually as just a pastime. You can shoot from your car, or hike as little or as far as you like beyond beaten paths. Any way you do it the rewards are rich.

Photographing wildlife isn't something people do only in remote mountain ranges or along lonely seashores or in national parks. Closer to home—almost anybody's home—are small worlds which may be teeming with wildlife. Just for example, hike out

around a typical country farm or ranch pond (there are an estimated 3,000,000 or 4,000,000 in the United States) and you will certainly find everything from bullfrogs and robins to cottontail rabbits and the nests of redwing blackbirds.

Even around many cities are metropolitan parks and similar rewarding places to hike with camera in hand. On the fringe of Columbus, Ohio, for instance, is Walden Pond, where any cameraman can shoot a dozen species of waterfowl on any winter's day at close range from a blind provided by the Metropolitan Parks Board. Another pond within the town limits of Castalia, Ohio, has been a sanctuary for large flocks of wild waterfowl so long that the birds can now be easily approached by photographers. Even in New York City there is an abundance of wildlife—on one recent early-morning Central Park safari an amateur cameraman of my acquaintance bagged wood ducks, mallards, redheads, canvasbacks, ruddy ducks, Canada geese, mourning doves, and warblers of all kinds, as well as a lonesome cottontail rabbit. Similar places exist everywhere from Albany to San Francisco Bay, and if nothing more, are good places to practice photo techniques on living targets before heading out on more ambitious photo safaris elsewhere.

Not so long ago we invariably thought about a wildlife photographic safari as being exclusively a journey to Africa. But the truth is that you can enjoy such an experience without crossing your own borders and possibly very close to home. Besides the actual wildlife shooting, a safari will take you to the most beautiful corners of our land and of the earth. That alone is worth an expedition.

2

Horseback Hunting

From the trailhead where we had transferred our gear from a truck onto pack and saddle horses, it was an easy nine-mile ride up the valley of Cascade Creek. All the way magnificent mountain ranges loomed high on both sides of us. It was cool and crisp, the tag end of summer, and the horses hurried without urging. When we reached the mouth of Stoney Creek and forded its clear, cold current, Malcolm "Mac" Mackenzie reined his horse right and followed a thin game trail across a grassy meadow aflame with fireweed. When the meadow suddenly narrowed into a box canyon some distance beyond, he dismounted.

"Let's camp right here," the young guide said.

For a few minutes, before facing up to the task of unpacking and pitching tents, my wife Peggy, her son Steve Politi, and I explored the immediate area on foot. It felt good to stretch stirrup-cramped muscles, and that lonely spot was made to savor and enjoy.

Nearby we found where Stoney plunged over a falls into a deep green pool, and this would be a convenient water supply. All around it elk tracks were etched deep in the soft earth, and a water ouzel ducked under a riffle at our approach. The entire scene was bathed by a golden September sun. A man might spend most of his life vagabonding about the outdoors as I have and find few camp-sites — or few moments — more attractive than this one.

Specifically the place was Banff National Park in the Rockies of southern Alberta, but not the Banff popular with summertime tourists. Circles of charred rocks were evidence that others had

camped here before us, but none recently. This was a remote wilderness portion of the park, reached only on foot—your horse's or your own—and few tourists ever see it. Our mission there was to hunt big game with a color camera—a saddle safari, really—and the hunting began before there was time to drive a single tent stake.

One by one we had unlashed the manteys and pack boxes from the four pack horses and had hobbled the animals to graze nearby. As we began to unsaddle the riding horses, Mac idly glanced up onto the open slopes above our campsite. What he saw made us drop everything.

"Animals," he said. Then after taking a better look through binoculars, "Grizzlies!"

Immediately we restuffed cameras, telephoto lenses, and film into saddle bags. Moments later we were riding upward through dense evergreen timber, following old elk trails to reach within photographic range of the bruins. Our aim now was to stay downwind of the bears, but to climb well above them, for two good reasons. First, the late-afternoon sunlight would favor our being above the animals. Second, and more important, it is normally safer to approach grizzlies from above than below. On reaching the upper edge of the timber, we tied the horses and proceeded on foot.

"We should be well on top of the bears now," Mac whispered, "so we can start moving along the slope and upwind." Suddenly the adrenalin was pumping; at least mine was.

As we had seen from the campsite now far beneath us, the slope was mostly open—covered with knee-high blueberry and mossberry bushes, here and there punctuated with islands of low alpine fir. Slowly we covered a hundred yards . . . two hundred yards . . . twice that distance . . . pausing often to scan ahead. But no bears; in fact, no living things were in sight anywhere. Mac turned to look at me, puzzled, before continuing very, very cautiously. That's when Steve tapped me on the shoulder and without a word pointed to a spot beneath and slightly *behind* us.

Not a hundred feet away a sow grizzly with two yearling cubs was standing erect and staring at us.

Coming suddenly and that close upon *Ursus horribilis* is never a comfortable feeling. It is even less comfortable when there are no trees nearby to climb. A slow retreat might have been wisest, but the instincts of a professional cameraman won out. I sat down, rested the 500mm telephoto on my knees, and aimed it at the

bears, which did not linger very long. They hurried away down the slope, stopping once or twice to stand and look back, and I ran off all the film in the camera before they disappeared. Mac had captured all of it in motion pictures. Not since a time many summers before in Yellowstone Park had I been able to take such good photographs of one of the most exciting animals on the face of the earth. It is becoming a very rare species too seldom seen.

Camp was a particularly happy place that evening after that fortunate bear encounter and following the thick beefsteaks Mac broiled over the open fire. Long after dusk we talked about a variety of subjects—everything from tomorrow's plans to grizzlies being close at hand to pack trips past and future. I recalled how pack trips are really as old as man's association with beasts of burden, and how the American West was first explored (won or lost, depending on how you view it) by pack-tripping soldiers, salesmen, trappers, prospectors, and finally settlers. We may think of packing as being strictly a North American invention, but the greatest pack tripper of all was Marco Polo, who consumed two decades traveling from Europe to China and back again in the thirteenth century. En route the Venetian had witnessed more of Asia's then incomparable wildlife spectacle than any other traveler in all history. It is a shame, Mac mused, that Marco Polo did not have photographic gear so that the many generations of outdoorsmen and conservationists since could see what has vanished from the world.

Only in Canada and the United States is the pack trip, or trail ride, used for recreation—for hunting, for fishing, or simply for enjoying some of the most magnificent places left on this continent. Now there is a new use: a pack trip also happens to be the best way to watch or photograph the wildlife of our Western mountain national parks and wilderness areas. The following few days—a saddle safari—in the Banff back country were ample proof of that.

Slightly before daybreak the next day I heard the muffled sounds of Mac building a campfire just outside the tent. Then the exquisite aroma of bacon frying penetrated inside. As I pulled on cold pants and laced up boots, a bull elk bugled not far away, and from the opposite slope of the valley a second bull challenged back.

"It could be an early winter," Mac said as I crawled from the tent, "because they're bugling earlier than usual."

While breakfast cooked, a salmon sun touched first the tallest peak, then gradually traveled downward, exposing more and more of the eastern slopes in bright daylight. About a third of the way

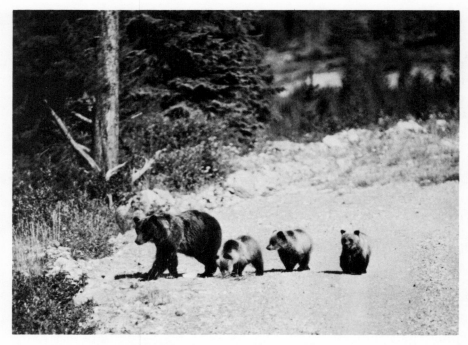

During pack trip in Banff, grizzly sow with triplet cubs crosses road ahead of riders. It's wise to give grizzly mothers a wide berth.

down one peak, it also exposed a band of bighorn sheep. From our camp a mile away the animals were not identifiable by eyes alone, but through glasses they became fourteen rams.

"There's our target for the day." Mac smiled and passed the binoculars all around.

Breakfast finished and dishes washed, Mac rounded up the riding horses and we saddled them. By the time the sun had penetrated to the floor of Cascade Creek valley, we were already following the parallel trail upstream until we found a place shallow enough to wade across. Then for the second time in two days—less than one full day, really—we had a sudden confrontation with grizzlies.

Another sow, this time with three small cubs, walked out into a wide place in the trail directly ahead. For a moment the big female stopped and studied us as if undecided about what to do. But quickly all four hurried away into the dense willow cover which bordered the creek.

What seems remarkable now is that I had time to make several exposures of the grizzly family. As Western riding horses go, mine

(which Mac had unaccountably named Applejuice) was a very nervous mare; she would invariably shy away or buck at any unexpected sight or sound, even from a chipmunk crossing the trail. But on this occasion the animal stood so completely still that I was able to hand-hold a long telephoto lens. Perhaps it's best not to try to understand horseflesh.

Once across Cascade Creek, we began to climb steadily straight up a very steep draw overgrown with dense buckbrush as high as a horse's head. In places there were elk trails to follow; but elsewhere the horses had to bulldoze right through the tough vegetation. Often we had to stop to rest the animals, which became thoroughly soaked with sweat. Visitors on their first pack trips are often astounded by the way good Western mountain horses can negotiate what seems to be impossible terrain. Steve was especially amazed as the powerful animals scrambled upward over rockpiles as well as through the buckbrush.

After we'd gained about 1,700 feet on horseback, we tied the animals near timberline and continued the ascent on foot. The final 1,000-foot climb was a lung-buster, especially with twenty pounds of photo gear, lunches, and a canteen of water on my back. Stopping often, we needed more than an hour to reach a windy ridge, opposite a point from which the band of rams had surveyed our approach without moving from their beds. All the while we worried that the sheep might flush and go elsewhere—and that our labors would be wasted. But probably because they haven't been hunted for almost a half century, the sheep did not bolt. Although bighorns are among the wariest of all big game, as any experienced hunter knows too well, they unaccountably become used to humans far more quickly than less elusive animals when they are protected.

At the top we sat down—collapsed temporarily—long enough to cool off burning lungs and to allow pounding pulses to return to normal. It is difficult to hold a camera and telephoto lens very steady when breathing as heavily as I was. Then while we rested, a remarkable thing happened. Several of the rams stood up and started walking slowly toward us, as if for a better look at the strange intruders in their lofty environment.

The rest of that day proved worth the hard climb many times over. Gradually the sheep became accustomed to our presence, and eventually they paid almost no attention to us. We spent several hours filming the rams, most of which were fairly young, from all angles and from such close range that only short telephoto lenses were necessary. With longer lenses we could even make closeups.

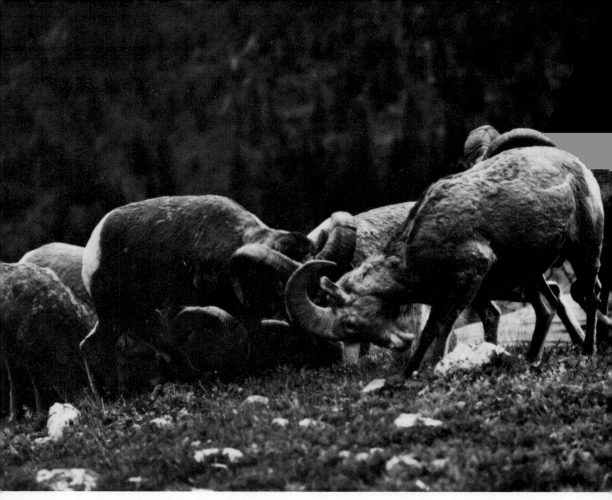

Young bighorn rams spar on slope high above Cascade Creek, Banff National Park.

Once a pair of rams trying to establish rank in the band lunged at each other and briefly crashed horns in their characteristic manner, and we photographed this, too.

In the past I had bagged a number of fine sheep trophies, and not one of these came easily. Nor were any as rewarding as the trophy pictures we shot this day high on top of Banff National Park. The long descent on foot and then on horseback was rendered much easier by memory of the remarkable intimate experience. That evening around the campfire, the inevitable muscle and saddle soreness had a bittersweet quality.

The final two days of the pack safari were as exciting as the first two. Each night coyotes came to serenade around the camp, but we saw none in daylight. We did meet two more lone grizzlies (although neither as close as the two families), making a total of

nine in just four days. That is a remarkable count in these times, when there is great concern among conservationists over the survival of the big bears.

We also saw and heard elk galore, because this was the period when bulls were busy gathering harems and there was a good bit of maneuvering in the open meadows around timberline. This is also the time when a very lucky photographer might find a pair of bulls fighting, but we were not quite that fortunate on this pack trip. We had already enjoyed our share of good breaks.

But exactly what is a pack trip—and specifically a photo pack trip? It is really camping out on horseback. Astride a saddle horse a cameraman can travel through remote and roadless country where motor vehicles cannot go or are not permitted to go. All of the gear follows behind on pack stock. These trips may be of any duration, and the longer the better. A single camp can be set up and daily excursions taken outward from there, or the entire outfit can be packed up and moved to a different location every day or two. The best course depends on where the animals are most easily found and photographed. It is worth noting here that a good many big-game animals can be approached much more closely on horseback than on foot.

It is easy enough to organize or join a photographic pack safari. There are horse concessionaires stationed in most of our mountain parks, and in addition many ranchers on the fringes of the parks and wilderness areas handle such expeditions on a part-time basis. Now a number of outfitters are specializing in trips to hunt big game with cameras. Our friend Mac Mackenzie of Banff already has much experience, and another good outfitter is Gene Wade of Hiland Guide Service, Cooke City, Montana. Wade covers the incomparable, lonely back country of Yellowstone National Park.

Often much wildlife photography is possible (along with mountain trout fishing and other activities) by joining one of the group trips sponsored each year by national conservation agencies. For information on these, contact the following: National Wildlife Federation, Conservation Travel, 1412 16th St. N.W., Washington, D.C. 20036; Wilderness Society, 1901 Pennsylvania Ave. N.W., Washington, D.C. 20006; or the Sierra Club, Mills Tower, San Francisco, Calif.

Outfitters usually make a good bit of equipment available. Normally they provide one saddle horse and one pack animal plus all the necessary tacking per rider, although extra pack stock may

be necessary for long or elaborate trips. A packer furnishes all camping gear, food, and tents—everything except personal items unless other arrangements are made. If the party is large enough, the packer will also furnish a horse wrangler, a cook, a trail guide, or all three. However, many riders enjoy helping with all these chores and thereby reduce their own costs for the trip.

All of our Western national parks and most of Canada's national and western provincial parks have excellent networks of trails which are well marked and maintained, even into the most remote areas. In the Western national parks alone there are about 15,000 miles of trails.

A wise outfitter will make his first day's ride short, especially if his riders are inexperienced. Each day thereafter the distance is extended, until at the end of a week a long ride is possible without any discomfort. Saddle soreness is rarely a problem if the first day's ride is limited to eight or ten miles. And toward the end of the journey almost anyone can easily travel more than twice that far.

Outfitter Mac Mackenzie lashes equipment onto pack horse for photo safari into remote portion of Banff National Park.

While younger people and those in good physical condition will get along better than older, inexperienced people in poor physical shape, age and experience are not all that important. I have been on pack trips with men and women well beyond seventy who were at least as thrilled by the adventure as anyone else. Besides, saddle soreness soon vanishes after eventful days of wandering in an alpine wilderness.

Several decades of protection (no hunting) and familiarity with humans inside the boundaries of national parks have gradually eliminated many wild animals' fear of man. They now tolerate a fairly close approach, especially if the rider does not dismount. In fact, large animals can occasionally become too friendly for one's peace of mind.

Several summers ago, during a trip to British Columbia's Assiniboine Provincial Park with my sons Park and Bob, we camped beside a mountain brook high in Policeman's Meadow. Our outfitter had hired a French student who was working her way across Canada (and who had never been in the bush before) to be the trip cook. No sooner was she established in the cook tent than she looked up to see a young bull moose peering at her through the tent flaps. Michelle exploded out the opposite end of the tent and raced far back down the trail before she was retrieved.

Maybe that moose really loved people. Anyhow, he followed Park when he went to collect firewood, watched us cook dinner, and stood around grazing with the horses. We couldn't fly-fish in the nearby stream for fear of hooking the friendly bull on the backcast. And during the night the ungainly animal tripped over a tent rope and became sufficiently entangled to pull it down.

No great amount of expensive personal gear is necessary for a summertime photographic pack trip. But a checklist should include the following items: comfortable and well-broken-in hiking shoes or boots (I like eight- or ten-inch-high birdshooter boots with Vibram soles); two pairs of jeans or riding pants; two flannel or light woolen shirts; changes of underwear and heavy socks; a Western wide-brim hat; foul-weather gear (I prefer a two-piece pants and parka suit of light, tough material); medium-weight sleeping bag and foam mattress; warm sweater or outer jacket; gloves; toilet kit; knife; camera and film; dufflebag; flashlight; and mosquito repellent. The outfitter may or may not furnish saddlebags, but in any case they are invaluable. In addition, carry good binoculars and bird, mammal, and plant guides. For much wildlife photography, you should have a long telephoto lens, at least 5×, to

fit your camera, even though such range is not always necessary. And since good fishing usually waits in all of the Western high country, why not also carry a fly rod or pack-type spinning gear?

Summertime pack-trip costs range (in 1973) from as low as $25 to more than $75 each day. The exact figure depends on the number of persons, the duration of the trip, and the services required—how much help the outfitter must hire. The larger the party and the longer the trip, the less it will cost each individual per day.

Many outfitters offer special rates for families, and these average about $100 per day or $550 to $600 per week for four or five. Less expensive than that are the several group trail rides organized each year by the Trail Riders of the Canadian Rockies, a nonprofit organization dedicated to enjoyment and preservation of the Canadian wilderness. These adventures run about ten days, accommodate twenty-five to thirty or so riders, and cost about $20 each per day. At that figure they are among summertime's best bargains. Although a group as large as this wouldn't have as many opportunities at intimate wildlife filming as a small party, they do see a good deal of game during the course of a trip. Inquiries should be addressed to T.R.C.R., c/o Banff Stables, Box 448, Banff, Alberta.

Pack-trippers enjoy many dividends besides the opportunities to photograph wildlife in its natural environment. There is the happy feeling of escape and the chance to see vast and changing panoramas at every bend of the trail. There is also the feeling of pioneering and the companionship of kindred spirits.

This isn't to say that all pack trips are unadulterated joy. There is nothing anyone can do about the sudden, sullen changes in weather which are part of life at high altitudes. Riders must not be surprised even by a snow squall in midsummer. Horses are not always predictable, and on certain chilly mornings an outfitter may have to delay his departure while he searches for lost livestock. At times mosquitoes and other insects can be troublesome, although never so bad that liberal doses of repellent will not discourage them. But these are minor hardships which become conversation pieces later on.

Except for such occasions as that rare blundering moose of Policeman's Meadow, mountain wildlife is never a hazard. Bears probably come first to mind as being dangerous, but I have never known of a problem or an incident with a bear, black or grizzly, during a pack trip. Sure they come around to inspect the camp

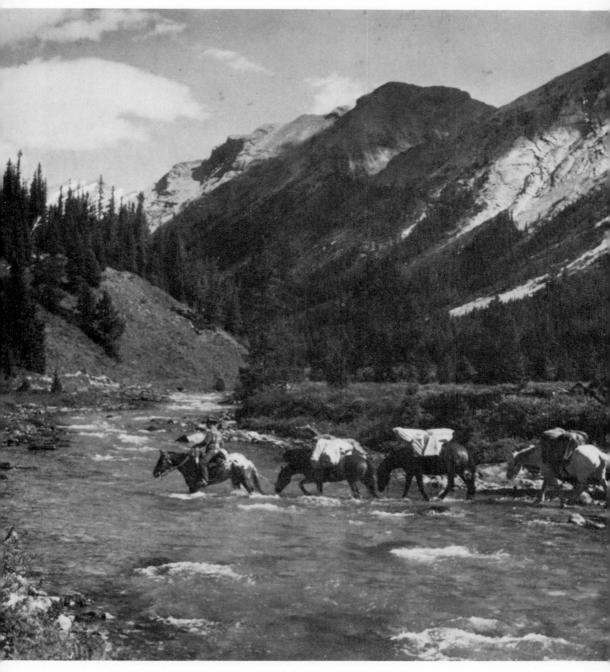

Camping gear and camera equipment packed, string of horses crosses cold creek to climb into high country.

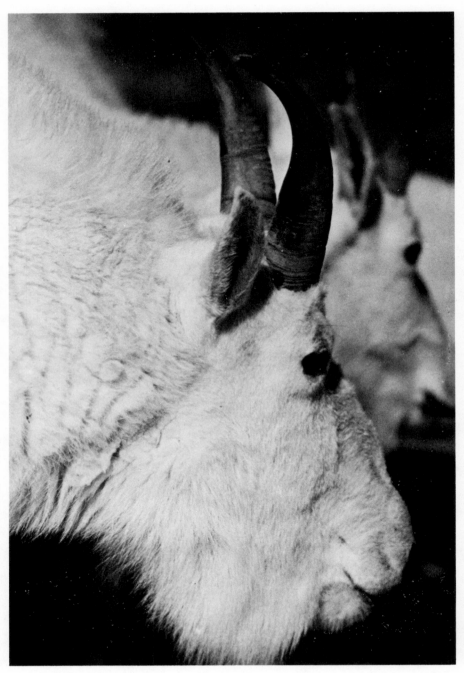

Close-up of mountain goat, an animal which is often tolerant of photographers who climb into his lofty environment.

from long range, but isn't the sight of a wild bruin an inducement to ride in the first place?

High altitudes can bother some riders briefly, and some trails may seem precarious to those unaccustomed to their mounts. But the altitude problems usually pass quickly, and no packer who values his reputation and future would ever lead guests over unsafe trails. Nor would he assign them horses which are not gentle, reliable, and sure of foot. In other words, the chance of accident on a pack trip is far less than when driving or flying to the starting point.

During recent years a new type of mountain adventure perfect for wildlife photography is being organized. It's called the pack hike, or hiking trip with pack stock. On these the cameraman hikes across game country carrying only one day's needs (lunch, foul-weather gear, camera, and film) in a light rucksack while an outfitter carries all of the camping gear ahead on pack animals. Camp is waiting at the end of each day's trail.

This is a compromise between backpacking and pack tripping — and has some of the advantages of both. Because only half as many horses are needed, the cost per person is much less. Of course it is a slightly more strenuous undertaking, and less mileage is covered during any given trip, but for some outdoorsmen these are not important considerations. Several pack hikes are scheduled each summer by the Wilderness Society, and the organization should be contacted for details. L. D. Frome, veteran outfitter of Afton, Wyoming, specializes in pack hikes deep into that state's Gros Ventre Mountains.

The only bad thing about any pack trip or pack hike is that it ends too soon. If you are a photographer, or simply want to savor the wilderness, put yourself in the saddle and see.

3

Cameras
and Accessories

A good many of the outdoorsmen interested in wildlife photography or planning a photo safari may already own a camera suitable or at least adequate for the purpose. That means a camera which is neither heavy nor bulky, is convenient to carry, and is sturdy and reliable. It should function perfectly both in warm weather and in intense cold. Most of all the camera should be one which can be used with interchangeable telephoto lenses.

But selecting a camera especially for the purpose can be difficult, because there are a bewildering number of good ones on the market. Although the perfect camera for shooting wildlife under many conditions does not yet exist, obtaining the best one boils down to every photographer obtaining what suits him best, what satisfies his own needs, and what he can afford.

Any camera is only a lightproof box or housing with five working parts: the lens, the diaphragm, the shutter, a film-holding and winding mechanism, and a viewing device or viewfinder. Some also have a sixth important part—a built-in exposure meter. The most important of the camera's working parts is the lens, because the quality of pictures is limited generally by the quality of the glass. The price of most modern cameras is determined largely by the quality of the lens.

There are so-called "fast" lenses and "slow" lenses—the "speed" in this case referring to the ability of a lens to collect and transmit light to the film. This speed is attained by using good glass and by complicated optical design which it is not necessary to explain here. More important to the cameraman is to know that

the maximum speed of any lens is always indicated with an f/number—such as f/11, f/8, or f/2—right on the lens. The lower the f/number, the faster the lens and the more light it can collect and deliver to the film.

For the wildlife photographer, a fast lens has important advantages. For one thing it permits using a faster shutter speed; that is very valuable because shooting wildlife is often a matter of trying to "stop" fast action. The faster the shutter speed, the less likely an action picture is to be blurred. Because they are better collectors of light, fast lenses also make picture taking possible when the light is poor. That also is a vital consideration, because a wildlife cameraman cannot always select an ideal spot in brilliant light in which his elusive subjects may pose.

Besides differences in speeds, lenses also differ in how sharply they transmit an image onto film. Although speed can be rated exactly—as f/3.5 or f/16—there is no easy way to measure sharpness. Some lenses have it, some haven't; other things being equal, the more you pay for a lens the sharper it probably will be. But to tell the truth, very few human eyes can detect the difference between the results of a very sharp and just a fairly sharp lens, even when comparable pictures are vastly enlarged on a screen. It's very difficult to distinguish between what is human error (unsteadiness when snapping a picture), subject action (a bird flushing), and lens sharpness when analyzing any photo. It's safe to say that nearly all medium-priced lenses will be satisfactory for nearly all amateur photography.

There are three types of shutters: the leaf shutter behind the lens, the leaf shutter between or inside the lens, and the curtain shutter in front of the film. The last is called a focal-plane shutter and is the one the wildlife cameraman should prefer in his camera, with some exceptions to be noted later. The focal-plane shutter permits easy interchanging of lenses, which is its greatest advantage. It also allows fast shutter speeds, up to 1/1000 and even 1/2000 second. But the focal-plane shutter does have one drawback: its uses with electronic flash are limited, because flash synchronization is possible only at low shutter speeds.

For flexibility on a camera safari, the photographer should have a wide choice of shutter speeds from 1/30 second to at least 1/400 or 1/500 second. If any camera-lens combination doesn't offer at least that, it's not well suited for wildlife filming.

A cameraman has two means of regulating his exposures: by setting the shutter speed or by setting the f/stop. I have explained

above that any specific lens will permit a certain maximum amount of light to pass through it. But a diaphragm regulates how much of the maximum passes through. Compare it to a valve on a pipeline. Opened wide, ten gallons of fluid per minute might pass through the valve; the more it's closed the less liquid gets through. The same is true with a camera lens. The larger the diaphragm opening, the more light passes through the lens when the shutter clicks.

Diaphragm openings are known by several terms: as the lens opening, lens stop, f/opening, f/stop, and f/number. But by any name they only measure the size of the diaphragm aperture and therefore how much light can get through it. Let's illustrate the actual example of an f/2 lens. As explained before, this f/2 indicates the maximum opening (or light capability), but the lens also has diaphragm openings marked f/2.8, f/4, f/5.6, f/8, f/11, f/16, and f/22. The amount of light—the exposure, really—is regulated by changing from one of these to the other, or from maximum light at f/2 to minimum light at f/22.

The intervals on any lens between f/numbers are called full stops because f/2 is twice as fast (permits twice as much light) as f/2.8, and f/2.8 permits twice as much light as f/4, and so on. On most good cameras it is also possible to set the diaphragm opening halfway between the full stops, at what are called half stops, for more exact exposures.

Let's pause here for a moment and consider exposures in a little more detail. Keep in mind (from the above) that f/8 will permit twice as much light to reach the film as f/11. Consider also that 1/50 second shutter speed permits light to reach film twice as long as 1/100 second. Therefore an exposure of f/8 at 1/100 second will be exactly the same—will produce the same picture of a stationary subject—as f/11 at 1/50 second.

Going a little farther for clarification: f/11 at 1/50 second equals f/8 at 1/100 second equals f/5.6 at 1/200 second equals f/4 at 1/400 second, and so on down the diaphragm. It is a matter of letting bright light into the camera briefly, or dimmer light into the camera longer, to equal the same total amount. Again compare it to the pipeline and valve. Wide open, the pipeline fills a bucket with liquid in a short time. But with the valve partly closed, it takes a longer time to fill the bucket.

A diaphragm has another function, and that is to regulate what is called depth of field. Depth of field is the distance before and behind the camera's subject in which all objects are in focus. The larger the f/stop number (or the smaller the diaphragm

opening), the greater the depth of field. This depth of field has considerable importance in more advanced wildlife photography and will be reconsidered later on.

Another integral part of any camera is the viewer or viewfinder. This is where every picture is composed; it shows the picture you will obtain when you squeeze the shutter. Today's cameras are equipped with one of two main types: the waist-level or chest-level viewer, or the eye-level viewer. The latter is generally preferred and is more common.

Chest-level viewers are mostly confined to twin-lens reflex cameras and to a few single-lens large-format ($2\frac{1}{4} \times 2\frac{1}{4}$-inch film size) cameras. The photographer holds the camera against his upper body and looks down into the viewfinder. There is some advantage in this for a cameraman who wears glasses. The viewing screen is protected from reflections by a folding hood. Nearly all cameras with chest-level viewers also offer adapters which permit eye-level shooting. For wildlife shooting alone, particularly of action or anticipated action, the eye-level system is by far the fastest and handiest.

There are occasions when open-frame wire or grid (often called sports-type) viewers will come in handy for capturing action which might materialize suddenly from any direction. With this the photographer pre-sets his focus and exposure, then more or less shoots in the general direction of his target, hoping to catch it somewhere in the frame. The open-frame viewer also allows the photographer to see beyond the edges of the picture he is composing or anticipating.

The final vital part of every camera is the film holding and winding mechanism. It is usually a simple system of rollers and sprockets, and it is not necessary to describe it here. However, the film winder should serve other purposes than just advancing film for a wildlife photographer. For convenient, rapid shooting, it should automatically cock the shutter for the next picture as each frame is advanced. It should also serve as a safety device which prevents double exposures, which clearly indicates the number of unexposed frames in the camera (through a window or dial), and which prevents winding the film *out* of its cassette after the last exposure on a roll.

An important development of the past decade or so is the trouble-free motor-driven film winder and advancing device, usually called motor drive. These are expensive, but are tremendously valuable to the most serious wildlife cameraman. They are

great for shooting picture sequences, but their value goes much beyond that. A cameraman can concentrate far more on his subject, without taking his eye from it, when he does not have to be concerned with the chore—really the distraction—of advancing his film. Too many really good bird and animal pictures are missed that way.

Modern cameras range in size from the miniatures which fit into shirt pockets and use 16mm roll film, to the large press or studio cameras which handle sheet film from $2\frac{1}{4} \times 3\frac{1}{4}$ to 8×10 inches in size. In between are the various cameras which use 35mm film and those slightly larger which use $2\frac{1}{4} \times 2\frac{1}{4}$-inch (120) film. These last are the only kinds really practical for successful wildlife photography today. The miniatures still are really novelty items, and the big box cameras are too heavy and cumbersome to use on fleeting targets. Also, film for big cameras is far too expensive for shooting birds and animals, except under near-studio conditions.

Probably the Polaroid, which produces pictures only seconds after shooting, should be mentioned. A Polaroid might be suitable for some outdoor photographer satisfied with album prints only. But at least as this is written, no Polaroid can be fitted with a telephoto lens, and they therefore have very little if any application for wildlife filming.

The selection of a camera—or rather a camera system—boils down to this: The only really suitable ones for the purpose are 35mm single-lens-reflex and $2\frac{1}{4} \times 2\frac{1}{4}$-inch single-lens-reflex cameras.

By far the most flexible and versatile of the two is the 35mm SLR (single-lens reflex). With any telephoto lens it is lighter and easier to use in almost all situations than the $2\frac{1}{4} \times 2\frac{1}{4}$-inch SLR equipped with a telephoto of the same magnification. The latter is more expensive; a photographer can figure on spending about twice as much for a 120 SLR than for the best in 35mm SLRs. The 120s are excellent when filming from a safari car, from a blind, or from some similar stable platform, and the much larger color slide or black-and-white negative takes reproduction and enlargement better. But with a long telephoto lens and waist-level viewer, the 120 SLR is not ideal for a photographer on foot or faced with sudden action situations.

With any waist-level reflex the image of an animal or bird traveling from right to left is actually going the other way on the ground glass, and it is not easy to get used to this inconvenience. But an eye-level prism adapter corrects this problem and it is possible to follow the target as when swinging a shotgun.

Probably because there are so many good ones on the market and the competition is so keen, a 35mm SLR is any wildlife photographer's best selection—as long as the "normal lens," with which it is sold, is interchangeable with telephoto lenses. "Normal" in this case means a lens which gives a picture exactly as the naked eye sees it. In the case of the 35mm camera, the normal lens has a focal length of about 50mm, and this focal length is stated on every lens of every kind manufactured. By comparison, the normal lens of a $2\frac{1}{4} \times 2\frac{1}{4}$-inch camera has a focal length of about 80mm.

A good many photographers who take their wildlife safaris seriously carry both a 35mm SLR and a 120 SLR all the time, and I am one of them. But more and more the 120 is employed just to shoot scenes, landscapes, plants, wildflowers, and other static subjects, but seldom birds or animals in action. It isn't as maneuverable or quick to operate. Probably the best advice to the outdoorsman who can afford two outfits is to obtain two identical 35mm SLRs with all lenses and accessories interchangeable back and forth between the two, rather than one 35mm and one 120.

There are a number of good reasons for the identical outfits. First, it is easier to get used to just one camera operation; you simply are more efficient and automatically get better pictures. When you have to transfer back and forth from one style to another, you are slowed down and make mistakes. There is also the matter of malfunction. No matter how well you care for even the finest camera, something can go wrong when you are far from a skilled repairman. When that occurs, the spare camera with interchangeable lenses becomes worth its weight in gold.

Still, neither the camera nor any of its accessories is the wildlife photographer's most valuable possession. Too often a photographer is congratulated for a good picture by the comment: "My, but you must own an expensive camera." Or, "I can't get pictures like that with my camera." But any camera isn't all that important.

One summer several years ago, I spent a few days driving a party of five friends through Yellowstone National Park. All had very similar photo equipment. We concentrated on shooting the wildlife—everything from herds of elk along the Madison River to rafts of waterfowl in Hayden Valley. Very often all of the cameras were aimed at the same time at the same targets. All should have been getting the same excellent pictures, because the weather was perfect and the wildlife was especially cooperative.

But I wasn't at all prepared for the results. Several months

later we got together for a slide screening, and no stranger would have guessed that all of us were together on the same trip. Not only did photo quality vary greatly, but the same animals were snapped at different times and in different stances by different people; some caught the animals at alert, exciting moments so that the pictures were really alive, and others snapped when the animals seemed only to be stuffed replicas and the pictures were dead. The moral here is that it is the man behind the camera, and not the price tag outside or mechanism inside, which really counts.

Since an increasing number of underwater parks and sanctuaries especially for marine life are being set up around the world, an underwater camera is well worth considering. Not long ago, underwater photography required very specialized and very expensive equipment (such as complicated waterproof housings fitted to above-water cameras), but today a number of moderately priced 35mm cameras for underwater work are available. These are very easy to operate (some even including built-in exposure meters) either with scuba equipment or only a snorkel mask and swim fins. With this gear many cameramen are discovering that the underwater world, especially in the sea, is at least as fascinating as the wildlife community above.

No matter what the camera, the owner should completely familiarize himself with every part of it. In fact it should become an extension of himself for the best results. The more the cameraman uses his camera, even in practice and without film inside, the more proficient he will become. And that is crucially important when his subjects are the beautiful but fleet creatures of the wild.

Camera Accessories

The most important camera accessory a cameraman can ever take on safari is a telephoto lens — and perhaps more than one. In many places satisfactory pictures will be out of the question without this optical aid.

A telephoto is a lens with longer than normal focal length. It magnifies the size of the subject while transmitting it onto film. In other words, it draws target and cameraman closer together. Its importance is evident when you are trying to shoot a shy bird or animal which is most determined to keep its distance. However, that is not the only employment of a telephoto, as we will see.

As stated in the preceding section, every lens is marked both with the maximum f/stop and the focal length, the latter in meters or centimeters. That is true of telephoto lenses, too. The greater the focal length of a telephoto, the slower the lens (the smaller the f/stop). Long-focal-length telephotos also have a shallow depth of field, and this is both a great advantage and a disadvantage.

It is easy to determine the magnification of any telephoto lens. Suppose a certain lens for a 35mm camera has a focal length of 200mm. Now divide 50mm (the normal focal length for 35mm cameras) into 200 and the answer is 4. In other words that 200mm lens is 4×, or 4-power, and reduces the distance between cameraman and subject to one-fourth of what it would be with a normal lens. By the same mathematics, a 300mm lens is 6×, and so on. When figuring the magnification for a lens designed to be used with a $2\frac{1}{4} \times 2\frac{1}{4}$-inch format camera, divide the focal length of the lens by 80. In other words, a 250mm telephoto for a $2\frac{1}{4} \times 2\frac{1}{4}$-inch camera is slightly more than 3×, or 3-power.

Telephoto lenses are today available in great magnification — to 1,000mm, 1,500mm, and even more — and the temptation too often is to buy the longest available to bring even the most distant wildlife up to within eyeball range. But it isn't that simple. The very long telephotos are not easy to use even in ideal circumstances; in truth they are impractical except in very specialized conditions. It is sound advice to purchase all telephotos with great care and caution, and following are some suggestions.

It is safest to stick to the telephotos designed by the manufacturer specifically as part of the camera system you own or plan to buy. If you have a Nikoblad (not a real name) camera, for example, get a Nikoblad telephoto designed to fit it, not something else which must be adapted to fit, or which is made to fit a variety of cameras and isn't the best for any of them.

Subjects are harder to arrest — and sharpness in pictures harder to obtain — the longer the telephoto you use. This is because the slightest camera movements are magnified and even a slight breeze or heat waves can have an effect. Therefore avoid the very long focal lengths, which can often be as disappointing to use as they are cumbersome.

Inexperienced cameramen especially should resist the temptation to buy anything longer than 500mm. Actually, better still is nothing longer than 300mm, or about 6×. It's well enough to acquire the super-long lenses if money is no factor and you can have several. But if you can afford only one or two, think about

telephotos in the 200mm to 300mm category. With experience and an increasing knowledge of wildlife behavior you will be able to get closer to your targets by means other than just optics alone.

Another newer type of lens which brings subject and cameraman closer together is the mirror or reflex lens. It has advantages and disadvantages, but the latter are not that serious. The mirror lens uses the same principle and system of curved mirrors as the reflecting telescopes used by astronomers. These are fairly lightweight, much shorter (say about half the length) than other telephoto lens of the same focal length, and at least in my opinion are easier and faster to use when pursuing wildlife than normal telephoto lenses. However, mirror lenses are somewhat larger in diameter, and as this is written are available only in fixed-aperture diaphragms. Most have *only* an f/8 or an f/11 lens, so exposure can be set or changed only by changing the shutter speed. That is a handicap, but not a great one. Somewhat more annoying are the bright halos or glitters which may appear on bright reflective surfaces when the photographer aims his reflex lens into the source of the light. But in good over-the-shoulder sunlight, a mirror type of telephoto produces excellent photos, and many of the illustrations in this volume were shot with that type of lens.

Mirror lenses are manufactured to 2500mm focal length, but I do not consider any longer than 500mm (f/8) to be practical on any kind of photo safari. Perhaps by the time this reaches print, mirror lenses will be available with adjustable f/stops; at least that is now the goal of many lens designers.

Still another type of telephoto lens now available for many of the 35mm cameras is the zoom. This gives the photographer an easy, quick choice of focal lengths all in one tube. The main advantage is having to carry only one lens instead of a selection. Typical zooms offer ranges from 90mm or 100mm to 200mm or 250mm. They are heavier and more expensive than telephotos of a single focal length. Some wildlife photographers have found that they do not get the same sharpness of image—the same sharp picture—at all focal lengths. Although zoom lenses have shortcomings for serious wildlife shooters, further development and new models just might change that situation.

Many camera hunters—including a number of busy professionals—like to mount their favorite camera and telephoto combinations onto gun stocks or similar shoulder devices for faster shooting. I have seen very elaborate rigs carefully tooled to fit the shooter's body and have no doubt that these work very well. Some

well-made commercial stocks are available. But for no better reason than personal preference I do not use these and consider them mostly as extra weight to lug around. And both weight and bulk are very important considerations when you must travel far on foot.

Wildlife filming safaris seldom take a photographer where weather and atmospheric conditions are always ideal. You must figure on encountering rain, wind, snow, heat, and humidity. Moisture and dust become important nuisances. Both hinder the smooth operation of cameras and affect the quality of finished pictures by getting in the lens. Anyone planning a safari anywhere must also plan how to keep his equipment clean and dry.

The usual zippered or snappered camera cases and equipment bags are next to worthless wherever there is rain or the slightest amount of dust. Heavy plastic freezer or garbage bags which can be sealed are much better. When traveling by plane or car, all of my cameras and lenses are carried and sealed inside sturdy aluminum luggage lined with polyurethane foam to soften shock, vibration, and rough handling. Later when in the field, each item is carried in a separate plastic bag, and I take along plenty of spare bags.

For pack trips or horseback traveling, all equipment also goes into plastic sacks, and these into compartmented saddle bags handmade especially to fit my cameras. I've had horses actually fall and roll on top of 35mm cameras in these bags, without damage to the equipment.

During backpacking safaris or whenever it is necessary to carry equipment far on foot, I use a light water-repellent nylon mountain rucksack. Again each item is protected in a plastic bag. For traveling over water, especially in canoes or small craft where there is moist spray, those same aluminum pieces of luggage will serve. It is also possible to obtain waterproof field radio "packs" in military-surplus stores. Designed to carry communications equipment during combat, they come in various sizes and will protect photographic gear under almost all conditions. They cost only a few dollars each.

Extreme cold is another weather condition a photographer might encounter. Cold itself does not harm equipment, but one thing absolutely to avoid is bringing cold cameras and lenses suddenly into warm rooms. The condensation which can result can cause serious trouble, especially inside lenses and diaphragms. Also do not leave cameras lying in bright hot sunlight, particularly not

with the uncovered lens facing upward toward the sun. Not only does the heat affect the film, but sunlight focused through a lens can sear or warp delicate parts inside.

An exposure meter can be helpful, even indispensable, to a wildlife photographer, especially when the light is poor or constantly changing. But a meter can also be a nuisance. There is no way to calculate the number of great wildlife photos which have been missed while the photographer was taking a light reading instead of aiming his camera.

Many, probably most, of today's cameras have accurate built-in light meters, and these are a vast improvement over the old meters which hung around the cameraman's neck. But the serious wildlife photographer shouldn't be totally dependent on these either. Long before going afield he should know the correct exposure for shooting subjects well illuminated in good sunlight. He should also be sensitive to changes in light and be able to adjust accurately for these. Of course this skill only comes with practice and experience, but it seems a waste to undertake a long trip, perhaps a greatly anticipated and expensive trip, and not really be prepared to make the most of it.

Probably this is a good point at which to digress and describe one tragic incident in the hope that others will not duplicate it. George Brown, as I will call him, booked on a photo safari to East Africa after several years of planning and saving. For the purpose he purchased a new high-quality 35mm camera with a built-in exposure meter and a selection of interchangeable telephoto lenses. He spared no expense in buying the outfit because this was to be the adventure of a lifetime.

Now Brown was a businessman and a very astute one. He never made many mistakes—and if he had applied the same common sense to his trip planning that he used in business, this tragedy wouldn't have occurred. It was simply that he didn't take the time to shoot even one role of trial film through his new camera before heading for Africa. When he returned after thirty days of extraordinary experiences, he had not one bit of it on film. The exposure meter on which he relied entirely wasn't working properly, and the result was thirty-five rolls of blanks or near blanks.

That word to the wise should be sufficient. Even if he had failed to test the new equipment, Brown would have fared well if he had only checked the exposure tables which come inside every single package of film. The tables are only approximate, but if your

exposure meter doesn't tally with them at all you know that something is wrong with it.

The type of exposure meter I have found handiest for my own needs is a spot sensor type. I carry it in a small pistol-type holster on my belt and use it when a critical reading is needed on some specific subject, usually a bird or animal in heavy shadow. With this meter it is possible to get an accurate reading on just a small object from far away, whereas built-in camera meters measure light on the entire scene, unless they are held close to the subject—which is utterly impossible in the case of lions, bears, or even the robins on the front lawn.

So many really fascinating photographic devices and gadgets are on the market—and some are even extremely helpful—that it becomes difficult to resist them. It is also easy to become a photo-gadgeteer rather than a photographer because so many of the devices are fascinating in themselves. But the cameraman who wants pictures he can brag about is better off to stick with the minimum gear. Still, there are a few more items of importance, and heading the list are lens shades or hoods. Unless you are shooting from the protection of shade, you need something to keep direct rays of the sun from the lens glass when shooting back-lit or side-lit subjects. Shades are made to fit all lenses and are inexpensive.

A wide-angle lens is one which moves the subject farther away, as opposed to the telephoto, which brings it closer. One of these may be useful in filming activities connected with a wildlife safari—say a camp interior scene—but it has virtually no use in shooting the wildlife.

Tripods provide rock steady bases for shooting many pictures and are positively required for motion-picture photography. A tripod can also be useful if you are alone and want to take a picture of yourself with a self-timer on the camera. But for wildlife still photography, it is only another cumbersome article to tote about. A unipod, being lighter, is some improvement, but better still is to perfect your own technique of holding the camera and lens completely steady. A clampod, a device which clamps onto a car door when the window is rolled down, is helpful when making a safari in which you are entirely confined to the safari car. These are small and take up little space.

Flash equipment—and there is a bewildering assortment of it available—has great application for some professional cameramen who shoot wildlife at night or under controlled studio situations. A

simple flash attachment may also be useful for camp and other pictures associated with wildlife photography, but probably not for the birds and animals themselves. It's almost impossible to approach within flash range of genuinely wild creatures.

For black-and-white photography, filters which fit onto the lenses can improve pictures. Yellow filters darken sky and outline clouds against a dark sky; orange and red filters darken skies even more than yellow and give pictures greater mood. There are a good many filters also available for use with color film—under the names "skylight," "haze," "pola-screen," "conversion," etc. They're advertised to "correct" color and eliminate haze, and Polaroid filters do indeed eliminate some bright reflective surfaces. But I don't normally bother with any of them and don't honestly believe they contribute much to better photographs. Just getting a bird or a bear to wait while I take its picture is enough to think about.

Care and Maintenance of Equipment

Far too often the major reason for failure to obtain the best possible pictures during a photo safari is neglect of equipment. A cameraman can be surrounded by the most exciting opportunities and still not capture any of them if he has not taken care of his gear. Care means keeping both the glass and the moving parts clean.

After every busy shooting session—and this may be several times a day during a safari—lenses should be cleaned carefully. For that purpose carry along a good camel's-hair brush and a supply of lens tissues. In a pinch it may be necessary to use something else to wipe the dust from a lens; in such an emergency be sure to use a very soft cloth which is lint-free. A rough cloth or a dirty one containing even the tiniest abrasive particles can scratch the chemical coating which covers most good optics. Do not breathe or blow on lenses for any reason, and also avoid fingerprinting any glass surfaces.

A good way to keep dust from collecting on a lens in the first place is to use a lens cap when not actually filming. However, there is a great hazard here if the camera is other than a reflex type—one in which you look directly through the lens when composing a picture. On other types, some really fine material has been lost when the photographer forgot to remove the lens cap before filming. Unfortunately that is possible.

Photographers on long trips anywhere are likely to encounter the worst possible conditions of dust, sand, moisture, and even frost, all of which can somehow permeate his photo equipment. Therefore everything should always be transported in dust-proof, waterproof containers (carrying bags), described in detail in the preceding section on photo accessories. That advice cannot be emphasized enough. Of course, it isn't possible to keep equipment totally protected *all* the time, but here are some suggestions.

On one trip recently I watched a busy photographer frequently change telephoto lenses as the situations warranted. Generally he was very tidy with his gear, but I noticed that he set aside various lenses when not in use without capping the open, unsealed ends that fit onto the camera body. As a result he was collecting a lot of dirt *inside* these lenses, which is a lot worse than the dust collected on the front glass. The latter can easily be cleaned by brushing; interior cleaning is much more difficult and may even require dismantling by an expert repairman.

Avoid placing cameras or lenses on any bare ground, but especially on sand beaches or where dry sand is blowing. If you must change lenses under such conditions, try to find some kind of shelter or windbreak, your own body if it is all that's available. After every day or so of photography in a dusty situation, wipe everything thoroughly, including the inside of your camera bag or whatever container you use.

Moisture—rain—can be just as troublesome and damaging. There is no denying that pictures of wildlife in the gloom of rain or a snowstorm can be very dramatic and well worth shooting. But no camera (except underwater models) can stand such exposure very long without small dribbles of water seeping inside and causing serious damage. If you must shoot during rain or snowfall, shield the camera with anything available, maybe just the ten-gallon hat you're wearing. Wipe everything thoroughly dry the minute you're finished.

Salt water can be the most insidious agent of all. When it gets into the moving parts of a camera, it can corrode them and cause irreparable damage. Every cameraman must be especially careful of all his equipment when he is working around the sea or ocean.

Often when a cameraman is going ashore by boat, or even when he is shooting seascapes near the water's edge, there is a salt spray so fine that it seems like nothing at all. But eventually the water evaporates and leaves tiny, powdery salt crystals behind. The salt powder is fine enough to sift inside and reach the moving parts

of a camera. Whenever this possibility exists, keep the camera covered inside its container or in a plastic bag.

The most critical time for a camera comes when changing film. Most often photographers are advised to change in shade (at least not in direct sunlight), but it is far more important to do so in a clean place where no dust or spray is blowing. Always be absolutely certain your hands are clean—that dirt, sand, or moisture is not clinging to them—because these substances are so easy to transfer inside to the winding mechanism.

Years ago, during a trip to Alaska to photograph Dall sheep, I had to change film high on an unsheltered mountainside battered by wind and windblown particles. My hands were numb with cold. Carelessly I allowed several particles almost too small to see get onto the rollers over which film passed as it was exposed and later rewound. It resulted in thin, parallel scratches over every picture made thereafter. I didn't discover the horrible error until I got home again and projected the slides on a screen. Although these were some of the finest sheep pictures I ever made, not a single one was fit for publication. This warning should be sufficient.

It is wise to check the rollers and winding mechanism frequently for foreign matter. They get dirty far more often than is generally suspected. An even better suggestion is to have all cameras cleaned regularly by an expert repairman, if possible by someone authorized to do warranty work for your particular brand of equipment. That is especially sound advice after any long safari during which the camera was frequently opened and much film was wound through it.

Never try to oil or otherwise lubricate moving parts of a camera to make things work better. All cameras are designed to function completely "dry." Oil is only another kind of foreign substance to be totally avoided.

Unless you happen to have unusual skills with delicate photo equipment, leave all repairs to those who are qualified to make them. On the other hand, it is worthwhile to carry along the camera handbook and a few miniature tools to make repairs in those desperate situations far from home. A much better idea, though, is to carry a spare camera.

Even just carrying the camera is no small matter nowadays on long safaris to distant parts of the world. When traveling by air, always carry as hand luggage—and do not check as baggage—*all* of your photo equipment (except perhaps tripods, etc.), and that

includes both exposed and unexposed film. There will be times and places, especially when dealing with foreign airlines personnel, when someone tries to prevent your carrying a bulky camera case into the cabin. It may even be too bulky for your own seating comfort. But by all means insist on handling it yourself and be firm with anyone who says otherwise. You simply cannot allow baggage handlers to be responsible for such valuable gear. Nor can you afford to have it stolen. Photo equipment is very attractive to thieves because it is so easily resold.

Nor should any photographer who values his pictures allow his film (exposed or not) to be passed through any of the bewildering number of devices designed to detect airplane hijackers. Some of these are "guaranteed not to expose film," but it's foolish to trust them when it isn't necessary; no laws yet require that film or cameras be so inspected. Instead a photographer should be prepared to courteously but firmly inform inspectors that he is perfectly willing, even anxious, to have everything minutely checked — *by hand by the inspectors.* But no more than that.

Before leaving the United States or Canada, every photographer should register any foreign-made equipment with U.S. Customs at any border crossings or international airports. The serial numbers of all cameras and lenses must be recorded; otherwise on return it may be necessary to pay duty as high as 20 percent on any gear which was manufactured elsewhere, as most modern cameras have been.

To date all types of fresh film have been available in unlimited supply completely across the United States and in Canada, western Europe, Japan, Australia, and eastern and southern Africa. High quality and prompt processing is also possible in these places. But photographers venturing elsewhere, especially to Asia or Latin America, cannot depend on finding what they may require. Film may be outdated, very scarce, nonexistent, or outrageously expensive. In tropical countries there is the additional danger that film may have been damaged by storage in heat. So the best advice is always to carry along more than you anticipate you will need, or at least as much as the law allows at your destination. If you're traveling with a spouse, or in a group, carry the maximum number of rolls of film permitted to enter for personal use and not for resale.

Do not count on obtaining additional cameras, lenses, or other photo gear in the numerous "free ports" or "duty-free shops" around the globe. To begin with, the odds are 50-50 you will not be able to obtain exactly what you need. (Items stocked are seldom

what wildlife photographers are apt to need.) And if you do, it may not be such a bargain anyway—after you pay duty on the item when returning to the United States. Recently a group of touring professional photographers checked the gear offered in several photo shops in Hong Kong, a place with a reputation for camera "bargains." They found that the prices were only slightly better than those for the exact same items in New York and Los Angeles stores.

But the best of all reasons not to depend on a camera purchased en route is that you're not even sure it works. A good many of them may not. It is false economy to take a long, perhaps expensive photo safari and take a chance on vital equipment you've never tested.

4

Camera Techniques

It is true that some of the most spectacular wildlife pictures — no doubt the majority — are made by professionals with unlimited time to devote to it and with very sophisticated equipment such as elaborate blinds, electronic flashes, and remote controls. But not all of them. A surprising number of fine pictures are shot by amateurs using uncomplicated gear. And anyone with sufficient interest can get at least pleasing results.

There are no secrets or mysteries about shooting good wildlife photos, nor is technical training that important. Very few of today's best and most frequently published wildlife cameramen had any formal training in photography as a profession. But all agree that good results depend on concentrating on the basics which apply to any kind of photography, on taking advantage of every opportunity, and on exposing plenty of film. Let's consider these in order.

Basics include such very obvious things as holding the camera steady, using the proper exposure, and composing the picture. The last is done in the camera viewfinder; the photographer snaps the shutter when what he sees there pleases him.

Let's assume you are photographing a deer which is in good range and is very cooperative, or at least in no hurry to race away. Before shooting, be certain the animal is in sharp focus, be sure the horizon is level, include *all* of the deer in the picture (in other words, do not cut off its head, antlers, or feet), and finally, be certain that there is no distracting material around the subject and especially in front of it. These points are very elementary, but at least in the beginning the wildlife photographer should consciously

41

check off each one. Eventually it will become second nature—involuntary—and the photographer will compose good pictures without really thinking about it.

There is one important exception to all the above. If you are confronted with an important action situation or a very dramatic event, shoot first and think about the composition checklist later.

Every really outstanding photo has a strong center of interest, and for the wildlife cameraman it is some wild creature. Ideally it should be in good bright sunlight, and often a delay of a second or two may allow it to shift into a better position in brighter light. But for a picture of that same creature which is especially striking—say a cover picture—try to achieve contrasts. If it is a light-colored animal, strive to shoot it against a dark background, say a dense spruce forest, a granite rock, or the like. If the target is dark, try to outline it against a light background, possibly early green vegetation or even snow. Of course there are always exceptions, and a typical one would be the picture of an animal such as a zebra or a snake against a neutral background to illustrate how well the species blends into its natural environment.

Composition depends on what the photographer is trying to achieve—on the kind of wildlife photo he wants. For instance, one cameraman (the counterpart of the big-game trophy hunter) may want pictures of individual male animals in magnificent poses. These are not easy to shoot. Someone else might prefer portraits, another action, and still others pictures of wildlife with young or in their natural environments. But probably the most rewarding safari is the one on which the photographer takes what comes along and tries to shoot all of these.

Often a cameraman can shoot both a picture which emphasizes or centers on the subject and another which stresses the environment simply by changing the f/stop on the lens. The smaller the f/stop (say f/2 or f/3.5), the more of the background will be blurred and the more the subject emphasized. But close down the lens diaphragm to f/11 or so and the background also comes into focus.

Not too long ago when both film and camera lenses were a good deal slower than today, photographers were correctly advised to shoot only when the sun was well above the horizon and shining directly on the subject. But that would be very poor advice now. Bright, over-the-camerman's-shoulder light is certainly welcome, but a traveler on a camera safari should never hesitate to shoot when the sun is very low, when light falls on the subject from behind (back-lit) or from the side (side-lit), or even when the target is in deep blue shadow. Some of the most exquisite wildlife pictures

of all have been taken in poor light. In fact, many species of birds and animals never emerge from the shadows at all, and there is no alternative but to make the most of very little illumination.

The best advice of all is to take advantage of every opportunity—to be ready for chances when they come along, no matter how unexpected. If it is a partially cloudy day when the sunlight keeps changing, also keep changing the exposure on your camera to match, even though nothing is in sight. Something might be, in a split second.

Always have an extra roll or rolls of film handy so that you can change the minute one is exposed. Too many photographers have been caught digging deep into film bags when they should have been aiming at a rapidly disappearing subject. Better still is to have a spare second camera loaded and ready to shoot whenever the other is empty. Even proper clothing can be important. I try to wear shirts, pants, and jackets with many roomy pockets so that film, filters, and lenses are always at my fingertips.

I have met many photographers who seemed very reluctant to snap the shutter—to use up much film—and that always seems hard to understand. Film is expensive, but when its cost is considered against the cost of taking a distant trip, it is a false economy not to use plenty of film.

Although filming wildlife may be the main objective of a safari anywhere, every trip furnishes other opportunities for good outdoor and adventure pictures. It has already been pointed out that the best wildlife filming exists in national parks and similar sanctuaries. These also happen to be the scenes of the greatest natural beauty left on earth. Why not make the most of it?

For most cameramen who revel in escaping into the natural world, shooting spectacular landscapes is especially fulfilling. But getting the best possible results isn't always quite so simple as just aiming at a distant mountain range and snapping the shutter. Too often what seemed a chain of massive, snow-covered peaks in the viewfinder becomes only a thin line of hills on the finished slide. But this deception is easily overcome.

For nine in every ten distant scenes, the telephoto lens is the best one to use. It brings such geographical features closer to the cameraman and "stacks" these up in the viewfinder. It also restores detail which is lost when a short-focal-length lens is used on a distant subject. In other words, the same telephoto lenses which make wildlife photography possible are often also the best for capturing the landscape.

Still another use for the telephoto is to shoot pictures—por-

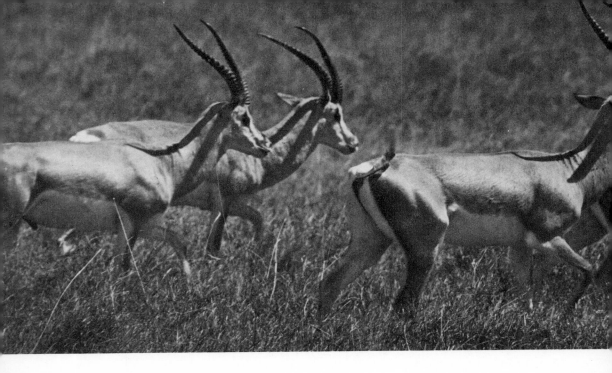

traits, really—of friends, colorful native peoples, outfitters, guides, game scouts with whom you share the trip. But revert to shorter lenses for photographing wildflowers, insects, or other similar natural features which are encountered on typical trips. Remember also that many kinds of smaller wildlife—jays, squirrels, mice—can be attracted to the vicinity of campsites. Given food tidbits, they may become very tame and are fun to photograph close up during idle moments.

Camp and trail life is also well worth photographing just for the memories. If the safari camp is in a scenic spot, shoot it from all angles. An evening campfire with friends silhouetted against it always makes a good picture. If on a pack trip, watch for opportunities to shoot the pack string winding its way into the mountains. Good subjects also are other photographers taking pictures of wildlife. Or if fishing wilderness waters is a dividend of the trip, shoot pictures of this activity, too. The possibilities are absolutely unlimited.

Stalking Game with a Camera

Of all parks in America, Yellowstone is where the most humans come in close contact with the most wild animals. And

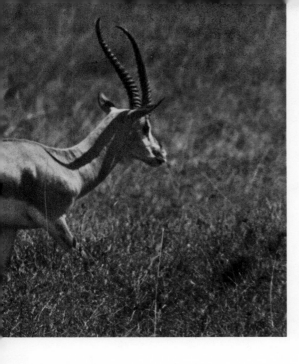

Each of these male Grant's gazelles is an outstanding trophy. A telephoto lens made the shot possible.

perhaps there is no better example than here that wildlife is neither dangerous nor a hazard to man, and that includes men armed with cameras. In fact it is amazing that far more incidents or "accidents" between humans and animals do not occur, considering the strange behavior of too many park visitors.

One day in late September I came upon a band of elk not far from a park road and in good position to be photographed. In the herd were eight cows and one huge master bull. Keep in mind that September is also the rutting time of elk, and that fact should have been obvious to anyone nearby; the bull was alternately bugling, urinating, and slashing out at small trees in his path with ivory-tipped antlers. Altogether it was a dramatic scene, and I grabbed a camera to film it from a safe distance.

Soon other cars stopped, and several other cameramen stood nearby snapping pictures. But one man who must have had scrambled eggs for brains kept crowding closer and closer, ruining the scene for everyone else. The bull became increasingly annoyed by his intrusion. When the photographer was only about twenty feet away, the elk swung suddenly around and narrowly missed impaling the man, who abandoned his camera. A tragedy almost occurred when there was no need for any incident at all.

It is difficult to explain that man's thinking, if any. Possibly he thought the elk were tame because they lived in a national park,

which of course is wrong. At the very least, he had no knowledge at all of wild animal behavior or reaction—and capturing wildlife on film isn't likely to be too successful without at least some knowledge of the subject.

Birds and animals have been studied for centuries, and recently more intensely. The equivalent of vast libraries has been written on wildlife behavior. Still, our knowledge of animals is limited. We do know that they are governed largely by instinct and past experience, rather than by ability to reason. Different animals depend on different senses to direct them, and most have far keener senses than humans have or can even comprehend. Compared to people, many creatures have such extraordinary hearing and scenting ability that they may depend on one of these alone to detect danger. A whitetail deer, for instance, is often able to note the presence of a hunter (or cameraman) by scent alone and make

Running animal shots (here a whitetail deer) result from an alert cameraman, swift reaction, and a shutter preset at 1/500 or 1/1000 second.

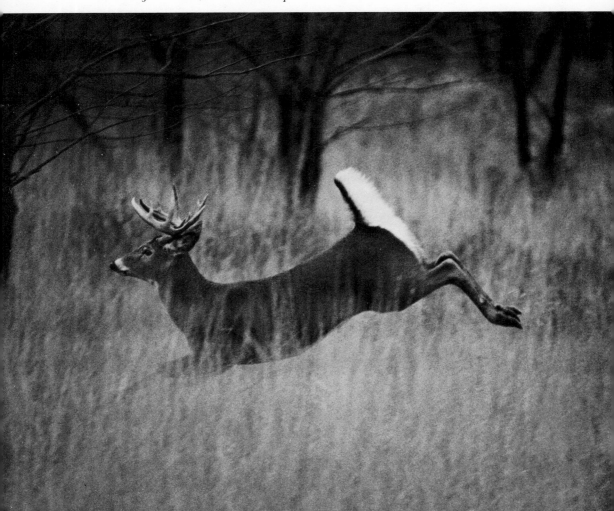

its escape without ever being seen. On the other hand, a hunter can walk through a wood which is literally full of whitetails and never spot one because his own senses are not well developed. It is important for a photographer to appreciate this superiority. To get good pictures, he must also be able to find the animals, to guess with fair accuracy what they will do when he finds them, and finally to approach within reasonable camera range.

When the first colonists waded ashore in North America, they were surprised to find that much of the wildlife was unafraid of them. Ruffed grouse could often be killed with sticks or stones, and wild turkeys shot with blunderbuss guns. But not for long. The targets soon became very shy, and after centuries of hunting pressure the tamest birds were converted to the wariest, which they are today. However, in national parks and remote areas of the West where they have not been hunted, ruffed grouse are sometimes still tame enough to kill with slingshots.

On islands of Antarctica and other regions where large colonies of nesting seabirds have been largely undisturbed, the penguins and other residents pay little attention to cameramen who come within a few feet of them. In the national parks of Africa, a pride of dozing lions may not even bother to look up at a passing safari car, and I have had elephants walk right through my safari camp. There are exceptions, but generally birds and animals become used to human presence (or at least tolerate it) in direct ratio to the length of time they have been unmolested.

The bighorn sheep of the Rocky Mountains, as already noted, are an excellent example. Hunters with wide experience regard this as one of the greatest trophy animals of all, and its high habitat makes it the most difficult to hunt of all native big game. But given a generation or so of protection, bighorns gradually descend from their lofty environment to spend more time in more accessible places. And in my own experience at least, the big rams soon become the easiest of our large native mammals to photograph. I know of a number of places where they can be very easily approached.

The message in all the above reemphasizes that national parks, refuges, and other sanctuaries are the best places to plan a photo safari. This isn't to say that all the wild residents are always available and ready to pose in these places and that good pictures are guaranteed. Far, far from it. But the odds are so much better than in open hunting areas that the latter aren't worth considering at all, unless you relish great challenge.

Even in protected places it can be difficult to find photo sub-

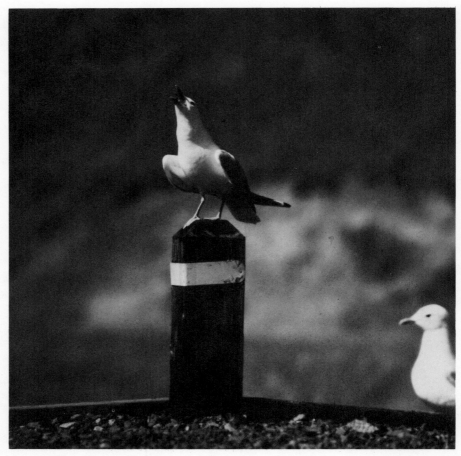

Good wildlife pictures are possible just by watching for birds which frequent campgrounds and parking areas, like this mew gull at McKinley Park, Alaska.

jects. But a good place to start is at a park headquarters, visitor center, or ranger station where personnel on duty can suggest general places to look and perhaps mark them on a map for you. Some national parks offer printed brochures which describe the best spots to find wildlife, and in other chapters we will mention some of the most important of these. Most organized photo safaris to wildlife reserves outside of North America will include guides who know where to go for best results. But when on your own in an unfamiliar place, it is usually possible to hire for a modest fee an observant game scout or ranger as your guide.

When on your own, knowledge of wildlife habitat is invaluable. You would not search in lodgepole pine forests for antelope (to use an extreme example) or on open sagebrush flats for elk. When looking for any targets of opportunity—for any wildlife which happens along—concentrate on what biologists call edge. This is where one type of cover blends into or adjoins another, say where a swamp borders a woodland or in the bottomlands along a stream. The greatest variety of birds and animals invariably exists here.

A most common mistake when searching for wildlife is to hurry. By far the best advice when shooting in a typical North American national park is to drive slowly along park roads; the slower you go the more you will spot. When you've located an animal, try to film it from the car if that is possible and practical. Many birds and animals have become used to passing traffic and even to vehicles which pause nearby on the berm of the road. But open a car door and immediately they flush or begin to drift away. In some places getting out of an automobile is not even permitted.

But let's assume you have spotted a moose some distance away on a hillside and there are no restrictions on getting out of the car. You have to get much closer to the target. The way to do it is slowly, and never directly. Rather take a path at an angle so it appears to the moose that he is not your objective. Pause often and look all around. Do not stare for long periods directly at the animal; watch out of the corner of your eye instead. Make an exposure or two at each pause, just in case you do not get any closer. And watch for signs of nervousness or unease.

Different animals give different signs that they are nervous or about to bolt, and many of these are fairly easy to detect. An animal which feeds uninterrupted during a cameraman's approach isn't yet ready to run. But the more frequently it looks up, the more likely it is to move away. Ears and tails are especially good indicators on large mammals. When these flick nervously, be ready for the animal to break into flight—at which instant a good action picture is possible if the photographer is ready.

With experience it becomes possible to tell just how far you can go—just how close an approach the animal will tolerate—by the animal's composure. This distance can sometimes be shortened by patience, by sitting down, looking away, and becoming another fellow creature on the landscape. When doing this, I have had animals actually graze closer in my direction. And very curious specimens have occasionally strolled near enough to shoot close-ups. When you are near or approaching wildlife, never make

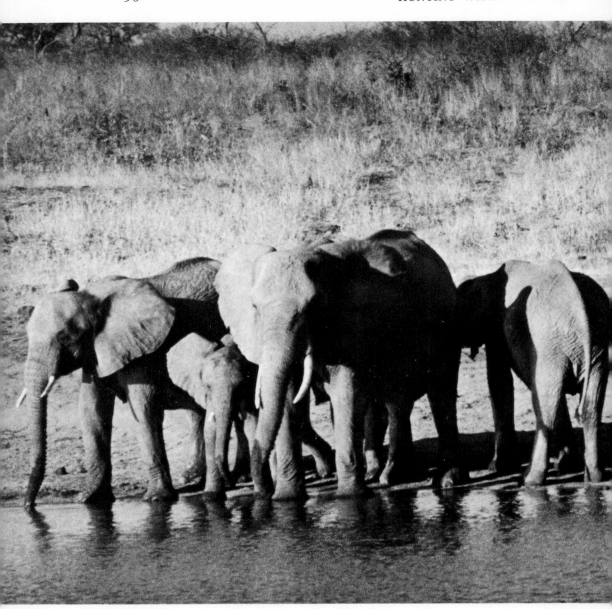

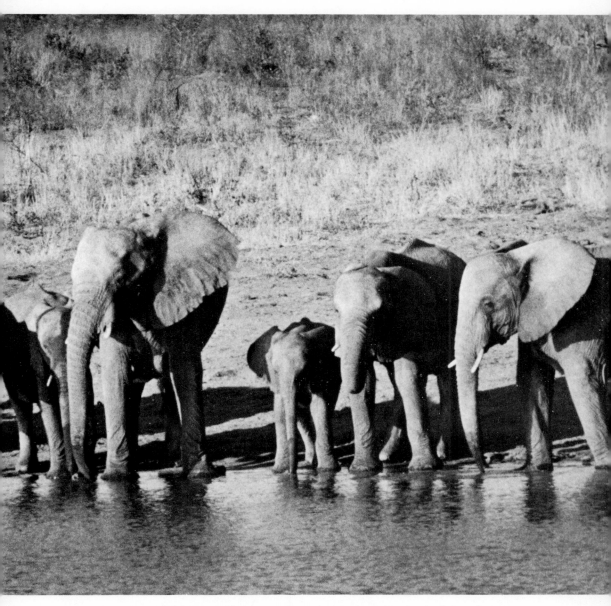

A waterhole at Rohodesia's Wankie National Park attracted this herd of female and young elephants. A camerman could spend many days in a place like this during the dry season—and see a constantly changing cast of animals.

sudden moves or sounds. Do not smoke, and try to act as disinterested in the target as possible. I'm convinced that most wild creatures are made more uneasy by a human staring at them than by his proximity alone.

There are two times when photographing big game that a photographer should *not* try to get too close to his subjects and in fact should use extreme caution. First, avoid close brushes with males during the rut; second, give females of any species with young a very wide berth. It is true that the period of the rut—mating—is a better than average opportunity to shoot especially exciting or dramatic photos, and the photographer should be alert to take advantage of it. But he should do so from a distance by relying more on a telephoto lens than on his two feet.

Seasons can make a good bit of difference in scheduling a photo safari. Springtime has some advantages if the targets are birds, because this is the period of colorful courtship displays for many species. Also nesting colonies and rookeries are active and may be photographed. But autumn is the best time to film great masses of birds during migration, as well as the rut of large mammals. The greatest concentrations of nearly all wild creatures, but especially of waterfowl, occur during midwinter. In addition, intense cold and the hunger make all animals a little more lethargic than normal and therefore easier to approach. But photographers shouldn't take undue advantage of winter weakness and frighten their subjects into using up vital energy reserves.

Periods of long drought, especially in regions which are normally wet, will also concentrate animals for a cameraman. The more abnormally dry the situation, the more a photographer might frequent the wet places which remain. In Africa during severe dry seasons, a cameraman can find more action in a short time around one water hole than by traveling all day across country.

It has been claimed too often that a hunter has all the advantage over a nonhunter when pursuing wildlife with a camera, but that isn't entirely true. An experienced hunter might be in better average physical condition, and he would no doubt realize that the best times to be afield are early and late in the day. But the stalking skills of the gun toter are not exactly the ones which pay off for a cameraman. Let me explain that.

When dealing with animals which are at least used to seeing people, as they are in national parks, it is a mistake to try to sneak up on them unseen. If you do—and even if you are successful—you will have only a brief instant, if any at all, to shoot

when the animal spots you. Sanctuary animals simply aren't used to being stalked and most of the time are alarmed by it. Far, far better is to stay in sight at all times, so that the subject can keep an eye on you and isn't startled. Then approach carefully and obliquely.

It is helpful to understand the relationship of one animal species to another—to be able to predict what a subject will do when confronted by other animals. Often these encounters provide the kind of action which make great pictures, and so it is important to be prepared for them.

One afternoon along Argentina's Patagonian coastline, I sat above a colony of breeding sea lions. During the morning there had been a good bit of activity in the group, mostly the jockeying of beachmaster bulls to steal cows from rival harems. But it was a hot still day, and by noon, most activity had temporarily ceased. I was about to put my camera aside when I happened to notice another very large bull swimming toward shore. He looked like trouble— like an accident searching for a place to happen. I picked up the camera again, focused on the newcomer, and followed his progress. At water's edge he was met by one of the resident bulls, and in the next few seconds I filmed a savage duel between two magnificent animals. Then abruptly the intruder retreated and all was quiet again.

Late on another afternoon in a Western national park, I sat in my Jeep overlooking a garbage dump. That's not a very romantic site for photography, but a variety of birds and animals are often attracted to such places. But this evening the only visitors were several ravens, a few California gulls, and one coyote. I was especially interested in shooting the coyote, which seemed entirely unconcerned about my presence.

But after a while, something besides me seemed to bother the coyote. Nervously it kept looking back toward a game trail and to a small brushy stream just below. On a hunch, when the coyote trotted away in the opposite direction, I focused on the spot where the trail emerged from the canopy of streamside willows. An instant later a huge grizzly walked right into my viewfinder.

Not always do hunches pan out so well; all wild animals are simply too unpredictable, and wildlife photography is a game at which successes do not always outnumber the failures. But no matter whether a vocation or avocation, pastime or hobby, it is a fascinating, even an addicting sport. The better one knows the adversaries and how they will behave, the more successes and fewer failures any cameraman will have.

Photographing Landscapes and Plants

As will be evident throughout this book, camera safaris carry photographers to scenes of the greatest beauty on earth. Even though filming wildlife may be the main goal, few travelers will want to ignore the magnificent landscapes, the beautiful environments in which the animals live. No picture record could be complete without pictures of the places visited.

Shooting a landscape may seem as easy as aiming at it and snapping the shutter—and indeed in some cases that is all there is to it. Still, it is very deceptive. How many times have you returned home only to find that the same splendid scene you saw with your own eyes is only a thin line across a color slide or print? Perhaps this is the most common disappointment of all. But how many times has the seascape which thrilled you lost all of its detail, or become pale and washed out? How often have telephone wires, power lines, or some unsightly litter suddenly appeared where you didn't notice it before?

Composition of any picture—and of course any landscape—is a matter of personal taste; beauty is in the eye of the beholder. By that definition any picture which pleases the photographer is a good one, and no two photographers will see a picture exactly the same. Still, there are several very good rules for shooting better scenics anytime, anywhere.

To begin, select one center of interest. It can be a certain snowcapped mountain range, a wild river meandering across a meadow, the steep sculptured sand dunes of a desert, surf breaking on a rocky seashore, or anything like these. In most cases it will be best to emphasize, to concentrate on the highest point in that mountain range, just one picturesque bend in that river rather than all of it, the highest sand dune and that section of shore (rather than a long length of it) where the surf has the greatest impact. In other words, isolate what is most dramatic or spectacular about any particular scene.

The next step is to get as close as possible to your scene, and that can be done in two different ways. Assume, as an illustration, that you are hiking a mountain trail and come upon an overlook. Beyond, a waterfall pours out from between rugged mountains to a green meadow below. You stop because here obviously is an inspiring alpine scene that begs to be photographed; it's definitely cover quality. But when you examine it through the viewfinder of your camera, the falls seem suspiciously far away. Looking closer, you notice that much detail is lost.

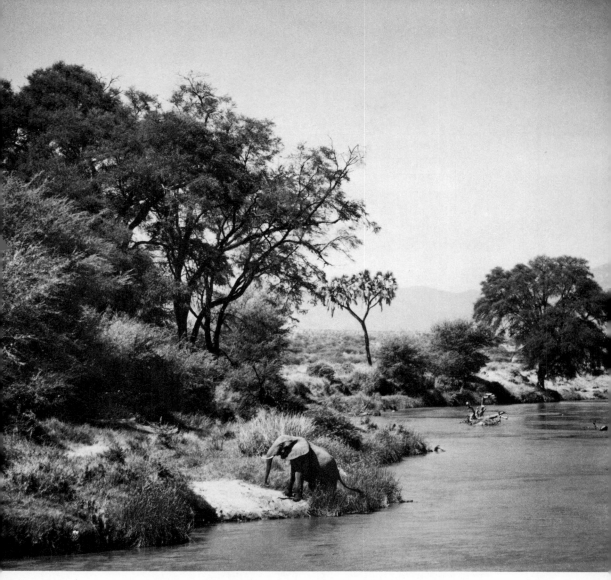

This photo reveals the elephant's lonely habitat along the Uaso Nyiro River of Kenya's Northern Frontier.

Now you have two alternatives. You can hike a little farther and try to find a viewpoint closer to the main subject — the falls. Or standing in the same place, you can substitute a telephoto lens to bring the scene closer to you. Either way, the difference between a so-so landscape photo and a really great one is a matter of distance between cameraman and his subject. In other words, get close — or closer.

When composing a scene at any range, be conscious of everything before you shoot. Be sure there are no distractions in

the picture; too many otherwise excellent compositions are dam-aged by wires, buildings, people who do not belong in the scene, even by a tree or badly out-of-focus shrub in the foreground. This isn't to say that foreground objects are always bad; in fact, everything from trees to unusual terrain features can be used as at-tractive frames for the picture, as we will note later. But watch out for objects, especially along the sides and bottom, that have no pur-pose and only detract from the scene.

Too many landscape pictures never make the grade because of incorrect exposure—usually underexposure. When using a meter, be careful to direct it toward the main subject—toward the moun-tains, desert, valley, or whatever—and not toward the sky or a vast open expanse of bright water. These latter give an incorrect reading.

Good, exciting landscapes can be taken at any time of day and no matter what the direction or source of the light. A cameraman should shoot any and every time he sees a scene which genuinely pleases him. Some of the best slides may result when there is little light at all, or light is directly in the cameraman's face. Trying to cut corners with film always seemed poor economy to me. I'll admit that today's color film is expensive, but it is still the cameraman's cheapest item.

The best times to shoot the most striking landscapes are early and late in the day, before midmorning and after midafternoon, or before the sun has had a chance to climb high overhead. Then the shadows are deepest and everything from details of rock and the ripples of a stream to the texture of foliage or bark of a tree is better emphasized. Also the color is much richer than with a high sun; the closer to midday the more flat and drab are most colors—and in fact so is the whole landscape.

The "brightest" of all landscapes are shot early and late with the sun coming from over the photographer's shoulder and directly onto the scene. But most of the time my own preference is for side light—for the scene to be illuminated by sun on one side or the other. There is more shadow to give contrast and depth, and to make just an attractive picture extremely beautiful.

Although most of us appreciate a scene which is bathed in warm, bright sunlight, it's a mistake to overlook panoramas drenched with rain or fog, or when snow is falling. A slow shutter speed emphasizes the raindrops or snowflakes. Especially good results can be realized when weather is unsettled—when part of a landscape is in sunlight while the rest lies in shadow of an ominous,

advancing storm. Often skies alone can "make" a scene; a fairly flat landscape may look . . . well, flat with a cloudless blue sky overhead. But with storm clouds or thunderheads gathering, it has an entirely different and more exciting mood. Don't pass up chances to film rainbows. Make them more striking by slightly underexposing.

Sunrises and sunsets are easy to shoot, although there is a point beyond which you get only streaking or light blotches instead of a colorful picture. As a rule of thumb, you can shoot any low-sun picture directly into the sun if you can look at it directly without sunglasses and without squinting. First snap it at the same exposure you would with over-the-shoulder sunlight, and then bracket. Both open and close the lens one or even two extra stops and make additional exposures at all of these. Among the exposures will be at least one outstanding photograph, and probably more than one.

Try never to split a picture exactly in half, either horizontally or vertically. In other words, do not permit the horizon or very strong "line" to run right through the middle of the picture. Either raise it or lower it in the viewfinder. Also move a dominant vertical subject away from the center, if only slightly, to greatly improve the composition.

Earlier in this chapter, contrast—arranging light subjects against dark backgrounds and vice versa—was covered. Achieving contrast is even more important in most landscape photography. Try always to arrange dark subjects against light ones, bright ones against shadow. Often it is no more difficult than changing the camera angle or moving to a somewhat different shooting position.

Earlier we mentioned using a natural frame within the photograph to focus the viewer's interest on the main subject. It is a technique well worth using. Particularly if they are in the shade and therefore dark, trees, overhanging branches, geologic formations, canyons, or other natural arches are excellent frames which also add depth and definition to a picture. Depth can be achieved in still other ways—for instance, by animal tracks leading away from the camera, a river meandering vertically across the foreground, or maybe a string of heavily loaded pack horses coming down a steep slope toward the photographer.

Just as a wildlife cameraman will surely encounter magnificent scenes almost wherever he wanders, so will he encounter astonishing varieties of colorful and exquisite plants. In many cases

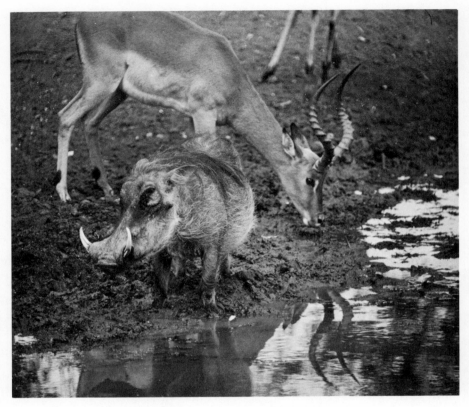

During dry periods, concentrate around water. Watch also for unusual pictures; this odd couple in Zululand matches beauty with a beast, a warthog with an impala.

they are the plants on which wildlife depends to survive. It is especially fascinating to film those which flower or take unusual forms.

The most satisfying way to shoot any blooms, berries, mushrooms, autumn leaves, seedpods, or the like is at close range—in fact, such very close range as to fill the viewfinder with the main subject. Of course, it is tempting to take pictures of whole fields full of flowers, but unless the blooms are extremely dense, these shots are disappointing because so much detail is lost. If a brisk wind is blowing these field pictures are only a blur. Better stick to small clumps of flowers—say a few primroses beside a mountain brook—or a closeup of one primrose alone.

Sharp focus is all-important in this closeup photography. The petals, veins, stamens, even the drops of dew on the flowers should

be absolutely in focus when the picture is greatly enlarged, as when a slide is projected onto a screen. That means the camera must be held rock-steady, and for this many cameramen prefer to use a small, sturdy tripod. As small a lens opening as the exposure allows should be used, except to achieve deliberate blurred effects.

Just as the camera must be held still, so must any flower be motionless at the instant a picture is snapped, and on windy days it may be difficult to manage. One convenient tip is to carry along a sheet of plastic, a piece of cardboard, or a square of plywood to use as a windbreak when shooting. The same board when colored (say a dark green) can also be used as a background in some closeups. Light or pale-colored wildflowers show up most dramatically when in sharp detail against a dark background. However, most of the time shadow can be used for this instead of something artificial. Of course, dark-blue and purple flowers are better seen against something light — pale-green foliage or the sky.

Some of the most exquisite of all closeups of flowers and berries are made when the light is behind them and filtering through the delicate petals. This backlight emphasizes the smallest details, such as pollen, furry stems, even tiny insects on the blossoms.

Closeup photography is possible with some of the short-focal-length lenses which are sold as the normal lenses on many 35mm cameras. But most cameramen will have to acquire a closeup attachment or tube or bellows extension, none of which is very expensive. When the camera is a single-lens reflex in which you view through the lens, you simply focus on the closeup subject as you focus on anything else. But when using other types, it will be necessary to actually measure the distance between subject and lens. For this carry along a roll-up steel tape, a carpenter's folding rule, or a focal frame. The focal frame is a rectangular frame of stiff wire which fastens to the camera at a fixed distance — say six inches from the lens. The focusing ring is then also set at six inches, and the picture snapped when the flower or other object is exactly on the same plane as the focal frame.

Some of the most exquisite of all closeup subjects (such as orchids, toadstools, moss, and lichens, for example) are rarely found in sunlight and instead exist mostly in the gloom on the floor of a forest. There are three ways to shoot these: by time exposure (for which a tripod will be necessary), with a muted flash, or with a reflector. The reflector may be only a sheet of crinkled aluminum foil which folds easily into pocket size. With it even a

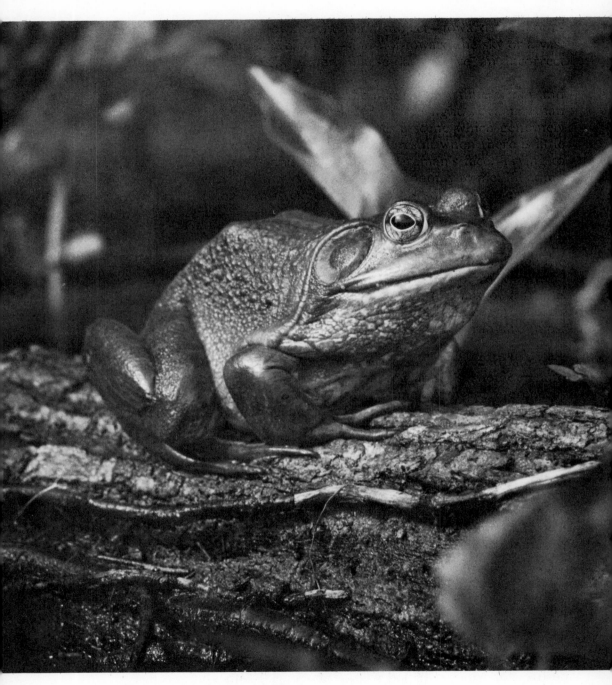

Some wildlife photos should emphasize the animal, as this closeup of a bullfrog on an Ohio pond.

small beam or shaft of sunlight can be reflected onto the subject from somewhere else nearby.

Few outdoor cameramen can resist shooting trees, especially such unusual ones as the bristlecone pines, the giant redwoods and sequoias of California, strange palms, banyans, and baobabs. The best way to show these and their peculiar characteristics is to isolate single trees in a low side light, perhaps silhouetted against the sky. Even the most distinctive tree evaporates into its background if it is photographed among many others.

Similarly, some scenes of forests or hillsides in the peak of autumn color are effective and pleasing. But better still are pictures of individual trees either totally isolated from others or photographed against a background of completely contrasting color —as a single scarlet maple against dark evergreen pines.

A photographer can devote time especially to shooting landscapes and plants, trees and flowers as he sees fit. Or he can do it only when little wildlife is stirring. Either way he will be rewarded with pictures of special beauty and appeal.

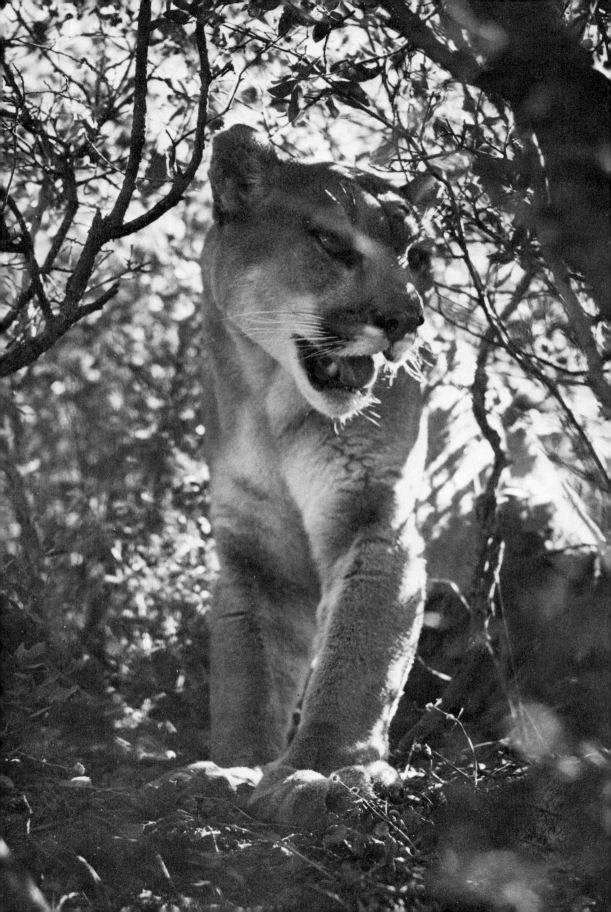

PART II

Camera Hunting in North America

The mountain lion — or cougar or puma — is North America's largest cat.

5

Florida and
the Atlantic States

The presidency of Harry S. Truman is one which Americans may debate for a long, long time both pro and con. But on one point there can be no question: His conservation record was extremely good. Among the achievements for which Truman can best be remembered is the establishment of 1,400,533-acre Everglades National Park in Florida. This unique and priceless sample of American real estate was saved only in the nick of time from "progress." Today the park is a promised land for both serious and casual wildlife photographers, and inevitably this chapter will concentrate heavily on it and nearby areas.

Flat—nowhere is it more than ten or twelve feet above sea level—the entire park is a sea of grass waving in a moist wind and punctuated by low mounds of timber called hammocks or hummocks. The ecosystem literally teems with wildlife, although that is never evident to a traveler who simply hurries through the place on the park's paved roads. It is a classic sanctuary, for example, to such rarities as the manatee (or sea cow), the Everglade kite, the Florida cougar, the North American crocodile, and a number of small birds. Other birds native to latitudes farther south are never seen any farther north than this extreme subtropical tip of the Florida Peninsula.

A complete and completely absorbing photo safari is possible in Everglades Park, and it should begin at Anhinga Trail. This is an easy, level hike, a third of a mile long, via elevated boardwalk over sloughs near the eastern entrance to the park. It is therefore normally crowded with park visitors, so the best advice is to arrive

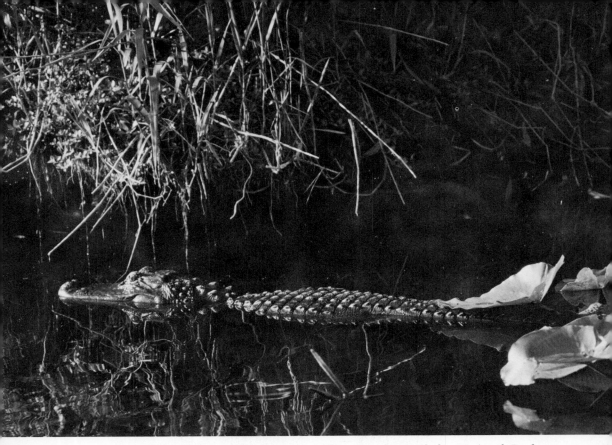

Endangered and poached elsewhere, alligators of Everglades National Park pay little attention to photographers.

just at daybreak. First, you will have the place to yourself, and second, it is the magic period when some of the Everglades creatures which are largely nocturnal are still moving about. Later, during still middays, the lukewarm sloughs along Anhinga Trail may seem to be completely devoid of life.

In just one morning's hike along the Anhinga Trail, a photographer might expect to shoot the following, which I find are listed in my own notes for May 3, 1971: many alligators, a family of otters, soft-shelled turtles, red-shouldered hawk, anhinga, coot, tricolored heron, snowy egret, boattail grackle, limpkin, catbird, common water snake, raccoon. That is an unusually long list just to observe for little more than two hours, but I photographed all. In the clear, tannin-tinted waters I saw largemouth bass, mullet, pumpkinseed sunfish, gars, and bowfins. If very lucky, you may see an alligator catch and eat a gar, as I did.

The Gumbo Limbo Trail, not far from the Anhinga Trail, is another half-mile loop hike through a hardwood hammock. It is

dim inside the timber and wildlife photography isn't possible, but it is an excellent introduction to the ferns, orchids, air plants, and semi-tropical flora of the area.

When driving southwestward toward Flamingo on the Gulf of Mexico, pause at Mahogany Hammock (largest mahogany trees in continental U.S.), Pa-hay-okee, and also drive the Shark River Loop Road, a 14-mile side trip which ends at a tall tower from which alligators may be photographed in their natural environment. I have also spent many hours photographing among the several tidal ponds beside the highway not far from Flamingo. Roseate spoonbills and the ibises are the most spectacular birds and easiest to see, but the lagoons are also the temporary home for countless other wading birds and shorebirds. It is even worth spending time near the boat docks around Flamingo because of the antics of tame, freeloading brown pelicans, redwing blackbirds, and laughing gulls (all of which are common there), especially when fishing boats return and dispose of surplus baits.

There are still other means to see wildlife which are unique to Everglades Park. Frequently boat-a-cades (bring your own craft) follow park rangers on all-day cruises through back-country waterways, and usually great numbers of wild creatures are encountered, many at close range because they have become used to the boats. There are marked canoe trails and daily sightseeing cruises of one to four hours on Whitewater Bay, plus an every-evening sunset cruise on Florida Bay. Although these cruises are interesting, they are not the most ideal for photography. Much better is a two-hour ranger-led tram tour which gives a good view of birdlife (especially of spoonbill and egret rookeries) which a century ago had been almost wiped out by plume hunters. A fishing trip out of Flamingo is almost always worthwhile, not only for the sport, but because a number of sea birds are likely to come within good camera range.

Although a large part of southern Florida has already been "improved" to the point of destruction and the natural beauty obliterated by developers, with little hope for the remainder, there are a few other sites worth a photographer's attention. With luck these will not be in the bulldozer's path. One is the Myakka River State Park, not far from Sarasota. Among the wildlife easy to see here are whitetail deer, turkeys, ibis, feral razorback hogs, raccoons, gray squirrels, bobwhites, woodpeckers, bluejays, and many other songbirds. All these have become very tame around campgrounds, and any cameraman can be excused for burning up film here.

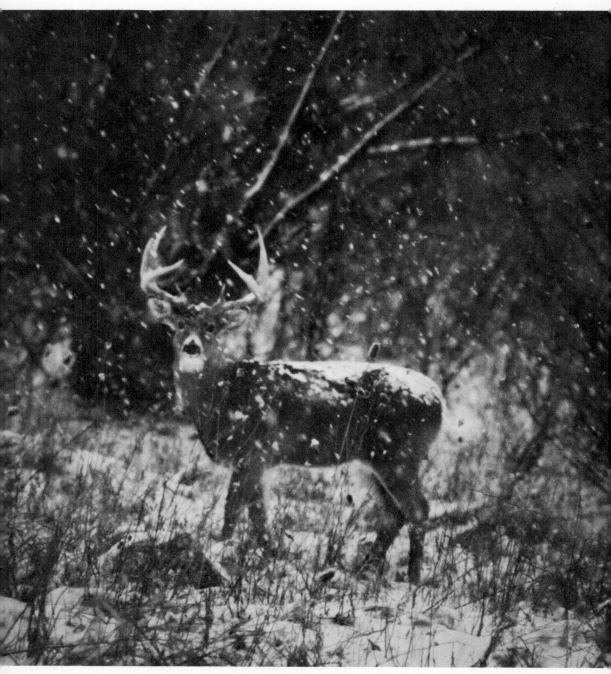

Trophy whitetail buck stares briefly back at camera before vanishing into a December snow squall.

For the entire length of the Florida Keys, endless human dwellings have replaced the former attractiveness of that ocean environment. Here is no place for a wildlife photographer, except that on Big Pine Key he might get a brief glimpse of a tiny Key deer, or elsewhere of gulls, terns, or black skimmers cruising the beaches. Another exception—and this a very good one—is John Pennekamp Coral Reef State Park in the Atlantic near Key Largo. It is the first such underseas sanctuary established in America. It can be explored via glass-bottomed boat, but the best way to see and photograph the fantastic underwater scenes and colorful fishes is by snorkeling with an underwater camera.

My own favorite photography spot in Florida is the National Audubon Society's 6,000-acre Corkscrew Swamp Sanctuary between Naples and Immokalee. Access is via an elevated boardwalk through an otherwise undisturbed swamp. All of the same wildlife the Everglades boasts can be as easily photographed here, and in greater solitude and haunting beauty. In addition, the background is the largest remaining stand of virgin bald cypress left in our land. Some individual trees tower over 130 feet.

Now endangered alligators perform for cameramen at Corkscrew Swamp, an Audubon Sanctuary in southern Florida.

A final point about southern Florida should be emphasized: Winter and early spring are the best periods for wildlife photography. Water levels are lowest and water areas most restricted; existing wildlife tends to concentrate around that moisture. Also the weather and humidity are by far the most pleasant for human activity.

The farther a photographer travels northward from southern Florida, the more limited are his opportunities to focus on wildlife. But one of the best places (and among the most unusual in America as well) is another national treasure at the headwaters of the Suwannee River in extreme southern Georgia.

Since well before the turn of this century, millions of dollars have been spent to drain (largely a failure), harvest the timber (mostly successful), and otherwise pillage or poach this vast and gloomy swamp known as the Okefenokee. From the time in prehistory when the swamp was first formed, its main importance has been as a rare and unique wildlife refuge. However, it never really achieved that status until almost too late—in 1936 when President Franklin D. Roosevelt officially established the soggy "land of trembling earth" as the Okefenokee National Wildlife Refuge. The purchase price was less than $500,000 for 331,000 acres, or about $1.50 per acre.

The refuge is mostly swampland crisscrossed by channels in which there is noticeable current, alligator "runs," floating islands, and a few interconnecting lakes. The southern part is mostly undisturbed brooding wilderness. The world's largest surviving population of alligators lives here. Raccoons, otters, and bobcats are numerous. The cougar has long ago disappeared, but black bears are still present. So are twenty-eight species of snakes (including the cottonmouth moccasin), the alligator snapping turtle (among numerous other reptiles and amphibians), largemouth bass, sunfish, bowfins, and 225 species of birds, of which many consider the swallow-tailed kite the most striking. Ivory-billed woodpeckers once were resident, and there is the very, very remote chance that a few could still survive in the swamp's vastnesses. But probably all are gone as they are everywhere else.

If there is any problem in filming the wildlife of Okefenokee, it is probably the difficulty of getting around, which must be done on water. You can use your own boat or canoe or light shallow-draft watercraft. Without your own boat, it is advisable (at least at first) to engage a native guide, and many of these are available on the edges of the refuge, as at Fargo, Folkston, Camp Stephen Fos-

ter, and Camp Cornelia and at Okefenokee Swamp Park just south of Waycross. Local guides also know the whereabouts of most wildlife.

Especially for naturalists, wildlife watchers, and photographers—and not for typical tourists—there is an excellent network of clearly marked canoe trails through the most picturesque portions of Okefenokee Swamp. The trailheads (starting points) are located at the following places: Kingfisher Landing off U.S. 1 between Waycross and Folkston; Davis Landing, also between Waycross and Folkston; and Suwannee Canal Recreation Area, reached from Folkston via Georgia route 23. All of these trails end on Jones Island near Fargo in the southwestern part of the swamp. Of course it is possible to start here and paddle northward, but that is going against the current and becomes extremely hard work over the long haul.

The number of canoeists permitted on Okefenokee Swamp canoe trails is limited to twenty per day to maintain the total wilderness mood. A free permit is required from the refuge manager

Near-perfect wildlife camouflage. Sure you can see the woodcock, but how about the pair of chicks crouched close by?

and can be reserved in advance. Overnight camping and open fires are allowed only at designated sites. Sleeping is done only in tree hammocks or in the canoes, and no travel is permitted after dark or before sunrise, because then it is too easy to get lost. Altogether, canoeing through Okefenokee—a camera safari over water—is high adventure as well as an efficient way to shoot splendid pictures of wildlife and the strange environment in which it lives. There are few places to match it for photographing great and unique natural beauty.

As elsewhere, the best wildlife photography destinations in the Carolinas are public places, but are widely separated—Great Smoky Mountains National Park and the Hatteras National Seashore. There are plenty of shooting opportunities in both places, although the wildlife is not very confiding. In the Smokies look for whitetail deer, an occasional black bear, ruffed grouse, and small mammals. At Hatteras the main targets will be shorebirds, found along the beaches, at times in vast numbers. But a combination of patience and luck will be necessary to get close enough for the best photos.

Proceeding up the Atlantic Seaboard, a cameraman can visit the numerous national wildlife refuges which have been established largely for waterfowl. At all refuges it is possible to see large numbers of ducks and geese, particularly during springtime and early winter, but it is difficult to approach them. Shooting must usually be done from long range and with telephoto equipment. However, a visit to any refuge headquarters might reveal a few special places where a photographer can make a closer approach. A list of the best refuges would have to include Mattamuskeet and Pea Island in North Carolina; Cape Romain and Santee in South Carolina; Back Bay, Chincoteague, and Presquile in Virginia; Blackwater and Eastern Neck in Maryland; Bombay Hook in Delaware; Brigantine in New Jersey; Monomoy and Parker River in Massachusetts; and Moosehorn in Maine. Autumn is a fairly good time for photographing shorebirds on the beaches of Cape Cod National Seashore.

From Chesapeake Bay northward, the best wildlife photography opportunities exist on private estates and sanctuaries. The only way to locate these is by local inquiry, and then you must request permission to avoid trespass. A few such places still exist even on densely settled Long Island. Gardiners Island in Block Island Sound is an extremely unusual place; despite its location, much of it, including a white oak forest, is virgin and uninhabited.

Fox squirrels, other small mammals and birds are easily photographed around many public campgrounds.

Many ospreys nest here. Permission to visit must be obtained from the administration of Southampton College. There is some sentiment today to purchase Gardiners Island and make it a national wildlife refuge or perhaps even a national park, and that acquisition is certainly long overdue.

One very interesting private wildlife preserve where all photographers are cordially invited is Remington Farms on the Chester River near Chestertown, Maryland. Owned by Remington Arms Corp. of Bridgeport, Connecticut, this place is really a demonstration farm which illustrates how proper management of land can also accommodate a large and varied wildlife community. It is an extremely good place to photograph Canada geese and a variety of Atlantic Flyway ducks. Very early mornings and evenings are good times to see whitetail deer as well.

During the summer, Acadia National Park in Maine is overcrowded with tourists, many of whom barely notice the glacial pools, granite cliffs, and clean coastal beauty around them. It is not a satisfying place to visit until well after Labor Day. Then summertime crowds begin to drain southward back to big cities, and a na-

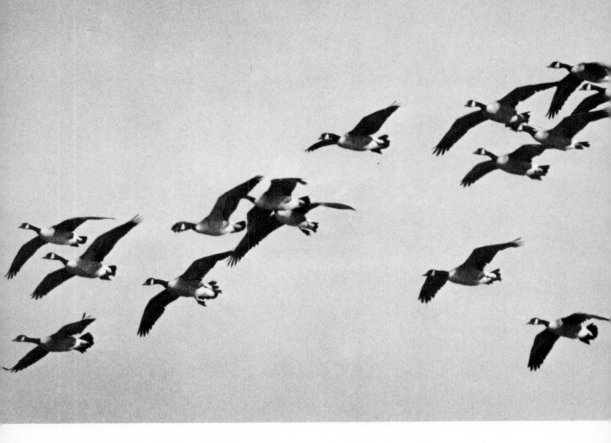

ture photographer can revel in both the most delightful, invigorating weather of the year and an opportunity to focus on unmolested wild creatures. Some species in evidence there and nearby are whitetail deer, beavers, bald eagles and ospreys (both of which seem to be disappearing), and ruffed grouse. Many of the numerous islands along the Maine coast, particularly around Penobscot Bay, are homes of seabirds, mostly of an increasing population of herring gulls in recent times. Most of the islands are in private ownership and access depends on getting permission to trespass. Grand Manan (actually in New Brunswick, but handiest from Maine mainland ports) is one of the best-known bird islands.

Speaking of islands, Buck Island Reef National Monument off St. Croix, Virgin Islands, is well worth more than just a passing mention. The island is a rookery of brown pelicans and magnificent frigate birds. It is also a rare place where green sea turtles, safe from poaching, can often be photographed when the females

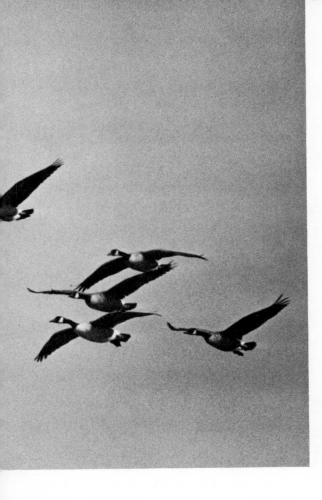

Many of the national wildlife refuges of the Southeast are good places to watch and photograph vast flocks of Canada geese en route from sanctuary to feeding grounds.

venture ashore to lay eggs in the warm sand. However, most of this egglaying is accomplished at night and a cameraman will need flash equipment. Perhaps the most exquisite Buck Island photo targets are the grottoes, live corals, sea fans, gorgonians, and many species of tropical fish which will pose for anyone armed with an underwater camera.

Easily accessible for an outdoorsman who has a seaworthy boat and keeps an eye on the sometimes fickle weather are the Marquesas Keys and the Dry Tortugas, which extend about seventy-five miles westward into the Gulf of Mexico beyond Key West. All these sun-bleached islands, especially Dry Tortugas (site of Fort Jefferson National Monument), are important nesting sites of terns and noddies. Many other ocean birds pause to rest here. Visitors can camp on the lonely beaches, fish, or swim in comfortably warm waters in between photographing the birds. The sea is also clear enough for the best underwater photography.

6

The Midwest

Compared to many other areas, the heartland of America cannot be considered a promised land for a wildlife photographer. There are few great wildlife spectacles because the countryside has been so intensively developed for agriculture, industry, and other human uses. Not much of the Midwest remains unchanged from the times two centuries ago when flocks of passenger pigeons darkened the skies during migration and when every wetland was alive with waterfowl.

Bald eagle nests along the southwest shore of Lake Erie, where watchers could easily see the huge national birds until a few summers ago, are now either toppled by storms or deserted by the parent birds, whose bodies contain too much mercury or pesticides to lay fertile eggs any longer. Of course, bison, elk, bears, turkeys, and cougars disappeared far in the past, though turkeys have been re-established in a few isolated areas. In most places even native cottontails and the introduced ringneck pheasant (which reached a peak of great abundance in the 1930s and 1940s) are hard to find, thanks to what is called "clean farming." The tall-grass prairies are gone, and so are most of the prairie chickens which dwelled in them.

Still, there are a good number of opportunities to keep a cameraman busy. They are scattered, it's true, but photo equipment need not gather dust no matter where the photographer resides. Several professional wildlife cameramen, most notably Karl Maslowski and Ron Austing, both of Cincinnati, have long made a good living from the wildlife subjects practically in their own backyards.

The skunk is one creature which can be photographed in suburban Midwestern backyards. Fed, unmolested by dogs, they in time become tame enough for closeups.

There are even a number of opportunities in densely populated Ohio, which can be considered the eastern limit of Middle America. Most noteworthy is a small pond of only about five acres in the center of Castalia, a snug northern Ohio village. The pond is formed by a clear spring which surges to the surface from reservoirs directly underground. Even during the most bitter weather when all other waters, including nearby Lake Erie, are frozen in the grip of winter, Castalia Pond remains ice-free. Having always been a refuge, it is naturally a magnet for a good many of the ducks which winter in northwestern Ohio. Furthermore, the waterfowl become very, very tame, and I know of no other place where it is possible to photograph mallards, black ducks, pintails, baldpates, common goldeneyes, and at times other species at such close range.

There are other similar places throughout the Midwest, often on the edges of large cities and often in the various metropolitan parks. An excellent example is at Walden Pond in Blacklick Woods, a segment of the Columbus (Ohio) Metropolitan Parks system. Here waterfowl are encouraged to nest and even to winter because the pond is kept from freezing by unseen underwater agitators. Not far away a concealed blind is located near water's edge for the free use of photographers. From this spot as many as thirteen species of waterfowl have been observed on a single bitter day in January.

Still another kind of park in which a patient photographer can expose plenty of film is the Cincinnati Nature Center, near Glen Este in Clermont County. A network of trails winds through the natural environment of the southwestern Ohio hills. In springtime a wildlife photographer is likely to forget his main objective; the wildflower "show" is that spectacular. But gray squirrels and a great variety of songbirds are always concentrated around a number of feeders, and that is doubly true in winter.

At the opposite western boundary of the Midwest, the ponds of City Park in Denver offer great chances to shoot ducks (especially gadwalls) and blue geese. However, the Midwest is a part of the country which was largely overlooked when national parks were set aside, probably for a combination of reasons. First, the land is considered too fertile, too valuable to "waste" on parks. Frequent attempts to establish a prairie or grassland national park have been thwarted before they were well underway. Another reason, probably, is that most of the Midwestern landscape does not have the magnificent or unusual geographic features which

In the Midwest as elsewhere, beaver dams and cuttings are easier to find than the beavers themselves, which are largely nocturnal.

usually typify a national park. However, the four Midwestern national parks that do exist are certainly good ones for camera safaris.

Always cool and misty even in midsummer, Isle Royale National Park is an island in Lake Superior about 45 miles long and averaging 8 or 9 miles wide. It is a natural ecology laboratory where there are no roads or cars, and no development of any kind except in one or two isolated shoreline places. The only noises heard are of wind, a thunderstorm, the cry of a loon, or the scream of an eagle. You reach the island by regularly scheduled motorship from Houghton on Michigan's Upper Peninsula, and after that get around the park on 120 miles of foot trails by backpacking. One, the 40-mile Greenstone Ridge Trail, follows the main backbone of the island.

Photo opportunities are numerous for anyone who will shoulder a pack. Moose are the easiest to see, but an observant hiker will soon spot the mink and muskrats, the beavers and snowshoe hares, which are common and not too shy. There is also the chance to encounter one of the gray wolves which keep the island's

herd of moose from overpopulating their fragile range. Also present on and around the remote island are bald eagles, ospreys, and two dozen species of wood warblers. Noisy pileated woodpeckers are easy to see in the forests, and herring gulls nest on some offshore rocks. In general, Isle Royale is an extraordinary place to escape, and the loudest sound you hear may be the click of your own camera shutter.

Mammoth Cave National Park, Kentucky, is best known for its dank underground caverns, the mysterious, crystal beauty of its cave formations, and Echo River, which flows 350 feet beneath the surface of the earth. But in the early-morning or late-afternoon sunshine on top, a photographer can shoot the whitetail deer, woodchucks, and squirrels he will surely encounter, probably within walking distance of the public campgrounds. Not too far away at the Kentucky State Game Farm near Frankfort it is possible to film, in semi-natural surroundings, the native wildlife of the Bluegrass region.

Wind Cave in South Dakota's Black Hills is one of America's smallest national parks. Most visitors are primarily interested in one of the fascinating cave trips. But here on the mixed-grass prairie is a very suitable site to shoot bison and antelope, both very

Whitetail deer is tough enough camera target at best, but albino is one in a million opportunity.

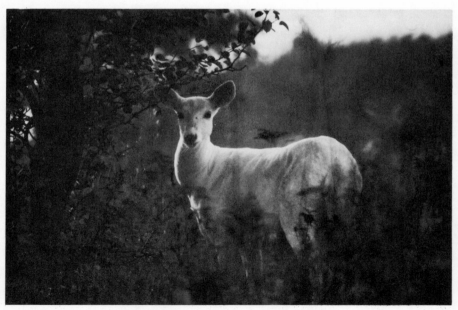

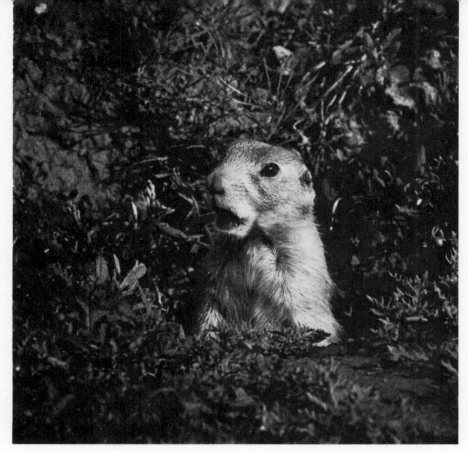

Once superabundant prairie dogs now survive in only a few scattered places, as here in Custer State Park, South Dakota.

confiding, in their original natural habitat. During a number of passing visits to Wind Cave, I have been even more absorbed in and have spent more time photographing the blacktailed prairie dogs. Their colony, or "town," which is a vast cluster of crater-shaped burrows, is one of the best and easiest to photograph of those few surviving anywhere.

Adjacent to and adjoining Wind Cave are other public lands where many wildlife targets can be found. Custer, the largest state park in the United States, contains a very large herd of bison (one of the biggest left) in completely natural surroundings. They can be located at any time of year by checking at park headquarters and then driving the lonely back roads. Most visitors also find mule deer, and these pay no more attention to cameramen than do the buffaloes. Years ago, Rocky Mountain goats were stocked in the Black Hills, and to the surprise of many, they survived and became well established. The big white animals are now easy to see in

the vicinity of Mt. Rushmore and especially atop Harney Peak (highest in the Black Hills), which is accessible by both hiking and jeep trails.

Rocky Mountain National Park, located on top of mountainous Colorado, is among the greatest scenic treasures of the United States. The peaks (which reach beyond 14,000 feet), the glaciers, the cold cascading streams, and the alpine meadows contain a good bit of wildlife. But somehow the wildlife here, even the more conspicuous species such as elk and bighorn sheep, have never become as visible as in other national parks. But for most outdoor photographers, the magnificent scenery is the main attraction anyway. September is the best month for shooting both wildlife and natural beauty, because by then most tourists have departed and the wildlife is more evident.

As elsewhere in America, the national wildlife refuges of the Midwest are among the best places to concentrate. Most were set aside primarily as sanctuaries for migratory birds, and we will cover some of the most important of these. But one of the oldest refuges was not for ducks and geese at all. Let's go back to the beginning, to a warm mid-October morning in southwestern Oklahoma.

This was a region where bison once filed across the landscape in never-ending hordes, in apparently inexhaustible numbers. But now on this day in 1907, the last one had long ago been eliminated. No wonder every rancher, cowboy, clerk, and Indian in Comanche County had gathered beside the dusty railway siding in Cache, the county seat. The next train was bringing a load of fifteen bison from New York's Bronx Zoo to try to restock the place! Of course, the stocking was highly successful, because the big beasts thrived on the protein-rich bluestem grass, and that was the beginning of what is now the Wichita Mountains National Wildlife Refuge.

Eventually a stock-proof fence was erected around the 240-square-mile preserve, a project which some insist actually fenced in the Old Wild West. Today photographers can drive slowly on the 100-odd miles of refuge roads and aim at elk or deer as well as sleek, fat bison. There is also a herd of longhorns, remnants of the earliest cattle-raising days. As elsewhere in Middle America, spring and autumn are the best periods for photography here.

Ottawa National Wildlife Refuge on the southwest shore of Lake Erie between Toledo and Port Clinton is a handy place to see wild waterfowl during migrations. In springtime vast flocks of whistling swans pause here. But one pool near refuge headquarters

always contains a good variety of common Mississippi Flyway species at fairly close range.

On Michigan's evergreen Northern Peninsula, the Seney National Wildlife Refuge sprawls over 95,500 acres of the Great Manistique Swamp. This wetland was acquired in 1935 as a sanctuary for Canada geese, ducks, and sandhill cranes. Throughout the summer a 10-mile nature trail is open (guided or unescorted tours can be taken) through interesting parts of the refuge, and along the way an astonishing amount of wildlife can be seen. Seney is one particular place I would like to spend more time filming in the future.

In next-door Wisconsin, 39,600-acre Necedah National Wildlife Refuge near Necedah is the home of a large captive flock of Canada geese. The mixture of marshland with sandy jackpine ridges is also good habitat for whitetail deer. But the latter are shy, and most of my pictures here are of animals running with white flags erect, rather than of big bucks staring curiously at the camera.

Tamarac National Wildlife Refuge, 18 miles north of Detroit Lakes, Minnesota, is an important concentration area for ducks and geese at the top of the Mississippi Flyway. Morning and evening hikes along the designated nature trails give good views of them, as well as of whitetail deer, beavers, and muskrats. Not far away, on State Route 34 just east of Detroit Lakes, is a private wildlife sanctuary called the Needlewoods Wildlife Range. It is open to the public and contains a good many animals and birds, many relatively tame, in a natural north-woods setting. There are other private wildlife parks of varying quality nearby.

Swan Lake National Wildlife Refuge in Missouri, an area of 10,700 acres in north-central Missouri, is an important stopping place for thousands of ducks and Canada geese in the fall. A program of banding, using the cannon net trap, is often in progress on this area and is interesting to film. Squaw Creek National Wildlife Refuge is a smaller area of 6,800 acres along the Missouri River in northwestern Missouri, but has one of the greatest concentrations of blue and snow geese during spring and fall migration. Often in late February and during the first two weeks of March and again in October and November, it is not uncommon to count 250,000 to 300,000 geese and ducks using the area. Quantities of food are raised for these birds, and they may be observed as they move from one field to the next. The refuge is just a few miles south of Mound City.

Agassiz National Wildlife Refuge, Minnesota, is among the

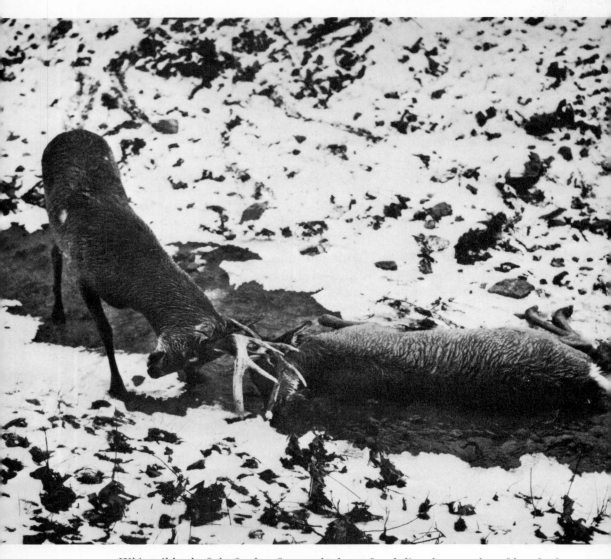

Whitetail bucks fight far less frequently than often believed—so a shot of hopelessly locked combatants, one already dead here, is rare. The photo was taken in northeastern Ohio.

most outstanding nesting areas. It is 61,000 acres and is in the northwest corner of Minnesota. It is an excellent example of an unsuccessful drainage project which has been restored for waterfowl use, and is well worth a naturalist-cameraman's time.

Horicon National Wildlife Refuge, Wisconsin, is still another unsuccessful drainage project along the Rock River in southeastern

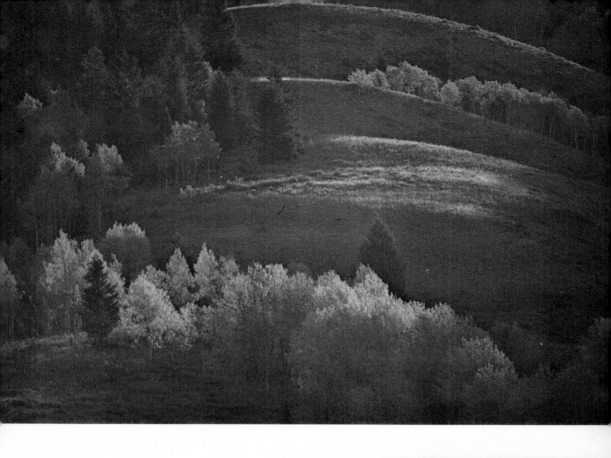

Above Autumn is an exquisite time to be photographing afield. Here aspens glow in morning sunlight against Wyoming foothills.

Right Every summer the Rocky Mountains offer the greatest wildflower show on earth, and photographing them is a fulfilling pastime. Backlighted here is the common bull thistle.

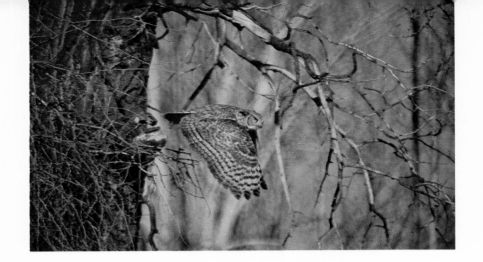

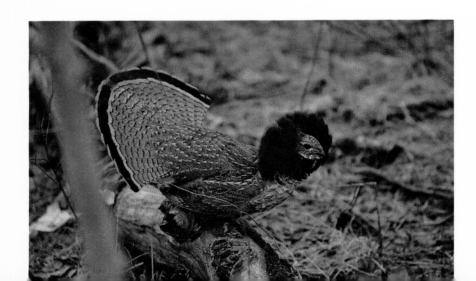

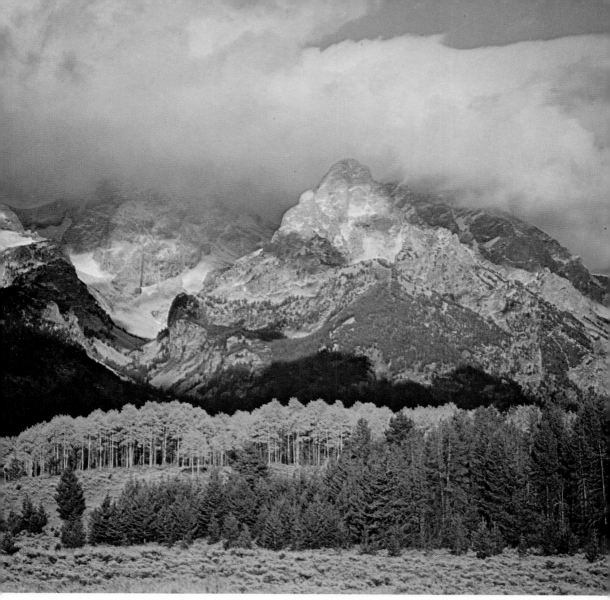

The Cathedral Group of Wyoming's Tetons with a squall forming high in the peaks. Especially beautiful scenes can be composed during unsettled weather.

Opposite page:
Top Essentially a night hunter, the great horned owl is often abroad in daylight, especially early in the morning.

Center A close-up lens or a close-up attachment on a normal lens is used for shooting flower portraits. The strawberry and other cacti bloom in springtime in the Southwest.

Bottom Photographing the wild ruffed grouse in the East would be a difficult task. Western birds are more confiding, especially in spring during courtship.

Unusual and striking photos are possible from the air if a fast shutter speed is used. This is a pattern of muskeg marshes in northern Manitoba.

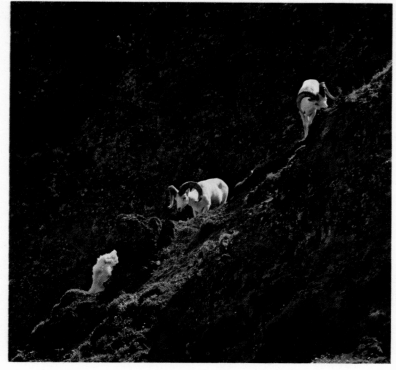

McKinley National Park is the only place where Dall sheep can be easily photographed. These rams were not overly wary, but a stiff climb was necessary to approach them.

Early-morning sunlight illuminates a waterfall far off the beaten track in Banff National Park, Alberta. Picture was made during a pack trip to photograph grizzly bears and bighorn sheep.

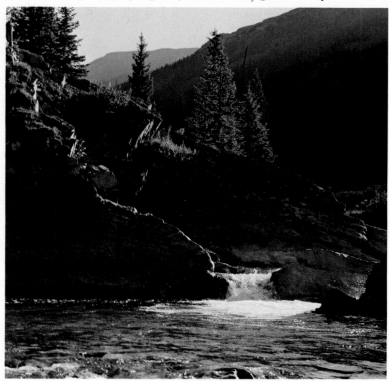

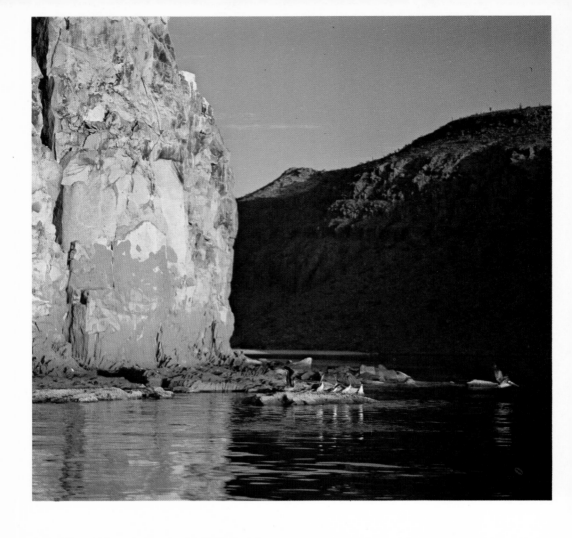

Above The Sea of Cortez coastline, Baja, is wonderfully rugged and scenic, particularly near La Paz, where this shot was made.

Left The anhinga or snake bird perches and dries its wings for a photographer wandering along the Anhinga Trail in Everglades National Park.

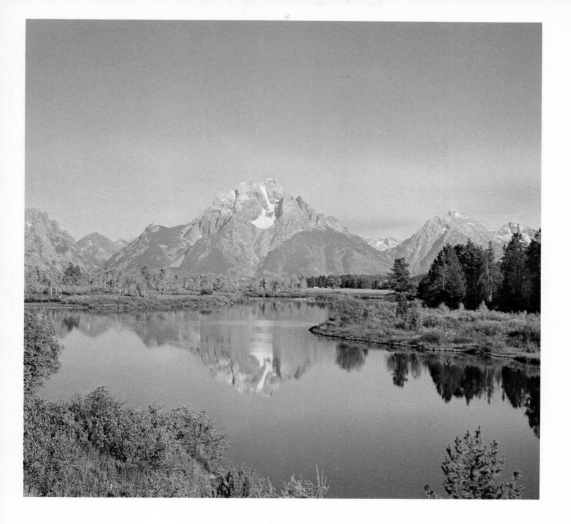

Above Virtually every visitor to Grand Teton National Park passes this scene where the main highway passes Mt. Moran, mirrored in an oxbow pond of the Snake River.

Right An egret flushes against a lush dark background of green vegetation. Light subjects against such contrasty scenes are often dramatic.

A Florida sunset is framed by strange shapes of bald cypresses. This photo technique works equally well in many places around the world.

Wisconsin, the 21,000 acres being chiefly marshland with levels controlled by dikes. Supplementary foods are produced around the marsh edges. Horicon is an important goose migration area, and a state highway which crosses the north end of the marsh was widened to six lanes because of traffic jams which resulted every October when photographers stopped to see the feeding flocks of geese that often exceed 100,000 birds. Headquarters for information is a few miles east and south of Waupun.

North Dakota is dotted with many national waterfowl refuges, large and small. On all of these, waterfowl management and nesting are the main considerations and so waterfowl are the targets of photographers. The largest, most important, and best known are Upper Souris (near Foxholm) and Lower Souris (near Upham) refuges, where thousands of ducks nest in springtime and tens of thousands gather in autumn. When filmed en masse against dramatic prairie sunsets and sunrises, these great flocks are nostalgic reminders of other times when wild waterfowl existed in such numbers almost completely across our continent. Besides the waterfowl, sandhill cranes, sharptail grouse, prairie chickens, gulls, black terns, and white pelicans can be seen on the two Souris sanctuaries.

A list of other photo possibilities (all national wildlife refuges) across North Dakota would include 16,000-acre Arrowwood, near Kensal; Lake Ilo, near Dunn Center; 22,300-acre Long Lake, near Moffit; 26,750-acre Lostwood, near Lostwood, where many shorebirds also pause in migrations; Slade, near Dawson; Snake Creek, near Coleharbor; and Tewaukon, near Cayuga. To that list add Sullys Hill National Game Preserve near Fort Totten, a 1,675-acre fenced-in preserve for elk, deer, and bison that contains a resident population of Canada geese.

In South Dakota, 94,000-acre LaCreek National Wildlife Refuge, near Marten, is the most noteworthy of three federal waterfowl sanctuaries. Mallards and blue-winged teal are the main nesting ducks here, but there are also nesting colonies of white pelicans and cormorants. Also very popular with birdwatchers and cameramen is Sand Lake sanctuary, near Columbia, because as many as 500,000 geese pause here during spring migrations northward. Waubay Refuge, near Waubay, has many nesting waterfowl but offers only very limited access to photographers.

This is a good point to say something about visiting national wildlife refuges anywhere for photography. Always stop first at refuge headquarters for information, and in most cases for maps and

wildlife checklists which are available. Besides the valuable infor-
mation on the best places to go (often blinds have been built and
are available free), some sections of the refuges may be closed and
must be avoided. Almost invariably, refuge personnel are friendly
to photographers and very willing to show off their lands and even
to guide visitors around.

Nebraska has four important wildlife refuges: Crescent Lake,
near Ellsworth; DeSoto, near Blair; and Valentine and Fort Nio-
brara, both near Valentine. Fort Niobrara is the oldest, having
been established originally for bison in 1912. Today the bison can
be seen at close range, along with elk, in an exhibition pasture as
well as roaming wild across the rolling, windswept hills. This ref-
uge is also well known for its fossil beds, from which twenty species
of extinct animals have been unearthed. At Valentine a cameraman
can focus on sharptail grouse, pheasants, many shorebirds, and
pronghorn antelope as well as on a great variety of waterfowl
during the annual migrations. An elk herd is located at Wildcat
Hills State Recreation Area near Scottsbluff. Here also is an ex-
tremely fine, picturesque campground, seldom crowded, for pho-
tographers traveling east or west across country.

Still farther west, in Colorado, is the 13,500-acre Monte Vista
National Wildlife Refuge, near Monte Vista. Located at a lofty
7,500 feet elevation, it nevertheless is mostly wet meadow where
as many as 70,000 mallards have been censused during one season.
More conspicuous, though, are the sandhill cranes, especially in the
spring.

Now for a final, and what may appear to be the strangest, tip
for wildlife photography in Middle America. Scattered over this
region are too many federal and state fish hatcheries to list here. In
nearly all of these where the warm-water species (bass, sunfishes,
pike, muskies, catfish) are bred and raised, water levels are lowered
or some rearing ponds are drained completely with the onset of
fall. Almost invariably this draining attracts large numbers and
varieties of shorebirds, wading birds, even birds of prey. It there-
fore is an excellent chance for photography, because with proper
permission, it is a simple matter to erect a blind near water's edge.
Why not make the most of it?

7

Texas and
the South

Readers who have followed or participated in the conservation crusade to save America's wildlife will recall the plight of *Grus americana,* the whooping crane. Just three decades ago, in 1944, only eighteen of the huge white birds were left alive on the earth. Some biologists had already conceded that the whoopers would soon follow the heath hen, passenger pigeon, and ivory-billed woodpecker over the brink to total extinction.

But on this occasion American conservationists responded in time to save that valuable native. The last remaining undisturbed wintering area of the whoopers—the tidal flats of the Blackjack Peninsula on the Gulf coast of Texas—was acquired as a sanctuary. It later became today's 47,260-acre Aransas National Wildlife Refuge, near Austwell. It is one of the most precious tracts of real estate in all outdoor America, and for wildlife photographers it is certainly outstanding.

Peggy and I last visited the refuge in late February 1972. Because there are no camping facilities within, we parked our camper vehicle just outside the entrance. Before the charcoal in our outdoor grill was burning brightly enough to begin the barbecue, a herd of eleven whitetail deer strolled close enough to stare at our strange activity. Myrtle warblers were busy in live oaks just above. A curve-billed thrasher lurked nearby on the ground. It was a most memorable beginning for a short photo safari.

Even before reaching refuge headquarters next morning to obtain maps and information, we came upon wild turkeys—or more specifically on two rival strutting toms, tail fans erect, sur-

rounded by a harem of hens. Backlit in the early Texas sun, the
birds were iridescent bronze-black figures in the thin morning mist.
It was an exquisite encounter and would have made the photo of a
lifetime except that these particular turkeys were very wary. Unlike
others we encountered later, these drifted away into deep shadows
and dense cover before any filming was possible.

The number of living creatures a visitor can see in a day's time
at Aransas is amazing. The main purpose of our visit had been to
see one of the rarest of all birds, and a glimpse of the cranes would
have been enough. But while completing a 24-mile circuit of the
refuge before noon of the first morning, we had compiled an as-
tonishing list of wildlife sightings.

Within a short walk of refuge headquarters is a narrow slough
in which are alligators, some very large. Except for Everglades Na-
tional Park I could recall no other place where these endangered
reptiles are so handy for photography in entirely wild sur-
roundings. Not far beyond the slough in a parklike picnic area
beneath blackjack oaks, we found a small herd of javelinas—col-
lared peccaries—rooting for acorns on the fringe of sunlight. Un-
like the turkeys, these paid little attention no matter how near and
from what angles we aimed the cameras at them.

Our notes show thirty-two deer spotted and other scattered
flocks of wild turkeys. American widgeon rested on every shallow
pond left behind by recent heavy rains which had drenched
southern Texas. But these waterfowl were more shy than other
wildlife we tried to photograph. Also very conspicuous were wood
ibises, egrets, herons, and spoonbills. Finally, from a tall observa-
tion tower overlooking Mustang Lake and a vast stretch of tide
flats, through binoculars we easily distinguished four tall white
birds which were whooping cranes.

The distance was too great for filming, but the sight was un-
forgettable. For the record, 90 percent of all visitors are able to see
whooping cranes between November and March—or as long, of
course, as the cranes are on the wintering grounds and not 2,500
miles away at their traditional nesting sites in the Wood Buffalo
National Park of northern Canada.

As this is written, the world population of whoopers is about
fifty, and that may be the maximum the refuge can accommodate.
The birds can also be seen, and occasionally at ranges close enough
for long-distance telephotography, from on board a commercial
motor ship which makes weekly excursions along the Intracoastal
Canal from nearby Rockport for that purpose.

One minor disappointment of our Aransas visit was that we did not see, even briefly, a red wolf. Like the whooper, this gravely endangered canine is making a final stand here, and a good photo of the animal would have been a very rare trophy indeed. Not very many pictures exist.

The entire southernmost portion of Texas, and not Aransas alone, is a happy hunting ground for photographers. One good index is that in the Rockport area alone, more different species of birds (226) have been recorded during the annual Audubon Christmas Bird Counts than anywhere else in North America during the tabulations made each holiday season. Using Corpus Christi as a base, it is possible to head out in almost any direction on a productive photo safari. Water's edge of Aransas Bay within the town limits of Rockport is an excellent situation for shooting shorebirds and ducks, particularly many pintails.

Perhaps the finest privately endowed wildlife refuge in the United States (and the world's largest) that is open to the public is the Rob and Bessie Welder Wildlife Foundation near Sinton. Covering about 7,800 acres of natural south-Texas scrubland, it is actually a bird and animal oasis in an area otherwise under intense cultivation. A portion of the Welder Ranch which dates from an

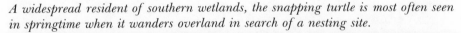

A widespread resident of southern wetlands, the snapping turtle is most often seen in springtime when it wanders overland in search of a nesting site.

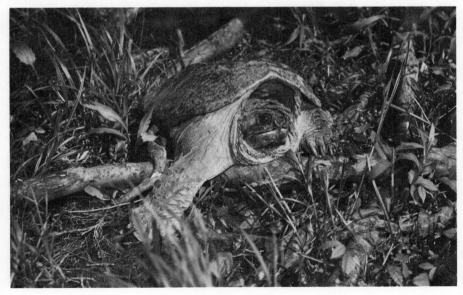

original Spanish land grant, it is home for fifty species of mammals, plus hosts of birds, amphibians, and reptiles. Most noticeable are the flocks of elegant wild turkeys and great concentrations of waterfowl during midwinter on a few ponds. At this writing, admission to Welder, which is free, is restricted to Thursdays, but a serious cameraman may be able to make other more convenient arrangements with the managers.

Traveling southward from Corpus Christi, a photographer has two options. One is to take the Kennedy Causeway over Corpus Christi Bay and then swing southward onto 113-mile-long Padre Island, most of which (80 miles) is included in Padre Island National Seashore. This is really a textbook example of a barrier island built by wave action and crowned by wind-formed dunes.

Wildlife photography here is no certain thing as at Aransas, but there are many opportunities for a patient photographer, particularly for one willing to camp at the Malaquite Beach facilities or elsewhere farther south where no facilities are provided, and all fuel and water must be carried along. Besides the splendid beach-

Very few creatures are dangerous to photograph. But amateurs should give the cottonmouth moccasin plenty of room. A telephoto lens is the ticket.

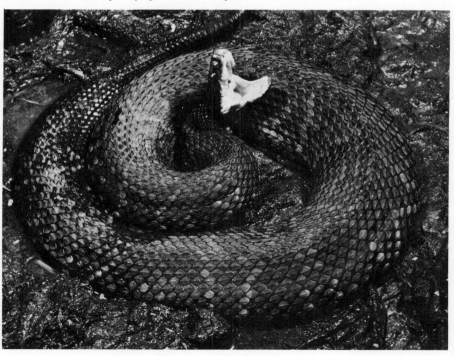

combing, there are many shorebirds, particularly sanderlings along the beaches, plus terns and gulls cruising the shoreline. Often coyotes and raccoons are easy to see (both are becoming used to campers' untidy habits), and occasionally loggerhead turtles venture out onto the sands at night. Hikers on the dunes might encounter lizards and snakes. It is wise to be careful of diamondback rattlers, which are not plentiful but do occur.

An important admonition about driving on Padre must be inserted here. Passenger cars and camping vehicles can be driven only 14 miles southward onto the Recreation Area. Beyond that turnaround four-wheel-drive vehicles are required, and even with these it is possible to become hopelessly bogged down in the soft sand unless you are careful.

The inland road southward from Corpus Christi leads to the 45,000-acre Laguna Atascosa National Wildlife Refuge near San Benito. It is a blending of coastal prairies, salt flats, mesquite, and huisache scrubland, of yuccas, cacti, shallow ponds, and resacas. In midwinter, concentrations of 100,000 or so pintails and twice that many redheads can be photographed. Mixed with these are several thousand snow and Canada geese. Three species of waterfowl uncommon elsewhere in the United States—mottled, fulvous tree, and black-bellied tree ducks—nest on the refuge. The rare white-tailed kite can often be seen in winter, and many small mammals live here. Except after heavy rains, good single-lane car tracks can take visitors to important parts of Laguna Atascosa.

One of the most fascinating of all national wildlife refuges is Santa Ana, a 2,000-acre tract of native subtropical forest (some of it virgin) within a bend of the Rio Grande River near Alamo. More than a mere wildlife sanctuary, it is a living museum of the kind of woodland environment which has been erased everywhere else on both sides of the lower Rio Grande Valley. It contains numerous species of plants, animals, and birds found nowhere else north of Mexico.

When describing any area it is too easy to list the rare species which occur and then omit to mention that the chances of seeing them might be small. But here at Santa Ana, a good many rare birds can not only be seen but can be filmed at intimate range because of blinds which refuge personnel have built and keep baited. We were able to shoot the green jay, black-headed and Lichtenstein's orioles, chacalacas, curve-billed thrashers, and a kiskadee flycatcher. With more available time, and better weather, we might have been able to double that list.

Here, also, is an area where the chance exists, although small, to see two uncommon wildcats—the jaguarundi and ocelot—which are residents of Santa Ana.

Upstream inside a great curve of the Rio Grande is Big Bend National Park. Especially in midwinter when weather is severe over most of the United States, this mixture of dark overpowering river canyons and scorched cactus foothills with the Chisos Mountains is a perfect escape for anyone who revels in spectacular desert scenery. It is among our favorite parts of America, even though it is not a really productive place for photographing wildlife.

Deer are scattered, nervous, and most often encountered at night. Bird life is scarce compared to elsewhere in Texas. Best photo opportunities exist around the riverine campgrounds, where white-winged doves, roadrunners, and woodpeckers have become fairly tame. But an all-round nature cameraman can find plenty of cacti and other unusual desert plants to substitute for the lack of wildlife.

A large percentage of all sandhill cranes which nest in arctic Alaska and Canada spend the winters in Texas. The largest concentration of all, between 50,000 and 100,000 birds, arrives in December at the 5,800-acre Muleshoe National Wildlife Refuge between Lubbock and Muleshoe in the western part of the state. It is worth the time of any photographer passing through the area to pause at this federal sanctuary.

For the past decade or two a unique type of big-game photography—in other words, an African or Asian photo safari—has been possible in Texas. A good many large ranchers in the hill country northwest of San Antonio have been importing and raising exotic animals from all over the world, mostly for trophy hunting. Today on some ranches, such as the YO near Mountain Home, it is possible to photograph herds of zebras, eland, kudus, ibex, barbary sheep, and deer from all over the world. This practice has increased to the point that both blackbucks and nilghai of India (for just one example) are now more abundant in Texas than in their native land, where they have all but disappeared. Of course, permission must be obtained to travel and photograph on these ranches.

Elsewhere in the South, the best wildlife watching is again on national wildlife refuges. In Louisiana, 143,000-acre Sabine in the extreme southwest corner and 32,000-acre Lacassine nearby offer the most opportunities to cameramen. During winter at Sabine, flocks of blue and snow geese are often encountered feeding close

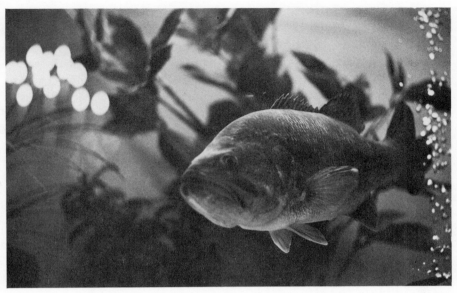

To film the largemouth bass, a native of the South, very clear water and an underwater camera are necessary.

The unhandsome pelican is nonetheless a graceful flyer and makes a gentle landing which is stopped by fast shutter speed.

to roads. Although primarily for waterfowl, both refuges support populations of glossy ibises, roseate spoonbills, and anhingas. Sabine also boasts one of the largest populations of alligators, and control of poaching has long been a major management problem.

Catahoula National Wildlife Refuge near Jonesville contains 5,300 acres to protect white pelicans and waterfowl. Seventy miles south of New Orleans is 48,800-acre Delta Refuge, with 120,000 wintering snow geese and about the same number of ducks. Since it is impossible to see the birds except by watercraft, permission to enter this refuge must first be obtained from the manager in Pilottown.

Four national wildlife refuges are located along the Mississippi Flyway in Arkansas and offer some photo opportunities. Waterfowl are the main subjects on each. They are Big Lake, near Manila; Holla Bend, near Russellville; Wapanocca, near Turrell; and 116,300-acre White River, near St. Charles. The last is the most important and is notable also for the uncut river-bottom stands of such hardwoods as oak, gum, cypress, and sycamore — when flooded, all excellent foul-weather habitat for mallards.

Wheeler National Wildlife Refuge, near Decatur, Alabama, is another waterfowl sanctuary where the numerous Canada geese are easy to photograph. There are three refuges in next-door Mississippi. They are Yazoo, near Hollandale; Noxubee, near Brooksville; and Gulf Island, with headquarters in Biloxi. The last really consists of four uninhabited offshore islands (Horn, Petit Bois, Breton, and Chandeleur) where waterfowl winter and where colonies of terns, gulls, and cormorants nest in summertime.

8

The Southwest

Early one recent spring, Peggy and I discovered a wildlife photography bonanza entirely by accident. I suppose there isn't anything unusual about that. But this time we were on a fishing assignment for *Outdoor Life* to the Ruby marshes of Nevada — or more specifically to the Ruby Lake National Wildlife Refuge.

Ruby is a most remarkable place. It is a shallow body of water trapped in a basin — the Great Basin — without an outlet. Located in Elko and White Pine counties of northeastern Nevada, it lies in a very remote part of a thinly populated state. The main 80-mile-long Ruby Valley is sandwiched between the rugged Ruby Mountain with peaks reaching to 11,000 feet and the Butte Range on the east. Refuge headquarters is 80 miles by unpaved road from Elko, the nearest town. It is best known, and only locally, for the excellent angling for rainbow trout and largemouth bass, both of which are introduced species.

With a square-ended canoe atop the Jeep Wagoneer and a small outboard inside, we arrived at Ruby tired and dusty from bouncing over a washboard road in mid-April. But the sight of the blue marshes edged in new spring green was a pickup. So was the neat Bureau of Land Management campground we found on a foothill overlooking the entire valley. Soon our tent was the only one pitched on the site, and by dusk dinner was cooking on an outdoor grill. At the same time we rigged up fishing tackle for an early start in the morning.

But we quickly found that even a serious angler might have trouble concentrating his attention here, at least in springtime.

Everywhere were waterfowl paired off in bright breeding plumage, the males in their proud, sometimes comical courtship displays. Besides the ducks, shorteared owls stared at us from hummocks on shore, and everywhere circulated large flocks of yellow-headed blackbirds. A golden eagle soared overhead, and after a marsh hawk quartered back and forth over the bow of the canoe, the temptation was too much; I put aside the casting rod and picked up a camera and telephoto instead.

From that point onward, Peggy and I fished only enough to catch a couple of hearty meals a day and then concentrated on exposing film. Fortunately the fishing didn't take too long, and thanks to the generally bright weather there, we made excellent pictures of canvasbacks and ruddy ducks, of cinnamon and green-winged teal. Altogether it was a remarkable duck-hunting trip without the usual bag limits and discomforts of a cold blind.

Shooting waterfowl at Ruby Lake, we found, can be accomplished in two ways. One is to drive the narrow roads atop the dikes which regulate water levels inside the refuge. Many birds become accustomed to cars and, preoccupied with courtship, permit a fairly close approach. A better method is to paddle easily and quietly along the ditches and channels which are opened for this type of boating during early spring. All photographers should check into refuge headquarters before launching watercraft.

Although quite exceptional early in the year, Ruby Lake is only one good destination for the nature or wildlife photographer in a part of America which is full of opportunities. Probably the best way to describe the best is to cover the region state by state. But before proceeding beyond Nevada, there is another place in the state worth mentioning: the Desert National Wildlife Range. This contains 1,500 square miles (it is bigger than Rhode Island) and was established primarily for the protection and management of desert bighorn sheep. About 1,500 of these live in the six dry and sometimes sinister-appearing mountain ranges inside the refuge.

Rarely are the sheep easy to see or photograph without spending too much time in remote parts of the range. But several head, including what is probably the largest desert ram yet measured, are kept in an exhibition area near the Corn Creek field station, 20 miles from Las Vegas on U.S. 95. Photographers are welcome there.

However, another and most unusual type of wildlife can be photographed on the range at night: native amphibians and rep-

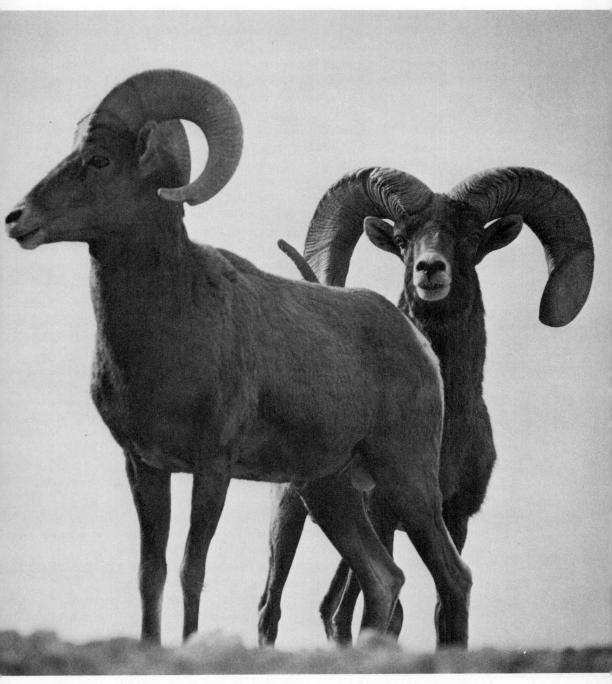

The desert bighorn ram at right rear is carrying massive horns which are near maximum for the species. Filmed at the Desert Game Range near Las Vegas.

tiles of the desert. The refuge has well-defined life zones from the creosote-saltbrush type of the lower flats (2,500 feet elevation and 4 inches average annual rainfall) up through yucca and Joshua tree, piñon and juniper, ponderosa pine and fir, up to bristlecone pine types beyond 9,000 feet. Amphibians are confined to the permanent springs area around Corn Creek, but upward from there live sixteen species of lizards and fifteen species of snakes. Few of these ever venture out under the hot desert sun and may even seem to be nonexistent. Some might emerge on cooler mornings and evenings. But most are evident only at night, when they can be spotted by traveling slowly along rough, often very steep jeep trails. Then photos must be made with flash, always keeping in mind that two of the reptiles (speckled rattlesnake and sidewinder) are poisonous. Several of the native species of nonpoisonous snakes here are very rare.

Arizona is fine photo-safari country, and that is especially true in winter when the weather is most attractive and when photography both of the stunning landscapes and the wildlife is most pleasant.

At Grand Canyon National Park in the north, the world's greatest example of erosion with its fantastic shapes and colors overshadows every other photo subject. But a cameraman who looks elsewhere than across that unbelievable chasm will find large and handsome mule deer and Kaibab squirrels in beautiful surroundings. Incidentally, it can become very cold with snow sometimes piled high on the Grand Canyon's south rim from late November through March. But this only emphasizes the incredible scene which yawns below.

Once in February, Peggy and I spent a long late-winter weekend with Drs. Ralph and Catherine Irwin, husband-and-wife naturalists, camping in Arizona's other canyon country—the Kofa Game Range of the extreme southwestern (Yuma County) part of the state. To explore this 1,000-square-mile refuge, Ralph uses a Jeep Wagoneer and tows behind a quarter-ton trailer which contains complete comfortable camping gear for four. Part of Kofa can be visited by ordinary passenger car, but some of the remote roads are passable only to high-centered vehicles with four-wheel drive.

Our mission on this weekend was to find and photograph the desert bighorn sheep. They thrive in this steep, harsh, ash-dry landscape punctuated with silent box canyons into which few humans ever wander. In one way the trip was a failure, because we

never did get close enough to the sheep to use even the longest telephoto lenses—not even around the few scattered waterholes or the shady caves in which the sheep normally bed. But no matter, because the wildflower spectacle more than made up for it.

We set up camps in meadows solid golden with desert poppies and slept in sleeping bags spread on the warm earth. Filming these blossoms distracted us from the original mission. We hiked through Palm Canyon, where Arizona's only native palms grow in a strange desert setting, and poked about the King of Arizona ghost gold mine for which Kofa was named. Then as a bonus at weekend's end, a band of mule deer crossed the track ahead of our Jeep and bounded up a steep rock slide to pose atop the ridge in silhouette against the sunset. This picture alone made up for missing out on the sheep.

One word about safaris in Kofa. No drinking water whatever is available, and when camping you must carry your entire supply. Maps of the range are available at headquarters in Yuma, and entry should not be made without one. Even with a four-wheel-drive car, a photographer should carry along spare gasoline and such spare parts as fan belts, tires, tubes, shovel, ax, and winch.

Also worth visiting in southwestern Arizona are Cabeza Prieta Game Range and the Imperial National Wildlife Refuge. Cabeza Prieta is similar to Kofa in that four-wheel-drive cars are recommended, sheep are the main big game, and the area is largely a desert wilderness. Occasionally, however, the range is closed to travel because there is an adjacent aerial gunnery range. Imperial is an important wintering place for rafts of waterfowl.

Havasu National Wildlife Refuge was originally established along the Colorado River near Needles, California, for management of Pacific Flyway waterfowl. The refuge is not a particularly good one for the average or amateur photographer. An unusual number and variety of small mammals are resident, but they are seldom seen in the daytime. A specialist equipped for after-dark photography will find forty-two different species, ranging from very common to very rare, from pocket gophers and desert kangaroo rats to kit foxes and pipistrelles.

The vicinity of Tucson must be included on any list of best places for wildlife photography in North America. A cameraman could easily spend a whole winter—or several winters—here with few dull moments. The weather is ideal for camping, and there are ample facilities. On the other hand there are excellent accommodations in town and at numerous guest ranches and resorts within a

Chukar partridge, a native of Eurasia, has been introduced into the Southwest and is now common in rough, dry areas.

50-mile radius. Many of the latter maintain their own waterholes, feeding stations, and even blinds from which wildlife watching and photography can be done conveniently and in comfort by guests.

But my favorite place is Saguaro National Monument, which is divided into two sections: the Tucson Section just west of town, and the Rincon Mountains Section to the east. The wildlife and plant communities are so rich and varied that it is worth describing in considerable detail to serve as a basic photography guide.

The plants and plant communities of Saguaro National Monument are adapted to various degrees of temperature and rainfall—factors also strongly influenced by elevation. At the Cactus Forest, the altitude is about 3,100 feet, and the average rainfall is 3 to 11 inches. The plant life represents that of the Sonoran Desert, which lies in northwestern Mexico (the state of Sonora) and extends into a small part of the southwestern United States.

In contrast, at the top of Mica Mountain the altitude is 8,666 feet, the average July temperature 68° F., and the annual rainfall from 21 to 35 inches. The plants are the type one would see in

parts of southern Canada, at much lower elevations, where the temperature and rainfall are similar to that of Mica Mountain. Thus, the effect of elevation here roughly corresponds to the influence of latitude on a continental scale.

During a visit a cameraman should learn to recognize the major communities by their typical plant members:

Lower desert (below 3,000 to 4,500 feet): creosotebush, saltbush, and needle grama.

Higher desert (3,000 feet): saguaro cactus, prickly pear, cholla, ocotillo, paloverde, and mesquite.

Woodland belt (4,500 to 7,000 feet): juniper, piñon, scrub oak, mountain mahogany, sumac, and manzanita.

Forest belt (above 7,000 feet): gambel oak and ponderosa pine, with Douglas fir, white fir, and aspen at the highest elevations within the monument.

Although some animals move from one plant community to another, many are adapted to life among the plants of one specific environment. Mule deer, for example, subsist on annual herbs and shrubby vegetation, and may be seen in both the desert and the woodland belt. The smaller white-tailed deer generally stay in the forest belt in winter and summer. They browse on aspen, buck-brush, and other shrubs and small trees along the crest of the Rincons.

Peccaries, or javelinas, are usually found in the Cactus Forest. They travel in bands of three to fifty, wandering through groves of mesquite along desert washes as they search for beans and pods of mesquite and the fruits and pads of prickly pear. Jackrabbits are desert dwellers, but cottontails (two species) also live throughout the monument.

Insects and other invertebrates play an important part in the desert ecology, aiding in plant pollination and providing food for birds and other animals. You may notice the tarantula hawks—large blue-black, red-winged wasps that prey on spiders. Several species of scorpions live in the desert and up the slopes. Be wary of them, for the stings of some species can be serious.

Badgers and coyotes range throughout the Saguaro Monument, feeding on rodents. In winter, the coyotes generally stay below 6,000 feet, where the rodents remain longer out of hibernation and the hunting is easier.

Among the reptiles, the desert tortoises live in the low desert area. There are gopher snakes, red racers, and rattlesnakes at various altitudes at different seasons; and the rare, and poisonous,

Arizona coral snakes live in the desert flatlands. However, snakes are not abundant and are seldom seen except by biologists looking for them.

The Gila monster is a famous reptile of the Southwest, the largest (up to 22 inches) and only poisonous lizard in the United States. Gila monsters have acquired a reputation that extends far beyond the narrow boundaries of their range, which is southern Arizona and extreme southwestern New Mexico. They eat birds' eggs, nestlings, and small rodents. Their thick, heavy bodies suggest sluggishness, but they can twist their heads and bite quickly. You are not likely to see any, for they are uncommon in the Saguaro National Monument.

Year-round residents of the Saguaro Cactus Forest are the curve-billed thrasher, cactus wren, Gambel's quail, roadrunner, Gila woodpecker, gilded flicker, pyrrhuloxia, house finch, and loggerhead shrike. The white-winged dove is here, principally in summer. All can be photographed.

In the foothills and mountains live the rare harlequin quail, Mexican jay, Bewick's wren, black-tailed gnatcatcher, red-shafted flicker, hairy woodpecker, and Steller's jay. Numerous others — such as the band-tailed pigeon and broad-tailed hummingbird — are summer residents. Many of the resident birds are not at all elusive and can be shot with a medium telephoto lens.

One way to locate photography subjects is drive the monument roads very slowly, beginning immediately after daybreak or an hour or two before dusk. But even the slowest driver will not be able to spot all that is concealed in the cactus forests as well as a photographer hiking the excellent trails on foot, photo gear carried in a light rucksack. On one occasion I passed within five feet of a perched screech owl and saw it finally only when I stopped for a moment to change lenses on the camera.

An even easier place to shoot some varieties of native wildlife is at the Arizona–Sonora Desert Museum adjacent to the monument. Actually "museum" is a misnomer, because it is mostly outdoors and is a completely natural cactus "garden" divided by nature trails. Wild and otherwise very shy Gambel's quail come confidently to artificial waterholes every morning. They are joined by mourning and white-winged doves, cactus wrens, and many other birds. Some mammals are exhibited in natural outdoor enclosures. In addition to these the museum is a splendid place to photograph all the indigenous cacti, and their blooms and fruits (in season of course), of the Sonoran Desert region. Admission to the museum grounds is $2.

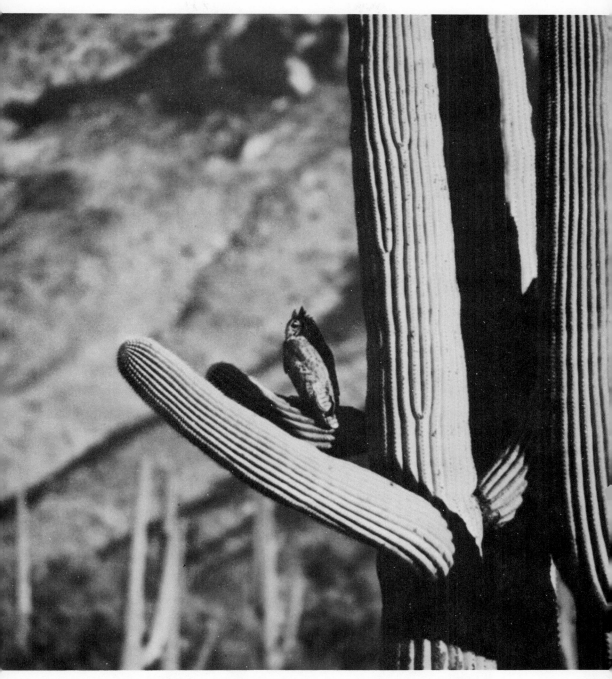

Driving slowly about Saguaro National Monument in late afternoon I came upon this perched screech owl.

In a recent travel-promotion brochure the claim is made that "more color film is shot by tourists in Utah every summer than in any other state." Extravagant as it is, the claim may be true, because from the standpoint of absolutely magnificent and extraordinary landscapes alone, Utah is among the most photogenic places on earth. Five of America's national parks are located here. Unfortunately, Utah is not especially good for the wildlife photographer alone; the wildlife is present, but except for a few scattered places it isn't easy to see.

Consider the national parks. Arches National Park is an extremely and grotesquely eroded region of sandstone with the greatest number of natural stone arches in the world. One—Delicate Arch—has appeared on so many magazine covers and calendars that it is almost as familiar as Old Faithful. A cameraman who delights in seeing strange scenes through the viewfinder can shoot himself into bankruptcy at this park near Moab.

A most handsome animal rapidly vanishing from its home in the Southwest is the cougar or mountain lion, here photographed in Utah.

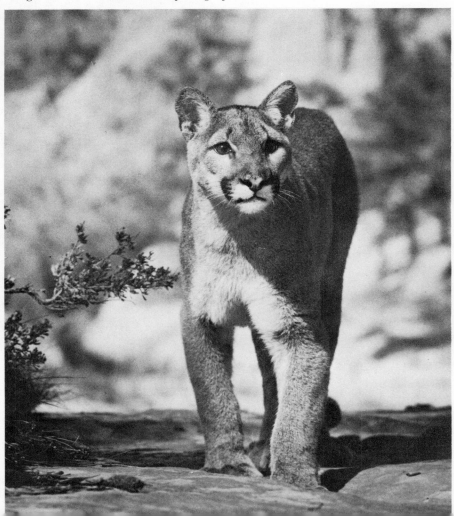

Also near Moab is Canyonlands National Park, 527 square miles of deep, dramatic, twisting chasms along the Green and Colorado rivers. There are scenes of sullen beauty around every river bend. There are three ways to see and photograph Canyonlands. Best is by float-tripping down the rivers, but there are also jeep trips on the canyon-rim trails and charter flights in light aircraft.

Mule deer, coyotes, bobcats, many high Sonoran desert mammals and reptiles, and even a few cougars are native to Capitol Reef National Park in south-central Utah. But a cameraman cannot count on seeing any very easily. As elsewhere in the state, though, the fantastic scenery more than compensates. It is best filmed early and late in the season as well as early and late in the day. The low light angle lends depth to the mountains and unusual geologic formations. It also emphasizes texture and delicate details which are too often lost in the overhead light of midday.

One other suggestion about filming in typical Utah situations: Overexposure is a common mistake in the dry, normally transparent atmosphere. Avoid this by bracketing exposures or by taking frequent exposure-meter readings. Also, the blue haze which shows up in pictures with a great distance between camera and a faraway mountain subject can be corrected by using an ultraviolet filter. However, there's nothing really wrong with a natural blue haze in most pictures. I suppose it's a matter of individual preference.

Bryce Canyon National Park east of Cedar City is a huge amphitheater 20 miles long, almost 2,000 feet deep, and fringed with brilliantly colored sandstone spires and pinnacles. It is always a photography wonderland, but probably more so during winter when the high country is covered with a layer of snow. At times there will be mule deer to shoot, but they are not dependable subjects.

Far more available are the numerous mule deer which frequent the Virgin River valley which is the heart of Zion National Park. From October through winter many animals are nearly always grazing in the glades and river bottoms from the park entrance near Springdale to the base of the Great White Throne, at least during mornings and evenings. After that, deer are best spotted when hiking upward on the trails from Virgin Valley. Mule deer may also be seen occasionally at nearby Cedar Breaks National Monument.

Utah's Bear River Migratory Bird Refuge contains 65,000

Perhaps the most tame and confiding of America's birds of prey is the Harris hawk.
Its range is restricted to the Southwest.

acres on the margin of the Great Salt Lake at the mouth of the Bear River, 16 miles west of Brigham City. It was originally established for the study and treatment of waterfowl suffering from lead poisoning and botulism (the latter is now largely eliminated). It is an outstanding nesting area and attracts a million or more ducks during migration, beginning in August. The mountains provide a good background for pictures. Birds may be seen while you drive on the dikes around a 12-mile unit. From March into December and from May to October are the best months to visit.

At times mule deer are also much in evidence at Bandelier National Monument, west of Santa Fe, New Mexico. The same is true on the dry, prickly hillsides about Carlsbad Caverns National Park, where the most rewarding photography by far is of the remarkable underground beauty. Flash equipment is necessary and there are special photo tours. A good bit of small desert wildlife exists here for a cameraman equipped for and patient enough for night shooting. The caverns are home for countless bats. Each evening from late spring through autumn almost inestimable numbers spiral out of the cavern's main entrance to feed on night-flying insects above the Black and Pecos rivers. Some unusual photos of the massed bat flights have been made against the orange evening sky.

Perhaps New Mexico's best choice for wildlife photography is Bosque del Apache National Wildlife Refuge, 20 miles south of Socorro and just off I-25. A self-guided auto tour for any kind of motor vehicles winds through the heart of the 57,100-acre sanctuary and gives excellent views of greater sandhill cranes (during migration), geese, and ducks. With luck a cameraman might also be able to shoot one of the rare and endangered Mexican ducks which exist in small numbers. Early each morning, watch also for mule deer, raccoons, coyotes, skunks, porcupines, and Gambel's and scaled quail. Such shorebirds as avocets, blackneck stilts, and killdeers are found on the refuge most of the year, and certain individuals become so used to vehicle approach that they are good camera subjects.

9

Wyoming
and Montana

At the turn of the past century, it became evident to the handful of hard-core conservationists in America that a remarkable resource which once seemed inexhaustible had all but vanished. Their alarm was justified. Estimates vary a good deal, but at the time when European settlement began in the New World, the number of bison roaming the landscape was somewhere between 20,000,000 and 75,000,000 animals. In other words, the species was among the most abundant of all the world's very large mammals. But in the early 1900s, only a few hundred individuals remained in scattered, hunted herds.

The systematic slaughter of the bison—or the American buffalo—is pretty well documented. Very rich and royal sportsmen came from as far away as Russia and Monaco to hunt the brutes, and even the poorest travelers aboard the first continental railways used to plink at them from inside dusty coaches and baggage cars. There was market hunting, too, to feed railway workers and miners laboring in remote camps of the West. Here began the era of Buffalo Bill Cody and others of his ilk.

But mostly the elimination of buffaloes was deliberate and calculated, because it also eliminated the Plains Indians, who could not exist without the animals. General Phil Sheridan was widely quoted as saying, "Every dead buffalo is an Indian gone." Bison hides were sewn into all types of garments, including bedrolls. Buffalo skins were traditionally fashioned into tents and crude leather saddles, into shields, bowstrings, and quivers, and the bones were made into various kinds of tools. Of course, the nutritious

meat was a major part of the Indian diet; it was eaten fresh, roasted, smoked, dried, and pounded into pemmican with the berries of late summer. Just possibly no single species of wildlife was more important to the survival of a race of people. The animals *had* to go.

One day in 1908, with both bison and Plains Indians virtually extinct, President Theodore Roosevelt acted in a manner which was characteristic of his life. In grassy foothills near Moiese, Montana, overlooking the Flathead River and in the shadow of the Mission Range, he set aside by edict 18,540 acres especially for the preservation of whatever bison remained. The area was named the National Bison Range, and buffaloes were collected from as far away as the New York Zoo to stock it. To this day the refuge contains one of the largest and healthiest herds of bison left on earth.

However, the Bison Range is more than just a refuge for one great animal. It is an extraordinary place for any traveler armed with a camera to shoot antelope, elk, mule and whitetail deer, and bighorn sheep as well as buffaloes in their natural habitat as he might have a century ago with a gun. The vast range is open to visitors the year round, except in midwinter, and there is a 15-mile circle drive on a gravel road through and over the heart of the sanctuary. It is well worth a day—or several days—of any cameraman's time to take the trip leisurely.

Late May is a good general period to visit, because it is calving time for the 400-odd buffaloes, which thrive on the rolling grasslands exactly as did their ancestors for countless centuries past. In spring it is also possible to see the spectacular courtship display of blue grouse at roadside in the highest parts of the range. August is another exciting period, because then the head bulls are maneuvering, often fighting head to head, for superiority during the early autumn rut. Although the bison are extremely interesting to observe during these two periods, cameramen must be very cautious about approaching them. Cows are anxious about their newborn calves, and later normally docile bulls are far more irritable and unpredictable than usual.

When in the vicinity of the Bison Range, two other national wildlife refuges are also very accessible and worth visiting because of their vast numbers and varieties of waterfowl. These are Pablo and Nine Pipe refuges, where the fall duck population builds to as high as 200,000 birds.

As important as it is to wildlife photographers, the National Bison Range is only one link in a chain of places in the two most

Except perhaps for Alaska, no part of America is as rich in wildlife resources as Montana and Wyoming. And no species is more symbolic of the wilderness here than the mountain lion here in the Bitteroots.

beautiful and (so far) least exploited Western states—Montana and Wyoming. Here is an ideal destination for a two- or three-week camera safari.

If such a safari is planned for springtime or early summer, it is most convenient to begin in Wyoming and gradually work northward. If scheduled for late summer or fall, the opposite direction may be wisest to take advantage of the benevolent weather. Let's assume it is June and describe an itinerary anyone can follow.

When driving almost anywhere across eastern Wyoming, it is possible to see antelope, and probably very many of them. Initially it may be difficult for inexperienced eyes to spot them, but eventually the white rumps of the animals will become more and more obvious. During the summer months, before fall hunting seasons open, the animals become more accustomed to passing traffic. With a good telephoto lens it is possible to get excellent pictures, especially in morning and evening, of some herds fairly close to the highways. But shoot from the car and do not step outside of it. The pronghorns will run away immediately if you do.

Devils Tower, an 865-foot-high column of volcanic rock, is the most conspicuous landmark in eastern Wyoming and also our first national monument, having been established in 1906. But to many, a large prairie-dog colony near the monument entrance is far more fascinating than the giant rock. The tiny residents are completely tame and a cameraman can spend hours, even days, filming the antics and even the life history of a species which once inhabited the entire West. Now it is confined to a few "towns" on public lands, and this colony is probably the best of all. Besides prairie dogs, a good observer here might be able to spot (and photograph) a coyote, a prairie falcon, or a now rare and endangered black-footed ferret.

Most of Wyoming's splendid wildlife spectacle is concentrated in the northwest quarter of the state, so aim in that direction. A good place to unlimber the cameras is just outside the tidy town of Thermopolis, site of the largest single hot springs on earth. Nearby in a state park is another wild herd of bison, which is easy to photograph against spectacular red earth buttes. From near Thermopolis take U.S. 287 over Togwotee Pass toward Teton County, which must rank with the best wildlife viewing places in the world the year round. Almost all of the county is public land and belongs to the American people.

The best-known, most celebrated part of Teton County is Grand Teton National Park, named for the awesome range of

mountains which seem to rise directly out of the Snake River and the sagebrush flats of Jackson Hole to about 14,000 feet altitude. Almost no foothills intervene between the two. But the awesome scene is also an attractive refuge for much wildlife, from tiny juncos, hummingbirds, and Audubon's warblers to huge, lumbering Shiras moose. Besides the park, which includes nearly 400 square miles of wilderness real estate, Teton County also contains the National Elk Refuge and a large chunk of the Teton National Forest.

A summertime visitor has a good many options for photographing wildlife. Easiest and least expensive (in fact free) is a leisurely hike along the excellent trail system inside Grand Teton National Park. Invariably such small mammals as yellow-bellied marmots, golden-mantled ground squirrels, porcupines, and picas will be encountered. In fact, some will freeload tidbits from passersby. More often than not, moose are also met, and at very close range. In summer males will be carrying velvet-covered antlers; the later in the season, the heavier and wider the antler spread will be. Female moose will almost always be accompanied by calves born only a month or so earlier. Understandably they are more shy than the bulls.

Following is one specific and easy hiking photo trip to take, even for persons of moderate physical ability. At the south end, or outlet, of Jenny Lake, catch one of the regular, half-hour shuttle trips by boat (cost: $1.75 per adult round trip) to the opposite (west) side of Jenny. From here it is a half-mile climb on a good trail to Hidden Falls, one of the most popular scenes in Teton Park. Continue, still on a good trail, upward past Inspiration Point and as far as your endurance permits into Cascade Canyon. You are almost certain to see moose within good photo distance of the trail, as well as golden-mantled ground squirrels, marmots, carpets of wildflowers, and lovely mountain panoramas. Carry a lunch in a rucksack and make a whole day's safari of it.

If you are carrying a cartop canoe, you have the perfect means to approach especially close to moose. Just paddle quietly and slowly along any lake shoreline and watch along the willow or lodgepole pine margins. With luck you might also see a mule deer or pine marten at water's edge. The best places to go looking for wildlife by watercraft include Jenny Lake, Leigh Lake (reached by launching at String Lake and then portaging $\frac{1}{4}$ mile to Leigh), Two Ocean Lake, Emma Mathilda Lake, and the Oxbow Pond right beside U.S. 89 near Moran.

Float trips downstream on the Snake River inside Teton Park normally take visitors within sight of some wildlife, especially of moose and bald eagles. Boatmen experienced with fast-flowing rivers can run downstream from one access site to another on their own; otherwise it is wisest to join with one of the numerous float-trip concessionaires licensed to operate on the Snake within park boundaries. No motors are permitted on float boats here.

Most mornings and evenings an excellent place to view moose and many waterfowl is in the necklace of small beaver dams, known as the Sawmill Ponds, not far from the park visitor center at Moose. Here cameramen can aim telephotos from bluffs over-looking the ponds at moose wading flank-deep in water and browsing on the lush aquatic vegetation and algae. No pho-tographic blind could be more conveniently placed than this per-fectly natural one. Here also is one of the very rare places from which beavers occasionally—repeat, occasionally—can be seen working in broad daylight. Look also for trumpeter swans and other waterfowl.

As elsewhere, the photographer who can wander off the beaten track—the farther the better by backpacking or pack trip-ping—has the advantage over the person confined to pavements. Perhaps that advantage is even greater in the Tetons, where there is a massive invasion of tourists throughout the summer months. Still, a surprising amount of wildlife is spotted without leaving the roads, especially for the traveler who arises early and stays out until dusk. But recently a means has been devised for anyone, regardless of age or physical condition, to get far off the roads and to explore the beautiful back country. It is, oddly enough, the same way the first Western travelers managed it, by covered wagon.

L. D. Frome of Afton, Wyoming, is a big-game guide and out-fitter who always felt restless during summertime, his off season. He also was a history buff who in his spare time had done research on old-time transportation methods. The obvious result, perhaps, was that he decided to build several covered wagons, all exactly to scale, and in them to take out tourists into parts of Teton National Forest which are otherwise inaccessible. Frome's only concessions to change were to add rubber tires and steel-leaf springs to his wagons for the comfort of passengers.

The result has been that today young and old can go wildlife watching as their ancestors did, on horseback and under canvas, in lonely mountain country which is also a major calving area for America's largest elk herd. Trips are arranged for a week, for a

few days, or just overnight. But the combination of pioneer living, golden evenings around a camp fire, the circle of Conestogas, deer coming to drink in a nearby stream at dusk, and the nighttime song of a family of coyotes make these covered-wagon trips memorable for non-photographers and serious shutterbugs alike.

Once summer and fall have passed no other region of equal size supports so much wildlife during the hunger moon. Shiras moose are easily the best adapted to cope with a terrible western Wyoming winter. With their long legs they can plod through deep snow more easily than elk, and they can also reach higher to browse. The wintering elk herd, on the other hand, must depend at least in part on man's generosity. The U.S. Fish & Wildlife Service, the National Park Service, and the Wyoming Fish and Game Department carry on supplemental hay feeding programs during the worst periods. In addition, a large part of the Elk Refuge, which is traditional elk winter range, provides some natural winter grazing. Because of this, winter mortality here is less than one percent of the herd, and this results from pneumonia and other diseases rather than starvation.

Nowhere is the role of coyotes better illustrated (and often filmed) than on the Elk Refuge, where they are particularly numerous. I have counted as many as a dozen in an afternoon and have seen six together in a pack. Though they will quickly and efficiently clean up the carcass of a winter-killed elk, refuge personnel have never once seen coyotes attack a dying elk, let alone a healthy one. The species simply cannot be considered a serious big-game predator.

It might appear that bighorn sheep are least fit to survive the winter. They are comparatively short-legged and must travel long distances from remote high summer range to find places where snow is not too deep to excavate. But somehow they make it. For one thing, a remarkable change in behavior takes place near the end of the hunting season and the beginning of winter snowfalls.

Any serious big-game hunter knows a bighorn is among the wariest of game, and a trophy ram is never easy to approach within rifle range during the season. But this extreme wariness vanishes in winter; scattered bands of bighorns stay wherever they discover grazing, and permit close approach. Often last winter I climbed to within a hundred feet of lambs and ewes while they dug for grasses and broadleaf herbs beneath the snow with their horns and hooves. From short range I was able to photograph a band of mature rams grazing beside a paved road.

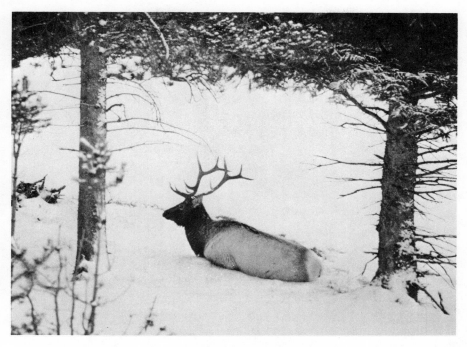

A herd of 8,000 elk spend winters in National Elk Refuge of Jackson Hole. Most are easy to photograph when snows are deep.

Winter is a greater ordeal for mule deer than for all other big game, and probably a smaller portion of them survive it. They cannot browse as high as moose or elk, and as the winter becomes colder and the snow deeper, it is easy to see the deer grow thinner and fewer in numbers. Eventually the mule deer become even more unwary than the bighorns and venture to the very edge of town.

From January through March and even beyond, there is an unbelievable surplus of big game to photograph in northwestern Wyoming. It is not necessary to visit Africa to view vast numbers alone; each winter 9,000 to 10,000 head of big game, plus smaller animals and waterfowl, are concentrated in a very confined area.

What happens is very simple. Deep, accumulating snows and rock-bottom temperatures at high altitudes cover food supplies and drive the animals downward, most going onto the National Elk Refuge where plenty of food is made available. Once secure in this sanctuary and nearby (as in Grand Teton National Park and Teton National Forest), most soon become tolerant of humans.

Sage grouse are never easier to see and "shoot" than during midwinter in Jackson Hole when deep snows cover the ground.

For me the winter of 1972–73 began and ended with wildlife mysteries. For several bright days in January, one area of snow-covered sagebrush flats near where I live was suddenly alive with sage grouse. The flock contained three dozen birds, mixed adults and young of the year. Townspeople drove out to see them because the flock never strayed far from one place. Then all vanished abruptly, never to be seen again.

And, as winter was about to end, just as suddenly a herd of eight bison appeared in place of the grouse. I could see them from my window as I typed the first draft of this chapter. The exact origin of the buffaloes remains unknown, because none were ever before seen closer to the spot than Moran Junction, 30 miles away in Grand Teton National Park.

As grim and hungry a time as winter in northwestern Wyoming is, it is also a test—nature's own elimination contest. The animals which survive are the hardiest, and therefore the most likely to produce young strong enough to face other winters.

Much of the wildlife drama described above can be viewed from the comfort of a car, or not very far from it. The only guide necessary is the one following, plus a road map of Jackson Hole.

A good place to begin a wildlife watching safari is at Hoback Junction, where U.S. 187, 189, and 89 intersect just south of Jackson. Drive slowly northward, paralleling the Snake River, and watch the bluffs on both sides for elk and mule deer. Usually there are moose, which are very dark and easiest to spot, in the snow-drifted bottoms. Most of the time bald eagles (more than can be observed anywhere south of Alaska) are perched in bare trees overlooking the Snake.

On reaching the town square in Jackson, watch for signs pointing to the National Elk Refuge. Then look for signs reading "Elk Rides," which are surely among the best bargains of any winter anywhere. These are trips via horse-drawn sled directly through and among thousands of elk. Many coyotes, ravens, and magpies are also seen. Aim a camera and the viewfinder will be solidly full of animals. From ten in the morning, sleds operate all day with knowledgeable drivers to describe the refuge and its fauna. The cost is only $1.50 per person and half fare for children. Even in Africa it is not possible to enjoy such an intimate encounter with so many large animals.

Despite the intense grip of winter, warm springs in the Elk Refuge keep some ponds from freezing solid. Two of these are located near the refuge maintenance buildings and are visible from the road. But the best viewing spot is on U.S. 187 just beyond the north town limits of Jackson. Rare trumpeter swans (often a good many), beautiful Barrow's goldeneye ducks, mallards, and other waterfowl spend the winters feeding here. They become very tame.

Moose might be seen anywhere on the highway toward Yellowstone, as far as Moran and the road to Jackson Lake dam. I have counted as many as thirty-six in this stretch. Watch especially in the willow flats along streams and midway on the left at the Triangle X Ranch, where many moose (and often buffaloes) feed with the ranch horses. A herd of mule deer spends each winter on the sagebrush slopes west (left) of the highway for a few miles north of Jackson—and at times of deepest snow may be right beside the pavement. A good side road to take goes east (right) at Gros Ventre Junction to the Gros Ventre Slide Geological area, where half a mountain fell away fifty years ago. Moose are usually somewhere in evidence, and in the red bluffs beyond the slide, be alert for a band of bighorn sheep. All the roads I have described here are kept open to safe passenger traffic all winter.

Also always open are the Teton National Park visitor center and museum at Moose, and the Elk Refuge and National Forest of-

Grazing bull moose was filmed within walking distance of author's home in Jackson Hole. Moose are permanent neighbors.

fice in Jackson. Personnel on duty in these places can pinpoint the best sites to watch wildlife. They also know about accommodations, restaurants, and current weather and road conditions in the region surrounding Jackson Hole. Nowadays do-it-yourself wildlife safaris are very popular in this picturesque part of the West—but that isn't any wonder. All you need is your own car, sharp eyes, binoculars, and a telephoto lens for the camera.

North of Teton County is Yellowstone, the world's first and oldest national park. It is a photographer's favorite anytime, but becomes better and better as the calendar year wanes. In springtime the first travelers along newly plowed park roads will see many elk and buffaloes, all gaunt with ribs showing after the long ordeal of winter in that lonely land. At one time it was also possible to see grizzly bears in some numbers, especially feeding on winter-killed or weakened animals. But a puzzling and deplorable park policy of destroying or eliminating bears which began in 1972 (presumably because they are dangerous to park visitors) has forever withdrawn this unique opportunity for Americans to see a magnificent and endangered animal.

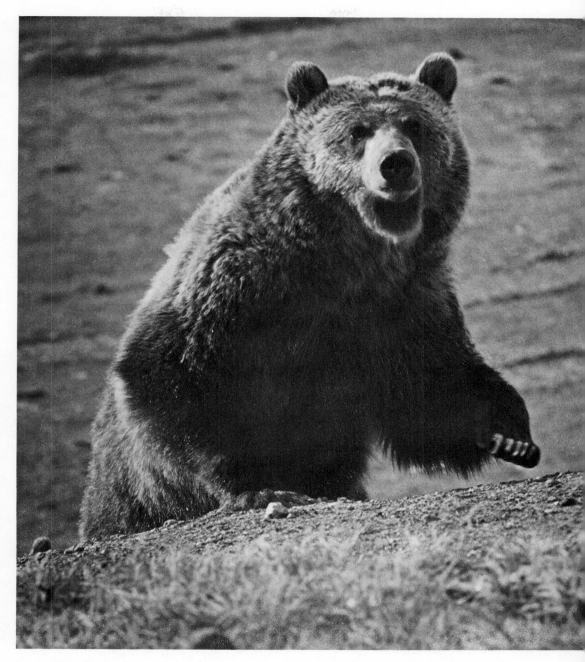

The future of grizzlies is nowhere very bright, not even in Yellowstone where this was taken. But it is the only place south of Alaska where the big bruin might rarely be photographed.

The average Yellowstone traveler in midsummer is certain to
see some animals, although most will have retreated to woodlands
and mountain meadows—to summer range—far from park roads.
There will be the occasional moose and bison, and probably a black
bear or two along some thoroughfares, but park personnel have
also been so busy trapping black bears that even these are be-
coming difficult to see.

With the advent of autumn and its frequent crisp, sparkling
days, elk become more visible in the meadows, particularly along
the Madison and Gibbon rivers. From mid-September well into
October, it is not unusual to see bulls, lovesick during the annual
rut, bugling and dueling with one another during the first hour or
so after daybreak. A drive through Hayden Valley will produce
sightings of moose and waterfowl gathering during the peak of fall
migration. Herds of bison are seldom far from pastures beside the

*Drive slowly along the Madison River inside Yellowstone Park, especially in early
morning, and watch for families of otters which frequently cavort close to the banks.*

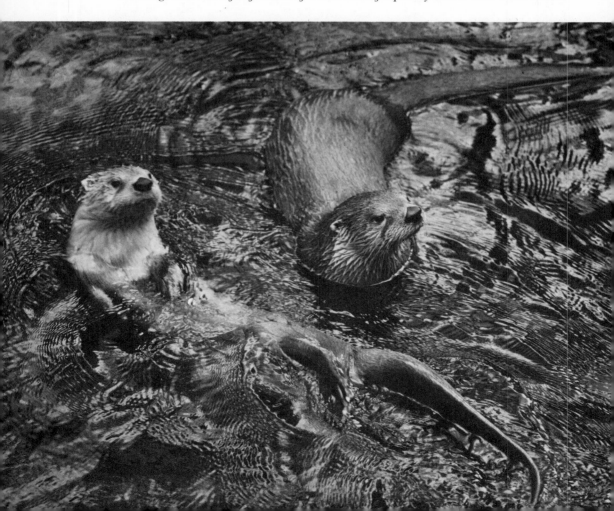

Firehole River north of Old Faithful. Here an outdoorsman can go trout fishing in a remarkable trout stream, while keeping an eye peeled for photo opportunities on both banks. I have spent many fall days casting for browns and rainbows on the fantastic Firehole while completely surrounded by a herd of shaggy bison. All seemed completely uninterested in my presence.

Winter is the time of times to visit Yellowstone. Then the entire Yellowstone plateau is smothered deep under a layer of snow, and the vicinity of the geysers and hot springs takes on a grotesque and almost unbelievable character. Water droplets and steam freeze on trees into ghostlike forms, and those big mammals which do not migrate from the park congregate wherever the thermal activity is great enough to keep a bit of green browse from being locked up by winter. Also the elk, deer, and bison seem to have no fear of photographers.

There are three ways to see Yellowstone in winter. Daily snow coaches (which carry eight to ten passengers and are heated) depart from both Flagg Ranch (north of Jackson) and West Yellowstone, Montana, to Old Faithful, where the only overnight winter accommodations in the park (at Snow Lodge) are available. From there side trips by snow cruiser are possible to Grand Canyon and elsewhere, all within close viewing distance of much big game. Better still is, beginning at Old Faithful, to strike out on snowshoes or cross-country skis (both available for rent) toward the Firehole River. This way it is easy enough to travel amid scenes of wintry splendor as well as among many unwary animals.

We might as well mention, however, that all is not entirely well in this winter wildlife paradise. The same preposterous parks policy which is dedicated to eliminating bears from the park has at the same time encouraged the wintertime use of snowmobiles. The resulting noise and litter of hundreds of machines at one time, especially on weekends, can totally destroy the wilderness mood of an otherwise quiet and lonely place. Also some snowmobilers have not been able to resist chasing and tormenting animals on their vehicles. This is despicable at any time, but doubly so when the elk are weakened by just trying to stay alive in subzero temperature and flank-deep snows.

Another way to see at least a part of Yellowstone in winter is via the Cooke highway from Gardiner, the north entrance, to Mammoth Hot Springs and onward 60 miles to Cooke City just beyond the northeast entrance. The road is kept open throughout the year, with only brief closures after heavy snowstorms. Bighorn

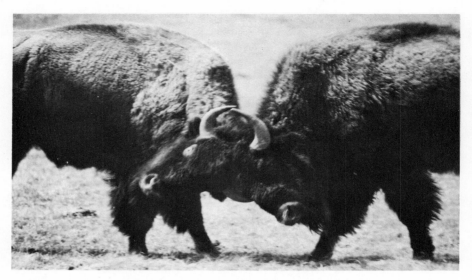

In late summer as rutting time approaches is excellent time to shoot bison at Yellowstone, Black Hills and elsewhere. Here bulls are engaged in serious shoving match.

sheep (usually rams) winter on the cliffs above the highway just north of Mammoth, and another band is often in sight near Soda Butte. Many coyotes, elk, and mule deer spend the entire winter around the small community at Mammoth, often being seen close to the numerous buildings and dwellings. The more severe the winter, the more animals are likely to be in evidence in this fairly confined area.

From Yellowstone mostly via Interstate 90 or 15 it is a day's drive (not including any stopovers at the National Bison Range) to Glacier National Park in the northwest corner of Montana. Glacier is another treasure in the U.S. Park System, and for anyone who will use its excellent hiking and horse trails, is ideal either to begin or end a Montana–Wyoming camera safari.

There is one road—Going-to-the-Sun Highway—across Glacier Park, and except for occasional sightings of elk or moose, game viewing is not really productive along the way. But arrange to be at 6,664-foot Logan Pass at daybreak and closeups of white Rocky Mountain goats may be the reward. Actually Glacier is the easiest spot anywhere to see goats; for a really intimate look at them, hike or ride out on the trail to Sperry Chalet and Glacier or almost any point along the Continental Divide. More than one

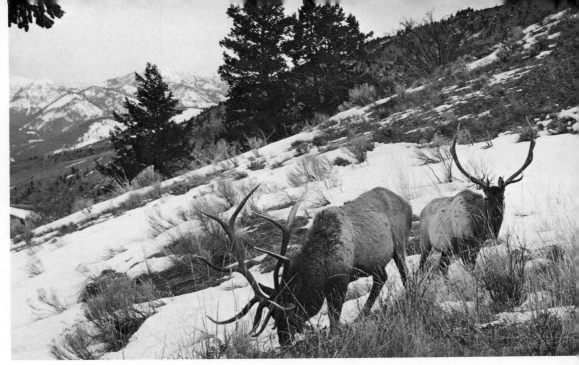

Notice the massive, nontypical antlers of the bull elk on the left. It has three antlers and is a unique photo trophy.

hiker to Sperry has been surprised to be awakened in the morning by goats climbing on the Chalet roof as easily as they scale the natural shale cliffs all around.

The vicinity of Many Glacier Hotel is often a good place to spot bands of bighorn sheep all through the summer and early fall. During October there is usually a concentration of eagles near Apgar, at the outlet of Lake McDonald, which many photographers come to shoot. Not long after that, winter closes the park.

The first photographer ever to visit the Montana and Wyoming Territories and to focus on the area's wildlife was one William H. Jackson of Omaha. Jackson accompanied a U.S. Geological Survey expedition there from 1872 to 1877. Despite the unbelievable hardships and the problems of wet-plate photography a century ago, Jackson's photos of the wonders of Yellowstone and the Tetons were good enough to focus the attention of many others to the region. Photographers nowadays have things much easier. Their equipment is better, and modern transportation takes them quickly from place to place. There are comfortable inns and hotels, and the natives now are friendly. But the wildlife spectacle is as great and fascinating as ever.

10

The Pacific States

One of the hottest photo safaris I can remember began exactly where and when a person can expect heat—Joshua Tree National Monument in southern California during late August. The temperature was 84° F. when I started hiking from an unmarked parking lot not long after daybreak, cameras in a rucksack on my back. By late afternoon the mercury had risen past 105°, and the hours in between might as well have been spent in a bake oven or a sauna. Not one vagabond breeze stirred the livelong day. But fortunately I was too busy to be really intimidated by the heat.

The thin sandy trail at first led down a dry wash where the vegetation was both brittle and widely scattered. When the path reached a junction with another smaller arroyo, it turned sharply left and then began to ascend into steep rocky foothills where the desert brush became slightly more dense. As I hiked along, I noticed scattered pellets of bighorn sheep. Otherwise there was no sign of life, human or animal.

Then suddenly the trail dead-ended on a sheer bluff and I stood overlooking a deep desolate depression eroded out of solid rock. Inside the depression and fed by a barely noticeable trickle of moisture was a pool of jade-green, algae-choked water. As unappetizing as it seemed, that water was the object of my trek. Nearby I found a small crumbling clapboard shelter (built by someone else long ago), and I sat down in the shade it provided, prepared to begin a long vigil. Lunch and two canteens of fresh water should sustain me until dusk.

Often waiting on stand for wildlife can be a long, tedious and

frustrating ordeal, all to no avail. I shuddered to recall the many wasted hours of the past spent waiting for nothing at all to happen. But this morning at Joshua Tree was a memorable exception. Less than twenty minutes after I settled as comfortably as possible, a desert bighorn ram strolled by the shelter, hardly glancing at me in passing. A moment later the full-curl male was followed by three more desert sheep. Eventually all three were drinking the syrupy green liquid of the pool below as if it were cold and pure. Belatedly I grabbed a camera and aimed it at the thirsty animals.

Off and on throughout the day, other sheep came to the waterhole to drink. Other visitors were mourning doves, several Gambel's quail, and a scrub jay. If the surrounding landscape seemed totally devoid of living things, there was plenty of action (even at hottest midday) around this one small place—this one water supply which must have been the only one for a vast area surrounding it. Here was both a magnet for wildlife and a bonanza for wildlife cameramen. I am always careful to carry everywhere more film than I can possibly use, but on this blistering hot day came very close to running out.

Such water sources as this one at Joshua Tree are surely worth any photographer's attention during the dry season, which here-

Burrowing owl with kangaroo mouse tries to stare down author's close approach with camera.

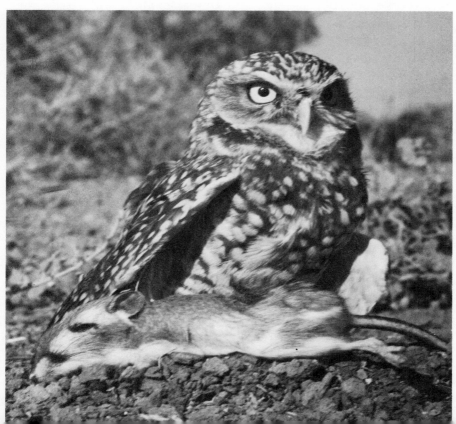

abouts is midsummer and therefore also the hottest time. The location of many of these springs is technically off limits, but on application, monument rangers will give written permission to visit them during daylight hours for photography purposes.

When photographing in Southwest desert areas—at Joshua Tree or anywhere else—a cameraman should proceed with care. Unless very experienced in cross-desert travel and familiar with such hostile surroundings, a hiker should not leave established trails. It is too easy to get lost. Always carry plenty of water—and leave a record of your planned itinerary with the rangers. Although rarely encountered in broad daylight, rattlesnakes do exist (and are very well camouflaged), and photographers should watch where they walk and sit. In addition, such mildly toxic pests as scorpions and certain spiders might also be encountered. Hike only in hiking boots with tops at least 10 or 12 inches high (*never* in tennis shoes or sneakers), and wear sunglasses and clothing which covers as much skin as possible. Walking shorts and short-sleeved shirts may be slightly more comfortable, but a hot desert sun can quickly burn human epidermis to a crisp. Smear exposed skin generously with an effective sun screen. Avoid sitting on or brushing against prickly or spiny vegetation.

To get back to Joshua Tree, there are no accommodations (except primitive campsites and picnic areas) in the entire 557,000-acre monument. Provisions and gasoline can be obtained at Twenty-nine Palms, Indio, and Desert Center.

Another area of southern California which a photographer might hurry past, but should investigate, is 2,000,000-acre Death Valley National Monument. It contains the lowest place (282 feet below sea level) and often has the highest summertime temperatures in the western hemisphere. The brief travel season there extends only from November through April. At other periods it is an inferno. But keep in mind that elevations rise to 11,000 feet (Telescope Peak) and that at times desert bighorn sheep and many small mammals and reptiles are fairly easy to photograph here. But of course the best photo subjects are the amazingly grotesque and tortured landscapes. In late winter there is a surprising wildflower show to film.

During the period when California was first being settled, the region was unbelievably rich in wildlife. As strange as it may seem today, grizzly bears and great herds of tule elk roamed over the lush valleys which are now paved over with concrete, freeways, supermarkets, and other monuments to human "progress." Of

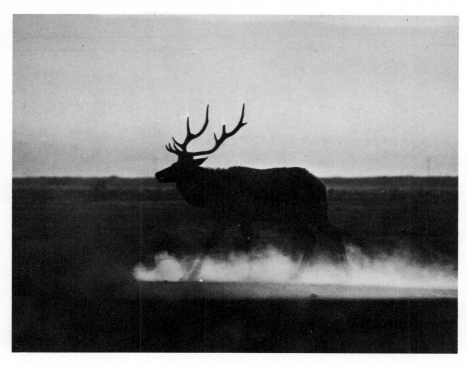

The rare tule elk is easily photographed, often at close range, at a state park near Bakersfield, California.

course, the grizzlies are long gone, and the tule elk were nearly exterminated. But cameramen can find a small band easy to photograph in natural surroundings at Tule Elk State Park just west of Bakersfield.

Photographing captive animals or those confined in zoos may have a certain fascination, but is no great challenge. More than anything else, this kind of photography can offer excellent practice with camera equipment—in how to use it quickly, easily, accurately, almost automatically when confronted with wild animals. That point is inserted here only because the San Diego Zoo just may be the best in the world, both from the size of its wildlife collection and from a photographer's standpoint. The animals are in the sunny outdoors, and here is an ideal stopover for a practicing cameraman who is just traveling through southern California.

The season for whale-watching, an activity unique to the Pacific Coast of the United States, opens each year when the first group of migrating California gray whales is sighted off San Diego's Point Loma, usually sometime in December. The 40-ton

mammals, on their way from Alaska's Bering Sea to the warm
calving and breeding grounds of Baja California, can be seen from
San Diego's shoreline. Between mid-December and mid-February
each year, about 10,000 gray whales make the trek to lagoons
halfway down the coast of Baja. As many as eighty whales a day can
be spotted by watchers during late January, the peak of the migra-
tion period.

The "whale parade" can be viewed in several ways. A free
whale-watching station at Cabrillo National Monument on Point
Loma offers a glassed-in observatory from which to spot whales,
look at whale-life exhibits, and listen to a taped description of
whales' habits. The monument grounds are open daily, 9 a.m. to
5:30 p.m., from early September (Labor Day) to mid-June.

Modern whale hunters armed with cameras and binoculars can
join one of San Diego's whale-spotting boat excursions during the
migration season. The boats locate and follow schools of whales as
they pass one to three miles off shore. The boats follow the whales
closely, and many a visiting whale hunter has been greeted with a
damp spray from a blowing whale just yards away. On some days
excellent pictures are possible.

For serious cameramen, there are six-day scientist-led San
Diego Natural History Museum expeditions which cruise down the
Baja California coast and enter bays, lagoons, and other spawning
areas of whales and other animals. Besides close-up views of
whales, elephant seals, bird rookeries, and other sea life, the ex-
peditions offer lectures and special field trips. College credit can
even be arranged.

The gray whales' three-month journey takes them 6,000 miles.
Whales navigate by sight, so they usually stay close to land as they
travel to and from their breeding grounds. After two months in
their Baja California retreat, the whales start their return trip to
the Bering Sea, often accompanied by 2,000-pound babies. Whales
mate one year and then return to the breeding grounds the fol-
lowing year to bear their calves. The last of the south-migrating
stragglers passing San Diego in March often are met by the first of
the returning herd. Northbound whales are not as easily seen from
shore, because they choose a route farther from the coast. During
the spring, excursion boats take whale photographers into the
northbound migratory lane to observe mother whales followed by
their new calves.

One of the whale's most pronounced characteristics is its spout,
and this is important for photographers to anticipate. The spout,

California gulls circle over salmon cannery, which happens to be a good place to locate the species.

or blow, is actually a sudden blast of released breath. Warm and damp, this condenses to a plume of vapor in the cool outer air. Whales generally blow about three times every five minutes. They surface from a cruising depth of 100 feet in order to exhale and take a first breath. Pre-focus and be ready for it with a fast shutter speed. They then swim about 20 feet under the surface until they blow and take a second breath. Then comes the final blow and third breath, followed by a deep dive in which the whale sometimes flips its tail out of the water. This tail-flipping dive is called fluking. After fluking, the whale cruises along 100 feet below the surface until he needs air again.

The journey of the California gray whale was well known to the early Yankee traders and whalers who first plied the waters off the West Coast during the early years of the nineteenth century. With the American expansion to the west, whaling stations were scattered from San Francisco to San Diego. Prized prey of the colorful hand-whaling industry of the late 1800s, the whales were also hunted by the crews of Norwegian steam whalers in the 1920's and 1930's. By 1937 fewer than 100 gray whales were recorded during the annual migration. Facing extinction, the big grays were given complete protection under an international treaty, and today the herd is estimated at 10,000 or more.

Daily whale-hunting and photography boats are operated out of Mission Bay by Islandia Sport-fishing and Seaforth Landings and out of San Diego Bay by H&M Sportfishers.

The six-day Natural History Museum expeditions include lectures, three scientist-led shore trips, berths, and all meals. For information on these accredited study-trips, write H&M Sport-fishers, 1401 Scott St., San Diego, Calif. 92106, or the San Diego Natural History Museum, P.O. Box 1390, San Diego, Calif. 92112.

In the early 1800s, Lewis and Clark sighted giant and unfamiliar (to them) soaring birds as far north as the Columbia River valley. Almost undoubtedly these were California condors, a species already rare as early as the Civil War. Today their shrunken range is limited to the foothills bordering the southern part of the San Joaquin Valley. A few pairs still nest in the remotest, highest parts of Los Padres National Forest, most within the boundaries of the Sespe Condor Sanctuary. Perhaps the ultimate achievement possible for an outdoor photographer in this part of America is to take a picture of this rare bird in its natural surroundings.

If you seriously scan any of the tourist and travel literature which originates in California, you soon get the strong idea that not much except Disneyland, somebody's berry farm, Hollywood, and the big cities are worth visiting. But more and more, exactly the opposite is true. California's most priceless treasures are the state's five national parks: Sequoia, Kings Canyon, Yosemite, Redwoods, and Lassen Volcanic. That is doubly true for any citizen who relishes extraordinary natural beauty and wildlife. Of the five, only Redwoods (the newest) is not good for wildlife photography. Let's consider the parks, traveling from south to north.

Sequoia and Kings Canyon, which connect, may contain more mule deer than any other Western parks or reserves. The animals are especially easy to see, even from a car, when driving among the groves of giant trees in late autumn. Perhaps too much traffic keeps them away from the roads earlier in the season. The best way to hunt wildlife with a telephoto lens is to hike the 100-plus miles which begin from twenty-eight trailheads through all elevations of the High Sierras. It is possible to encounter anything from tiny juncos to a bobcat or a wandering black bear.

Yosemite is also best visited in fall if wildlife photography is the main goal. But the scenery of Yosemite Valley is distracting because it is among the world's most exquisite, most awesome, at *any* season. It is an understatement to say that the opportunities for

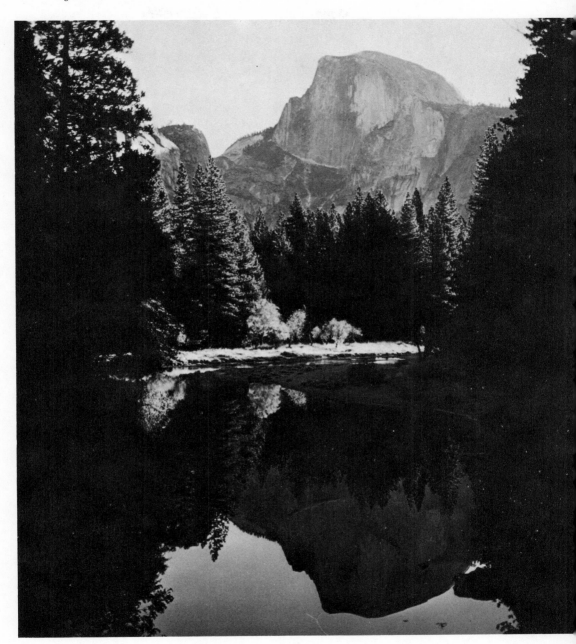

Some of the most awesome landscapes on earth can be photographed at California's Yosemite National Park. This picture was made very early on a fall morning.

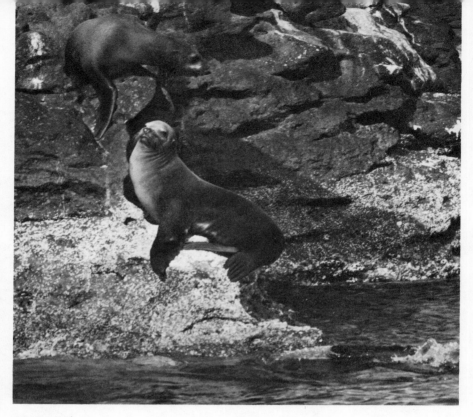

Herds of California sealions can be seen on many offshore islands of the Pacific Coast from Oregon southward to Baja.

shooting scenes are unlimited. As in Sequoia, a trail hiker will see the most wildlife. Or drive the winding road northward from Fish Camp to the main Yosemite Valley Road. There in autumn many mule deer concentrate in beautiful meadows near Wawona Hotel.

Lassen, at the southern end of the Cascades, is the smallest of California's national parks and also the least developed. To get off the trails with lunch, camera, and lenses in a light rucksack is to invade a high-altitude wonderland of dormant volcanic activity which shelters its share of wildlife. It has one great advantage over Sequoia and Yosemite in that on a typical summer's day, a photographer will encounter fewer other people. There are campsites as well as more formal accommodations in all of California's national parks, but all are closed during winter. In addition, the mid-summer demand for space is so great that most places are filled or reserved far in advance.

About 25 miles off the coast of Santa Barbara is the Channel Islands National Monument. The small archipelago includes Anacapa Island, a nesting ground of brown pelicans (now fast disappearing everywhere) and Farallon cormorants, and Santa Barbara Island, which contains a large breeding rookery of California sea

lions. But possibly more conspicuous even than the birds and sea lions is the giant cereopsis, a treelike sunflower which is found here in greater abundance than anywhere else on earth. Private transportation must be arranged to visit the islands from Santa Barbara or Ventura. Primitive camping is permitted on Anacapa, but there is no fresh water available anywhere.

Because more waterfowl travels the Pacific route than any other of the four North American flyways, migration-watching and photography of ducks and geese is good at various points from Puget Sound all the way southward to the Salton Sea, the latter being the site of a 36,500-acre national wildlife refuge. In between are Columbia, McNary, and Willapa refuges, in Washington; Malheur, in central Oregon; Stillwater, near Reno, Nevada; and Lower Klamath, Kern, Merced, Modoc, Sacramento, and Tule Lake, in California. Merced is outstanding as a concentration point for rare Ross's geese. Sacramento Refuge, which is a winter haven for whistling swans, snow geese, and cackling geese as well as for countless of the more common waterfowl, is a most important link in the federal refuge system. It is also a good spot for bird photography.

A special word here should also be inserted about Tule Lake Refuge, in the center of the Klamath Basin, where 80 percent of all migratory waterfowl in the Pacific Flyway pause. It is such a magnet that during October it even draws ducks from as far away as Idaho and across the Cascades. Here gathers annually the greatest concentration of waterfowl on our continent and probably on earth. That means plenty of birds to shoot on film.

Crater Lake National Park, Oregon, where a 12,000-foot peak erupted violently 10,000 years ago (quite recently, geologically speaking), is an excellent place to take a short camera safari. Yellow-bellied marmots are commonly seen in rock slides everywhere, and badgers are not too shy of observing cameramen, who might also have a fair shot at a red fox. Golden-mantled ground squirrels gather tidbits around parking turnouts, and tame gray jays and Clark's nutcrackers follow hikers around the Crater Lake rim trail.

A hiking cameraman is also wise to watch always for golden and bald eagles, California gulls, ravens, and even an occasional peregrine falcon. In 1969, a photographer aimed his 300mm telephoto lens at a peregrine perched on a dead snag overlooking Wizard Island in the lake. He was just an amateur with a moderately priced camera, but the shot was good enough to capture the

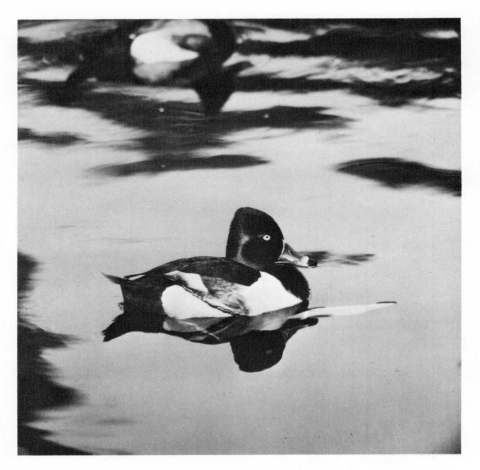

Ringneck ducks can be seen on any of the national wildlife refuges in Pacific Coast states.

cover of a national magazine. It was also the first picture the photographer had ever sold. Similar opportunities are waiting wherever cameramen and their wild subjects are likely to meet.

Unlike the ocean beaches and shorelines elsewhere, those in Oregon belong to the people and forever remain undeveloped. As a result, a wandering cameraman will encounter scenes of great beauty from border to border, as well as a good bit of marine and edge-of-the-sea life. Colonial sea birds nest on Oregon Islands and Three Arch Rocks national wildlife refuges. Other colonies of mixed sea birds breed on Copalis, Flattery Rocks, and Quillayute Needles refuges off the coast of Washington. Farther north in

Puget Sound are Jones Island, Matia Island, San Juan, and Smith Island sanctuaries, where puffins, murres, pelagic cormorants, gulls, guillemots, petrels, and auklets nest every springtime.

North Cascades National Park is one of America's newest, and I have not yet been able to explore that portion of the Cascades range. But it should certainly be worthwhile. Mount Rainier National Park is better known for its spectacular glaciers, and alpine wildflowers and even as a basic training ground for neophyte mountain climbers than for wildlife. But mountain goats can be stalked on rocky crags above 6,500 feet or so, and mule deer appear at dusk at lower elevations. Another fairly conspicuous animal is the hoary marmot.

The Olympic Peninsula of Washington first received national attention because of its wildlife and especially for a large member of the deer family, the Roosevelt or Olympic elk. About 5,000 of these still survive, all in the western portion of Olympic National Park. But at least during the summertime tourist season, the animals are not easy to see without undertaking a lengthy hiking or pack trip deep into the high country of the park's interior. Easier to photograph are blacktail deer, marmots, goats, and sometimes black bears. Olympic's dripping rain forests and even the more open glades of the high country are enchantingly beautiful and most photogenic dry or wet, but dankness does not contribute to the best wildlife photography. Nor does the characteristic drizzly weather.

Citybound photographers can find a bonanza or two along the Pacific Coast. In Oakland, California, is Merritt Lake, often claimed as America's oldest wildlife sanctuary. Not many places, especially within the limits of a metropolis, furnish better opportunities to shoot North American waterfowl with a camera.

11

Baja California

Late on a cool and golden afternoon in March 1973, I turned the Jeep Wagoneer from a smooth asphalt road onto a single-lane rocky track which descended steeply through a forest of cactus and twisted, leafless brush. From the turnoff it seemed that the track might lead us to a campsite near the Gulf of California. But soon it seemed to meander into nowhere and disappear altogether. When we were just about to turn back, we had a glimpse of blue sea, and 100 yards farther emerged upon one of the most secluded, most beautiful beaches we've ever found.

"We have discovered paradise," Peggy said.

It was a small paradise indeed. Steep sandstone cliffs formed a sheltered cove around an arc of ocher sand which was washed by a gentle surf. No signs of civilization, not even human footprints, were to be seen anywhere. The only other living things then in view were several willets and tiny sanderlings patrolling the beach and magnificent frigate birds circling far offshore. We parked at the top of the dunes, kicked off our shoes, and for a few minutes just enjoyed the lonely scene. A lone western gull settled to the sand nearby, suddenly saw us, and flew away again.

"We'd better unpack," I said finally, "and make camp before dusk."

Thanks to plenty of previous experience, we needed only a few minutes to pitch a tent and otherwise get organized. Peggy was poking about in the grub box to prepare dinner when all at once our plans were changed. Near the mouth of our cove a school of fish began to feed on the surface. Then miraculously a squadron of

brown pelicans appeared to feed on the fish. For a few moments it was exciting to watch their head-on power dives before something rang a bell.

"Do you think they're trying to tell us something?" I asked.

"Maybe so," Peggy answered as both of us raced back to the Jeep, she to set up tackle and me to grab a camera.

There was no chance at all with our light spinning tackle to reach the school of fish still ripping the Gulf offshore, because the action had surged to almost 200 yards away, but that didn't make any difference. Peggy needed only a few casts into the dark rocks nearby to catch three cabrillas, Mexican groupers of about 1½ pounds each, and that was enough for dinner. I didn't get any pictures of the pelicans at all. But what I will always remember most about that place and that glorious evening were the cabrilla fillets cooking over the coals of a fragrant driftwood fire as twilight blended into night. Stars never seemed closer to earth than when we finally turned in. We had discovered paradise. Our own.

Even in a career devoted to outdoor adventure—in which camping is a commonplace experience—I have known few situations to match that one. In fact, too few still exist in the world nowadays. But strange as it may seem, that beach was neither private nor inaccessible. That place was near the tip of Baja California and is easy enough—in fact it has become *too* easy—to reach right now.

Baja California, Mexico, is a unique region on earth. It is a thin, mostly mountainous peninsula, 40 to 150 miles wide, which extends southward for more than 800 miles, almost as if an extension of southern California. It is isolated from mainland Mexico by the Sea of Cortez, or Gulf of California. Mostly very dry and in many ways inhospitable to human settlement, Baja has a population of only a million people, and nearly all of these are concentrated in the northern border towns. The interior is largely uninhabited except by desert or semi-desert wildlife. The long, spectacular, island-studded coastline contains rich aquatic life and more species of fishes (over 350) than anyone has yet completely catalogued. The underwater photographic potential is absolutely unlimited and today still untouched.

Summed up, Baja is something of a photographer's promised land, an ideal destination for a photo safari.

Until recently most of Baja has also been off limits to all but the most hardy and adventuresome outdoorsmen or to those with a good bit of money to spend. Much of the peninsula was roadless,

or practically so; you had to enjoy or at least overlook hardships to
travel overland. Four-wheel drive was a must to get anywhere
safely. The alternative was to fly to only a few places where both
airstrips and facilities primarily for hunters and fishermen ex-
isted—and of course this was expensive. Now that situation has
changed, and is continuing to change, as we will see.

I first explored Baja in April and May 1964 with Glenn Lau,
an old friend and then a summertime fishing guide on Lake Erie.
Beginning where pavement ended near San Felipe at the top of the
Gulf—the Sea of Cortez—we drove nearly 1,000 miles over steep,
sometimes rocky, sometimes incredibly dusty roads to La Paz near
the southern tip of the peninsula. We needed thirteen days to
make the trip, several times covering fewer than 100 miles a day
and seeing almost no one. At times we cleared road by removing
boulders by hand. Nights we simply unrolled sleeping bags wher-
ever darkness found us. It was never an easy or comfortable trip,
but was tough physically. Still, it remains an absolutely extraor-
dinary adventure neither of us will ever forget.

En route and in scattered places Glenn and I found good
shooting for quail, jackrabbits, ducks, and even brant. We noted
signs of deer, desert bighorn sheep, and even cougars, but never
saw the animals themselves. But the hunting in no way matched
the fishing or photo opportunities we enjoyed almost the length of
the Gulf coast wherever we could sample it. It was simply terrific!

But for anyone who genuinely loves the outdoors, Baja has
even more than sensational angling, for which it is best known. It is
hauntingly beautiful. Here you can swap the neon and noise, the
congestion and flaming newspaper headlines of home for sun, soli-
tude, peace, pure air, and complete escape. That explains why I
always wanted to get back to Baja. Therefore in early 1973 with the
transpeninsular highway from Tijuana and Ensenada on the verge
of completion (it was finished in early 1974), we decided to go
again and see what changes had occurred—and found a good
many.

Peggy and I decided to make the trip in reverse of the first
one—from south to north—for a number of reasons. Most impor-
tant was that fast, efficient, regular car ferry service exists between
several cities on mainland Mexico's Gulf coast (Mazatlán, Topolo-
bampo, Guaymas) to ports on Baja (La Paz, Santa Rosalia). Also,
more than the entire southern half of the transpeninsular highway
had been paved. This plus the ferry service made it very practical
to take to rec vehicles, even motor homes, and to trail fairly large

boats over to Baja. We found many Americans doing this—going over on one ferry and returning on another.

We crossed on one of two ferries which make almost daily runs from Mazatlán to La Paz. Fare then was $40 for the Jeep, plus $12.50 each for passage and a double stateroom. Departures are at five p.m. with arrival in La Paz at ten the next morning. La Paz is an attractive town of about 40,000 and was once the center of a pearldiving industry. On landing there, we took the highway (Route 11) south toward Cabo San Lucas, land's end where the Gulf of California meets the Pacific.

Probably I should insert here that we were prepared to be self-sufficient, as anyone wandering off the pavement on Baja should be. Besides complete, but not elaborate, camping gear (tent, bags, foam mattresses, two-burner gas stove, cook gear, and large grub box of varied tinned, freeze-dried, and concentrated foods), we carried ten gallons of pure water (plus halazone to purify water), spare tanks of gasoline, spare car parts (fan belt, axle, spring, plugs, tires, a tool kit), shovel, ax, rope, much photographic gear (all in tight dustproof containers), and fishing tackle. If repeating exactly the same trip again, I would have carried a cartop boat and outboard motor, or at least the motor alone. It would have permitted extra opportunities to visit offshore islands.

From La Paz it is a pleasant drive through mountainous country to touch the Gulf again near Rancho Buena Vista. Here was one of the first areas of Baja to offer facilities to fishermen, and it is still one of the greatest, especially for billfish. During the first trip nine years before, Glenn and I hooked seventeen striped marlin in two days of fishing from a small boat. Even during the fastest fishing period (May through June) such a score would be out of the question today—anywhere. Marlin and sailfish still rank with the best here, but the Japanese commercial long-line fishermen have virtually infested these Mexican waters and have taken a great toll.

From an idyllic camp on the secluded beach, we explored and photographed the Cabo San Lucas area. A good many luxury hotels exist here now for any who would like to do these things (or go fishing) in great luxury. We also found a good U.S.-style camp park for trailers and other recreational vehicles. Eventually we turned back to La Paz again, burning film on seascapes which would put most "South Sea islands" to shame.

The La Paz area offers a wide variety of accommodations from hotels to trailer sites and recreational vehicle parks of high stan-

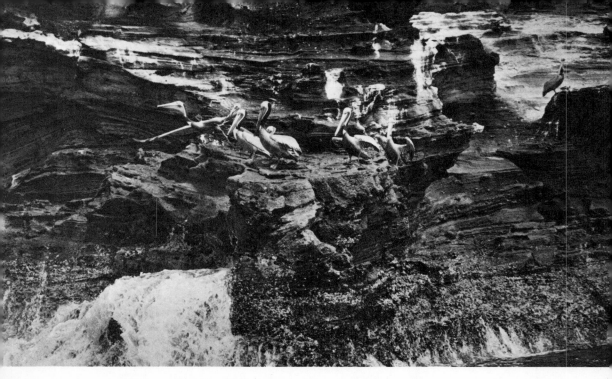

Victims of DDT and disappearing elsewhere, brown pelicans can still be observed in small numbers along the Baja California coastline, here near La Paz.

dards. Many fishing boats of all sizes are for rent, and there are good launching facilities for travelers who bring their own on the ferry. If he is cautious and pays attention to weather, and to tide fluctuations and frequently strong currents, a visitor can have an exciting time exploring the waters around La Paz. Sea birds are abundant, and we photographed the colonies of California sea lions which live on Esperitu Sanctu and other nearby islands. A confident scuba diver with underwater cameras could spend unlimited time shooting here, because both the submarine geography and the fishes are exciting. North of La Paz is a fairly long and inaccessible stretch of coastline before again striking ultra-productive water and a region often called Juanaloa.

Entering Mexico for an extended safari trip is not the difficult experience it may have been in years past. But any visitor is wise to plan well ahead and carefully for a Baja trip. Not only must you have proper equipment, but you must know all the necessary regulations and obtain the proper documents.

At this writing, for trips longer than seventy-two hours, each U.S. or foreign citizen must obtain either a six-month single-entry or six-month multiple-entry tourist card. Proof of citizenship (passport, birth certificate, or voting affidavit) is necessary to obtain

a tourist card. Single-entry cards are available at all border stations on arrival; six-month permits can be obtained at Mexican consulates in the United States, Canada, and Europe and at some travel agencies. A car permit is not required for Baja alone, but anyone traveling between Baja and the mainland by ferry does need a permit obtainable at any border post. Proof of ownership is necessary to obtain a car permit. All photo equipment should be registered with U.S. Customs before entering Mexico. Take along all the film you anticipate needing, plus extra, and do not depend on getting it once in Mexico.

Visitors are strongly advised to purchase Mexican automobile insurance before crossing the border, because authorities recognize only policies issued by companies licensed to transact insurance business in Mexico. If they lack local coverage, persons involved in accidents are held and their vehicles impounded, regardless of the seriousness of the accident, pending an investigation which may seem endless. Foreigners are given less than preferential treatment. Mexican insurance policies are issued by the day, month, or year and are issued immediately on application in all U.S. border towns.

The following publications are extremely helpful for planning, in the approximate order listed: Baja California Map issued by the Automobile Club (AAA) of Southern California, Los Angeles; "Baja California Sur" and "Baja California Norte," both very detailed booklets also issued by the Automobile Club of Southern California; "Kym's Guide and Map" (25¢), Triumph Press, Box 75445, Sanford Station, Los Angeles 90005; and "Sunset Guide to Baja California" and "Sunset Guide to the Sea of Cortez," both by Lane Books, Menlo Park, Calif.

On the 1964 trip mentioned before, Glenn Lau and I drove to Loreto, a small port on the Gulf of California in Juanaloa. It is one of the most beautiful regions on that entire 800-mile-long peninsula and is the headquarters for great saltwater fishing. From the U.S. border, we needed a full week on steep, tortuous, rocky, at times almost impassable roads to reach Loreto in a four-wheel-drive vehicle. But the sport we found was worth the difficult trip many times over.

However, in late March 1973, Peggy and I drove northward toward the same destination on Mexico Route 1, a wide and smooth, recently completed, two-lane paved highway. From La Paz it is about 220 miles — say four and a half to five hours — to Loreto, all but the last 30 miles of it through dull scrub country. Suddenly

we began to climb steadily upward into the Sierra de la Giganta, one of the main mountain ranges which form the backbone of Baja.

If this portion of the Sierra de la Giganta together with the coastal region of Juanaloa existed elsewhere on earth, it would be a world-famous national park. It's that spectacularly beautiful, that wonderful. It's also that worth saving in its present primitive state for all posterity. Jagged purple mountain ranges poke mile-high peaks into clear skies, and below them grow lush forests of cacti and elephant trees. Some bighorn sheep and mule deer still exist in the most inaccessible parts of the Giganta range. If they were protected, travelers would begin to see them more easily at close range. Just before descending abruptly to the seacoast, we enjoyed magnificent views of the azure Gulf of California from the winding, switchbacked road. It was impossible not to stop often to take pictures of those breathtaking landscapes.

That night we camped in a cactus thicket at the foot of the mountains and close to a protected bay called Puerto Escondido. Other parties of Americans had found the place before us, and their campfires glowed in the blue dusk when we arrived. After dinner we unrolled foam mattresses and sleeping bags on the ground. Tree swallows glided back and forth silently above our beds, and I was sorry it was too dark to photograph the red pyrrhuloxia which watched me extinguish the camp fire. The last sounds we heard before falling asleep were California quail clucking in the brush nearby and the evening song of a mockingbird.

Loreto is just a few miles north of Escondido, and after breakfast we went there to try to charter a fishing boat. A good many Americans were already on hand, but we were lucky enough to get the last boat—and far from the best.

There is no point here in describing in detail the remainder of that day, except to mention a few highlights. We *could* have filled up the boat with yellowtails, which ran to twenty pounds. If one school stopped feeding, a short cruise soon turned up another. All we had to do was find a flock of feeding, mewing gulls or pelicans, and there were plenty of these. This time the instincts of an angler won out over the instincts of a photographer, because I found that I could take yellowtails right on top with a large popping surface plug. It was excitement difficult to match. At noon a sandwich and a cool beer never tasted better, mostly because it was an excuse to stop fishing for a while. My arms and shoulders were very sore. That evening we broiled yellowtail fillets over an open

The Sierra de la Giganta of central Baja California desperately deserves to be set aside as a national park.

fire at our Puerto Escondido camp, and probably I never slept more soundly. The sun was well overhead before I stirred.

Our next destination northward, still on paved Mexico 1, was Mulegé, another small seaside village which (similar to Loreto) owes a new prosperity to great fishing and visiting anglers. At the mouth of the only river in all Baja, the town has a very lush tropical setting unlike anywhere else on the long peninsula. Common egrets, green herons, black-crowned night herons, and double-crested cormorants abound. A highlight here was when we spotted an arctic loon so far from its northern nesting grounds.

At the time of our safari, paving of the transpeninsular highway, Mexico 1, had been completed to near Rancho Mesquital, which is just north of El Arco, a small and dusty settlement on the imaginary line or half-way point which separates Baja California Norte (a state of Mexico) and Baja California Sur (a territory). Actual grading had then been completed another 50 miles or so to Rancho Rosarito.

Just north of Rosarito we found a fork marked by a weathered, almost illegible sign. To the left went Mexico 1, then about 275 miles of corrugated, washboard surfaces (now paved) mixed with deep powdery dust to the beginning of pavement south of Ensenada. The right fork pointed toward the Gulf of California and over about 150 miles of some of the worst roads in Baja or anywhere else to rejoin pavement at San Felipe. Here the carrying of so much emergency equipment could be justified.

We selected the right (eastward) fork because fishing is vastly better in the Gulf than in the Pacific, especially so early in the year, and also because it is much more scenic. But I should emphasize once more that it is *not* a route to be undertaken without a four-wheel-drive vehicle (absolutely *no* big recreational vehicles) in good state of repair and with a complete inventory of spare parts. Furthermore, travelers taking this route should have experience in back-country travel and be equipped to be entirely self-sufficient —in other words, to camp in primitive fashion.

The earliest development of Baja was accomplished by hardy Jesuit, Dominican, and later Franciscan priests who everywhere left behind missions which were remarkable for their times. Many Baja travelers today enjoy searching for these and find that some are in a splendid state of survival for photography. From Rosarito we drove 21 miles over a narrow but fair road to Mission San Borja, one of the oldest and best preserved, perhaps because it is so remote, so inaccessible, and so seldom seen by anyone. We found

the small adobe settlement surrounding it to be now deserted even though a warm spring bubbled out of a nearby mountain to sustain life. We camped near the ghost town and slept better than we might have if we had known about the next stretch of "road" just ahead.

Starting soon after daybreak, we needed over five hours to negotiate 21 miles of rock-strewn, upside-down, cactus-covered landscape. Without four-wheel drive it would have been impossible, and rusted shells of passenger cars abandoned on the way were proof of that. It was a huge relief to reach the only moderately bad road which continued to Bahía de Los Angeles, a bleak settlement in an absolutely exquisite setting on the Gulf shore. Like Juanaloa, this is one of the two or three most beautiful sites in all Baja. It is doubly beautiful at the end of such a bad drive, even though a high wind was blowing on our arrival.

It would be almost impossible to visit Bahía de Los Angeles without meeting one Mama Diaz, a stout and formidable woman (who reminded us of Golda Meir) who rents accommodations (Diaz's Bungalows), boats for fishing or island exploration, and tackle and sells both auto and aero gasoline. She also sells groceries (even cold beer) and offers advice in good English on a variety of subjects. Incidentally, the bungalows were among Baja's best bargains at $20 per night for two. Although not deluxe, the plumbing worked well enough and the tab included three excellent Mexican cooked meals.

Los Angeles Bay is comparatively sheltered water because of the many islands offshore. Largest is 45-mile-long Angel de la Guarda, which from the mainland resembles the silhouette of a giant dragon's back. Some of Guarda's peaks reach to 3,000 feet, but this and adjacent islands are best known as sea-bird nesting sites. Boobies, frigates, pelicans, and terns nest on the barren, waterless shorelines. Endemic races of lizards and rattlesnakes can be found by island hopping and exploring ashore. It is a situation made to order for photography.

North of Bahía de Los Angeles we enjoyed a fairly good road through cactus forests where jackrabbits were plentiful and a kit fox ran on the track ahead of us. It was also the most beautiful wildflower spectacle I have ever seen, following as it did a month of unseasonal rains, the heaviest in many years. For many miles the sandy earth was an unbroken tapestry of sand verbena and primrose. We camped that night on a beach near Bahía San Luis Gonzaga, where there are a number of primitive fishing camps, but

surrounded by far too much litter to be attractive. Sleeping in the
open was far more appealing, and next morning we were awak-
ened by hummingbirds buzzing in the flowers beside our bags.

This general region is where a traveler comes in greatest con-
tact with a very strange cactus, the boojum tree, which exists no-
where else. Resembling a giant inverted radish, a goblin, or a
ghost, depending on how you view it, the boojum is a wonderfully
grotesque subject filmed against a sunset, perhaps with black vul-
tures perched in the crown.

As stated before, Baja California's road system (except for
paved Routes I and II) is poor, and often even that is under-
statement. One particular portion is also slightly hair-raising and
not recommended for weak hearts. It is a 20-mile section (or about
half) of the road we drove northward from Gonzaga to Puertecitos.
It is cut almost entirely through volcanic slag and over rock ridges,
and there are short, extremely steep grades with no room for pass-
ing and with sharp jutting rocks forming an obstacle course. The
20 miles require at least five hours to negotiate.

Actually this road, which roughly parallels the Gulf, is an
amazing example of practical engineering. It is maintained entirely
with hand tools by a Mexican and his son who subsist solely on
donations from a handful of grateful passersby each day. All
along the way are abandoned cars and trucks, some of which rolled
off the track into deep ravines. Crude crosses mark graves of some
casualties of the road. It was an immense relief to finally descend to
Puertecitos, where the road widens to a fishing camp-colony,
mostly of Americans. Here we found formal camping facilities,
cabana rentals, gas, groceries, and the first cold beer since Bahía de
Los Angeles. A tired traveler can bath in hot-spring pools nearby
or rent a skiff for the good fishing just outside the town's shal-
low anchorage. Civilization at last!

The final leg of our Baja safari consisted of 51 miles of fairly
good, soft sand road to San Felipe and then the paved road which
extends 130 miles all the way north to Mexicali and Calexico on the
U.S. border. Its sand portion required two hours, but was pure
pleasure after the preceding day. At San Felipe are all the facilities
and accommodations any travelers need. For photographers who
did not mind roughing it in the least, they seemed plush indeed.

However, all wildlife photography on Baja does not entail
bouncing over bone-jarring roads and exploring in the boondocks.
There is an entirely different side of it—the Pacific side.

Probably by accident, as refuge from a terrible storm he en-
countered during the 1850s, one Captain Charles Scammon en-

tered a sheltered lagoon which still bears his name and is midway down the west coast of the peninsula. What he found was hard to believe: a vast mating ground and maternity site for tens of thousands of giant gray whales after their annual 6,000-mile trips (the longest migration of any mammal on earth) from the Bering Sea. Scammon and the other whalers who learned about the bonanza slaughtered the vulnerable whales until by 1937 only about a hundred were left.

Since then the giant mammals have been protected and have made a remarkable recovery. Today an estimated 6,000 to 7,000 complete the marathon migration to Scammon Lagoon, with the first arrivals in January. During the next few months many one-ton calves measuring 12 to 14 feet long are born. The calves swimming beside their mothers and the mating antics of adults are easily observed and photographed by cameramen in small watercraft. In fact, many expeditions for this purpose are scheduled each year by the San Diego and Los Angeles Museums of Natural History, as well as by the Smithsonian Institution.

On all of these trips led by qualified scientists (and sometimes by skilled professional photographers as well) there is more than just whale watching. Visits are made to Isla Cedros and other islands on the outer edge of Bahía Vizcaino to photograph sea-bird colonies, sea lions, and particularly the herds of sleepy, accommodating elephant seals. These naturalist safaris by sea invariably are highly rewarding, often exciting adventures on small passenger motor vessels beginning and ending at San Diego or Ensenada.

Compared to other areas of North America, Baja is still a frontier. The Gulf of California portion can be explored by seaworthy boat, but should not be attempted by inexperienced hands with unsuitable craft. Any cruise should be carefully, intelligently planned, and the logistics would make any such trip very expensive. For most the best way to take a safari is still by road, sometimes by the lack of them.

Until present road conditions are improved, passenger cars and camper vehicles should *not,* repeat *not,* be driven south of Puertecitos on the Gulf side. Such vehicles *have* been driven all the way to La Paz, but the number of casualties is high and the wear and tear is prohibitive. If you do not have a proper vehicle, stay on the pavement of Route 1 from Tijuana or tour Baja via car ferry from the southern end.

Vehicles most suitable for Baja's nonpaved roads are high-centered pickups with four-speed transmissions, four-wheel drive vehicles, dune buggies, or some motor bikes. No matter what the

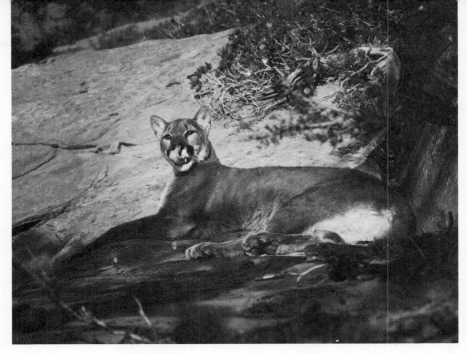

Mountain lion, among America's most handsome animals, is vanishing from much of its original range.

transportation, the best advice is to drive slowly and if possible to make any off-pavement trip with another vehicle, especially if extensively exploring the infrequently traveled side tracks.

Do not overload any vehicle, and consider installing heavy-duty shocks as well as "helper" springs or extra leaves in the springs. Skid plates should be installed under the oil pan and under the gasoline tank if it is exposed. Tires should be in good condition, with thick treads and strong sidewalls, the latter being especially vulnerable. It is easy to puncture sidewalls on some of the roads we encountered.

A list of other essential items for extended off-the-pavement Baja travels should include the following: at least two spare tires, tire pump, tire-repair equipment, a tow rope testing to 5,000-6,000 pounds, high-lift bumper jack and/or 3-ton hydraulic jack, two spare 5-gallon cans of gas, fan belt, spark plugs, and shovel. Buy gas wherever it is available and do not let supplies run low. Filter any gas bought and siphoned from drums through a chamois-cloth filter.

Eventually other new transpeninsular highways will be completed and travel will be opened to a steady flow of all passenger cars. For some of us who savor escape and treasure lonely places, that will not be a happy day. But it will open up a promised land to all photographers. And they should be thankful for it.

12

Alaska

As recently as 1794 when Captain George Vancouver sailed through the turbulent funnel of Icy Strait between Chichagof Island and the Alaska mainland, the explorer noted that a towering wall of ice completely blocked the entrance to what might have been a minor inlet. What he saw, actually, was the face of the immense glacier which completely covered what is now Glacier Bay. In less than two centuries since Vancouver's voyage, that glacier has retreated more than 50 miles, exposing a hauntingly beautiful inlet surrounded by fiords, dark young evergreen forests, and farther away by the perpetually white peaks of the St. Elias Range. It is among the most beautiful places in America or anywhere else.

Now early every morning throughout the summer the MV *Sea Crest* carries passengers where Captain Vancouver could not explore. It departs the dock at Bartlett Cove, Glacier Bay National Monument, and cruises northward over normally calm waters toward Muir Glacier. Whether or not the craft is able to plow through ice floes which infest Muir Inlet and actually reach its destination, the base of the glacier, makes little difference. In any case the exciting day-long trip is the means of seeing an astonishing amount of wildlife.

From Bartlett the *Sea Crest* brushes close to the Beardslee Islands, and often humpback whales (and, rarely, killer whales) are sighted here cavorting on the surface. Glacier Bay is also alive with birds: countless northern phalaropes, black-legged kittiwakes, arctic terns, harlequin ducks, pigeon guillemots, and marbled and

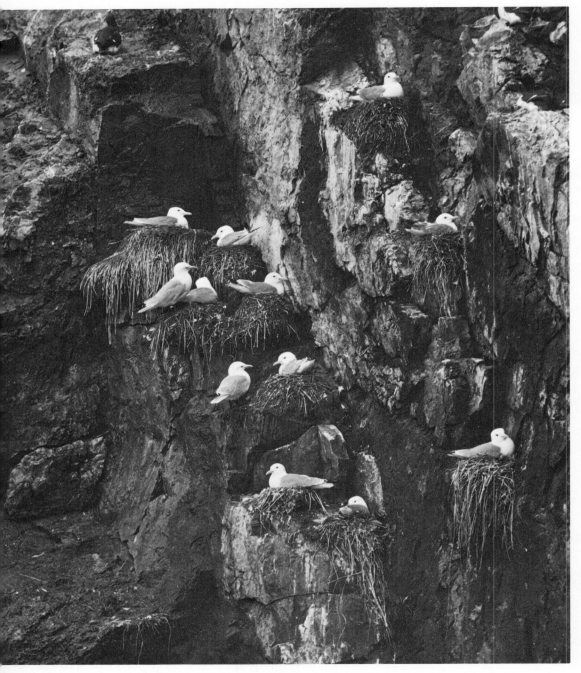

Black-legged kittiwakes nest serenely on sheer cliffs of volcanic cone island in Bering Sea.

Kittlitz murrelets flush ahead of the boat. Beyond the Beardslees, the *Sea Crest* slows and passes close to South Marble Island and North Marble Island, both being important rookeries of kittiwakes, glaucous gulls, tufted and horned puffins, pelagic cormorants, and bald eagles. During June it is possible to photograph many of these nesting birds with a telephoto lens right from the deck of the boat.

On entering Muir Inlet, more and more hair seals are sighted basking on floating icebergs, and sometimes these also can be closely approached. But probably the best targets for a wildlife cameraman are the white mountain goats which inhabit the sheer cliff slopes of Mt. Wright near Muir Point. At times they will be too high up to be "shot," but I have seen them on thin ledges only a few hundred feet above the boat where they obligingly posed during our close approach for a whole battery of cameras.

Other wildlife can be seen, although not so easily. Coyotes scavenge along the tidal beaches. Brown and black bears are common, and on a few occasions every summer, the rare blue (or

Bald eagle settles down onto nest beside Nonvianuk Lake, Katmai National Monument.

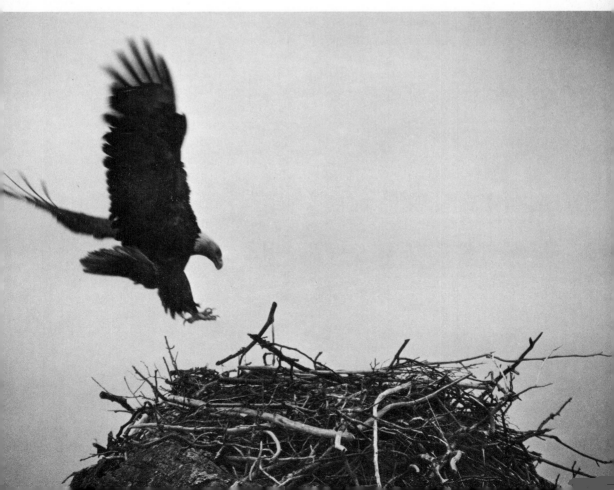

glacier) bears are spotted. This strange color phase of the black bear occurs nowhere else except this corner of wilderness Alaska. Moose and Sitka blacktail deer also are numerous in this great 4,400-square-mile national monument. Fishing is excellent for halibut, king salmon, and silver salmon throughout the summer within the salty waters of Glacier Bay.

Glacier Bay National Monument is comparatively difficult to reach. Owners of seaworthy boats can travel to Bartlett Cove, where lodging, fuel, and docking facilities are available, by way of the protected inside passage which exists all along Alaska's magnificent southeastern coast. But boatmen are warned about the sometimes savage tides which surge in and out of the mouth of Glacier Bay. The only other way to reach Bartlett Cove is to fly or take the Alaska car ferry to Juneau. Then it is a short fifteen-minute hop by charter float plane to Bartlett's dock, or a flight by wheel plane to a landing strip at nearby Gustavus where personnel from Bartlett pick up all arrivals.

Despite the impact of "progress" on Alaska during the past generation or so, which shows discouraging signs of mushrooming, the forty-ninth state is still among the most exciting places on earth to visit. There is no land of comparable size anywhere to match it for grandeur and immensity. Except in scattered areas, Alaska's natural beauty remains relatively unmarred and "unimproved." And with possible exceptions in eastern and southern Africa, or Antarctica, no more magnificent wildlife spectacles survive in the world. In addition, Americans are welcome in the Great Land, a situation which is not always true when traveling elsewhere nowadays.

Still, it can be a bewildering place for the newly arrived—for the first-time visitor who is anxious to enjoy the tundra and forests, the waters and wildlife he has read about. The most frequently traveled tourist routes never lead to the best wildlife areas or to the places which most thrill outdoor cameramen. Nor is it possible to just drive the roads as in Yellowstone Park, say, and see the wildlife as you go. Alaska isn't like that. Other provisions must be made to escape the beaten tracks. Too many trips have been wasted by visitors who failed to do so.

As surprising as it may seem, good advice on where and how best to savor Alaska is not readily available in Alaska. Check with any airline office, any travel agent, or even at official tourist centers and all can tell you how to see Eskimo villages (invariably dirty and disappointing), where to go fishing (unusually good), where to pan gold (it's possible), or where gold-rush-type saloons with rinky-tink

pianos are open for business. But very few of them can advise where to photograph a grizzly bear or where exactly to find the nesting colonies of sea birds. So let's start from the beginning.

There are three ways to reach Alaska in the first place: by flying, by driving the Alaskan (or Alcan) Highway, or by a combination of using the coastal car ferry system and driving.

Flying is the fastest and most comfortable, and all things considered, the least expensive. Several airlines have daily scheduled nonstop jets from Seattle to various points in Alaska, and there is also nonstop service both by foreign and domestic airlines from points in the East. Once in the state there are rental cars (as well as pickup campers, small trailers, and other types of rec vehicles) at slightly more than Lower Forty-eight rates. But vehicles have only limited use, as we will see. Mixed blessing that it may be, the modern aircraft remains the only practical way short of organizing a major expedition to reach many of Alaska's wildlife wonders.

Beginning at Dawson Creek, B.C., the Alaskan Highway is an 1,800-mile road, unpaved until reaching the Alaska border at Tok. It is alternately very dusty and very wet, mostly with a washboard surface, and except for brief intervals it does not pass through very attractive landscapes. Travel is necessarily slow. Spare parts and tires still should be standard equipment for the driver. In other words, travel via the Alcan is more relished by travelers who simply like to drive than those who like to see the land and its creatures. From the lower U.S. border, allow at least six days to reach Anchorage.

Although not much wildlife viewing is possible along the Alcan Highway, an occasional moose may cross the road, and at Mile 1059 in Yukon Territory is the boundary of Kluane National Park. The still-roadless and trailless park contains grizzlies, caribou, and white sheep. The slopes of Sheep Mountain on the west side of the highway contain a herd of about 150 Dalls which, if you climb to their elevation, can be photographed.

No one traveling to, from, or in Alaska by motor vehicle should be without a current copy of *Milepost,* a complete and indispensable guide. It can be obtained for $3.95 from the Milepost, Box 4EEE, Anchorage, Alaska 99509.

Car ferries via protected inland waterways to Alaska are expensive but have much to recommend their use. You can start by catching the Seattle-to-Victoria boat, then the British Columbia ferry (almost daily departures) at Kelsey Bay, Vancouver Island, and proceed to Prince Rupert, where a transfer is made to the

Alaska ferry system (also daily). Or you can skip the Seattle and southern British Columbia portions by driving to Prince Rupert, B.C., over a generally good highway, the final stretch paralleling the Skeena, River of Mists.

Both ferries offer a leisurely, fresh look at incomparable coastal-fiord scenery with a good mixture of sea birds for an alert cameraman. Most trips see many humpback whales, and rarely there is an orca or two. A noteworthy convenience of the Alaska ferry is that travelers can stop off at will at any or all of the coastal towns along the way at no extra cost. One stopover which is most worthwhile is either at Juneau or Auke Bay, from which places Glacier Bay National Monument and Mendenhall Glacier are accessible. All ferries are very busy and loaded to capacity during the peak of summer travel, so reservations should be made well in advance.

I should insert here that any kind of camping vehicle can also be taken aboard the car ferries and that one of Alaska's most scenic campgrounds (Tongass National Forest) exists here in the shadow of Mendenhall Glacier. Although Alaska's glaciers are huge, numerous, and well known, this is probably the most accessible. Hikers or backpackers can walk to the face of it and then, by U.S. Forest Service trail, continue around to the top, where mountain goats are often seen. Both Mendenhall and Auke Creek near the visitor center are convenient sites to observe spawning salmon during a run which usually peaks in mid-July.

Also within reach via chartered small boat from Juneau or Auke Bay is Admiralty Island and its brown bears. They can be seen from the water around small streams when salmon are spawning. But nowadays the bruins are much harder to find than the ugly mountainsides of recently clear-cut timber which have scarred the pristine beauty of Admiralty. It is a shame that the U.S. Forest Service does not regard this splendid example of Alaskan coastal rain forest as too valuable to be denuded and sold to the Japanese plywood industry, as it is today. I have also seen Admiralty salmon streams choked off by silt and debris from this clear-cutting.

The Alaska ferry system reaches its terminal north point at Haines, from where a cutoff road connects to the Alaskan Highway for the final (and most interesting) 550-mile stretch to the border at Tok.

Having reached Tok, the visitor who is driving can continue another 425 miles to the state's best-known wildlife area, 3,030-

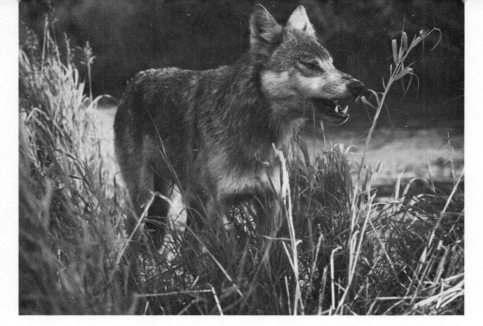

Alaska is the only place on earth where on rare occasions wild gray wolves may be photographed, in Katmai National Monument and McKinley Park. This was filmed on the American River, Katmai.

square-mile McKinley National Park. The final 208 miles are over the unimproved Denali Highway to the park's east entrance. I have sacrificed far too many car and trailer tires to the Denali's abrasive surface, but have always felt the vast views of tundra and the Tangle Lakes, of the whitened Alaska Range, and the herds of caribou and long-tailed jaegers were more than compensation.

McKinley is America's wildest park, being developed only to the extent of one 80-mile gravel road across the northern portion, an antique hotel at the entrance, and some of the finest camp-grounds (because they are entirely undeveloped and to date never crowded) anywhere. This is the only U.S. national park in which barren ground caribou and Dall sheep can be seen at all (and both are always on view somewhere) and where the odds are favorable to spot a grizzly (best places: Sable Pass and Toklat Creek). Other mammals commonly observed are moose, red foxes (very tame), arctic ground squirrels, lynxes, and snowshoe hares. Even sightings of wolves are not too uncommon any more, especially very early in the season.

From Anchorage there are two alternatives to reach the park: by driving 240 miles on Route 3 via Wasilla Willow and Cantwell to the east park entrance; or by taking the Alaska Railroad (it also runs from Fairbanks) to the park entrance and there taking a bus

from the McKinley Hotel. If you are without camping equipment, be certain to have reservations at the hotel.

As this is written, auto travel across McKinley Park's one road has been restricted, and it may be restricted even further to maintain the wilderness atmosphere. Only motorists with reservations at the designated campgrounds may drive into the park. All other access is by bus which delivers and picks up passengers at designated places at intervals throughout every day.

One other "formal" accommodation exists just beyond the north boundary, near Kantishna and the west end of the park road. That is the tented Camp Denali, now fairly well known to visitors who most desire escape, a wilderness experience, and the most marvelous view of Mt. McKinley. Advance reservations are necessary.

Not yet discovered and invaded by large numbers of sightseeing-type tourists, McKinley can somehow addict anyone who genuinely loves the outdoors. As elsewhere in Alaska, the weather is often dreary and damp, but this only heightens the great and lonely beauty of the place. Visit whenever there is the opportunity, but keep in mind the two best periods both for wildlife watching and the weather. These are in springtime as soon as possible after the road opens (usually about June 1 or slightly before), and after Labor Day until the park gates are closed.

One of my most poignantly memorable experiences occurred at McKinley on a still, hazy day late in June. At that time so near to the Arctic Circle there is almost endless daylight, and so I cooked breakfast in camp at Igloo Creek at three a.m. Then, spotting a band of Dall rams bedded on newly green slopes just to the north, I shouldered a rucksack full of photo equipment and lunch and started climbing in their direction. My plan was to approach the animals very slowly and very carefully, to stay with the rams all day and let them really become used to me. That is a good tactic, even though McKinley's sheep are not nearly as wild as those which are hunted. When alone and on foot here, a photographer should also travel deliberately so that he does not stumble upon a grizzly bear—as I had done once in the past.

There were seven rams in the band, and all were mature animals. But by studying all through a telephoto lens, I soon saw that one was absolutely outstanding with heavy, widespread horns of more than a full curl. On a hunter's wall, its head would have ranked high in *Boone & Crockett Records of North American Big Game*. Like all the others it watched me as I approached, stopping

frequently, resting, never climbing directly toward the sheep. Probably I expended as much as two hours in the stalk.

When I reached a distance of 100 yards and closer, one by one the rams stood up and stretched. All showed some signs of uneasiness and slowly began to drift away—slowly grazing uphill—all except one. The large ram did not move.

After sitting down for about ten minutes, I began to climb once more, and again all the rams except that biggest one continued to keep their distance. That was puzzling, because aren't older animals supposed to be warier and wiser? Why wasn't the oldest one the first to avoid me? When I had closed the distance to only 100 feet and the ram still did not follow the others, only then did I understand.

At that range I could see that the animal was very thin and dying. It made one weak effort to stand up, but couldn't make it. The fine old ram had survived its last winter, but that ordeal had been too much. Now it was only waiting for the first wolf or grizzly to come along. Rather than harass the sheep needlessly, I hurried back down the hill to find something else to photograph in another part of the park.

On June 6, 1912, a volcano explosion of proportions almost impossible to comprehend occurred between the villages of Katmai and Savonoski on the Alaskan Peninsula. More than 40 square miles were covered with as much as 700 feet of ash and pumice. Al-

This young mountain goat was photographed from the deck of a cruise boat which daily travels into Glacier Bay from the lodge at Bartlett Cove. An extraordinary amount of wildlife is seen from the boat every day.

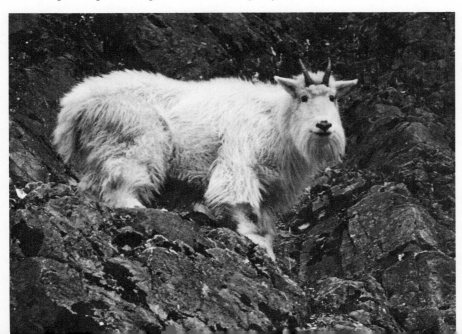

together, 7 cubic miles of white-hot ash spewed out of Novarupta Volcano into the atmosphere, some of it finally drifting down as far away as San Francisco. On the site, the eruption created strange phenomena of buried rivers, springs, and countless fumaroles thereafter known as the Valley of Ten Thousand Smokes.

Today all but a few of the "smokes" are extinct, and there is a deep green lake which seldom freezes in the crater of the volcano. But the entire 4,200-square-mile region now constitutes Katmai National Monument, another of Alaska's—America's, really—most precious possessions. Fortunately it is not an attraction every tourist would enjoy, and during any one year's time to date, no more than 6,000 individuals have ever seen the place. These have been divided among sports fishermen (Katmai is one of Alaska's best trout and salmon fishing areas) and people who enjoy the outdoors and wildlife for other reasons, or very often a combination of the two.

Practically speaking, Katmai cannot be reached except by Wien Air Alaska daily scheduled flights from Anchorage to King Salmon (one and a half hours), followed by a shorter hop in smaller amphibian aircraft to the Brooks River Ranger Station. There the same airlines concession operates a comfortable camp consisting of cabins, a small store, and a family-style dining lodge. Not far away is a U.S. Park Service campground complete with overhead cache to keep food away from brown bears, which are regular visitors all summer long. Except for one spot to be mentioned later, this just may be the best place of all to photograph the great beasts.

From Brooks Camp hiking trails lead to Brooks Falls, where, beginning toward the tag end of July, sockeye salmon are constantly in the air to hurdle the barrier. They can be seen spawning in calmer water above the falls. And it isn't unusual to see brown bears feeding on the spawners.

Daily a bus or four-wheel-drive Jeep leaves Brooks Camp for a steep, sometimes rough 24-mile trip on the monument's only road to the lip of the Valley of Ten Thousand Smokes. A ranger-naturalist accompanies each trip and leads any interested hikers down deep into the valley. If they choose, they may stay overnight and be picked up on the next day's trip. These are always worthwhile outings for birders seeking new northern species, and moose are always seen. During recent summers most trippers have enjoyed close looks at wolves, which more and more frequent the area and are becoming used to the human intrusion.

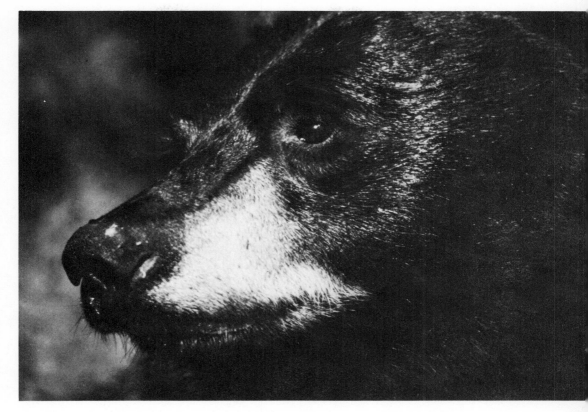

Black bears are common in Alaska's southeastern panhandle. They are easiest to see in early summer along salmon-spawning streams.

From either Brooks Camp (which is nearest), or directly from Anchorage or King Salmon, it is possible to charter an aircraft to see the most extraordinary bruin spectacles anywhere. Each year in mid-July, hordes of salmon about to spawn surge upstream from Kamishak Bay into the McNeil River, which is the center of a state game sanctuary. When the salmon arrive, brown bears are in numbers there to meet them; as many as thirty-four have been counted on the site of a falls at one time. And the background is as wildly beautiful as the bruins fishing for salmon. Virtually all of the best salmon-bear pictures ever filmed were made in the rapids here just above tidal saltwater.

Except for a natural rock overhang which can be used for shelter on one bank, there are no facilities for humans on or near the McNeil River. To get into the McNeil estuary, you charter a

plane and a pilot who knows the region. Then keep an eye on both the weather and the tide tables, because landing can be difficult at low tide. And you take all the gear you need with you to camp on the spot for as long as you plan to stay.

Probably it is evident by now that traveling in Alaska is not inexpensive or uncomplicated. The vast distances and the need to use aircraft account for that. Some of the following places I will describe are especially expensive, but considering the dwindling status of the world's wildlife today, the investment may be worth it over and over.

Each summer 80 percent of the world's northern fur seal population (about 1,500,000 animals) returns to the U.S. Pribilof Islands to breed, and there about 65,000 of the animals are harvested for seal skins by international agreement with the Soviet Union, Japan, and Canada. Until a few years ago only a relative handful of humans had ever seen the dramatic arrival of the seal herds, the beachmaster bulls, the fighting for harems and courtship antics of these interesting sea mammals. But today it is quite easy to see the seal herds. The actual harvest of fur seals by native Aleuts has been severely criticized as cruel and barbaric, and we will not discuss the morality of it here. But the management harvest is sound, and it is a pity that populations of other animals around the globe are not as healthy and do not have as bright a future.

But there is far more to see and photograph on the Pribilofs than just the rocky beaches swarming with seals. Several flights each week via Reeve Aleutian Airways carry cameramen to St. Paul Island (largest of the Pribilofs), where all are accommodated in a quaint old hotel. From this base daily trips are made not only to shoot seals, but to vertical cliffs which overlook the Bering Sea and which contain countless thousands of nesting sea birds. It is very easy here to focus on tufted and horned puffins, common and thick-billed murres, red- and black-legged kittiwakes, pelagic and red-faced cormorants, crested, least and paroquet auklets—all species not easy to see at such intimate range elsewhere.

Summed up, a photo safari to the misty, lonely, windswept Pribilofs is among the greatest adventures possible in Alaska today. Even the most blasé birdwatchers find it an extraordinary spot to look for Siberian as well as North American species. The best time to go is from late June through July. Be prepared for long, cool days, perhaps with a drizzle. Trips can be arranged through Alaska Tour & Marketing Services, 312 Park Place Bldg., 6th & University, Seattle, Wash. 98101.

It is even possible for an Alaskan visitor to have intimate glimpses of the Pacific walrus, without having to explore among the treacherous and shifting ice packs during the winter and spring months. All summer long a bachelor herd of several thousand large bulls headquarters on Round Island of the Walrus Island group in Bristol Bay. Round is really a volcanic pinnacle which juts straight upward out of a usually angry sea and is normally shrouded in fog. But the walruses find the thin beaches to their liking, and are very tolerant of photographers. They share another portion of the island with Steller's sea lions. During July and into August even the narrowest cliff ledges of Round Island (as well as the adjacent islands) are occupied by hundreds of thousands of glaucous-winged gulls, common murres, auklets, and back-legged kittiwakes.

Access to the Walrus Islands involves flying Wien Air Alaska's scheduled flight to Dillingham and then Kodiak Western (via small amphibian) to Togiak, an Eskimo village, where a boat with Eskimo skipper can be chartered for the 35-mile trip to Round Island. Keep in mind that the waters hereabouts can be turbulent.

Amchitka and the bomb tests, Prudhoe Bay and the proposed oil pipe lines have projected the Aleutian Islands and the Arctic North Slope into news headlines of late. But because of their nature and remoteness, the Aleutians are not easy places to visit; at least not to observe the wildlife in a very satisfactory manner. In the arctic, the caribou herds are usually so widely dispersed and so unpredictable in their movements that there is no guarantee of seeing the animals except from a plane far above. However, excursions to Prudhoe and to Barrow run every day through the summer, and some wildlife may be encountered.

Similarly, most of the great sea-lion rocks and bird-nesting areas in the Aleutians are far from any scheduled air service, and even then are separated by dismal weather and very heavy seas. Perhaps it is best to dismiss this lonely archipelago as a travel destination for the time being.

In the category of high adventure is a trip to see the musk-ox of Nunivak. This island lies just across Etolin Strait in the Bering Sea and is another part of Alaska where cool, damp weather is characteristic. To reach Nunivak you catch the once-a-week flight from Anchorage via Bethel to Mekoryuk, the only permanent community on the island. At Mekoryuk, Eskimos and boats are available to cruise the coastlines in search of the big arctic oxen, most of which are concentrated in the tall tough grass which grows on top of coastal sand dunes. When you spot the animals, you go

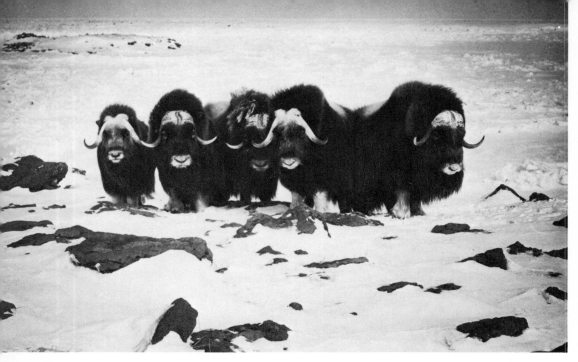

Muskoxen can be photographed easily, but an expedition to Nunivak Island is necessary. Fortunately there is regular weekly air service. All of these are large males.

During summertime a herd of about 800 bachelor bull walruses headquarter on lonely rock outcroppings in the Bering Sea.

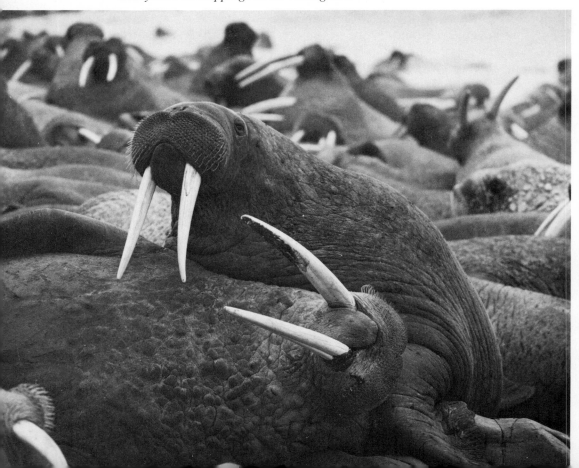

ashore and stalk them, keeping in mind that most run (rather than form a protective circle as written) when they see you. The reindeer there are not so shy. I found the rivers and lagoons of Nunivak rich in other life as well—spawning salmon in the riffles, harlequin ducks, eiders, and scoters in the clear pools below, and bald eagles hovering overhead.

Not nearly so remote geographically as Nunivak, nor as well known, are three national wildlife refuge island groups in the Pacific and on the outer fringes of the Alexander Archipelago in southeastern Alaska. These are St. Lazaria, Forrester Island, and Hazy Islands. St. Lazaria is a 62-acre former volcano at the entrance to Sitka Sound and only about 15 miles from the old Russian capital. It is a damp island in a heavy rainfall area, and landings are not always easy and sometimes unsafe when the sea is

Polar bears are holding their own along Alaska's arctic coasts, but are not accessible to cameramen anywhere in the state.

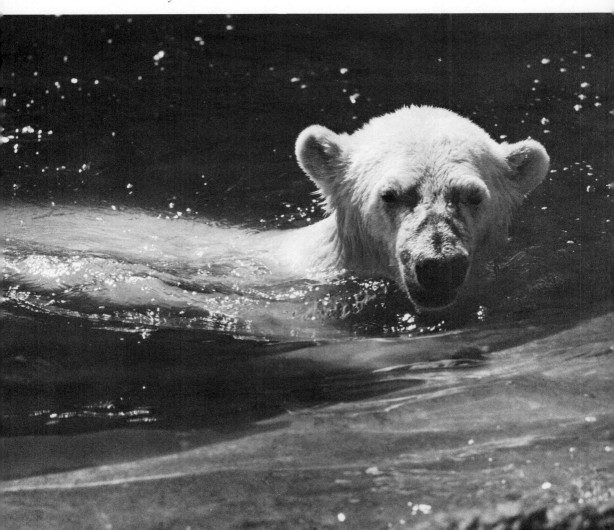

wild. But the treasure of bird life is worth both risk and rough disembarkation to see. Altogether, 50,000 birds of eighteen species breed in this confined space, including such burrowers as tufted puffins, rhinoceros auklets, and Leach's and forked-tailed petrels. The cliffs provide nesting sites for glaucous-winged gulls, common murres, eagles, and pigeon guillemots.

The barren Hazy Islands are just 30 miles from Sitka. There are forty-odd islands, and in summer they contain a population unknown and nearly impossible to estimate, as well as a colony of sea lions. There is good reason for the mystery, since only three or four known parties have ever been ashore because of the islands' isolation and the steep cliff shores which rise to as high as 150 feet above sea level. Perhaps the ultimate in wildlife photography adventures would be to make the next successful landing.

Not nearly so formidable is Forrester and adjacent smaller islands which total 2,800 acres about 80 miles southwest of Ketchikan. Almost all remnants of a World War II military installation built there have been obliterated by the elements, and now the place belongs to about 300,000 sea birds and sea lions. Access isn't really easy, but landing is possible, and so is a limited amount of camping, which would be a wilderness experience difficult to match.

Of course there are other places to film Alaska's matchless wildlife. But just to visit briefly the places I've described would require many summers — maybe the most golden summers of an outdoor photographer's life.

13
Canada

Churchill, Manitoba, is not the sort of destination one normally considers for a holiday or pleasure trip. It is a remote outpost of Canada where the Churchill River discharges into Hudson Bay. It is reached only by daily Transair flights from Winnipeg, or by a long railroad ride across barren northern wilderness. Accommodations in Churchill are few and barely adequate. Extremely dusty when the weather is dry and thoroughly waterlogged during wet periods, the town might not even be on any maps were it not for its ice-free port facilities during midsummer. Most of the grain raised in Canada's prairie provinces is shipped to Europe from here.

But recently Churchill has achieved another kind of prominence. Naturalists, birdwatchers, and wildlife photographers are belatedly discovering the place. From late summer through early fall, more and more of them brave the changeable, often formidable weather. No wonder, because this is the only place on earth where it is easily possible to see and photograph polar bears during summer and without organizing or joining a major expedition deep into the Arctic. It isn't at all unusual, in fact, to travel a short distance beyond town limits via taxi and spot one or more of the great white bears which are resident almost year-round in that sector of Hudson Bay. The best time for a visit to Churchill is September; then the mosquitoes are gone and the bears are becoming very active.

There is other wildlife and natural beauty to enjoy around this northeast tip of Manitoba during late summer. Blue, snow, and Canada geese are beginning to gather and refuel on grass flats,

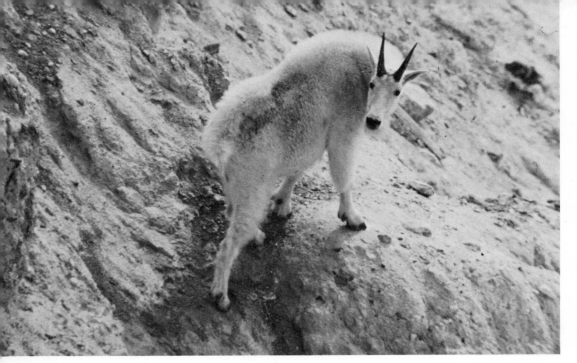

Drive the "calendar highway" from Banff to Jasper in Alberta and mountain goats can be spotted in numerous places, as here on a salt lick overlooking the Saskatchewan River.

golden with early fall frosts, before continuing their annual migration toward the Gulf of Mexico coast. Even more spectacular is the temporary concentration of shorebirds all along the bay front and within walking distance of town. These birds also linger for several weeks before continuing southward, some of them to well beyond the equator. While they remain all are beautiful camera subjects as they feed busily and flush suddenly into tight formations on the lonely tidal beaches. A photographer could profitably spend an entire day, as I have, sitting in one place near water's edge while the shorebirds perform all around and grow gradually more used to the human presence.

Of course the Churchill region is only one of countless areas where a camera safari is possible in Canada. It is even only one of many possible in the arctic or subarctic latitudes. Consider, for example, Bathurst Inlet, Northwest Territories, a bleak outpost on the northernmost mainland coast of Canada and well beyond the Arctic Circle. No European ever laid eyes on the place until Sir John Franklin passed by in 1821 while searching for a Northwest Passage to the Pacific. But the old explorer didn't tarry long where summer temperatures rarely exceed 50 degrees and where the land still bears scars of the last ice age some 8,000 years ago. But

today there is a modern lodge open for visitors near a series of waterfalls at the mouth of the Burnside River. There at the end of the day a tired traveler can enjoy electricity, hot showers, cold drinks, tidy accommodations, and home-cooked meals. But these amenities are as nothing compared to the extraordinary opportunities for shooting wildlife.

Karl Maslowski, well-known award-winning producer of wildlife motion pictures, has spent several summers shooting lecture movies while working out of Bathurst Inlet Lodge. He considers it one of the most productive places for wildlife photography he has found anywhere and that is saying a good deal. Maslowski writes: "Once you get to Yellowknife (N.W.T.) by scheduled flight, the lodge flies you to camp via an Otter float plane. There you live in converted old buildings of a historic and once-abandoned Hudson Bay trading post. Good small boats and outboard motors are on hand, as are reliable Eskimo guides to go anywhere. They especially know where to find wildlife. Scenically it is one of the most — if not the most — picturesque places I have ever seen in tundra country, what with lots of rolling hills, islands, and sheer cliffs. The best time to go is from late June through the month of July, when the camp caters mostly to people interested in natural history. Incidentally, that also is mosquito time, and visitors should be prepared for it.

"Bathurst is the best place I know to see peregrine falcons, and one year we found a very accessible (for the species) gyrfalcon nest. I had to use a system of ropes and slings to lower myself and the camera tripod over the edge of a cliff overhang so that I could aim a telephoto directly downward toward the nest.

"Other subjects easy to photograph around Bathurst include redpolls, northern horned larks, lapland longspurs, snowy owls, and white-crowned and Harris' sparrows. All nest close by. I have also filmed arctic wolves, barren ground grizzly bears, barren ground caribou, and musk-oxen here with ease. But all these large mammals are unpredictable; one year you may hit it right and the next year you will not.

"Glaucous gulls and eiders nest on islands nearby. At least a half-dozen different shorebirds nest around Bathurst, including the golden and semipalmated plovers and the northern phalarope. It is also a great place (as is Churchill, incidentally) for typical arctic flora. Ravens and golden eagles are easily observed. Although I have never found exactly the right set-up for filming them, I'm sure somebody else could manage it. There is only one trouble with

wildlife photography around that spot: the fishing for arctic char and other fishes is so spectacular that it interferes with my concentration."

Another possible headquarters for an arctic wildlife photo safari would be Arctic Outpost Camp on Victoria Island, N.W.T., which is 1,100 miles north of Edmonton. This is really a sport fishing camp (for arctic char and lake trout) with all amenities, but in the treeless country thereabouts are musk-oxen, wolves gulls arctic foxes, and ptarmigan and many other birds which nest close by. The owners of Arctic Outpost Camp also maintain other primitive camps at Hadley Bay, which is within 250 miles of the Magnetic North Pole, and 200 miles south of Cambridge Bay at Parry Bay on the uninhabited Kent Peninsula.

During August of 1972, Peggy and I spent several days tenting on the Kent Peninsula beside a small freshwater river which raced over a shallow rapids between lichen-covered granite cliffs to salt water. Probably no other humans were nearer than 200 miles in any direction. The primeval scene alone was worth the two-hour flight by small float plane across ice-choked Dease Strait to Kent. As soon as the plane flew away, leaving us to our own devices, we realized an instant exhilarating feeling of complete isolation, even of abandonment. Only the rush of rapids and the occasional squeal of gulls interrupted the peace and silence.

If we did not take full advantage of the photo opportunities around us, it can only be blamed on a great game fish, the arctic char, which spends its life in the ocean and returns here annually to spawn. Schools of them were constantly surging in and out of the salt into the foot of the rapids; we could watch their swift movement in alcohol-clear waters from the clifftops high above. Fortunately (or maybe unfortunately) the chars would strike any lure tossed toward them, and we spent far too much time fishing. Among the birds we saw, between hooking and releasing chars, were snowy owls, Sabine's gulls, black brant, and long-tailed jaegers.

Another arctic fishing facility which can be used as a photo-safari headquarters is Chantrey Inlet Camp at the mouth of the Back River and 250 miles north of Baker Lake. It is reached from Baker via a World War II vintage Grumman Goose "flying boat." As at the other camps, accommodations in the Arctic are expensive because of their remoteness. Figure on about $1,000 per week, including air transportation from a point in southern Canada. Charter flying by float plane while in the Arctic is extra. Count on

June through August weather to range from 35 to 70 degrees F. Every photographer should carry rain gear and a generous supply of insect repellent at all times.

Not quite so remote, although even less accessible in 1973, is Canada's newest national park, Nahanni, in the Mackenzie Mountains of the extreme western Northwest Territories. Almost unknown, this is a fantastically spectacular region of the South Nahanni River watershed. It includes some still-unexplored mountain country, caves, hot springs, tumultuous rapids and whirlpools, considerable big game, and a waterfall (Virginia) twice as high as Niagara. As this is written, Nahanni Park can be entered or explored only by boat expedition upstream on the South Nahanni River. But a road from Fort Simpson to Fort Liard, which will pass Nahanni Butte and the south boundary of the park, is (in 1974) under construction. In time this is likely to become an important destination of wildlife and nature photographers.

Of course, less expensive camera safaris to more accessible parts of Canada are possible. One, a pack trip into the back country of Banff National Park, has already been described in Chapter 2. Similar pack trips can be arranged into remote alpine country of all the western mountain parks of Alberta and British Columbia—Jasper, Glacier, Mt. Revelstoke, Kootenay, Yoho, and Waterton Lakes. Add to the list Assiniboine State Park, B.C., which immediately joins the western boundary of Banff. The same excellent, well-marked trail system in all of these parks can be used by hiking or backpacking cameramen as well as by packtrippers and trail riders.

At almost any time of year, but particularly from the tag end of summer throughout autumn and winter, much wildlife can be seen by driving the 200-mile paved highway from Lake Louise (Banff Park), where it separates from the Trans Canada Highway, to Jasper village in Jasper National Park. If this is not the most scenic drive in all of Canada, it is very close to it. Moose, elk, and mule deer are almost always encountered. Watch for occasional black bears. In winter, bighorn sheep frequent the slopes just overlooking the Trans Canada Highway and Vermilion Ponds just north of Banff town. Moose are common around or in the Vermilion Ponds. Goats might be seen at long range on steep, open mountainsides anywhere, but expect them especially (and close up) where Route 93 parallels the Saskatchewan River flowing just to the west of the road and at a site where a goat crossing is indicated by a highway sign. Sheep can almost always be found around the

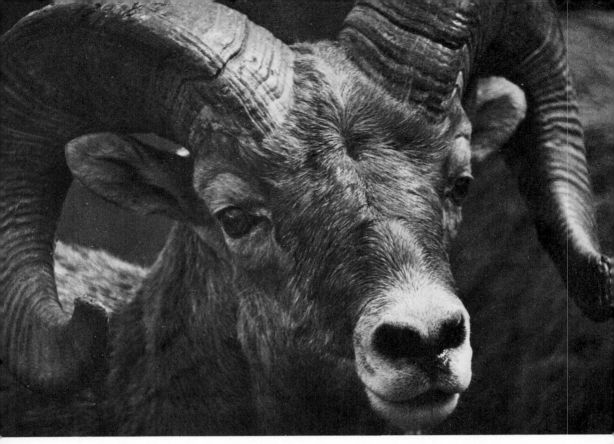

Nowhere are bighorn sheep more confiding than in portions of Alberta's beautiful Banff National Park. During winter this young ram was spotted feeding close to a park highway.

Columbia Icefields, and if they are not immediately in evidence, inquire locally for their whereabouts. Even in a region where spectacular views of mountains are commonplace, a side trip for wildlife watching on an unimproved road from near Jasper village to Maligne Lake is highly recommended. The postcard views of Maligne Lake are deservedly world-famous.

From west to east across Canada are scattered other wildlife-photography opportunities, and a sampling of the most outstanding follows. Dall or white sheep may be seen and stalked near Mile 1059, at Sheep Mountain, along the Alaskan Highway in Yukon Territory. That is about 140 miles north of Whitehorse. Elk Island National Park, about 20 miles east of Edmonton, Alberta, is excellent for shooting bison in a northern prairie environment, especially during late August when the rutting period occurs here. Travelers will find good uncrowded camping facilities at Elk Island after mid-August. The park is a small one, but very pleasant and attractive in its autumn foliage.

The only remaining herd of wild forest bison on this continent survives in the Wood Buffalo National Park just south of Great Slave Lake. The animals (there are about 9,000) are not difficult to photograph there, but first it is necessary to fly to Fort Smith, N.W.T., and arrange for four-wheel drive ground transportation into the sanctuary. Incidentally, this is the world's largest national park and it contains much other wildlife than bisons alone.

Moose, deer, and waterfowl can be seen in Prince Albert National Park of north-central Saskatchewan and Riding Mountain National Park of western Manitoba, although neither of these is ideal for a camera safari alone. In Ontario, the famous Miner Sanctuary near Kingsville is a very worthwhile stopover for passersby.

In eastern Canada, the most adventurous cameramen will be interested in 8,290-square-mile Baffin Island National Park. Located astride the 66th parallel on the Cumberland Peninsula of Baffin Island, it is an area of breathtaking fiords and deeply carved mountains dominated by a massive icecap which covers about one-fourth of the park. It is reached from Montreal by jet service to Frobisher Bay and thence by regular smaller aircraft flights to Pangnirtung, which is near the south boundary.

Cape Breton Highlands National Park, Nova Scotia, comprises 367 miles of hilly or low mountain landscapes. A photographer will find whitetail deer, moose, lynx, and beavers in the forested areas, plus many varieties of sea birds along the coastline. Gaspésian Provincial Park in the Shickshock Mountains of Quebec's Gaspé Peninsula is the home of woodland caribou, moose, black bears, and many of the songbirds which nest in northern forests. Bonaventure Island, just off the east tip of the Gaspé Peninsula, is well known as one of the largest and best sea-bird rookeries of maritime Canada. Not difficult to reach, it has long been a favorite of some of America's most serious bird photographers.

In 1535, the French explorer Jacques Cartier, cruising the icy waters of the Labrador Current about 40 miles east of Newfoundland, approached an island which reminded him of the gray back of a giant whale in the mist. Small boats were sent ashore to land, and the crews returned with a full cargo of great auks—fresh meat to eat and clean down for bedding. Of the visit Cartier wrote: "This island is so exceeding full of birds that all the ships of France might fill up with them—and no one perceive that any at all had been removed." Like so many Americans today, when evaluating our natural resources, the Frenchman was dead wrong.

Cartier wasn't the first to visit Funk Island, later to be named

The beaver is a familiar native all across Canada, and its presence is evident in the wilderness areas of every province.

after an Old English word for "evil odor" or "vapor." Eskimoes and Vikings arrived first; polar bears regularly visited even before that. After Cartier came centuries of Bretons, Basques, Portuguese, and others to harvest the treasure of the current, the astronomical number of fishes. But they also harvested what birds they found on Funk. By about 1800 all the great auks were gone from Funk, and on June 3, 1844, the last two on earth were caught, strangled, and carried away from Eldey Island by Icelandic fishermen. None were ever seen alive again.

Although the auks are gone, as are the once numerous gannets, Funk today may be Canada's greatest bird spectacle by far. Although it is only 800 yards by 400 yards in area and nowhere higher than 50 feet above the raging gray seas which surround it, about 2,000,000 birds nest here annually. About half of these are common murres; the rest are Atlantic puffins, razor-billed auks, and assorted other sea species. It would be difficult to undertake a more exciting or more adventuresome photo safari anywhere than to this speck in the North Atlantic ocean.

First, fewer than two dozen humans with cameras have visited Funk during the past century because of the island's remoteness and the difficulty of effecting a safe landing. One visitor, Leslie M. Tuck of the Canadian Wildlife Service, recently spent three weeks

alone on Funk; he reports most birds to be unafraid of pho-
tographers who approach carefully. But as on islands elsewhere
that sea birds nest en masse and seldom see humans, one sudden
motion may send a ripple of fear through hundreds and cause all
to trample nests, eggs, and young chicks alike.

Part of the island, any visitor will soon discover, is blanketed
with a layer of what appears to be soil, but is really a graveyard of
decomposed bodies of millions of great auks which were captured
and skinned. Puffins dig burrows in this "earth" and in doing so,
excavate the bones of the auks. Today these tons of brownish,
disintegrating skeletons, plus the seventy-five or so skins scattered
about in several of the world's museums, are all that remains of a
species of bird which, by its trusting disposition, would have been
an ideal model for wildlife photographers. One hopes that the
same fate does not soon await other species of wildlife around the
world. If others are doomed, cameramen will hardly be the only
victims; the relative abundance of wildlife is an unfailing index of
man's own chances of survival. Each species that disappears is
another nail in his collective coffin.

There are countless other extraordinary concentrations of
wildlife in Canada, many less well known than Funk or Bonaven-
ture, and at the same time far more accessible. It is just a matter of
locating them, perhaps by inquiry and possibly even by accident.
Consider, for example, an experience I had in 1969 in north-cen-
tral Manitoba. Something similar might happen to any inquisitive
vagabond.

I was exploring and fishing the region around northwestern
Lake Winnipeg, having driven by a then newly opened gravel road
to Grand Rapids, a bleak community at the mouth of the Saskatch-
ewan River. The road was built and the town had tripled in size
because of a huge hydroelectric power dam built by Manitoba
Hydro across the Saskatchewan there. The purpose of the struc-
ture was "to open up Manitoba's evergreen north country and to
help realize that province's unlimited potential."

But mostly the dam only obliterated forever one of the most
spectacular river rapids on earth (which had been 10 miles long), a
thousand miles of scenic shoreline on Cross and Cedar lakes, and a
vast waterfowl breeding area. One thing I had noticed near Grand
Rapids was that scattered flocks of white pelicans frequented the
tailwaters of the Saskatchewan River just below the dam. They
seemed to be feeding on fishes ground up by the mechanism of
creating power.

"Do any of these birds nest near here?" I asked John McKay, a

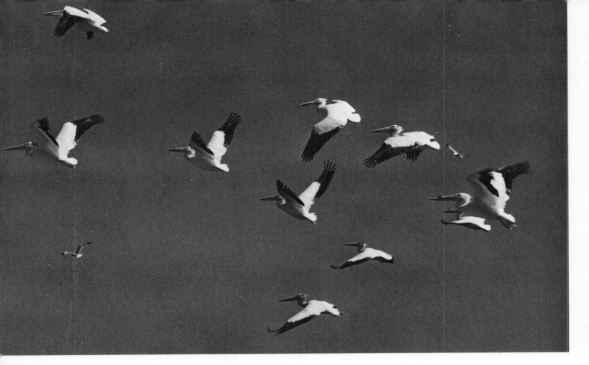

Adult pelicans in Manitoba.

Cree wildlife warden with the provincial Department of Mines and Natural Resources.

"About forty miles away," he replied, "on an island in a shallow lake. But it is not an easy place to reach."

Because he had other business in that region—illegal poaching of moose, to be exact—McKay thought he might be able to take me to the island. That meant being up before daybreak and loading a shallow-draft skiff with an outboard motor onto a flatbed trailer which wasn't built originally for hauling watercraft. Then followed a drive over a powdery dirt road toward Easterville, an Indian village which had to be completely relocated when rising waters of the hydro dam inundated the original site. Finally McKay found the faint turnoff to the lake. From here it was little more than parallel game trails, or ruts, until the trailer bogged down in soft earth short of water's edge.

But McKay and I managed to wrestle the boat to the lakeshore and to extricate the trailer. This consumed a good part of the morning, during which a cold west wind swung into the north and became even more fresh. We had a wet trip of about three miles to the island in the face of the wind. I was wet to the skin when the boat finally grounded beyond water's edge and I waded to shore. Platoons of birds came out to greet us but not to welcome our intrusion.

The island was only about 20 acres in total area, fairly flat, with one grassy hillock near our landing spot. At first the only pelicans in evidence were skeins of birds which simply passed overhead and away. Instead the birds which greeted us in increasing, noisier numbers were low-circling and diving ring-billed gulls. Their screaming created a steady din. We had come ashore too close to a community of gull nests and young birds, and they did not like it. McKay and I retreated, climbed the grassy knoll, and from that undisputed place surveyed the island. That seemed to satisfy the gulls; at least they were not so vocal.

What spread around us was a spectacle which anyone who thrills to wilderness scenes and wildlife would appreciate. The island, half of it in knee-high grass and the other half carpeted by the litter of past nesting seasons, seemed to be neatly subdivided. There were three separate subdivisions where pelicans were segregated. The gulls occupied only the thin strip along the shore near our beachhead. Common terns inhabited a section farthest away from where we studied the scene through glasses. In a single clump of willows near the center of the island were four blue-heron nests, two of which contained a total of three young birds. There was some mixing of species around the "boundaries," but mostly pelicans stayed in pelican country, terns in tern country, and so on.

Because I did not want to disrupt the nesting by wandering widely over the island, and because the future of white pelicans appears less certain than that of their neighbors here, I spent most of my available time on the island filming and watching them. McKay said that we could not stay too long and besides we could have trouble towing the boat away.

I estimated that there were between 1,200 and 1,500 while pelicans of all ages on the island and slightly smaller numbers of gulls and terns. It was evident that nesting had started early in the spring, because there were young pelicans of every age from almost full grown (although still flightless) to just out of the egg. Many eggs remained as yet unhatched in scattered nests. It was a perfect situation to observe development of the species from egg to adult.

The nests on this island were scarcely nests at all. The circle of twigs, feathers, and flotsam on bare ground was more of a site marker than a safe depository for eggs. The average nest contained two eggs. In a few instances there were one or three eggs and a single nest we found had four. The latter may have been

deposited by two pelicans. All of the eggs were dirty and mud-colored. A few were flecked with blood, but by rubbing carefully with a thumb, I found the shells to be whitish underneath.

Young pelicans of any age are most unattractive and compared to their young neighbor terns and gulls are helpless. When first hatched they are blind, naked, reptilian, and rosy-colored or even scarlet. As they grow older the livid color gradually bleaches to gray and then to white. They become ridiculously fat and woolly on the backs. Also I noticed that the larger they grew, the more they congregated with other young pelicans of the same age and traveled about together within the pelican community but apparently not outside of it.

I photographed several female pelicans feeding young, and that is a curious thing. The mother regurgitates a fishy soup into her lower mandible, which is actually a small trough. Then the youngster clambers or tries to thrust itself into the open mouth for

Ugly, reptilian young of white pelicans like these, shot on island rookery in northern Manitoba, turn into graceful flyers.

the meal, unfeathered wings flopping to maintain balance. At first glimpse it appears that the adult is trying to swallow the young one.

By midafternoon the weather had become decidedly unpleasant, and the change was sudden. The sun evaporated; with it good photo light had disappeared. Now the wind was whistling from the northeast and McKay predicted that it would soon rain. He thought we had better leave and I packed away cameras and telephoto lenses in waterproof containers for the trip back.

I'm certain that a longer visit to the island might have revealed much more wildlife nesting there. I also would have used up much more film. Although I did not take time to look for nests, I did flush a white-winged scoter, a blue-winged teal, and a Canada goose from the tall grass. And once during a break in the constant din of gulls, I heard the haunting song of a white-throated sparrow. It was a fitting end to a photo safari on a white-pelican island.

As a postscript it would be encouraging to report that the pelican colony is now doing well on that lonely Manitoba island—and that the future of the species in general is bright. But that is not the case, according to Kees Vermeer, pesticide biologist of the Canadian Wildlife Service in Edmonton. Already in 1969 there was much room for concern over these white pelicans in particular and for the pelican situation in Canada in general.

Indians living in the bush during summertime robbed rookeries of eggs. According to Vermeer, commercial fishermen who net in many Canadian lakes, still destroy white pelican eggs on a large scale. More recently—ominously—pesticides have entered the picture. Although the organochlorine residue levels are still low (on the average two to three parts per million D.D.E. in eggs) compared to that in other fish-eating birds, it is still another discovery to make serious citizens of Canada and the world shudder.

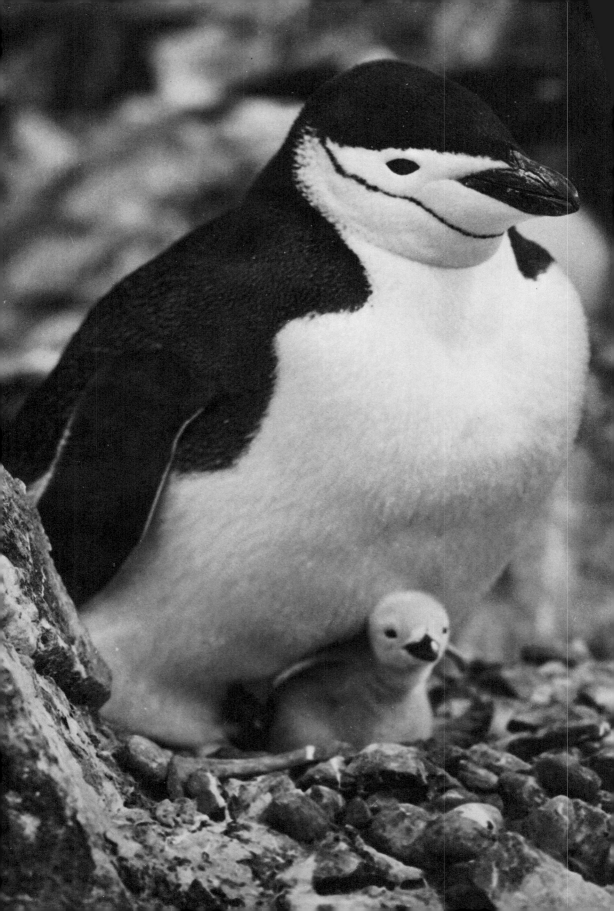

PART III

Camera Hunting Abroad

Chinstrap penguin female guards chick only a few days out of the egg. Both birds pay little attention to nearness of author and camera.

14

South America

When Ferdinand Magellan waded ashore on or near the Valdes Peninsula of Patagonia over 450 years ago, he was the first European to do so and apparently he did not linger very long. Inland he found only a hot and windy semi-arid steppe. Most noteworthy about the landing was the nickname, *Patagones* — big feet — which his Spanish crew gave to the local Indians. Of course the name has survived to this day in Patagonia.

But if anybody more than noticed the extraordinary wildlife spectacle which thronged along the Valdes beaches and offshore, and at nearby Punta Tumbo, it wasn't recorded in any great detail. The restless Portuguese explorer was in search of other more negotiable wealth which would better finance his adventures.

Sometime between December 6 and December 23, 1833, aboard the H.M.S. *Beagle,* Charles Darwin sailed within a few miles of the Valdes Peninsula and perhaps even within sight of it. Unaccountably the expedition did not pause here. In retrospect that is unfortunate, because we are now denied the naturalist's description of what would have been the most remarkable marine wildlife community he would ever see.

Even before Darwin's time a steady pillage of the Valdes wildlife had begun. First to suffer was the right whale, so named because it was the "right" whale to kill — in other words, slow-swimming enough to catch, and fat enough to float when killed, with a treasure of oil and whalebone in each carcass. Early in the seventeenth century a large right whale was worth $12,000, while a fully equipped whaling ship could be bought for half that amount in

New England. By about 1900 none (or almost none) still returned
to traditional spawning grounds off the Valdes Peninsula and
nearby, although a small herd has somehow managed to survive. It
is now being studied and protected.

Less fortunate was the southern fur seal, which was eliminated
altogether from mainland South America. When whales became
too rare to pursue economically, whalers turned to southern ele-
phant seals; now only one mainland rookery of these oceanic
elephants still exists. It is on Valdes and contains about 3,000
breeding animals. Although always the least valuable commercially
of the southern-hemisphere seals, the southern sea lion was also
nearly wiped out by sealers during the last century. On the entire
South American mainland they now may be seen in only two
places, Valdes and Punta Tumbo. There is no way to estimate
inroads into the sea-bird populations, but they have fared much
better than the mammals. Still a surprising, even astonishing
amount of wildlife remains in this area, which desperately deserves
national-park status and today is an excellent objective for a wild-
life photo safari.

Consult a map of Argentina. Following the coast,
1,000,000-acre Valdes Peninsula at 42° 31′ south latitude projects
into the Atlantic as the most prominent geographical feature. It is
hatchet-shaped and is connected to the mainland only by a 3-mile-
wide isthmus. By paved road, Valdes is about 900 miles from
Buenos Aires, and there is daily commercial air service from
Buenos Aires to Trelew, about an hour and a half away from
Valdes by car. In other words, here would be a fairly remote place,
except for improving modern transportation which makes it very
accessible. Today it is the only place on earth where it is possible to
drive a car to within sight of elephant seals.

Punta Tumbo, to the south, is also about an hour and a half
from Trelew, and at least compared to Valdes has seen very few
tourists. It is now necessary to cross private lands to reach the
place, and a toll is charged. More than 1,000,000 Magellan
penguins annually nest here, and these birds alone might be con-
sidered the single most extraordinary wildlife spectacle in Argen-
tina, possibly even in South America. The only possible rivals
would be in the Galapagos or the rockhopper penguin and black-
browed albatross rookeries of the Falkland Islands, to be described
later.

In addition to the Magellan penguins, the rugged and rocky
cape at Tumbo is also the nesting place of skuas, oystercatchers,

kelp gulls, dolphin gulls, and four kinds of shags (rock, king, olivaceous, and blue-eyed), and the guanay cormorant has recently appeared there. Its nearest known nesting site previously was 1,300 miles away on the Pacific. Sea lions use the Tumbo beaches, although in far smaller numbers than on Valdes. Altogether it should be considered a national treasure to be carefully sustained for all times.

We visited Patagonia in January 1973, during the Argentinian springtime when the elephant seals had come ashore onto the Valdes gravel beaches which are traditional breeding grounds. The beachmaster males, which might measure 20 feet from nose to tip of tail and weigh $3\frac{1}{2}$ tons, first establish territories and then gather harems. That means confrontation, fighting, and bloodshed; the bull which can stretch his neck farther and "stand" taller during a face-off is almost always the winner.

Female elephant seals come ashore about a week later than the males, and soon after their black, woolly-haired, 4-foot pups are born. These young are suckled for only about twenty-three days, after which they are at home in shallow water. By comparison, sea lions suckle pups for seven or eight months.

All elephant seals are insulated with about 6 inches of subcutaneous fat, and the eyes are unusually large so that these

Bull elephant seals debate for supremacy on beach of Valdes Peninsula, Argentina. There is desperate need to make this area a national park.

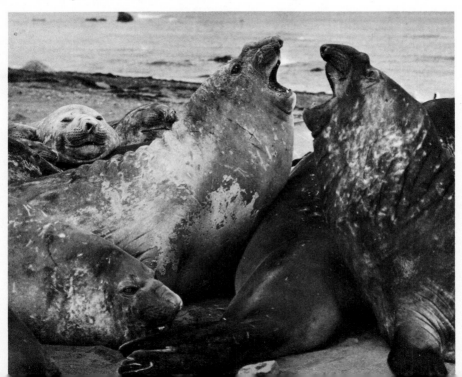

mammals can hunt in deep, very cold water where little surface light can penetrate. They are able to dive to 250 feet and possibly beyond that. The fore limbs are used as flippers and the hind limbs as a propulsion unit as fish use their tails. Probably there is only one function for the large inflatable noses of the males (for which elephant seals were named)—as a resonating chamber when the animal roars during mating.

We arrived too late to photograph most of the elephant seals' activity. All that remained were long rows of torpid bulls lying and drying out like cordwood on the sunny beaches. Earlier during the actual mating and defense of territories, they would have savagely disputed our close approach. Now only a few bothered to look up and belch noisily, hoping we would go away and let them sleep. It is hard to take exciting pictures of such uninterested subjects.

Not so with the sea lions. Our trip coincided with the peak of breeding—and in fact with the most exciting time in the life cycle of the species. Males had already established territories and harems, but unlike the elephants, these were jammed so close together that there was constant fighting among dominant bulls, with younger bulls trying to intrude. Each herd was a seething mass of activity and noise, of growling, grunting, barking. There was also a very pervasive stench about the place.

A large male southern sea lion is the most handsome, at least the most lionlike, of all the world's eared seals, and here is the greatest place to film them. Males grow to 9 or 10 feet long with massive blunt heads. Blackish brown, most have heavy manes of long dark hair, but during our visit, I couldn't find one without open wounds on an already scarred face or neck. Some were bloody and many wounds were draining. We found one bull far separated from the herd whose injuries were so severe that it seemed his days were numbered. Next day he had vanished.

At Valdes, sea-lion cows give birth in December or early January to pups from the previous year's mating. They mate again soon thereafter, and the mating may take place in or out of the water. During this they pay little or no attention to the small pups. Many young ones perish when the adults roll on top of them; others, pathetic, seem to have been abandoned.

We photographed skuas following and waiting to tear apart one tiny pup which was either lost or left behind by a lovemaking mother. The dead young usually are soon found and eaten by giant petrels or sheathbills, if not by skuas. We also saw one younger, outraged bull (apparently unable to acquire a harem)

catch a tiny pup and repeatedly shake it as a terrier shakes a rat, and toss it into the air until it was dead. That may seem to be strange or brutal behavior, but is not uncommon in a sea-lion colony.

One day we hiked out the entire length of Punta Tumbo, to land's end, and that day-long trip is worth describing. The first bird encountered was the Magellan (or Magellanic) penguin, and if time had permitted I might easily have counted more than 1,000,000 in what seemed to be a very strange environment. After Antarctica, one is likely to visualize penguins against snow, ice, or at least a rocky background. But here the most ancient kind of bird on earth was nesting on a hot, dry, sandy desert. Only the strong guano smell pervading the entire area was consistent with the desert scene.

Most of the nests were in underground burrows, and in fact vast areas were honeycombed with burrows. But wherever a low brittle bush (the only vegetation) existed, there were either a pair of eggs or a pair of chicks in the shade of it, the parents not having bothered to excavate. None minded being photographed at close

Flock of Magellan penguins gather on shore before plunging into southern Atlantic at Valdes Peninsula.

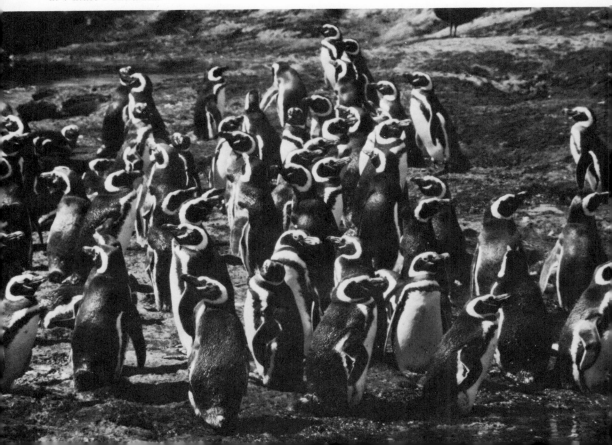

range. My own path through and among the nesting or incubating penguins was accompanied by heads poking out of holes, twisting for a better look, and by loud braying all along the way. It reminded me of a wet landing several years before on Dasseneiland, near Capetown, where the Magellan penguin's closest relative, the jackass penguin, was nesting on a similar bleak and wind-swept shore.

At water's edge nearest the Tumbo nesting site, thousands of penguin parents were constantly entering and leaving the sea to feed, in spite of several sea lions cruising just offshore. Still unknown is whether southern sea lions have always preyed on penguins or whether it is only a recently noted predation. Lately several qualified observers have seen them capture Magellans just as we have seen leopard seals capture Adelies in Antarctica.

Beyond the fringe of the farthest-out Magellan penguin burrows I paralleled the north shore of Punta Tumbo to shoot a cluster of sea lions on a picturesque beach. I was halfway there when a heavy brown bird swooped down, brushed the top of my hair, turned about, and dived directly toward me a second time. An instant later it was joined by a second attacker. Each time I had to duck and hold up a knapsack to protect my head. I had accidentally wandered into a community of scattered skua nests and had almost stepped onto a tiny chick, perfectly camouflaged against a nest which was no more than a few twigs and feathers on coarse sand. When I stooped to photograph the young bird, its mother landed a few feet away and faced me, wings outspread and screaming.

This brown skua of Patagonia is a very remarkable bird. Another, the south polar skua, is the only living creature besides humans to have reached the South Pole. It is a cousin of all gulls, but it is far more eaglelike in behavior and is among the most adaptable of all birds. Here we found the skuas living entirely on the Magellan penguins. While being divebombed at another skua nest, I photographed a chick no more than a day or two old already stripping flesh from a dead penguin chick. The baby skua paid no attention to me or even to its furious parent.

I have already mentioned that four kinds of shags nest near the tip of Punta Tumbo, but the same vicinity contains a rookery of kelp and dolphin gulls. That is a handy arrangement for the gulls, because they constantly hover over the shags and pounce on any egg exposed for even an instant in its cup-shaped mud-and-feather nest. We photographed dolphin gulls, which are the most aggressive, flutter a foot or so above the ground to drop and break shag

eggs in order to eat out the contents. The first white sheathbill to come along will eat the shell; there is no waste. Sheathbills are unique birds in many ways. The only members in the world of their family, Chionididae, they are bold maritime scavengers which superficially resemble pigeons and breed on Antarctic or sub-Antarctic islands. Structurally, sheathbills are a connecting link between gulls and shorebirds. The name refers to a strange horny sheath over the base of the upper bill which partly covers the nostrils. Valdes Peninsula and Punta Tumbo are about as far north as sheathbills ever may be filmed. There they comb the shoreline for mullusks and crustaceans, steal either eggs or unguarded chicks from any other sea birds, and gorge on the afterbirth and droppings of sea lions and elephant seals.

Any ornithologist could compile a long list of ocean and edge-of-ocean birds at Valdes. Besides those we've already described are both antarctic and arctic terns, the latter being in January at the opposite end of the earth from their own nesting range. Add cayenne and royal terns to the list. Noisy and colorful along the rockier shorelines we saw common and Peruvian oystercatchers. On sand beaches, Falkland plovers mingled with sanderlings and semipalmated sandpipers. It's always a wonderfully changing scene which serious cameramen can appreciate.

Some faint steps have been taken to preserve the fauna of the Valdes-Tumbo area. The government of Chubut Province has set aside a few pitifully small coastal areas as reserves, but these are not nearly enough and there is no provision yet for really patrolling and protecting them. Valdes especially would be easy to patrol and administer because of its narrow isthmus access. This is important, since its very isolation now makes law enforcement difficult.

Creation of a national park here would also provide a secure home for such Patagonian land fauna as guanacos, Darwin's rheas, maras, flamingos, crested ducks, Chilean eagles, elegant crested tinamous, and others which are fast disappearing. None of these can be easily filmed anywhere in the wild. Already gone, probably forever, are the Patagonian jaguar and puma, the native red fox, and the beautiful pampas deer. The list should not be allowed to grow.

In the long run, a national marine park in Patagonia would prove far more valuable—a matter of far greater national pride—than all the beach bungalows and condominiums which could possibly be jammed into the area.

As recently as two centuries ago, the rich wildlife communities

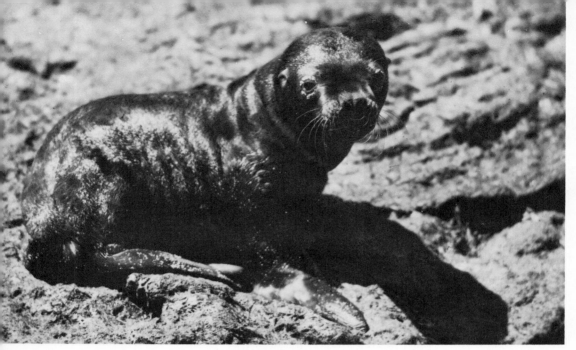

A baby sea lion abandoned by mating adults on Argentina's Punta Tumbo. Mortality is high here among southern sea-lion cubs.

The jaguar — this one photographed in Cienaga de Zapatosa, Colombia — is another of the world's big cats in deep trouble because of overexploitation.

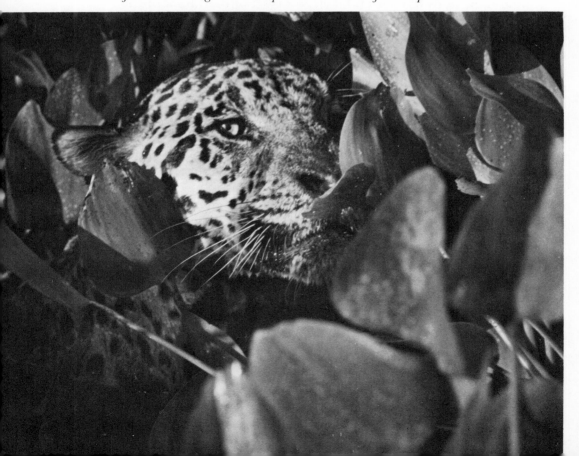

of South America from the humid Amazon jungles to the tips of the Andes matched those of any equal land mass on this planet. But since colonization first began, this has been an entire continent where preservation of wildlife (or any kind of conservation effort) has never interested the people or the politicians. Particularly today the emphasis is on overgrazing the pampas, culling the native fauna, and cutting down the magnificent forests as fast as possible—and let the next generation worry about consequences. As a result the only really extensive wildlife communities surviving are those at Valdes-Tumbo and on such scattered offshore archipelagos as the Falklands and Galapagos. Wildlife photographers will travel far and work hard to find any great rewards on South America's mainland.

Consider first the Falkland Islands, which are almost unknown except to stamp collectors and which are by no means recommended for ordinary tourists. But perhaps one kind of tourism will save them from the total destruction which has occurred on so many other island ecosystems around the world.

Isolated about 260 miles off the southeast coast of Argentina (which claims the British-controlled islands and calls them Islas Malvinas), 340 islands totaling about 4,500 square miles rise from a cold, gray, often angry sea. These range from tiny rocky islets on which few humans have set foot to the two main land masses of East and West Falkland. Treeless, rolling, dull in color, and with great expanses of tundra—all this under threatening skies and lashed by fierce winds—it is not a pleasant land in which to live and so is relatively unpopulated.

Still this bleakness has a haunting beauty of its own, and at the time of the first recorded landing in 1690 by the British navigator John Strong, it contained a wildlife community impossible to comprehend today. Those birds, especially the five species of penguins which have survived nearly three centuries of intermittent exploitation, are likely to attract significant numbers of adventure-tourists in the future. Here is a happy hunting ground for wildlife photographers.

This isn't to say that the Falklands are an undisturbed wilderness. The first settlement was French and began in 1764 when Louis de Bougainville brought pigs, goats, and horses as well as people. The tradition of overgrazing by livestock which continues today was begun then, and it has had serious effect. Sheep fared so well that vast grasslands were soon denuded to produce wool for English mills.

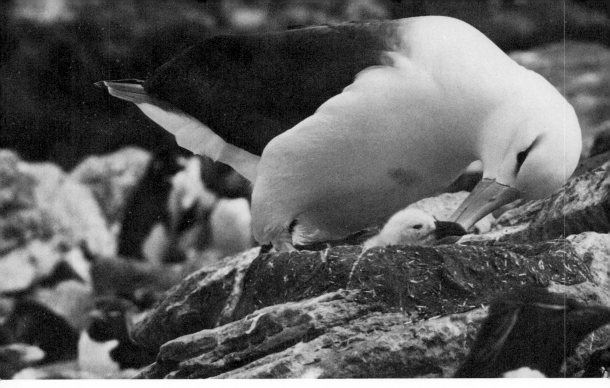

Black-browed albatross of the weatherbeaten Falkland Islands tends chick while author sits with camera only a few feet away.

Courtship ritual of steamer ducks of Falkland Islands. These birds also have lost ability to fly because of lack of natural predators.

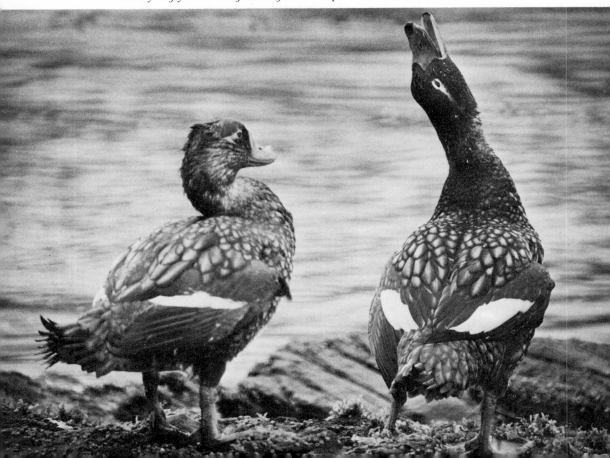

To illustrate the poor land use and how the islands have changed, consider the following. In 1842, Sir Joseph Hooker, botanist of the Ross Antarctic Expedition, catalogued many native plants which are either difficult or impossible to find today. Among the most common plants then were tussock grass, bluegrass, and cinnamon grass. Most widespread and important of these, because it was a tough binder of the soft peat soils, the indigenous tussock grass once covered nearly all coastal areas in thick dense belts. Now it survives in only a few isolated spots. In a 1970–71 field survey, naturalist-author Ian Strange estimated that no more than 12,000 acres of pure tussock remain.

During a visit to West Point Island of the Falklands in January 1973, we realized the absolute importance of tussock grass. A livestock-proof barrier had been erected to fence off one corner of the island. On the side which sheep grazed, coarse grass was manicured down almost to the soil, which in steeper places had eroded away to bare Paleozoic quartzite rock. On the opposite side of the fence, tussock grass grew chest-high, surrounding and sheltering many scattered nesting areas of rockhopper penguins and black-browed albatrosses. On their treks to and from the water, often for long distances, the penguins used the same paths, winding through the lush, tall grass, which they have used for ages past.

We have photographed at close range nine of the world's seventeen species of penguins, but none have been more interesting subjects than the noisy, quarrelsome rockhoppers here at West Point. Parents were engaged in everything from incubating eggs to feeding almost full-grown young in very confined quarters, sometimes side by side with the much larger and more sedate albatrosses. All of the penguins were far more tolerant of a cameraman poking telephoto lenses toward them than of one another. Whenever an argument over territories or trespass broke out anywhere, it seemed to spread over the nesting colony like a series of echoes, but happily without serious casualties. A dividend of our exploring around the rockhopper nests was the discovery of two pairs of macaroni penguins.

In addition to the rockhoppers, more than half the breeding birds of the Falklands depend somehow on tussock grass. Once-numerous gray-backed storm petrels and sooty shearwaters lost nesting sites—burrows which they dug in the fibrous bases or under dead stems—and such passerines as the native Falkland thrush and tussock bird lost valuable insect feeding grounds. The Magellanic penguin, an underground nester, was also a loser when

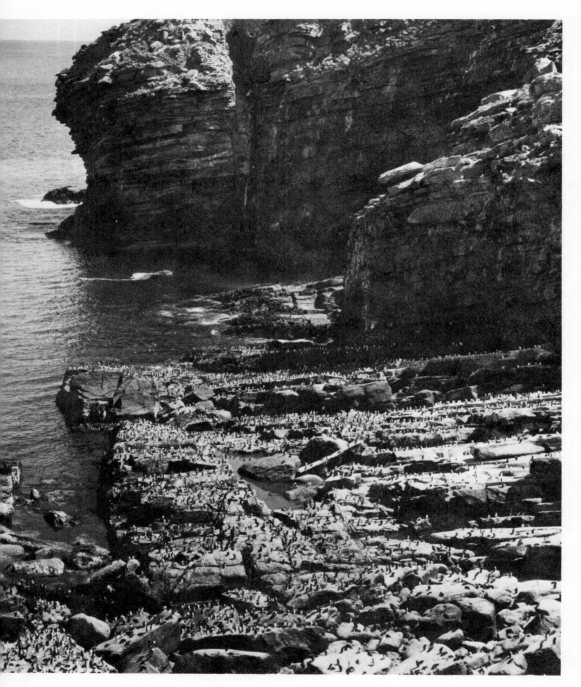

Thousands of rockhopper penguins nest on bleak shore of West Point Island in the Falklands.

tussock grasslands vanished, but somehow was able to adapt to the loss. It simply dug burrows in open coastal areas and can be filmed in this vicinity.

About 15,000 fur seals inhabit the Falklands today. Some elephant seals have survived the long years of hunting and the apparatus, now rusting, built to render out their fat. However, the 1972 population of about 30,000 sea lions is apparently diminishing, probably because of a sudden change in the marine food chains of surrounding seas. Recent years have seen much deterioration, at least change, in the ocean ecosystems bordering South America. Today, all at once, many species of fish are absent from places of former abundance.

Although any detailed natural history of the Falkland Islands from whaling to penguin hunting may read like a bloody tragedy, there is hope for the future of the wildlife. All wildlife anywhere is a renewable resource; given protection plus a suitable place to live, it will somehow survive. It may even prosper. That explains why a surprising amount of wildlife survives in parts of the Falklands today.

A single rockhopper colony contains more than 2,000,000 birds, and the total population for the species is now estimated at 5,000,000 or 6,000,000. There remains an equal number of Magellanic penguins, plus about 100,000 pairs of gentoos, a few macaronis, and about 50 pairs of king penguins.

A total of sixty-one bird species nest in the Falklands, and a few of these breed nowhere else; sixty-five additional species have been recorded as visitors. Easily photographed are several species of geese: upland, kelp, ashy-headed, and ruddy-headed. A very tame endemic race of flightless steamer duck is fairly abundant and is the most notable of several varieties of ducks. A list of other endemic races of birds would include the tussock bird, ground tyrant, Falkland thrush, grass wren, pipit, military starling, black-throated finch, night heron, diving petrel, skua, and Rolland's grebe. Any photographer can score well here during frequent breaks in the overcast because most of birdlife, and especially the penguins, is accommodating.

Most Falkland Islanders still regard wildlife as no great asset and in some cases as a competitor to making a living. But at least a few are showing concern about its future, perhaps because they realize it will attract tourists whereas the wool-growing industry is threatening to decline. At this writing about 18,500 acres have been set aside as seventeen or eighteen separate wildlife refuges or

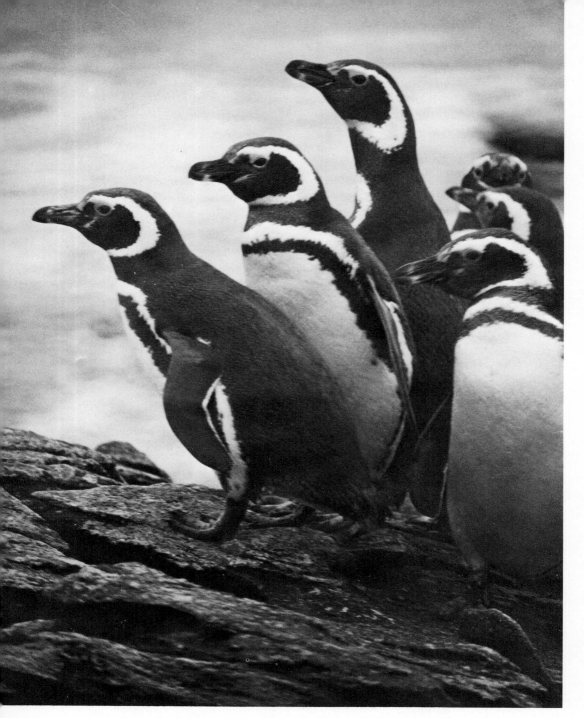

Magellan penguins show no apprehension as photographer approaches on New Island, Falklands. Here is one of best places on earth to see and film masses of wild birds.

sanctuaries of various status, most being in private ownership and still liable to change in status.

Easiest access is in January and February, via the *Lindblad Explorer* en route during its annual cruises to Antarctica. In addition, Aerolineas Argentinas, an Argentine government carrier, makes scheduled twice-weekly flights (with plans to increase the flights) from Comodoro Rivadavia on the mainland to Port Stanley. There small boats can be chartered for cruising among the islands.

In contrast to little-known Valdes or the Falklands, so much has recently been written about the Galapagos that anything else may seem repetitious. But for wildlife photographers as well as natural scientists, absolutely no more remarkable, no more unbelievable place exists. Birds, mammals, and reptiles are as tame as Darwin found them when that unpaid naturalist spent five weeks exploring the volcano-formed archipelago in 1835. Many cameramen who appreciate the world's remaining wild places consider a visit to the Galapagos a rich emotional experience as well as the greatest of all possible photo adventures.

Scattered across 23,000 square miles of the Pacific about 600 miles due west of Ecuador, and bisected by the Equator, the Galapagos are both unearthly and enchanted, eerie and exquisite. Biologic wonders abound on and around the twelve major islands and on the innumerable lava piles which are smaller. Just possibly these are the least hospitable islands on which men have ever long attempted to live. They are extremely hot, and few contain much fresh water. Still this showcase of world evolution contains a wealth of wildlife so unique, so extraordinary, that it is almost impossible to describe. And nowhere else, surely, is that wildlife so tolerant of humans carrying cameras.

"On the tenth of March," wrote Fray Tomás de Berlanga, bishop of Panama, "we sighted an island of seals, and turtles, and such big tortoises that each could carry a man on top itself, many birds like those of Spain, and many iguanas that are like serpents. All were so silly they do not know how to flee, and many were caught in the hand. But sweet water was almost nowhere; two men and ten horses died of thirst."

The above was written in 1535, three hundred years before Darwin, and Berlanga was almost certainly the first person to see and describe the Galapagos. Miraculously his description of wildlife would still be true today on some islands and nearly so on others. One important change is that travelers—cameramen—will find visiting the islands, named for the tortoises which could carry a

man, much easier and much safer than did the peripatetic bishop or any earlier visitor.

There are a number of ways to explore the Galapagos. One, perhaps the best and most expensive, is via the three-masted schooner *Golden Cachalot,* which in size and overall design generally resembles Darwin's *Beagle.* For the typical three-week cruises, passengers are limited to twelve and there is a crew of six. Less expensive is to travel on one of the larger motorships, such as the *Lindblad Explorer,* which makes three circuits of the major islands every March through May. Visitation is possible the year round, but springtime is ideal because then most birds are nesting and the seas are calmest. However, very prolonged rough seas are never characteristic in this doldrums belt of ocean along the Equator.

No matter whether done by schooner or larger passenger vessel, all trips are scheduled to include most of the following important islands. Cruises usually begin and end at Baltra, an abandoned U.S. seaplane base of World War II and the only uninteresting island of the Galapagos.

James (or San Salvador, or Santiago; all islands have at least two names, one English, one Spanish) has a desolate landscape of lava flows, cinder cones, and craters, and the first creature to greet any visitor there is the endemic mockingbird which may land on either a shoulder or a telephoto lens. A crater lake here often contains flamingoes. Here also are many sea lions and excellent opportunities for snorkeling. Pinnacle Rock and Sullivan Bay viewed from atop James comprise one of the most magnificent landscapes in all the islands.

The largest colonies of oceanic birds nest on Tower, the smallest and most remote of the major islands. Hundreds of thousands of red-footed boobies, swallowtail gulls, storm petrels, and magnificent frigate birds nest in all available sites from steep cliffs to the flat rocky "deck." Although the ocean depth drops sharply off Tower to 100 fathoms, a rainbow mixture of beautiful fishes live here on the edge of Darwin Bay. So does a colony of friendly fur seals.

Narborough (Fernandina) is visited for the large herds of marine iguanas, for sea lions and brown pelicans, but especially for the strange flightless cormorants and the Galapagos penguins, all of which try to ignore photographers rather than escape from them. Darwin observed that Narborough itself resembled "pitch spilling over the rim of the pot in which it was boiled." That was an apt description.

More flightless cormorants and penguins greet most visitors

making a beachhead on Albemarle (Isabela). It is not always possible to land on Duncan (Pinzon), but the strange saddle-shaped tortoises there make the effort well worthwhile. Charles (Floreana) Island is best known for the sun-bleached barrel mailbox which has existed at least since 1793 in Post Office Bay. You mail a letter and it may reach its destination a year later. On another part of the island is a lake of very shy flamingoes. Of all Galapagos wildlife, these are the most difficult to photograph. At Champion it is worth going ashore to see the very tame and distinct race of mockingbirds which are always visible and may be a nuisance.

Hood (Espanola) features some of the most spectacular topography in the Galapagos and also the most colorful of the marine iguanas. Color and size of these vary from island to island; they are the only race of these iguanas on earth which have adapted to a sea habitat. Sea lions abound around Punta Suarez. Nesting colonies contain astronomical numbers of waved albatrosses, blue-footed and masked boobies, shearwaters, and white-tailed tropic birds.

Tiny Plaza Island is the most convenient place to photograph land iguanas, which here have learned to expect bananas or other fruit every time photographers come ashore. If the gifts are not readily available, the iguanas will not hesitate to search inside pockets and camera bags to find them. Although nowhere more than 50 feet above sea level, Plaza is covered with a low-growing red and yellow portulaca which in evening light gives it an alpine appearance.

During our trip on the *Golden Cachalot,* two days were spent in Academy Bay of Santa Cruz (Indefatigable) Island. I suppose it was well spent, since the scientific studies underway at the research station there are both interesting and valuable. Also it is possible to see the giant tortoises being raised under controlled conditions, a program aimed at eventually restocking the islands from which they have been eliminated. But far more exciting was the day-long trip on foot into the misty highlands in search of wild tortoises.

Midway in the adventure we also found some trouble, as well as the endless fascination, in paradise. Consider the following notes from my diary beginning Tuesday, May 4, 1971: "We cruise throughout night and arrive James Is. 0630. Anchor close to sand beach. View from shipboard much different than any so far. Hillsides greener with tall trees. Licorice odor of palo santos drifts outward on damp early a.m. air. Few boobies and pelicans diving actively along beach. Go ashore 0830 at Espumilla Beach, precisely where Darwin once made a landing.

"Our surf landing is very wet. Behind beach is series of murky

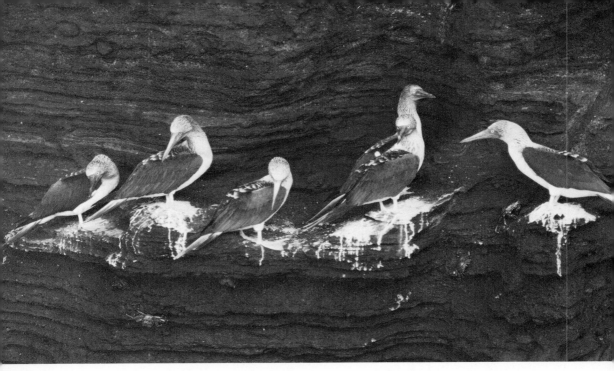

Blue-footed boobies roost on dark volcanic rock cliffs of Tagus Cove in the Galapagos Islands.

Pacific surf pounds against rocky shore of Hood Island, Galapagos, nesting site of thousands of waved albatrosses and other sea birds.

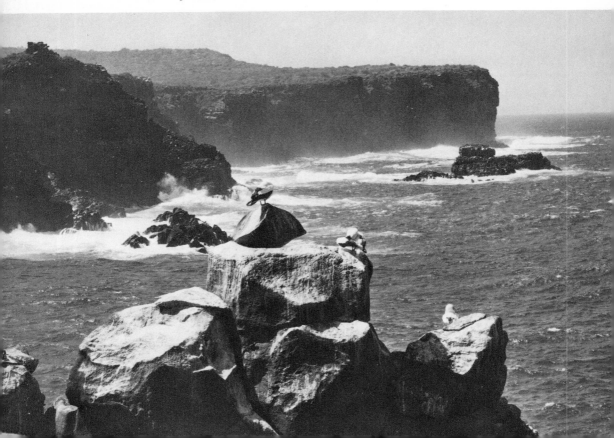

jade lagoons where we hope to find flamingoes. No luck. Do find several pintails, one on nest with 3 eggs. Also note whimbrel, northern phalaropes. Red mangroves around lagoon also have familiar yellow warblers, vermilion flycatchers, mockingbirds, many Darwin finches which we can't identify, but all tame. Then a very sad sight found walking beach. I count fresh tracks of 58 turtles leading from water's edge to egg-laying sites in low dunes. But every one pillaged—dug up—and from tracks, feral hogs are the culprits. No reproduction possible here.

"We see one wild donkey running away plus plenty domestic goat sign. Definite browse line on trees as far as both can reach. Bad. Also ground underneath paved with pellets. Note that feral animals are far wilder than wild creatures here.

"Late a.m. go fishing, but no action on trolled jigs. Instead watch flocks of Audubon shearwaters trading around us. Also pass vast school of giant mantas apparently in migration. Later crew discovers that sometime during previous night a marlin has rammed

Flightless cormorant of the Galapagos has lost ability to fly through evolution—and has also lost fear of man with cameras coming into close range.

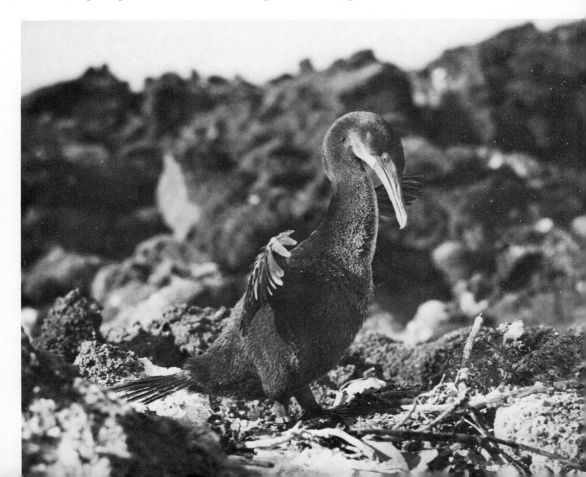

Land iguana is another strange species endemic to the Galapagos. They have no fear of human intruders and in fact will climb up onto a patient photographer's gear bag.

the *GC* amidships 4 ft. below water line. Bill penetrated 3″ planking and then 10″ beyond. Broke off two slivers 20″ long and left these in hull. What possible explanation?

"1500 go ashore at salt mine abandoned long ago where old buildings, equipment, pipes are falling down, rusting. Hike $\frac{1}{2}$ mile to deep crevasse on lava shore where ocean pours into blue grotto around which sea lions lounge on cliffs. Water is clear to 25′. We strip, snorkel, and sea lions follow us into water. Many cavort, play close, peer in masks, seem to be entertained by us. One lightly nips a flipper. Grotto also full of colorful small fish—butterflyfish, Moorish idols, tangs—and golden groupers at grotto entrance. Shoot many underwater pix. Sorry when I get bad cramp in leg and have to come out.

"Wednesday 5 May 71. Return ashore 0600 to salt mine where caretaker, Leonardo Apollo (who is here serving a prison sentence in this isolation—James is otherwise uninhabited), meets to guide us on interior trip to try find tortoises. Take stuttering old farm tractor and cart up steep trail for first $1\frac{1}{2}$ mi. Then on foot 4 mi. over crisp lava ridges and thru palo santo forests, still steeper and steeper to beyond 1,000 feet. As sun rises intense heat follows.

Once the number of Galapagos tortoises ran well into six figures. Today a cameraman is lucky to locate a few in the wild, as here on Santa Cruz Island.

"Constant birdsong all along our hike—finches, vermilion flycatchers, Galap dove. Note pair endemic Galap hawks. Photo all these. Also encounter feral goats, one huge black feral swine. Too bad we couldn't shoot these, but not with cameras. About 1200 Apollo turns suddenly off thin trail, crouches, follows spoor and comes upon giant tortoise in sunny glade, then a second nearby. Exciting moment to find these prehistoric relics in lonely natural settings. Shoot many rolls film.

"Big discovery en route back to beach. Joe Cross jumps aside, grabs small tortoise 13″ long and about 3 lbs. Very rare find (says Apollo) since few ever reach this size before being eaten by feral hogs. Photo and release little one. Also photo two more hawks near nest atop lava cone. Reach *GC* again 1430 hot, tired, dehydrated. Jump in water from deck. Swimming never more pleasure.

"While we hunt tortoises other crewmen scuba nearby. Discover cache of amphorae in deep water, bring aboard 2 encrusted with barnacles, filled with shells and small octopus. Amphorae of Spanish design, for storage in V-shaped bilge of (maybe) buccaneer galleon. Though many amphorae clustered here, no sunken ship. Why? Note Darwin, when in Galap, spent most time on James."

There simply are no dull moments when exploring the Galapagos. For any wildlife cameraman a cruise of the islands can be the adventure of a lifetime.

A number of other islands of Latin America, totally unlike the sparsely populated Falklands and Galapagos, deserve some mention here. Bonaire, one of three major islands of the Dutch West Indies and just north of the South American mainland, is home for a colony of 2,000–2,500 flamingoes, which are conveniently photographed. The local government has also set aside a refuge for other sea and shore birds and has stopped spearfishing on certain offshore reefs. Everywhere in tropical seas, the difference between extremely good and poor underwater photography potential is whether spearing is permitted or not.

Trinidad and Tobago also offer unusual chances for bird photography, some of which may soon vanish before the alarming increase of human population and unrestricted development across these two remarkable islands just north of Venezuela.

Trinidad is southernmost of the necklace of Antilles islands which curves northward from near the Orinoco Delta. That accounts for the rich mixture of both mainland and Caribbean bird species. The most spectacular site for photography is Caroni Swamp, not far from Port of Spain, which contains a bewildering variety of birds, all of which are eclipsed by the scarlet ibises. Each evening these fly to roost past cameramen who can rent boats and anchor them nearby. Equally productive can be a visit to the Asa Wright Nature Center (formerly known as the Spring Hill Estate, a former coffee plantation), 1,200 feet high in the tropical mountain forest, or Northern Range, near the center of the island. The center offers all accommodations to naturalists, birders, and nature photographers. Not all of the species seen here are easily filmed. But a patient person can try the several species of hummingbirds which frequent the main gardens. Many exquisite orchids grow on the steep hillsides, and the flowering immortelles with air plants thriving in the crowns are among the most photogenic of all the world's trees. Every other day or so, naturalist-guides lead parties deep into the dank caves hidden below Spring Hill to see the strange oilbirds which nest there in the total darkness. Flash equipment is necessary to photograph these birds.

Tobago is best known for the Birds of Paradise imported long ago from New Guinea and released on Little Tobago, an islet just off the east end. However, these are rarely easy to see, and a cameraman will be more interested in two other possibilities. One is

Buckoo, a coral reef off the west end of Tobago, where the water is very clear and the fish tame enough for good photography. The other is the Grafton Estate, once a thriving sugar plantation, but now reclaimed by native forest.

At Grafton, Eleanor Alefounder, descendant of an old Tobagan family, has been feeding birds for three decades. Now such unique species as cocricos, Swainson's motmots, jacamars, bare-eyed thrushes, red-crowned woodpeckers, and many others can be filmed almost at leisure from only a few feet away. No situation exactly to match this exists in the entire Caribbean Sea.

At this writing, numerous organized photo and naturalist safaris have been offered into the interior of Surinam, Guyana, far up into the Amazon interior of Brazil, and to the vicinity of Iguazu Falls of the Parana River, where the boundaries of Argentina, Brazil, and Paraguay join. The native wildlife, with emphasis on birds, is abundant in all of these places. But we have not taken any of these trips and cannot verify their value to serious photographers.

15
Europe

When summed up, wildlife photography in Europe today cannot be described as very productive. The continent is too densely populated, too developed both industrially and agriculturally. In the Russian portion of Europe, where probably the most wilderness and wilderness animals remain, access to tourists is either impossible or too ensnarled in red tape to make it worth the effort. Better to travel somewhere else and get better pictures anyway.

Still, in spite of human development, Europeans (excepting those in the Mediterranean countries) have always maintained an interest and even an affection for wildlife — so much so that nature reserves are numerous, though usually very small. In Great Britain alone are twenty-two national nature reserves of at least 500 acres each to protect the wildlife treasures. Elsewhere are interesting national parks, which we will describe briefly. However, few will offer birds and animals in sufficient numbers or unsophistication for a really satisfying photo safari.

From the standpoint of easy accessibility, large numbers, and many varieties of birds, the Waterfowl Trust at Slimbridge, Gloucestershire, England, probably has no equal. In a maze of ponds, channels, and open grain fields of the Severn River bottoms is the largest collection of waterfowl species in the world. Altogether 145 species are captive and on display here, and most can be photographed with at least semi-natural backgrounds. Far more worth filming are the large numbers of Bewick's swans, whooper swans, barnacle geese, and other waterfowl which swarm here from arctic nesting grounds to spend the winter. Besides the

Siberian red-fronted goose is among the most colorful of all waterfowl. It can be seen at the World Waterfowl Trust near Gloucester, England, along with other European species.

attraction of waterfowl, flamingoes from Chile and Africa have been encouraged to nest here in separate environments.

Slimbridge can be reached by railway or car (and fast motorway) from London. Comfortable inn-type accommodations are nearby. Admission to the trust is about $2 daily, but a $12 membership assures entry the year round and the use of special blinds with concealed approaches for closeup photography. The same membership permits entry to Peakirk and Welney wildlife refuges, where additional waterfowl photography is possible. Midwinter is not the most pleasant time to visit England and often can be bitterly cold, but it does catch all the wintering flocks of birds on hand.

Caerlaverock Wildfowl Refuge in Dumfriesshire, Scotland, also associated with the Wildfowl Trust, consists of 800 acres of grasslands and tidal merse on Solway Firth. About 3,000 each of

barnacle geese and pink-footed geese, as well as greylags and white-fronted geese, spend winter here, and they can be shot from a system of observation hides with screened access. Use of the blinds is restricted to certain days and limited numbers of cameramen, so permission must be secured well in advance. At other seasons, merlin, hen harriers, golden plovers, and several species of native wildfowl can be seen.

Cairngorms National Nature Reserve in the Grampion Mountains of Scotland provides an alpine-arctic rugged environment which is excellent for wildlife watching. Many of the indigenous mammals of the British Isles and birds difficult to observe elsewhere can be seen here. But any photographer must devote much time and have favorable luck to obtain results. The wildlife is not that confiding.

Skomer Island National Reserve is the greatest natural attraction in Wales, being located off the southern coast near Milford Haven, Pembrokeshire. Access is by charter boat. There is a breeding colony of gray seals. Thousands of razorbills, puffins, fulmars, guillemots, kittiwakes, and Manx shearwaters nest on the steep, sometimes clifflike shores.

About 50 miles west of the Outer Hebrides, normally shrouded in mist and lashed by constant storms of the North Atlantic, are several islands of the St. Kilda National Nature Re-

The mouflon is the Mediterranean member of the wild mountain sheep family which exists in an arc from Corsica across Asia to the Rocky Mountains.

serve that have been uninhabited by humans since 1930. Projecting like mountain tops from an angry sea, they have supported Britain's largest, most spectacular bird rookeries since before the Ice Age. The list includes gannets, guillemots, kittiwakes, razorbills, Manx shearwaters, Leach's petrels, great and lesser black-backed gulls, herring and common gulls, skuas, and shags. But not even the crudest accommodations exist, and landing anywhere by boat in the stormy waters is a perilous undertaking, even for the most persistent photographer.

A number of very picturesque national parks, some fairly old, have been set aside in the Alps. Swiss National Park, in eastern Switzerland near Davos, has ibex, red deer, roe deer, and chamois which can sometimes be photographed by hiking cameramen. Austria's Hohe Tauern Nature Conservation Area is similar. Also in Austria is the Neusidler See and Seewinkel Conservation Area, on the Austria-Hungary border about 30 miles from Vienna. Ornithologically it is considered one of the most important wetlands on the continent. Many species breed here, and the lowland marshes are a major wintering site for 200,000 geese.

Gran Paradiso (Italy) and Vanoise (France) national parks are contiguous in the southern Alps and contain some of the most gorgeous alpine panoramas in all Europe. Ibex and chamois are easily seen, but are shy and agile enough in lofty places that pho-

Red deer of Europe is most easily photographed on private estates and reserves in British Isles.

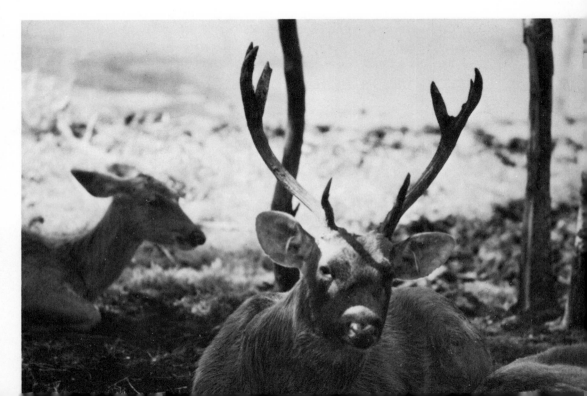

tography can be frustrating. There is a network of car roads in Gran Paradiso, but the best access and photography is by hiking along a good system of trails. There is a campground and several refuge huts in the high country. Ample accommodations surround and are near all of the parks and reserves in the Alps region.

The Reserve Zoologique et Botanique de la Camargue, located on the Rhone River's delta with the Mediterranean, is the most important and spectacular sanctuary for birdlife in France. Between 7,000 and 7,500 pairs of flamingoes breed here. Other important nesting species are the gull-billed tern, slender bill gull, Mediterranean black-headed gull, penduline tit, moustached warbler, and squacco heron. Some winters as many as 200,000 waterfowl gather at Camargue, and the site also attracts many birds of prey. There are hotels for visiting photographers nearby at Les Saintes Maries-de-la-Mar.

Special permits are required to visit (by boat) the Reserve Ornithologique des Sept Iles, a small archipelago of rocks and reefs off the northern coast of Brittany. It is a picturesque seabird rookery with about 55,000 residents, most of which are puffins. Guides, boats, and accommodations for Sept Iles can be found in Perros-Guirac.

During the 1960s, conservationists from all over the world donated money in a crash program to save a vast area of Las Marismas (marshlands) of the Guadalquivir River delta in southern Spain. Threatened with development, here was the finest wilderness area in all of southern Europe and probably also the area richest in wildlife. The miraculously untouched landscape has been described as "a relic from prehistoric times, a living museum of a period long before the dawn of culture in Europe." The area was officially called Coto Donana National Park when it was finally created in 1969.

Coto Donana is a splendid park for wildlife photography. There are fallow deer, red deer, pardine lynx, foxes—altogether a total of 32 different mammals. Birds exist in unbelievable variety and numbers, from passerines and waterfowl to waders and many birds of prey. There are a few blinds from which to film vultures and such rarities as the Spanish Imperial eagles. The only trouble is that permission to enter the park (issued *only* by the park director) is harder to obtain than an unrestricted visa to Russia or China. Photographers should not make plans to visit here without having an authorized permit well in advance. Access is by car from Seville.

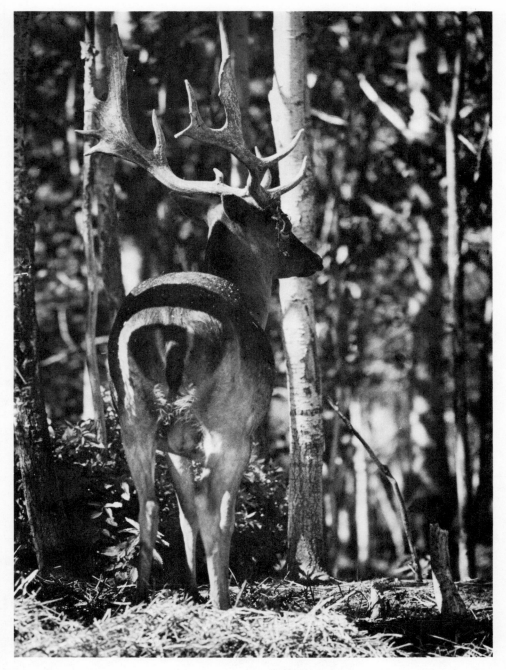

Exact original range of the fallow deer is not known, but today the species can be filmed in several sanctuaries and private game parks across Europe.

At this writing, plans are underway to create a Pyrenees Inter-
national Park. Except possibly for the Caucasus, the Pyrenees have
a greater mood of wildness, and just possibly more wildlife, than
any other mountains on the continent. This new park would in-
clude Spain's present Valle de Ordesa National Park and several
smaller game reserves on the French side of the border.

There are a number of national parks in Yugoslavia, including
Fruska Gora (in Serbia), Paklenica (in Croatia), Plitvicka Jereza (in
Croatia), and Postojna Caves (in Slovenia). However, we do not
know firsthand their potential for wildlife photography. Nor are
we familiar with Srebarna National Wildlife Sanctuary in Bulgaria,
said to have a wealth of birdlife. Also unknown to us are Retezat
National Park of the Carpathians; Bucegi Mountains Nature Re-
serve and the Danube Delta Reserve in Romania; and Kisbalaton
Nature Reserve in Hungary.

Eastern Poland's Bialowieza National Park is well known be-
cause it contains the last virgin forest of any consequence in central
Europe, as well as the world's only free-roaming herd of wisent, or
European bison. Red and roe deer also inhabit the woodlands.
Bialowieza is said to be a good spot for cameramen who might also
want to visit the Mazury Lakes, Jezioro Lukniany Reserve, Ojcow
National Park, and Slowinski National Park on the Baltic while
traveling in Poland.

Skaftafell National Park in Iceland is a kind of living sample of

*Reindeer roam across tundra areas of Scandinavian national parks, especially in
Finnmark.*

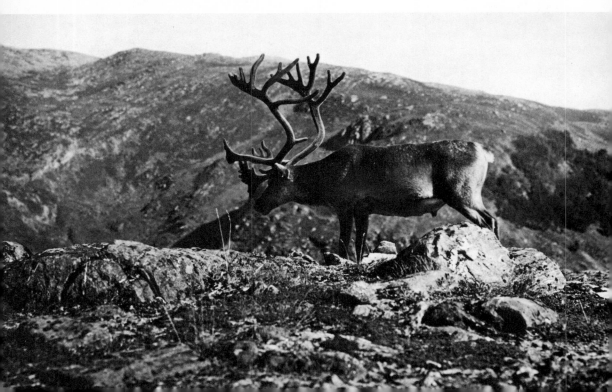

the Ice Age; the glaciers and icefields are most photogenic. But there isn't much wildlife except for the rookeries of ringed, common, and gray seals on the ocean shore nearby. Skuas, black-backed gulls, and some other sea birds nest in numbers on Iceland's Eldey Island Nature Preserve.

There are a number of wildlife sanctuaries in Scandinavia that are probably worth visiting. But a visitor should keep in mind again that rarely is the wildlife unsophisticated enough for the best filming. In some of these at least limited hunting and trapping still goes on. Reindeer usually are the least wary of all species encountered.

A list of Norway's refuges includes remote, roadless Borgefjell National Park; Hardangervidda, which is being proposed for park status; and Rondane and Fokstumyra bird sanctuaries. Sweden's oldest and most accessible national park, Abisko, is in Lapland north of the Arctic Circle. Access is by railway, since there are no park roads. All of the larger mammals of northern Europe (brown bears, moose, reindeer, wolves, lynx) are present in Padjelanta, Sarek, and Stora Sjofallet national parks, which together cover 3,300 square miles and comprise the largest wilderness remaining in northern Europe where the topography is more spectacular than the wildlife community. Finland's national parks, Pallas, Ounastunturi, Lemmenjoko, and Oulanka, are similar to Sweden's, being also beyond or astride the Arctic Circle. All of Scandinavia's parks favor hikers over other types of travelers.

The largest bird sanctuaries in all of Europe are on the Røst Islands. Here millions of sea birds of all species can be seen throughout the summer—and the sun is above the horizon at all times between the end of May and the middle of July. These 365 Norwegian islands and skerries face the ocean off the Lofoten Isles in the Land of the Midnight Sun. Bird photographers will find this an ideal spot.

The largest bird sanctuaries are found on the islands of Vadøy and Storfjell; neither of these has human inhabitants, but they are populated by millions of birds. Røstlandet is the largest island, supporting about 800 people who make a living from fishing and also collecting eiderdown.

Glea Island is cosmopolitan enough to boast a radio station and a village shop. It is just across a narrow sound from Røstlandet. There are no hotel accommodations, but Røst Fiskarheim has beds for a dozen visitors, and the shop can sleep six. Aside from these beds, camping is done in the usual way. Inquiries about

local conditions and rooms can be directed to the shopowner, Mr Olaf Pedersen, Glea Island, Røst, Lofoten. Visitors may also write to Bodø Travel Association, Sjogaten 14, Bodø.

Røst Islands lie even farther north than Fort Yukon in Alaska, but these islands are warmed by the Gulf Stream, which moderates the climate to a great extent—a fortunate thing for the bird populations. The fastest way to get here is by air, which takes two hours. Alternatively, there is a train which takes about a day and a half from Oslo to Bodø and then a local steamer (six hours more) to Røst.

Europe's second-largest bird sanctuary is also in Norway. It is Runde Island, which faces the ocean in Norway's fjord country. It is reached by fjord steamer from Aalesund in two hours. There are no hotels on this island, which is only 4 square miles in area. Aalesund is only an hour by air from Oslo, or one day's journey by train and bus. The trip is probably well worth the photographer's time, as this island provides nesting grounds for over 2,000,000 sea birds. It is mountainous with steep precipices to the west, and rises to about 1,000 feet above sea level. The entire population consists of about 300 persons who live in two villages connected by a narrow road on the east coast.

This island is one of the most spectacular in the entire area, with rock pillars rising directly out of the ocean. The photographer might also tour grottos and rock caves; some are up to 250 feet in height and many of these are still unexplored. The reason for this extraordinary landscape is that Runde is one of the few islands to escape the grinding, leveling glaciers of the Ice Age.

Rundebranden is the largest bird rock on Runde. A trail ascends gradually to the edge of a precipice, and at this point the photographer has a marvelous view of the birds below. Kittiwakes constitute the largest colony, but puffins are also seen here in large numbers. There are also razorbills, guillemots, gannets, fulmars, shags, herring gulls, common gulls, oystercatchers, curlews, common eiders, and shelduck. Rarely you may see a golden eagle, and occasionally you see white-tailed eagles, eagle owls, and peregrine falcons.

The Norwegians themselves are particularly interested in the gannets, since Runde is the only place in the country where they may be seen. They began arriving in 1957—there were seven pairs—and have gradually increased in numbers to the present when there are about seventy-five.

There is a tremendous commotion on and over Runde in the

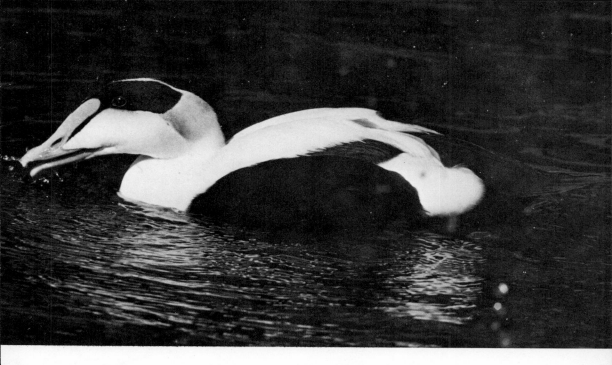

Northern eider (or common eider) is a duck with circumpolar distribution.

spring when millions of birds begin courtship and nest-building. There is much shrieking and flapping and swooping while the birds collect moss and straw from the wet sea cliff about a mile from the nesting grounds. Watching this, one would imagine many midair collisions, but the natives insist this does not happen. The birds, they say, have and closely follow a traffic pattern. When flying out to gather material they follow the seaward course, but when returning they stay to the landward line.

Visitors are not permitted to approach the nesting birds. This has been the law since 1957, so the best time to visit Runde is from July onward. Although there are no hotel accommodations, the local farmers and fishermen are known to be very hospitable—even to the point of taking people on a trip off the bird rocks in their own boats.

Certainly many excellent wildlife reserves exist in the Soviet Union; at least that is the government's boast. But there is little point in listing these since visitation by nonresidents in 1974 and the foreseeable future is virtually impossible.

16

Eastern and Central Africa

More than a half century has elapsed since the summer of 1920, when Paul Rainey, an American motion-picture producer, arrived by ship in Mombasa, Kenya Colony, on what was probably the first African photo safari. But the trip ended in tragedy soon after it began.

Rainey's first mistake was to hire Fritz Schindelar, a colorful local character who wasn't entirely qualified to deal with dangerous game, as guide and outfitter. Schindelar had a reputation for being a daredevil and proved it one afternoon after spotting a lioness slinking away into a donga.

"Set up the equipment," he advised, "and get ready to roll. I'll ride in there on horseback and flush it out."

Braced behind a camera he had to crank by hand, Rainey wasn't prepared for what happened next. Instead of bursting out into the scene on cue, the big yellow cat waited silently in ambush amid the shadows of the thornbush. Five, ten minutes passed as the guide beat the brush without response. Rainey wiped the sweat from his face and figured the animal had made good its escape. He started to fold up his tripod. Then with one sudden savage rush from nowhere, the lioness was on top of the horse, tearing Schindelar from the saddle. On the ground it mauled him terribly.

Three days later the guide died, and that ended camera safaris in Africa for some time to come. It wasn't until the Martin and Osa Johnson expedition in the 1930s that the American public really "discovered" African wildlife for the first time.

But times have changed. Nowadays thousands of pho-

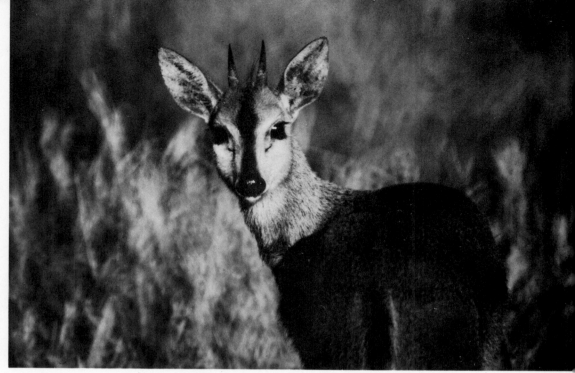

The steinbok is a small, delicate antelope which rarely gives a photographer time to aim and focus.

tographers undertake photo safaris every year, and few suffer any greater hardships or discomforts than a minor sunburn, a mosquito bite, or a slightly sore behind from bouncing all day over corduroy tracks in the back seat of a Land Rover.

Nor are modern safaris the exclusive pleasures of those with plenty of time and money to spend. Before World War II, a trip to anywhere in Africa was a costly undertaking which required many months and complicated planning. But since then modern jet aircraft and improved ground transportation have made it possible to accommodate many more people much more economically. Now an all-expense picture-taking safari to the best game fields of eastern Africa could be made in 1974 for under $2,000 from New York City and return. That fact alone has made these hunting trips the best bargains in adventure travel available today, at a time when the dollar's value is declining. More on how to take advantage of them later.

Nearly all photo safaris to eastern Africa begin and end in Nairobi, one of the largest and busiest cities on that continent. Not too long ago, lions prowled on the outskirts of town—and surprisingly enough they still do in Nairobi National Park, which is surely

unique anywhere on earth. Nowhere else is there a wildlife sanctuary with such an array of birds and big game located so close to a major city, only four miles by taxi or rental car from the New Stanley and Hilton hotels in the heart of the business district. It is possible to focus on lions, cheetahs, and vast herds of ungulates within an hour or so after clearing customs at Nairobi Airport.

Although only 44 square miles in size, Nairobi National Park has a variety of environments typical of eastern Africa, and with a driver-guide or with a handbook, this is a good place to get acquainted with the common species of wildlife. Except that you will encounter a good many other photographers, a visit here can be almost as exciting and worthwhile as to Kenya's other, more distant parks.

One hundred miles northwest of Nairobi via paved road is Nakuru National Park, a shallow alkaline lake in a deep depression of the Rift Valley. Although covering only 40 square miles, it is nonetheless the home of about 1,000,000 flamingoes and 400 other species of birds, more than have been counted in the entire British Isles. The world-famous ornithologist Roger Tory Peterson called it the "most fabulous bird spectacle of all." Every photo safari to eastern and central Africa should include Nakuru, as well as nearby Lake Naivasha, whose lagoons and channels fringed by papyrus and blue water lilies are another water-bird wonderland. Too often overlooked is the towering cliffs area 8 miles from Naivasha known as Hells Gate. Here can be seen a variety of birds of prey, some hard to find anywhere, many rock hyraxes, and often many head of big game.

Amboseli, 1,200 square miles in area, is probably Kenya's best-known game reserve. Astride the main paved highway between Nairobi and Arusha in Tanzania, it is the place where countless pictures have been taken through the years with snow-crowned Mt. Kilimanjaro towering behind herds of elephant, zebras, or a black rhino with an especially long horn. I have been to Amboseli a number of times and have always enjoyed it, but this sanctuary is not my favorite. Unfortunately the wildlife of the park (which is in Masai country) must share the normally arid range with vast herds of Masai cattle, especially during the peak of the dry season. Consequently, vast areas may be grazed bare, and large portions of the reserve resemble a giant dustbowl. Possibly by the time this reaches print the cattle situation will be improved.

A far more attractive reserve is 700-square-mile Masai Mara, in southern Kenya. It adjoins Serengeti National Park in neighbor-

ing Tanzania. Bisected by the Mara River, it is a cool region of vast rolling plains punctuated by acacia-wooded hills and dense thickets. Many kinds of antelope populate the grasslands, and the most numerous and most handsome lions in Kenya prey on them as they always have before this became a cameraman's paradise. Occasionally the life-and-death drama occurs before the camera of some fortunate photographer, as it nearly did to John Moxley and me late on an afternoon in January.

We were driving back to the comfortable safari lodge at Keekorok and keeping an eye on the landscape for a herd of animals which we might silhouette in the golden sunset soon to develop. But what caught our eyes instead was a pride of seven lions. Five were adult females, and the other two three-quarters-grown cubs. The cats crossed the road in a draw just ahead of us, paused, and then fanned out into a sort of skirmish line on our left. All were lean and with tightened stomachs, obviously hungry and hunting. Right away we spotted the object of their intentions: a female zebra with a small colt standing at the edge of tall grass.

We parked on a knoll nearby to watch the lion strategy. Crouched down to stay well hidden, they began a pincers movement which seemed certain to encircle the targets. The zebras, as always, were alert, but seemed to have no idea of their predicament as the cats crawled closer and closer. Given another 50 yards or so, John judged out loud, and any one of the lionesses would be close enough to begin the final fatal rush. I watched the nearest through binoculars and could see her ease forward silently step by step, tense and ready, perfectly hidden.

But we never saw a kill, which until that instant seemed absolutely certain. One of the young lions, perhaps tired of the long tedious stalk, stood upright for only a split second and probably for just an inch or so above the grasstops. Still, that was enough to abort the stalk—enough for the zebra mother to spot the stalker. In the next instant she and the colt were in full flight. They both had too good a start for the shorter-winded cats ever to catch up with them.

Later that evening, while sitting beside a roaring bonfire outside the lodge at Keekorok, we heard lions roaring in the distance, and in fact there was sporadic roaring much nearer to us all night long. After every eastern African safari travelers return home with certain vivid memories and sensations. For many, the most indelible of these are the sounds of lions hunting in the night.

Accommodations in all of the eastern African game parks are

constantly being expanded or improved, and so many new ones are planned or under construction that it is impossible to be entirely up to date here. But Keekorok at Masai Mara is, and is likely to remain for a long time, one of the finest safari lodges in that part of the continent. It is comfortable, and perfectly situated between a waterhole and a convenient airstrip for small craft. In an excellent year-round game area, buffaloes and waterbucks wander about the compound paying little attention to the human guests. In fact, I was awakened one night by a buff rubbing a huge wet nose against the screening of a bedroom window above my head. It also ate all the flowers which had been planted in a small bed just outside.

Aberdare National Park, a 2,288-square-mile reserve directly north of Nairobi, is an area of moorlands and forest of the Aberdare Mountains, mostly above 10,000 feet. Wildlife is not as abundant or at least not as easy to see as in the lower grassland parks. But the mountain vegetation is magnificent, and there is the opportunity to glimpse such rarities as the bongo, red duiker, giant forest hog, and black leopard.

Most photographers visit Aberdare by way of Treetops Hotel, built high in the crowns of large trees, from the Ark or Secret Valley, all on the fringes of the park. In all of these it is necessary to spend overnight, because then the viewing is best beside nearby floodlit waterholes. The viewing is done in luxury from comfortable chairs on verandas or overlooks, maybe even with a cold drink at hand. Visitors at Secret Valley are almost certain to see leopards, probably several, which are baited to the spot. But by far the best way to enjoy Aberdare Park is to camp at one of the approved sites and to be out on the trails at very first light every morning.

Another area not typical of most in eastern Africa is Mt. Kenya National Park, where a cameraman will not see great numbers of game, but does have a chance at such rarities as bongos, leopards, bushbucks, and bush duikers. The main features are the twin peaks, both exceeding 17,000 feet and snow-covered although astride the Equator. By four-wheel-drive vehicle one can ascend the Sirimon Track, which begins near Nanyuki, and climb through magnificent stands of juniper, through bamboo forests and beyond. Here is a lofty region where deep gorges divide open glades and where a lucky photographer may discover elephants or buffaloes lolling in a trout stream. But if not, the giant senecios and lobelias, plants peculiar to this alpine environment, are just as interesting as camera subjects. Camping in the high country is the

best bet at Mt. Kenya National Park; the nearest formal accom-
modations are in Nanyuki.

The largest national park in Kenya is 8,000-square-mile Tsavo,
a region mostly of open savanna and semi-arid desert scrub. Two
rivers furnish permanent water in the park, the Tsavo through the
west and the Athi through the eastern section. The rivers join just
above Lugard Falls, where the scenery is most spectacular.

An entire photo safari could be spent at Tsavo alone simply by
driving the 500 miles of vehicle roads. As elsewhere during the
driest seasons, most of the wildlife will be concentrated nearest the
rivers. A list of conspicuous big game would include eland, fringe-
eared oryx, waterbucks, impalas, and gerenuks, but primarily this
is an elephant park. So many live here that vast numbers die off
during periods of extreme drought, and it even has been necessary
to crop the herds so that they do not destroy their own habitat.

*Photo shows why the gerenuk is often called the giraffe gazelle. It stands on hind
legs to browse on high tender tips of acacia trees.*

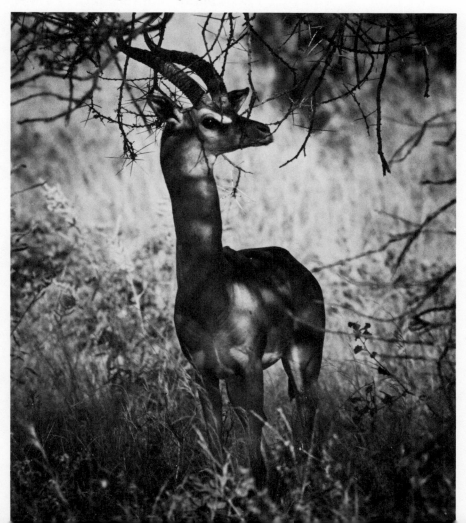

A good place to photograph elephants is from a reclining chair, with bar service, from the vantage of Kilaguni Lodge, one of several accommodations ranging from lodges with and without catering service to primitive campgrounds. Here the tuskers daily drink from and often bathe in a waterhole about 100 yards away. Set the camera on a tripod and wait for the show. But a far greater daily elephant spectacle is that at Mudanda Rock, a mile-long spine or outcropping which forms a natural water reservoir the year round. From a point above the water, cameramen can watch hundreds of the biggest land mammals on earth arriving and departing, often in a continuous procession.

There is still another natural wonder at Tsavo — Mzima Springs, where every day 50,000,000 gallons of cool water gush from underneath a lava formation to form an alcohol-clear pool. From a submerged observation chamber, travelers can watch and film both the herd of hippos and the schools of barbels which live there. It is the most intimate look possible at the hippopotamus anywhere outside the confines of a zoo.

We have never yet visited Marsabit or Meru national reserves, but both are high on the list for the future. Marsabit, 800 square miles in area, is located in the lonely Northern Frontier of Kenya and consists mostly of one magnificent forested mountain which rises abruptly out of a dark lava-desert wilderness. It is the only park anywhere where a photographer has a good chance to aim at a bull elephant with 100-pound tusks. Greater kudus are fairly numerous, and some animal rarities here include the striped hyena and aardwolf. Marsabit was the setting for the Martin and Osa Johnson photo safaris of the 1930s, the first really successful photo ventures to the Bright Continent. No accommodations exist at Marsabit.

Meru is best known as the area where Joy Adamson rehabilitated the lioness Elsa into the wild. From two picturesque lodges there is good viewing of many kinds of game, some fairly uncommon, such as reticulated giraffes, Grevy's zebra, lesser kudu, beisa oryx, and cheetahs.

A wildlife photographer might slowly wander around the world and find few places more hauntingly beautiful than Samburu-Isiolo Game Reserve, the third of Kenya's wildlife sanctuaries located in the Northern Frontier. Although a region of splendid rugged landscapes in a sparsely populated, seldom visited region, it is nonetheless accessible by good roads 213 miles from Nairobi. The 65-square-mile reserve is bisected by the Uaso Nyiro

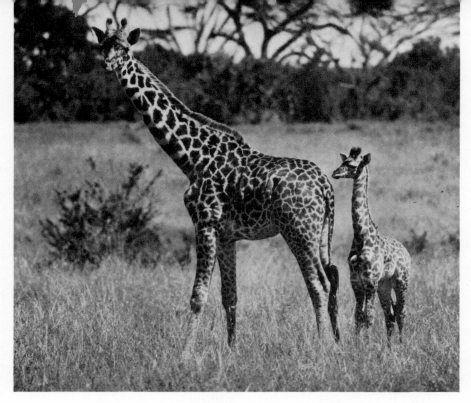

Almost everywhere in Africa the giraffe is an appealing and willing photo subject.

River, and this magnet concentrates a great abundance of wildlife nearby the year round.

During the dry season, abundance is understatement. No matter what the season, however, it is vital for a cameraman to be out as soon as possible after daybreak, and we found this to be especially true at Samburu. Everything, it seems, is moving at once. During a single morning of hunting with cameras, Peggy and I noted the following during only an hour of driving slowly along park trails: a herd of elephants accompanied by a troop of baboons (or so it seemed), going for a morning drink and bath; a pride of lions calling it a night to rest in the shade; giraffes going nowhere in particular; assorted zebras; several gerenuk; many impalas; a leopard just barely missing a meal. Perhaps our own approach spooked the Grant's gazelle which the cat had been stalking when we first spotted it.

But even after the morning game ride, photography went on right through breakfast. It happens that the dining room (as well as all cottages of the Samburu Game Lodge) is located among giant trees on a bluff overlooking the Uaso Nyiro. From there, while

eating, we could aim telephoto lenses at crocodiles in the water below, or at the vervet monkeys which came to steal sugar from the tables. After breakfast the fringe of the swimming pool was a gathering place for many colorful birds — buffalo and white-browed sparrow weavers, superb starlings and spotted barbets — all baited there for photographers by a bowl of corn flakes. Then toward late afternoon the big game begins to move once more. More elephants return to the river, and the spectacle of a whole herd silhouetted against the low sun and reflected on an oily current alone is reason enough to make an African safari. For me Samburu is as genuinely wonderful as any place I've been in Africa.

During the winter of 1966, old friends Frank Sayers, Joe Cross, and Jack Antrim joined me in a combination photo and hunting safari which none of us ever may be able to make again. Our outfitter was Brian Herne, then as now among the most capable men in that exacting business. The reason it may be impossible to duplicate our adventure is that (at this writing) Uganda is in terrible upheaval — bordering on civil war, really — and no tourists are encouraged or even permitted.

Our trip began in Kampala, Uganda's cool, once-attractive capital, and aimed northeastward into the dry Karamoja, once the stomping grounds of the old elephant hunter W. D. M. "Karamojo" Bell. We camped in the shadow of Debasien Mountain, pitching tents over the fresh footprints of lions, while listening to the strange night sounds of many birds. Even before a bonfire of dry hardwood was ablaze, it had become cold enough to don heavy sweaters. The last sound I heard that night was the dull-saw-like coughing of a leopard somewhere close by in the pitch black.

After several days in that memorable Debasien campsite, we continued northward past Moroto and to the then-new Kidepo National Park, which is on the Sudan-Uganda border. Of all the Karamoja wilderness, no part was more starkly beautiful than this pristine valley surrounded by dry hills on a quiet morning or evening. There was little evidence, at least for us, that poaching had become a terrible problem around the edges of the park and that a kind of desultory warfare with poachers existed along the Sudanese border. Then one day one of our trackers found a network of wire snares placed along a game trail and we understood much better. Not much later, poachers murdered two game guards in the same vicinity.

Kidepo was the first place where we ever came under an elephant charge — of a whole herd, that is. We had stopped to pho-

tograph the animals, which were coming rapidly from the direction of Sudan. As soon as the nearest spotted us, all came head on, trumpeting, and they meant business. We had to drive fast to get away. Brian blamed it on the constant harassment they encountered beyond Uganda's boundary.

Most of the Kidepo animals at that time (it was much better on a visit I made alone several years later) were more nervous than in other parks, probably because of the illegal hunting which wasn't yet under control. But there were exceptions, notably a pride of lions which never wandered too far from the camp rondavels because a waterhole was conveniently nearby. One night one of our party (who will remain anonymous) had to rush outside, suddenly, and so stumbled right into the middle of the cats, which were lounging on the cool stone veranda. It is a good thing he did not have a weak heart. It may have been an even greater surprise for the lions. At least that was the last time we ever saw them in the vicinity.

From Kidepo our itinerary took us to the Zoka Forest, the Nile Elephant Sanctuary, and finally to Murchison Falls National Park, all on the Blue Nile. Murchison Falls is where the Nile roars

Because of Uganda's political turmoil, photographers may never again be able to shoot the giant crocodiles of the Nile below Murchison Falls.

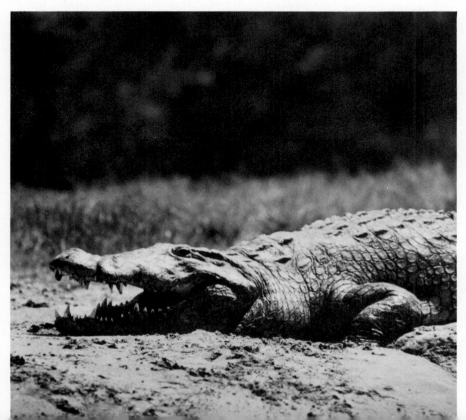

through a gorge only about 30 feet wide and then down into a murky pool below where Nile perch live in abundance. Here also the largest crocodiles left on earth survive and feed on the perch. Probably my first view of Murchison Falls is doubly memorable because a tremendous bull elephant was posing quietly in the warm mist at the base of it.

Murchison Falls National Park is one place no enthusiastic wildlife photographer should have missed. It is no longer possible to go there. There it was never necessary to travel far to locate elephants; several large ones were always handy as photo subjects right around the main lodge at Paraa. This was also a place to see other familiar eastern African game in large numbers, but with emphasis on Uganda kob and fine big waterbucks. However, nothing at Murchison could match the daily morning trip by launch up the Nile from Paraa to near the base of Murchison Falls itself. The continuing wildlife spectacle along both banks was so great that it is not easy to describe.

There were hippos, of course, but these were not always the easiest to see because they often kept hidden in the water. Not so the elephants, bathing tusk-deep, which barely looked up when washed by the wake of the passing boat. Crocodiles—some measuring 15 feet long—slid into the water as the craft came close. If the croc was a female which had just deposited eggs in a compost pile of earth, monitors pounced on the nest immediately. Fish eagles screamed from perches almost directly overhead, pied kingfishers fluttered above the roily river before diving for a fish, and a flock of African black skimmers flushed from a sandbar, circled the launch in perfect swishing unison. Around every bend was another thrilling scene, another cast of bird and animal characters, none temperamental about being photographed day after day. At least that's the way I remember it.

From Murchison our safari aimed toward Queen Elizabeth National Park, recently named Ruwenzori, which probably is more fitting since the park lies at the base of the Ruwenzori Range, Uganda's beautiful and mysterious Mountains of the Moon. We found this a region of lush vegetation, of swamps and grasslands bordering on tropical forests. In the Kazinga Channel which connects lakes Edward and George, any photographer could approach buffaloes and elephants at point-blank range by launch as we did. North of there the scene changed radically to one of old volcanic craters and crater lakes, all with the Ruwenzori looming in the background early in the morning on clear days.

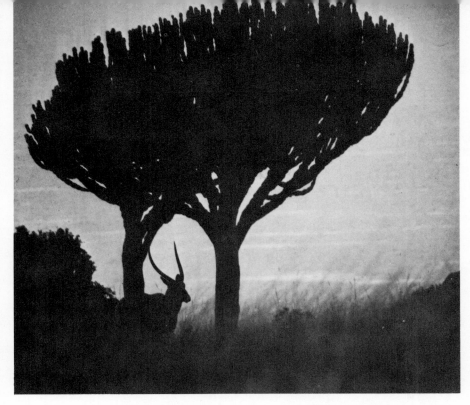

Giant euphorbia is frame for male waterbuck and dusty sunset near Murchison Falls.

Hippo is a common mammal in many African parks and sanctuaries. However, the animal is nocturnal and aquatic, and so seldom seen at very close range.

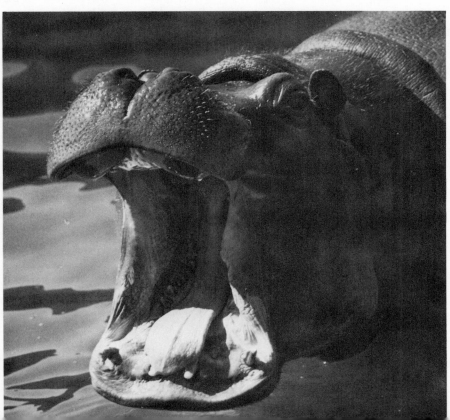

We filmed hundreds of hippos crowded into a few sloughs by the dry season, with prehistoric-looking whale-headed storks sharing the same habitat. We also found the tree-climbing lions of Ishasha, but along the edges of the Maramagambo Forest did not see any of the chimpanzees which live there. Out on the open grassland areas were herds of zebras and Jackson's hartebeest great enough to completely fill a viewfinder.

It is sad enough that these three exquisite parks of Uganda — Kidepo, Murchison, Ruwenzori — are now closed to travelers and perhaps pillaged of the wildlife as well. But worst news of all (as this was written) was that Murchison Falls might soon be eliminated altogether. Plans to build a large hydroelectric dam on the site have been approved by the government, and work is expected to begin. That would be a terrible tragedy any way it is considered.

I remember with mixed joy and sadness the numerous trips to Tanganyika (Tanzania after independence). Few other nations in the world can match its immense natural beauty and its incomparably rich wildlife resources. Few governments have set aside so much land for national parks and to preserve wildlife. All the world's conservationists can praise that.

On the other hand, the human population is increasing at a frightful pace and is putting pressure on both the parks and the game for uses other than just viewing and enjoyment. Poaching has become so serious — so organized — that law and order are being seriously undermined. And more subtly, the once friendly attitude toward visitors is deteriorating, although photographers can still visit the major game areas freely and in security. Let's take a close look at these sanctuaries.

Nowadays most photo safaris in Tanzania begin at Arusha in the north. From there Manyara National Park is only two hours away on a hardtop road. For its small size, only 123 square miles, Manyara may be among the most remarkable parks in all Africa. Here groundwater forests of giant fig and mahogany are mixed with acacia woodlands where the lions practically live in trees. It's always easy to find elephants, and the Cape buffaloes here carry the most massive black horns I have ever photographed. Manyara also has a wealth of bird life, some of it very easy to approach along the north shore of Lake Manyara. The undulating pink shading which drifts over the lake, as seen from the fine hotel atop the Rift Wall overlooking it, turns out to be a flock of thousands of flamingoes.

Party on photo safari shoot lion in tree from open roof hatch of safari car.

Continuing westward on the main road from Arusha is the Ngorongoro Crater Conservation Area, one of the most extraordinary game haunts in Africa or anywhere else. It is also one of the world's largest calderas (or craters), covering 102 square miles and being more than 2,000 feet deep. Elevation on the rim averages 7,500 feet, and some scenic views into the crater from its edge are even more breathtaking than those from Mt. Kilimanjaro, also in Tanzania.

My first visit to Tanzania many years ago is also the most indelible in my memory. With Keith Cormach, then a professional hunter, I began the ascent from Manyara to the rim at daybreak of a cool—no, cold—and damp morning. As we neared the crest, a dense fog reduced visibility ahead to almost nothing. That's how we nearly collided with a herd of elephants in our path. For a queasy instant, all turned and faced us, uncertain, and only a few feet away. One trumpeted and swung its trunk in our direction.

Then all moved over into the lush dripping trees on one side until we passed. A little farther along we suddenly came upon the second road block—five big bull buffaloes. Almost sullenly, they gave us room to continue onward.

From the rim and still in dense fog, we entered the crater by way of the Lerai Descent, an extremely steep, narrow, one-way track negotiable only by four-wheel-drive vehicle. In low gear we slowed down almost to a crawl, and even so seemed to be suspended in a gray void. Then almost a quarter-mile directly below the rim we encountered sunlight and entered an entirely different bright new world. A martial eagle sat in a dead snag nearby and watched us as we stepped out of the car to stretch and view the astonishing scene all around.

The bottom of Ngorongoro caldera is mostly an open, green plain punctuated by fresh and brackish water lakes and by two dense acacia forests known as the Laindi and Lerai. No matter which way we looked were herds of big game scattered across the 15 miles toward the horizon, which was the opposite rim.

All of the so-called big five of dangerous African game—lions, leopards, black rhinos, buffaloes, elephants—can be seen here. On a trip several years later in 1969, John Moxley and I saw and pho-

Half-grown black rhino calf is "shielded" by mother from approach of car bearing a cameraman. This is one big-game species which photographers should regard with care.

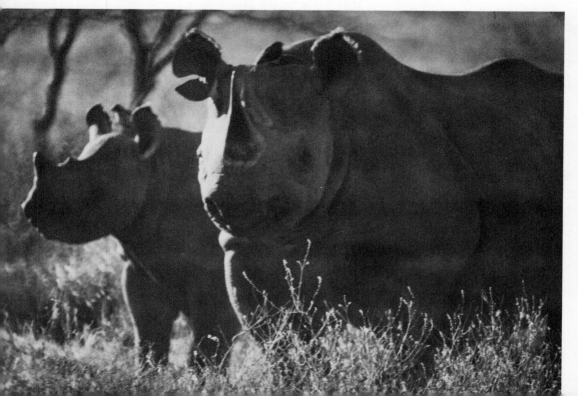

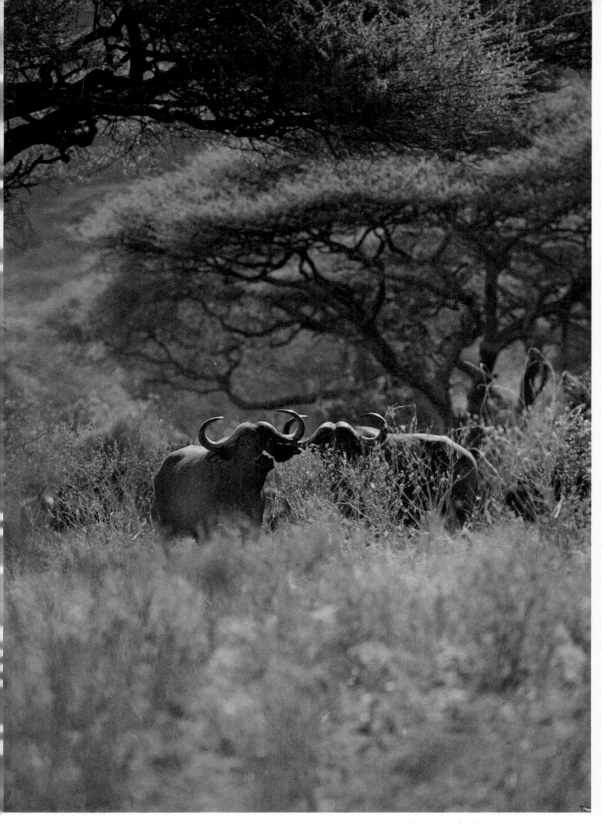

A pair of splendid male Cape buffalo lurk in thornbush of Tanzania's Manyara
National Park. Photo shows both the beast and its natural dense habitat.

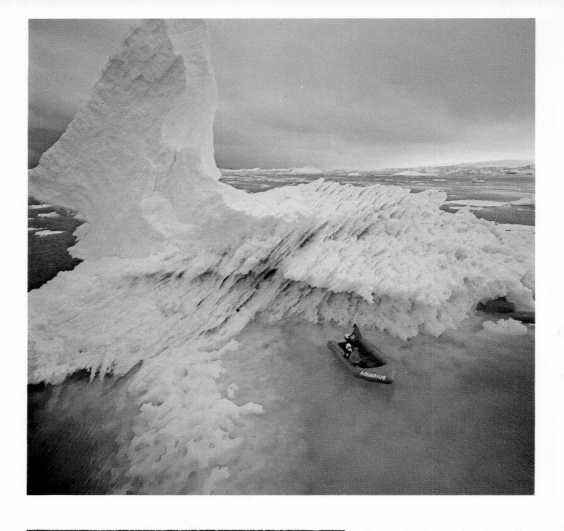

Above Iceberg in Paradise Bay of the Palmer Peninsula, Antarctica. The picture was taken not long before midnight of the long Antarctic summer.

Left The tiger is nowhere easy to see or to photograph any more. Probably the best bet is Nepal's Mahendra National Park.

A rare and beautiful trophy of camera hunters in eastern Asia is the mandarin duck, close cousin of the American wood duck.

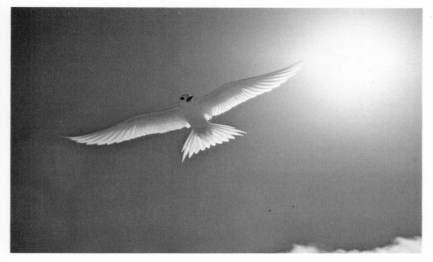

A fairy tern, most ethereal of birds, glides past the sun over Lisianski, outer Hawaiian islands.

Male magnificent frigate bird displays both for mate and the cameraman in the Galapagos. Most birds are unbelievably tame here.

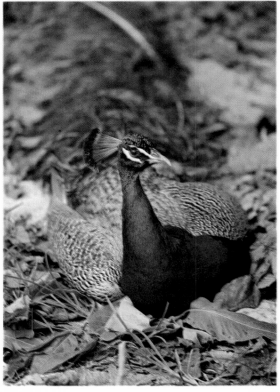

Above Lions are among the easiest of all big-game animals to shoot on an East African photo safari. This female was filmed during the final golden sunlight of the day, an excellent time to be afield.

Left Most spectacular of the world's large birds, the wild peafowl can be photographed in a few of India's wildlife sanctuaries.

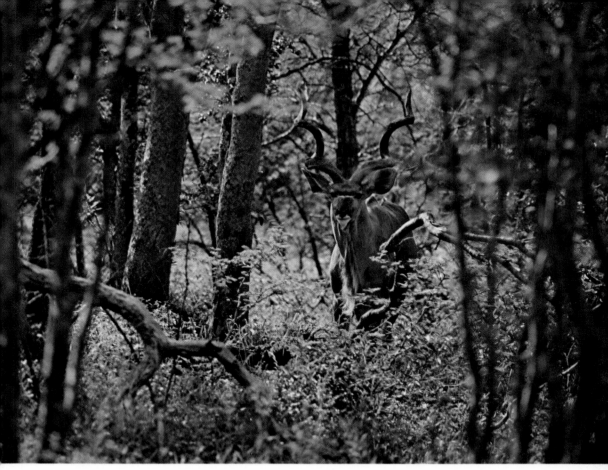

A coveted trophy of hunters, a magnificent male kudu such as this is also a remarkable camera trophy. A long telephoto was used.

On Kariba Lake, Rhodesia, it is possible to take a photo safari by boat. This male waterbuck was photographed swimming from one island to another.

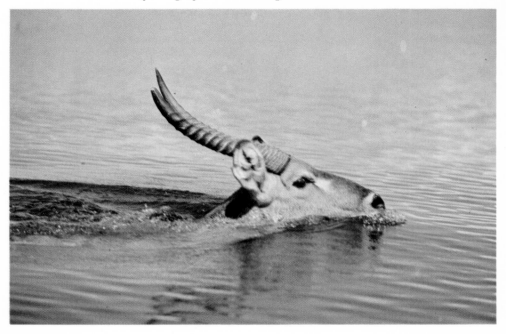

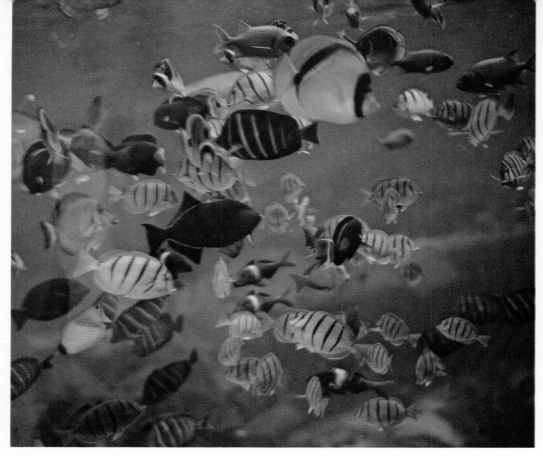

Colorful fishes cluster around the underwater camera in the alcohol-clear waters surrounding the Hawaiian Islands.

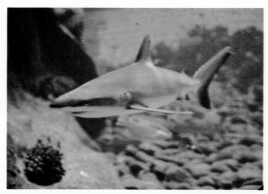

Left Blacktip shark cruises along shore of outer Hawaiian Islands.

Bottom left This angelfish is one of thousands of species which inhabit reefs and underwater canyons of the warm Indo-Pacific and Australasia.

Below A snorkeler or scuba diver equipped with an underwater camera is likely to encounter the Pacific barracuda, usually a willing subject.

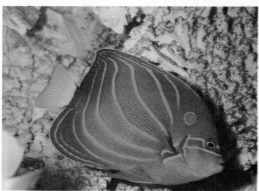

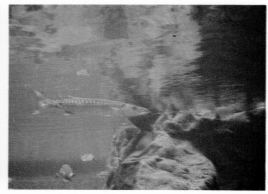

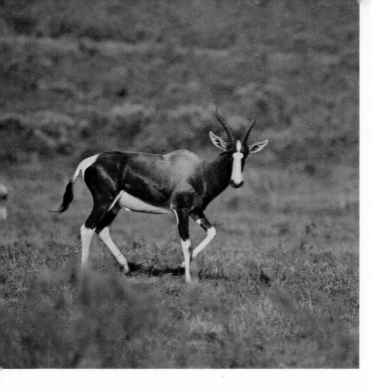

Left The bontebok is southern Africa's most striking antelope. Photographers find them very confiding in the Bontebok National Park.

Below The million-odd flamingos of Kenya's Nakuru Lake have been described as the world's greatest bird spectacle. Any photographer can easily, conveniently shoot it.

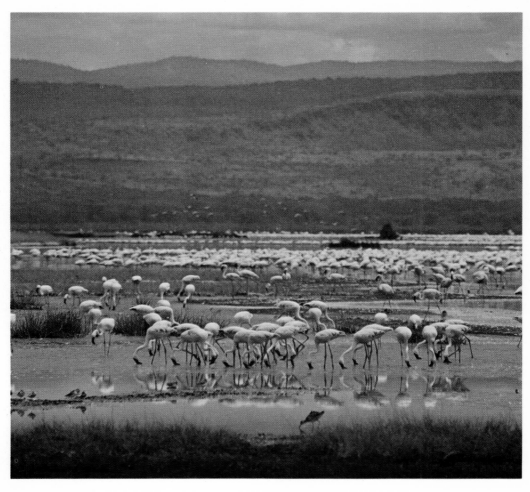

The mood and haunting beauty of Kenya's Northern Frontier is revealed in this sunset-rainbow scene at Samburu-Isiolo National Park.

tographed four of the five (all except the leopard) all at one time! The lions are an especially handsome lot, the males having manes which vary in color from rich red to tawny or salt-and-pepper to black. Apparently the cats are well-fed, because the crater literally teems with zebras, Grant's and Thomson's gazelles, blue wildebeest, eland, and waterbucks.

I know of no better place than Ngorongoro to photograph cheetahs, hunting dogs, or spotted hyenas, the last being super-abundant and even active during daylight. This is one place where hyenas hunt in packs and probably are the principal predators of the plains game — the ungulates — while lions often assume the role of scavenger by feeding on hyena kills. Wading and water birds are abundant around the lakes, and Egyptian geese are especially easy to approach for photographs.

If any trip to Africa was limited to one place — to a single, great wildlife experience — Ngorongoro might be the best place to take it.

Continuing onward from Ngorongoro, through an important big-game migration corridor which unfortunately was opened recently to agriculture, the highway leads across the vast Serengeti Plain. The heart of this, 5,600 square miles, is the famous Serengeti National Park, which adjoins Masai Mara Reserve in Kenya. It is really a much, much larger edition of Ngorongoro, with the most stupendous concentration of large animals (mostly zebras and blue wildebeest) in existence, but without the spectacular crater background.

On one day in 1966, I counted 125 lions during one day's touring. No wonder, because it was also often possible to stand in one spot on a knoll and no matter which way the camera was aimed, for 360 degrees all around, there were masses of animals in the viewfinder. Leopards also are fairly numerous and at times can be found in daytime resting in trees along the Seronera River.

I visited Mikumi National Park several years before it was declared a 450-square-mile faunal reserve. Then the animals were wild and photography was not at all productive. Today, according to reliable sources, a photographer should be able to shoot Masai giraffes, hippos, rhinos, waterbucks, bohor redbucks, Lichtenstein's hartebeests, sables, and probably lions during any safari of a few days.

On the same safari which included Mikumi, I also visited Ngurdoto Crater and the Momella Lakes region, which are now included in Arusha National Park. With Mt. Meru or Kilimanjaro

hovering above a blue haze in the background, these mountain crater lakes are among the most superb views on the continent. There is a good bit of wildlife in the park, but because of the lush vegetation, it is not the easiest to photograph. As soon as possible after daybreak, look for elephants, buffaloes, rhinos, bushbucks, and giraffes. Even harder to see are the colobus and blue monkeys of the high forests. My own major recollection of Arusha Park, aside from the grandeur of the landscapes, was of a crowned hawk eagle in pursuit of some unseen target, perhaps one of the monkeys.

Ruaha National Park is a 5,000-square-mile wildlife sanctuary in central Tanzania, large parts of which remain thoroughly unexplored even as late as 1973. Most of the park lies between the Ruaha and Njombe rivers and contains few vehicle tracks. A small airstrip is four hours by light plane from Nairobi and two and a half hours from Dar es Salaam. This remote, completely unspoiled African wilderness has many elephants and is the top spot in eastern Africa to photograph greater kudus, sable, and roan antelope. Reaching the place is obviously neither easy nor inexpensive, but it is a park so far free of tourists and a cameraman can have it entirely to himself.

Many who have made photo safaris to eastern Africa have considered it the greatest adventure of their lives—until the next one. The trips are genuinely addicting. Fortunately, safaris to Tanzania and Kenya today are not prohibitively expensive. There are a number of ways to go, mostly depending on time available and budget.

The ideal safari is also the most costly. Only a minimum group of say two to four already-acquainted, compatible photographers go together on one of the old hunting-type trips. That means chartering a complete outfit: outfitter, "hunting" cars, cargo trucks, all camping gear (sleeping and cook tents, portable shower, toilet, propane refrigerator), plus all necessary staff (guide, spotters, cooks, drivers, handymen). This kind of group is flexible, can go almost anywhere anytime, and does not depend on the regular safari lodge accommodations, which are often overbooked during the busiest seasons. Many of the old established safari firms which once catered to big-game hunters alone, such as Brian Herne Safaris in Nairobi, now specialize in photo safaris. Figure on $200 per person per day for this type outing, with air fare additional.

For considerably less than half that amount, a photographer can join one of the numerous tours circulating in eastern Africa all

the time. From fifteen to twenty-five persons make up the party, and the tour may be of two or three weeks' duration and include such popular parks, already described, as Amboseli, Nakuru, Masai Mara, Serengeti, Treetops, Manyara, Ngorongoro, and Tsavo. Travel is usually by minibus, each of which carries six to eight passengers. Itineraries usually make the most of available time in the field, and if anything, are often too rushed. Meals are adequate, sometimes even excellent. Overnight accommodations are in comfortable safari lodges or clean tented camps.

There are all types of tours. Some specialize in big game alone, some in birds, although most are general. Among the least expensive are those sponsored or at least packaged by the major airlines which serve eastern Africa. Somewhat more costly, and worth it for serious photographers, are those sponsored each year by such conservation organizations as the National Audubon Society, National Wildlife Federation, East African Wildlife Society, and various natural history museums. These are invariably led and interpreted by qualified naturalists who know the African wildlife and its environment. The cost per person runs about $75 to $100 per day exclusive of air fare.

Large travel agencies also offer outstanding bargains. For 1973–74, Lindblad Travel of New York, specialists in adventure tourism, ran twenty-four-day tours of Kenya and Tanzania parks, plus Botswana and Zambia, for $1,250 plus air fare. Almost certainly these will be continued for many years with slightly increased fares. To save traveling time, and cram as much more photography as possible into a twenty-three-day trip, Lindblad offered all-expense wing safaris (between parks by light chartered aircraft) in Kenya-Tanzania for $1,800 plus air fare from New York.

It is possible to travel about eastern Africa by rented car (all types available in Nairobi), and for an experienced hand that gives the most freedom of all. Camping gear can be rented, too. But there is a language barrier, and an unfamiliar or timid person is far better off letting someone else do his planning. Probably it is also cheaper.

Before passing from eastern and central Africa, four other countries should be mentioned briefly: Ethiopia, Sudan, Chad, and Zaire. Ethiopia is in an extremely sad situation. As recently as a generation ago the country's rich wildlife treasure was almost intact, but very little worthwhile remains today, all government publicity claims to the contrary. For many years there has been worldwide pressure to establish several national parks to protect the

unique fragile environments and such rare and endangered wild-life as the walia ibex, mountain nyala, gelada baboons, simien foxes, and others. Much aid money from the United Nations, from several other countries, and even from private sources has been pumped into Ethiopia for the past two decades, but nothing was ever accomplished. The money went into ratholes. Awash and Simien national parks were set aside in 1969 and 1970, but since then, in characteristic fashion, nothing has been done to secure them.

Some game, notably oryx, Grevy's zebra, Bright's gazelle, and lesser kudu, all kept wild by lack of ranger patrolling, can be seen at Awash, which has immense potential for tourism. Some wading bird photography is also possible at Lake Abiata and elsewhere nearby, all about a half day's drive from Addis Ababa. But that is a pitiful summary for a nation which was once one of the most beautiful countries on earth and is now among the most ravaged by its people and a lethargic government. As this goes to press Ethiopia is in a state of revolution and its future is uncertain.

The situation at Dinder, Sudan's potentially great national

Of several varieties of zebras, the Grevy's with its elegant striping is the handsomest. They live in dry scrub or semi-desert areas.

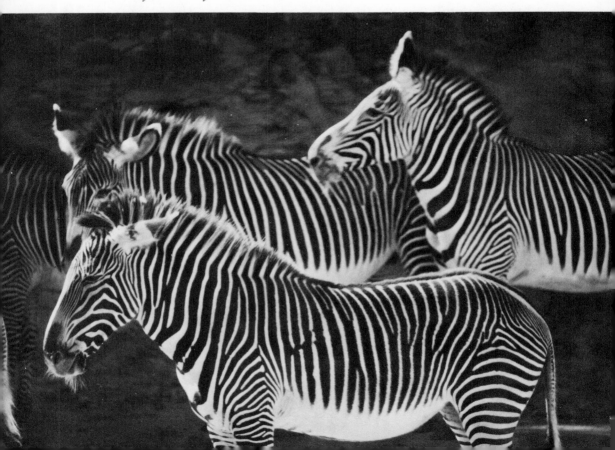

White-faced tree ducks photographed in Ethiopia, where all wildlife is in trouble.

park, is not now clear because it is threatened by a giant irrigation project. It is also located in an area of turmoil between Arabs and blacks during recent times. Nor is word available at this writing of Zakouma and Siniaka-Minia parks in Chad, a country hard hit by the devastating drought of 1973. Formerly Zakouma was the best (if not the only) place where one could fill out a photo trophy list by shooting red-fronted gazelles, tiang, striped hyenas, central African duikers, and some other uncommon beasts.

We have not done any photography in Zaire and include the following only because it comes from the reliable naturalist Bernhard Grzimek, who toured there in 1972–1973. Garamba National Park, 1,800 square miles on the Sudan border, once contained half of the world's population of white rhinos, plus a long list of other wildlife. But during the turbulence of the early 1960s, rebel simba brigands and Sudanese refugees wiped out most of the rhinos and everything else. Apparently all is under control today and the game is making a good comeback. Upemba National Park in Katanga, Zaire's second largest reserve, also suffered in the

fighting following independence. Its wildlife also appears to be increasing rapidly under good protection.

Albert National Park, one of the world's most beautiful, happily was least affected by the 1960s. Astride the Equator, this sanctuary contains all of the main habitats of tropical Africa (except desert, semi-desert, and marine biotopes), from open savannas and acacia woodlands to mountain rain forests of the Ruwenzori. According to Grzimek, Albert has few equals on the continent for the astonishing variety of wildlife a photographer can see during even a short safari. There is even the chance to film chimpanzees and mountain gorillas, although newly established Kahuzi-Biega National Park is better for the latter. At least a few of the 300 or so gorillas there are now tame enough that visitors are likely to see them in three to four days of observation.

Summed up: Zaire might possibly be a fresh destination for a productive African photo safari.

17

Rhodesia

Ever since photo safaris to Africa became very popular, as they surely deserve to be, eastern Africa has always been the place to go. That is no wonder; as described elsewhere in this volume, the eastern African countries contain an astonishing wildlife population which is easy to photograph in their numerous national parks. But beginning in the early 1970s, some subtle (and some not so subtle) changes have been taking place which might detour travelers to other places.

No matter whether justified or not, some visitors to eastern Africa have not felt entirely welcome—or at least have been uneasy. Travel in Uganda was closed altogether by a political crisis during 1973. Poaching around the fringes of the parks has in places become such a menace that governments have been unable or unwilling to control it. Exploding human populations are putting even greater pressures on the parks.

But perhaps there is another reason why at least some sophisticated travelers are looking beyond eastern Africa. Many simply want a change of pace—to explore new scenery and shoot different or unusual camera trophies. They naturally direct their attention Southward, where, because of the greater distance to be traveled, safaris are more expensive, but the wildlife spectacle is at least the equal of anyplace on the continent and perhaps in the world. Consider Rhodesia for one example.

Rhodesia is an orderly, tidy, Montana-size, landlocked country of 150,803 square miles, 5,690,000 population, a generally excellent dry climate, and a wealth of wildlife and wilderness areas

which are considered national treasures. During the Southern
Hemisphere winter (August), Peggy and I spent several weeks on
a camera safari in just the strip across northern Rhodesia, and
it easily ranked with the most exciting of thirteen similar pre-
vious trips to other parts of Africa.

The country, which was founded by Cecil Rhodes less than a
century ago, is best known for Victoria Falls on the Zambezi River,
which is also the boundary between Rhodesia and Zambia to the
north. The 355-foot falls (twice the height of Niagara) is surely
among the world's greatest natural wonders, and the national park
which surrounds it has an abundance of game, particularly of
elephants. The tuskers and other wildlife can be seen on game-
viewing drives close to the luxury hotels beside Victoria Falls, or
from evening trips by launch up the Zambezi to Kandahar Island.

However, the single most compelling attraction in Rhodesia (at
least for us) was not Victoria Falls, but rather Wankie National
Park, which is close by. Larger than Connecticut, it is surely one of
the finest of all wildlife sanctuaries. Although 300 miles of roads
crisscross just the northern half of Wankie (the southern half is
maintained as purest wilderness), other vehicles are seldom en-
countered because only a limited number are permitted to be in
the park at any one time. Visitors may stay at any of three rest
camps (Main Camp, Robins, Sinamatella), which have all amenities,
inside the park, or at Southern Sun Safari Lodge, just outside the
park boundary. The latter is probably the most attractive and lux-
urious accommodation of its type we have ever enjoyed.

Because 10,000-odd elephants roam Wankie Park, no visitor
has any trouble seeing them. In just four days of steady shooting,
Peggy and I estimate that we saw between 600 and 700 pachy-
derms. Our guide for much of this photography was John Herbert,
a native Ohioan, a biologist once employed by the Smithsonian In-
stitution, and presently a big-game researcher with Rhodesia Na-
tional Parks. Since our visit fell toward the end of the driest season
and nearly all game was concentrated within reach of a limited
number of waterholes, Herbert advised that we spend most of our
own time around these same ponds. Elevated elephant-proof plat-
forms have been erected at two of the "busiest" waterholes (Guva-
lala and Nyamandhlo) to give photographers the best possible
viewpoint.

One day at Guvalala revealed a continuous parade of wildlife
and was an extraordinary experience. Among the earliest arrivals
on a cool morning (we shivered even inside heavy jackets) were

baboons, a silver-backed jackal, and herds of greater kudus, including groups of five or six giant males together. Any one of these kudus with massive spiraled horns would have been a bragging-size trophy for a hunter. Of all the big game we saw approach the waterhole, we were surprised that the kudus were the least shy of all. Normally they are considered to be extremely wary.

Sable antelope, also including a number of magnificent males with black scimitar horns, were more suspicious and halting than the kudus, but at the same time were much more trusting than the roan antelope which occasionally appeared on the scene. Once the roans spotted us crouched in the platforms (or elsewhere waiting with cameras near water's edge) some of the more nervous bulls would not come to water at all.

Impalas arrived in large herds all day long and did not become suspicious until reaching the fringe of the pond. There they drank, but meanwhile kept eyes focused on the crocodiles, which were largely unseen, although permanent residents. Once while making a scientific study of waterbucks, John Herbert had observed a full-grown female being caught and dragged under by one of the crocs. It is no wonder the smaller impalas were watchful.

Zebras, blue wildebeest, and tsessebes watered during the cloudless, gradually warmer day, and so did a few elephants. But as always it wasn't until late afternoon that the vast numbers of elephants began to arrive. From then until dusk their movements in and out resembled a minor migration, which indeed it was.

I have aimed telephoto lenses at my share of tuskers, but still the fascination for the giant beasts never ends, perhaps because their antics can be such an embarrassing imitation of human behavior. Sedately, slowly, in single file, one all-male herd approaches through a mopane scrub, here and there picking off succulent leafy snacks on the way. But once water is sighted, the rush begins and it becomes every elephant for himself. All other animals are scattered. Smaller or younger elephants already drinking are rudely shouldered aside, and there is a good bit of controversy and threatening among the new arrivals over which deserve the best drinking places. Once that is settled, all drink, loiter, loll, bathe, jostle, and squirt one another with mud, pretty much as people on a crowded Atlantic beach might behave on scorching summer weekends. It doesn't take too many tuskers to completely occupy one waterhole of less than an acre in extent.

Of course all of these tusker antics are made to order both for wildlife photographers and film manufacturers. When the males

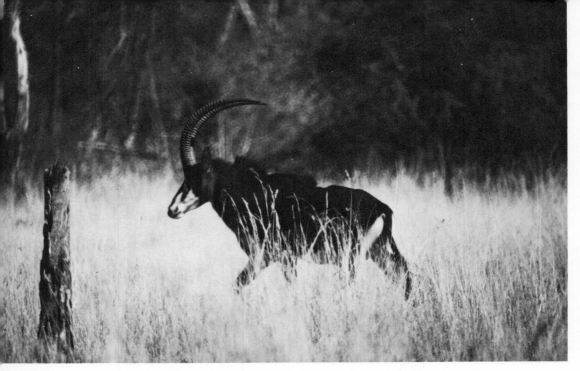

Sable antelope may be the most magnificent big-game trophy in Africa and is not easy to shoot on film, except at Wankie, Rhodesia.

Bachelor greater kudu bulls meet at a waterhole and there is competition for who drinks at which preferred place. A few minutes later a small herd of sable antelope, and then roan antelope, came to this spot.

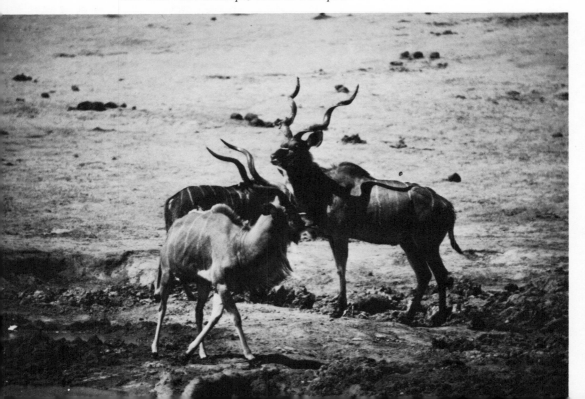

finally left the waterhole, several strolled almost directly under the viewing platform, pointing trunks upward toward us as they passed. Such proximity is unsettling and can make the adrenalin pump. I wondered if the structure really *was* elephantproof, because earlier I'd seen the brutes pushing over trees of substantial size just to browse on tender twigs of the crown.

Following the bulls, a family herd appeared, composed mostly of cows with calves of various sizes. We noticed that one very tiny calf (according to Herbert, not much more than a week old) which was still pink around the ears was kept hidden as much as possible from our view. At least one protective female seemed always to stand in front of it, even when it tried to nurse. The serious drinking done, several of the older "teen-age" calves began scuffling and creating a general noisy nuisance for all the rest. Suddenly, with patience apparently exhausted, one large female swung about, charged the pair, and swatted both with a trunk. That imitation of a tired, distraught American housewife ended the disturbance, at least for as long as the herd was in sight.

On moonlit nights, game viewing does not end at dusk and in fact may be just beginning. Accompanied as it is by strange night sounds, after dark on a platform is absolutely unforgettable.

Far away and then perhaps closer, a lion roars and is answered. A hyena laughs. Next an emerald-spotted wood dove begins the descending lament which is one of the most haunting sounds of the African bush. Zulus huddled in the gloom around flowing campfires translate the "du, du . . . du; du, du . . . du" as "my mother is dead, my father is dead, my brothers are dead; oh, oh, me, I'm next."

Elephants continue to come and drink all through the night, and in the moonglow their huge bulks are silhouetted against the silvery water. Now their splashing and stomach rumblings are more distinctly audible than in daylight. At intervals the waterhole scene becomes completely deserted of animals and all is silent. That's when—almost miraculously—a leopard stands by the pond, although nobody saw it come. Then an instant later it is gone, as if it evaporated. No animal anywhere blends better into its environment day or night.

From Wankie we drove the 100 miles to the west end of Kariba Lake, the 175-mile-long, dragon-shaped impoundment on the Zambezi downstream from Victoria Falls. We reached the lake at Mlibizi, where fishing-camp owner Mike Johnson introduced us to the local brand of tigerfishing (it's great, and for a great game

species). Simultaneously he outboarded us to within telephoto-lens distance of the neighborhood herd of hippos before all submerged.

The main feature (besides the fishing) of Mlibizi is one particular hippo which wanders ashore every night to graze on the flowers and manicured lawn of the camp. Fishermen guests normally give the animal a wide berth, but late one night during our stay one slightly tipsy visitor stumbled head on into the hippo in the dark. For the man it was a sobering experience, and the entire camp was awakened by the noise he made in retreat.

It is possible to travel the entire length of Kariba by every-other-day modern hydrofoil and car-ferry service. After a day's pause at Bumi Hills Safari Lodge, which almost every evening is surrounded by feeding elephants, we continued to Camera Africa's Spurwing Island camp, which is adjacent to Rhodesia's Matusadona Game Reserve. There we enjoyed a unique kind of game photography unlike any other tried before.

Lanky, enthusiastic Geoff Stutzbury is the boss at Spurwing's comfortable thatched-roof safari camp, beside which Cape buffaloes and waterbucks, even the occasional elephant, graze without

Camera held at low angle permits this shot of Rhodesian elephant silhouetted against a typical sunset of the dry season.

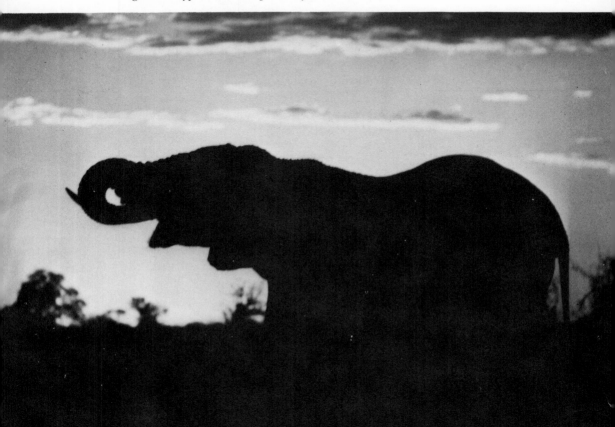

conflict. He is also the chief guide. His specialty is taking cam-
eramen to within point-blank range of big game by a flat-bot-
tomed, shallow-draft, camouflaged, plywood outboard boat. Al-
most at water level up front are two windows for aiming telephoto
lenses forward. Geoff manages the craft from astern, first motoring
as close as possible to the target, but cutting the power and making
the final approach in silence by drifting ahead of the wind.

On our first morning at Spurwing, our host had a suggestion.
"Let's just go tigerfishing along the Matusadona shore," he said,
"and see what we find there."

It was an ideal arrangement, unless you happen to be a more
addicted angler than a wildlife photographer. The first fish was
barely thumping its last tattoo on the bottom of the boat when
somebody spotted a herd of elephants on shore strolling toward
the water. That ended the fishing as Geoff swung the boat around
to try to intercept them.

Any kind of wildlife photography can be suspenseful, and the
closer you approach to potentially dangerous mammals, the more
so. That may give an idea of how it feels to drift slowly, directly
toward a herd of animals, each one of which weighs four or five
tons. Wavelets lap against the boat and one tusker stares sus-
piciously at the curious, floating, approaching object. You do not
speak or make any moves, because you want to get as close as pos-
sible, to show the wrinkles in the old bull's face and trunk in the
pictures. Still—the closer you get, the more things can happen.

Now with a single elephant filling the entire viewfinder, I start
shooting and then switch to a shorter telephoto lens. Nervously
Peggy changes film in one of the emptied Nikons. Maybe the
elephant suddenly hears the sound of my motor drive, or maybe
the breeze carries our scent inshore. Anyway, with ears flattened
against its head, one animal trumpets and retreats from water's
edge. All the others, now alarmed, follow. But we have plenty of
pictures of the world's largest land mammal.

Although the best game photography is by a boat such as
Stutzbury's, a system of dirt tracks on the mainland of Matusadona
opens up a good bit of new territory to the cameraman. Most con-
spicuous on the grassy flat areas along the Kariba shoreline are
great black herds of Cape buffaloes. Unlike other places where
they are protected, impalas here are wild, and if a photographer
can shoot fast from the hip, he may catch an entire group
bounding through the air with the grace and beauty which only a
North American whitetail deer can match.

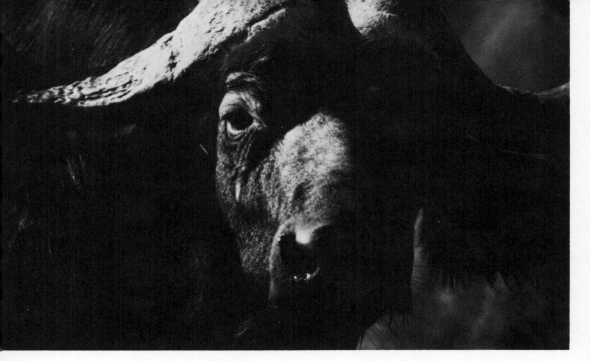

Cape buffalo bull stares uncertainly at cameraman in Rhodesia's Wankie National Park.

Perhaps because he is constantly looking for detail, a wildlife cameraman has some advantage over the wildlife watcher alone. In other words, he often sees animals behave in unusual ways which are difficult to explain. An incident late one afternoon at Matusadona is an excellent example.

The land there is fairly flat but is punctuated by rivers which are almost entirely dry except during the rainy seasons. Since our visit came in August, these river beds were nothing more than soft dry sand traps for vehicles without four-wheel drive. Shifting into low range, we were crossing one river bed when we noticed three bull elephants just upstream. None saw us approach. One was extremely large by southern African standards, having tusks of about 60 pounds. But that isn't what was most unusual.

By some instinct the big bull had located a reservoir of water *underneath* the sun-bleached sand river. It would poke its trunk deep into an excavation in the sand, pump up a trunkful of muddy water, and either drink it or toss the lukewarm liquid over its back. While we watched and photographed, the elephant remained so occupied for over a half hour.

But a puzzle remains. Why didn't that large bull and his friends walk only a few hundred yards farther (as most other local

tuskers seem to do) to Kariba Lake, where there was an unlimited supply of fresher, cooler water available both for drinking and ablutions?

Wankie and Matusadona are not the only places for a camera safari in Rhodesia. In fact, a vast amount of real estate has been permanently gazetted into national parks and game reserves. These include all of the different types of natural environments in that country. Most visitors first arrive in Salisbury, the capital, and if they have only a short time to spend can make the short drive by rented car to nearby Robert McIlwane National Park just beyond city limits. Even here all native high-veld species of big game (except the big cats and elephants) can be easily seen, and the sable antelope are especially available to cameramen.

Mana Pools Game Reserve, in extreme northern Rhodesia and also bordering the Zambezi River, is a beautifully forested region where hippos may be the main attraction for most travelers. Rhodes Matopos National Park, just south of Bulawayo, is small, but is among the most scenic. It is almost routine to shoot white rhinos, giraffes (especially), buffaloes, and many antelopes against grotesque or balanced granite rock formations. Mushandike National Park is a chance to collect such rarer camera trophies for the files or album as grysbok, gray duikers, and klipspringers. Chimanimani National Park, with mountains rising to 7,500 feet, is the highest and most rugged corner (on the Mozambique border) of Rhodesia. It is an especially good region for hiking, backpacking, birdwatching, and trout fishing, but is not particularly fruitful for wildlife photography alone.

Gona-Re-Zhou Game Reserve, bordering Mozambique on the southeast portion of Rhodesia, is the most recently opened to photo safaris. Containing 5,000 square kilometers and second to Wankie in size, the reserve has large populations of elephants, black rhinos, and Cape buffaloes. It is the best place north of Zululand or South Africa to shoot nyalas. Roads in the reserve are still rough and restricted to four-wheel-drive cars, but they wind through magnificent wilderness landscapes and along attractive rivers.

Request for detailed information on Rhodesia's wildlife areas should be addressed to the Rhodesia National Tourist Board at 535 Fifth Ave., New York, N.Y. 10017, or to Box 8052, Causeway, Rhodesia. Actual bookings may be made through the Rhodesia Department of Parks and Wildlife, Electra House, Jameson Avenue, Salisbury.

*Puff adder blends well into sandy soil background. This snake is poisonous, but is
sluggish and no great danger to photographers on safari.*

Of all places in Africa, perhaps, Rhodesia is the best country in
which to make a camera safari entirely on one's own devices, if so
desired. In other words, it is possible to fly there and on arrival to
rent a car and caravan (a small sports or camping trailer) for
touring the game parks with toilet facilities and barbecue (braai)
sites and often with electrical hookups. All these are the equivalent
of the very good private (such as the KOA system) and national
parks campgrounds in North America. And the costs are simi-
larly nominal.

For the caravaner, all main roads are paved, well graded, and
clearly marked. There is no language barrier; English is always
spoken. But travel is equally uncomplicated for photographers who
prefer not to drive and camp. Rhodesia Airlines offers good
daily service to Wankie, Victoria Falls, Kariba, and elsewhere,
where cars with or without guides and drivers are always available.
Summed up: Rhodesia is a recommended destination for any
serious wildlife photographer, no matter how he chooses to go.

18

Southern Africa

One of the most fulfilling days Peggy and I have ever enjoyed was spent entirely in darkness—inside two wooden blinds called Bube and Masinga. Both of these stand beside waterholes at Mkuzi, a 62,000-acre game reserve of the Natal Parks Board in Zululand, South Africa. Ordinarily I am not a good or patient blind-sitter, but on this day in August 1973, we witnessed the constant arrival and departure of thirsty animals and birds within point-blank range. This was the heart of a very dry season. Seldom has time ever passed so quickly. I suppose we focused on several thousand subjects from early morning until dusk, and most of the time we did not need telephoto lenses; the targets were that close. We may have set a record for exposing the most film in a single day.

There are a good many reasons for a naturalist cameraman to visit and explore southern Africa. Game reserves and national parks are numerous and well managed. Wildlife is abundant, varied, and generally confiding. But at least during the annual dry period, which spans from July until the end of September, Mkuzi could prove to be the highlight of any African photo safari south of the Equator.

The blind—or hide—at Bube is situated beside and above a peanut-shaped waterhole—or pan—so that there is water on three sides of the person hidden inside. To ensure that the pan does not dry up during the South African winter, a steady trickle of water is pumped from underground. Together with a similar arrangement at adjacent Masinga, there is enough water to supply nearly all of the resident large mammals of this reserve at the edge of the

Smallest of all antelope and at times the most difficult to film is the dik-dik, this one in southwest Africa.

Lebombo Mountains. When these are concentrated within a day's reach of the daily drink which all need, photography is never easier. No guides or spotting or stalking skills are necessary; you simply sit down, aim through the portholes, and shoot.

For our 1973 safari in South Africa, we rented a minibus with a bare minimum of gear, figuring to camp inside it whenever possible and elsewhere to take advantage of the inexpensive rondavel or hutted accommodations. At Mkuzi the campground is located in a dry, parklike forest; the tab for parking space, outdoor barbecue pit, and use of the "ablution block" (toilet, shower) was $2 per day. Only two other families shared the facilities, which might have handled twenty or more.

The blind at Bube is entered via a long log-camouflaged tunnel which permits access without frightening any game nearby. We arrived shortly after breakfast just as a small herd of impalas joined a band of baboons and several blue wildebeest already drinking there. A few of the latter looked up, but just for a moment, on hearing the noise of the motor drive of my camera. The rest paid no attention at all.

Besides the matchless opportunities to film unfrightened game at such point-blank range, that day (as well as a later visit) provided an excellent study in wildlife behavior. Zebras and wildebeest came quickly and confidently to the waterhole, often galloping the last 100 yards or so when the water came in sight. Without hesitation all would wade out deep enough to drink noisily and maybe also to roll on their backs on the muddy banks. We wondered if this confidence could be explained by the fact that no lions, natural predators of both zebras and wildebeest, live within the reserve boundaries. For the record, cheetahs are the only big cats resident here, and they normally concentrate on smaller mammals.

Both greater kudus and the magnificent lowland nyalas visited in numbers, the kudus being most cautious and shy. At least one fine bull nyala came to browse on the tender tips of papyrus almost directly under me, but would pause and stare every time the motor drive advanced film. The white-striped chestnut nyala females seemed far more nervous around the pan than did the bulls, a situation exactly the reverse of what I had found when hunting for a trophy bull several years before.

The longer we sat and watched, the more life became evident. We could hear hadeda ibises quarreling somewhere in the tree crowns overhead, but couldn't spot them. Ring-necked and Namaqua doves flew in to refuel in large numbers. One gorgeous purple-crested lourie drifted in from nowhere on silent wings, drank, and disappeared as quietly as it had arrived. After a long time of remaining unseen, we also suddenly realized that at least two crocodiles inhabited the ponds. Only the tips of their ugly snouts, which resembled dead black twigs floating near the bank, betrayed their existence. Peggy and I decided that their lurking presence explained why all impalas approached the waterhole so very carefully and only after studying the shoreline for a long time from a safe distance.

Still it was high drama and suspense as we watched a single impala fawn approach—step by dainty step—toward a place where we knew a croc waited submerged. Slowly I swung the camera about in case the reptile struck. But just in the nick of time, some instinct spooked the uncertain, small impala and it retreated. Then it made a circle, following older members of the herd to drink from another place. Later the same crocodile did lurch out of the water to try to catch a dove which had landed and was preening only a foot or so away. But it missed the small feathered hors d'oeuvre, probably only by a fraction of an inch.

For long periods all was relatively quiet around Bube, because the larger visitors made no commotion. But that quickly changed as helmeted or crested guinea fowl approached the water. The latter sounded like the native steel bands of Trinidad in concert, or metal instruments striking taut heavy wire. Warthogs made wallowing noises when rolling in the murky green water close to the bank.

Maybe the most curious residents of the Bube pan were a flight of red-billed oxpeckers — tickbirds — which seemed to headquarter nearby and operate a delousing station for any new arrivals which required the service. As soon as a herd of impalas, say, approached the pond, the oxpeckers would greet and inspect the various animals, find one which was infested with ticks, and then go to work removing them. Some of the antelopes stood patiently during the ministrations; others tried to shake off the persistent birds. From our own observations, it can be assumed that warthogs are the favorite targets of ticks, because on several occasions we saw them almost completely covered by the birds.

As recently as 1960 or so, the white rhinoceros was listed among the world's most critically endangered species. Perhaps a

Impala buck undergoes thorough delousing by flock of red-billed oxpeckers or tick birds.

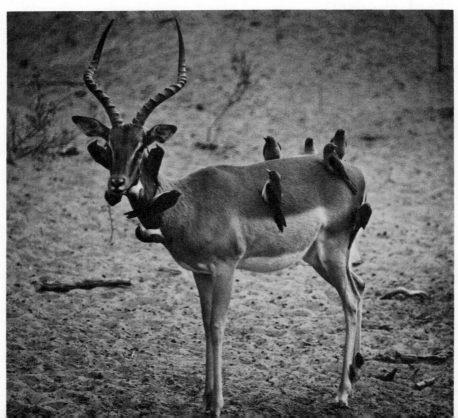

dozen survived poaching along the Uganda-Zaire border in eastern Africa, and possibly the number in Umfolozi-Hluhluwe exceeded a hundred. But since then one of the most encouraging wildlife conservation episodes of recent times has taken place. Under strict control and protection, the white rhinos reproduced and prospered so well that they soon filled both parks to capacity. And the surplus has been great enough to restock other sanctuaries in eastern Africa, Rhodesia, Malawi, and elsewhere in South Africa. Umfolozi-Hluhluwe is today the best, easiest place both to see and photograph at very close range this second largest land mammal on earth. It is a very willing, docile subject.

The only lions in Zululand may be seen at Umfolozi. The driver on the reserve's numerous roads is certain to encounter many nyalas, greater kudus, buffaloes, impalas, steinbok, gray duikers, giraffes, and possibly a black rhino or two. Cheetahs and leopards live here, but it requires time and luck to see them. Most photographers keep to the roads, but a hiking safari on the Umfolozi Wilderness Trail is possible, camping overnight along the White Umfolozi River. These walks are especially worthwhile for the birdwatcher and very serious photographer.

The white rhino represents another conservation success story. Once almost exterminated, it is abundant and a willing subject of photographers in Umfolozi and Hluhluwe reserves, Zululand.

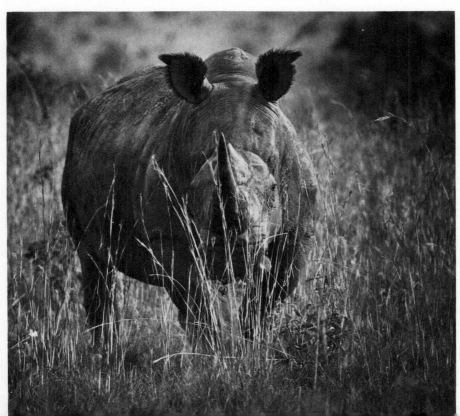

Ndumu Game Reserve is located in the extreme north of Zululand, on the boundary with Mozambique, and it is the most unusual of its type in southern Africa, being a damp, lowland area surrounding a number of large pans. The wildlife found here tends to be riverine or aquatic in environmental preference. Some of the most important photo targets are the hippos, reedbuck, and crocodiles, besides the mammals commonly found in other Zululand reserves. Normally shy bushbucks are abundant here, and I have never found them easier to photograph anywhere.

Over 370 species of birds have been recorded at Ndumu. Some of the easiest to shoot around the pans are the fish eagles, jacanas, spoonbills, goliath herons, spurwing geese, and pelicans. Also located inside the reserve is an experimental crocodile farm on which the reptiles are raised to restock those Zululand waters from which the reptiles have been exterminated. During our visit in August 1973, an 18-foot man-eating crocodile which had been captured alive was on display in a complete natural pan habitat. Crocs of that size are virtually nonexistent in the wild nowadays, and this one is a most impressive photo subject.

In addition to the above game reserves of Zululand, administered by the Natal Parks Board, there are a number of private game parks or game ranches nearby which in many ways are even more productive for the wildlife cameraman simply because the game is more concentrated and probably in greater numbers per acre. The vast areas are encircled by gameproof fences, but keep in mind that everything else is perfectly natural.

The best and largest of the private sanctuaries by far is Ubizane Game Ranch, a few miles west of the townsite of Hluhluwe. It is owned and managed by an old friend and former game ranger, Norman Deane. All native mammals of Zululand except the large cats are here in numbers, and they have become so used to visitors aiming telephotos that they pay little attention to the intrusion. A daily fee is charged for guide, safari car, and the opportunity to expose an unlimited amount of film. Visitors to Ubizane have the option of staying at either of two luxury hotels: a Holiday Inn several miles away in Hluhluwe or the Southern Sun Safari Lodge just inside the Game Ranch. Or they may camp in the vicinity.

South of Zululand, in Natal, are two other remarkable wildlife sanctuaries, both being in the Drakensberg—Dragon's Mountains—and both being notable for magnificent landscapes as well as for opportunities to film unique wildlife. The outstanding main feature of Royal Natal National Park is 11,150-foot Mont-aux-

Sources, the highest peak in southern Africa and one of the loftiest places on the continent. On its lower slopes white-tailed wildebeest, gray rhebok, and mountain bushbuck can be seen beside trout streams, with waterfalls in the background and in springtime on a carpet of wildflowers.

Not far away is 92,000-acre Giant's Castle Game Reserve, also in awesome, sometimes snow-covered alpine scenery. This park is similar to many U.S. national parks in the number of horse and hiking trails which penetrate into remote areas. The hutted camp (where all except foodstuffs are provided, as in other Natal game parks) is among the most delightful I have enjoyed anywhere. Nearby I photographed the rare Cape eland, red hartebeest, oribi, and mountain rhebok. In company with a naturalist-ranger I also had a good glimpse of the very rare lammergeyer, or bearded vulture, which nests in the crags and thin atmosphere on top of Giant's Castle.

From Zululand, Peggy and I drove northward through Swaziland to Kruger National Park, one of the world's oldest, largest, and (at least in South Africa) best-known wildlife areas. Extending for 220 miles along the Mozambique border, it contains about 8,800 square miles. According to a census made in 1971, there were 230,000 head of big game alone inside park boundaries. That statistic includes the following totals: 150,000 impalas, 20,000 buffaloes, 17,000 zebras, and 13,500 blue wildebeest. About 1,200 lions and 900 leopards prey on the ungulates. The number of elephants was figured at 7,900, more than enough for every visitor to get good glimpses of them. About 300 to 350 African hunting dogs roam the park, probably making this the best site of all to see these fascinating but persecuted predators. During an earlier visit in 1967, I saw two packs of the wild spotted dogs; in 1973 none.

Kruger is so vast that even with so many large mammals present, it is possible to drive great distances at times without finding many photo targets. That may be doubly true during the winter dry season (June through September), when almost all living things are concentrated around existing waterholes, rivers which have not completely dried up, and pans supplied with water by windmills. The locations of these are marked on park maps available at every entrance and every ranger station and rest camp. Two of the most consistently good viewing places for wildlife are in the vicinity of the rest camps at Skukuza and Olifants, the latter being located on a high bluff overlooking a wide meander in the Olifants River.

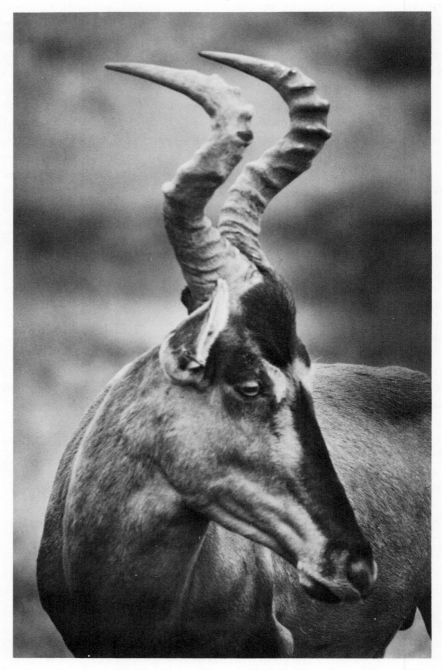

Red hartebeest is one of the less common mammals of southern Africa. This fine male was photographed at Giant's Castle, Drakensberg, Natal.

Both rest camps and campgrounds are immaculately maintained by the park staff and are not too expensive. They are booked well in advance during the peak travel season of August. But Peggy and I came away feeling that regulations of the park are designed far more for easy administration than for the greatest enjoyment and appreciation of visitors. For instance, travelers must be off the roads and ensconced in the rest camps till too late in the morning and far too early in the evening—well after sunrise and before sunset, precisely the best times for wildlife photography. Shops and stores at rest camps are open only at odd hours.

It is difficult to find a knowledgeable ranger anywhere at Kruger, even around a headquarters, and there is almost no interpretive service—no one to ask where to locate wildlife. Also visitors may not get out of their cars, which is well and good, except that too many roads are built to skirt, rather than go near, places where big game might concentrate. In other words, you get a lot of tantalizing very distant glimpses of game, often out of reach of the longest telephotos. This is unfortunate, because Kruger is truly a remarkable wildlife sanctuary. Unfortunately, photographers often can obtain better pictures in one of the private game reserves which border Kruger Park on the west.

Addo Elephant Park, 40 miles north of Port Elizabeth, offers a chance to photograph all that remains of the once-vast elephant herds of Cape Province and the Great Karoo. But the hundred-odd tuskers are separated from visitors by a rail and steel cable barrier where they are baited twice daily with hay and ripe oranges. Far more worth visiting in southern South Africa are Mountain Zebra National Park, near Cradock; and Bontebok National Park and the Cape Nature Reserve, on the Cape of Good Hope, both of which contain herds of the beautiful and once endangered, tricolored bonteboks.

Kalahari Gemsbok National Park, which is located on a salient between Botswana and Namibia in the Kalahari Desert, is remote, accessible only by a long and dusty drive either from Kimberley (closest point of commercial air service) or Windhoek in Namibia. I have not yet visited Kalahari Gemsbok, but the report of wildlife motion-picture producer Karl Maslowski is that there are vast herds of gemsbok and springbok, concentrated wherever there is a small amount of water. Other attractions of the park are prides of magnificent desert lions, strange and stark desert scenery, Bushmen, and the opportunity to have a lonely, brooding bit of real estate all to yourself.

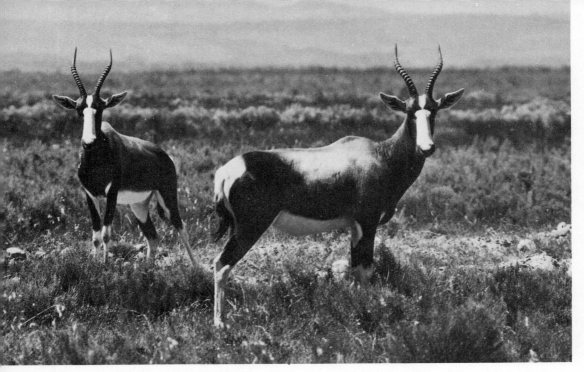

Not long ago only a handful of these tricolored bonteboks survived on earth. Today they're out of danger. These were filmed at the Cape Nature Reserve near Capetown.

The Etosha Game Reserve of northern Namibia was until recently the largest game sanctuary on earth, stretching from the Namib Desert along the Atlantic Coast 200 miles eastward, and including all of Etosha Pan, an extensive but usually dry lake. The reserve once included a portion of remote Kaokoveld and Ovamboland, but at this writing was being partioned to satisfy native land claims and for other obscure reasons. Just the same, Etosha remains an absolutely ideal place to witness and photograph animals in virtually the same uncountable numbers in which they have always existed there. The landscape is flat and perhaps to a cameraman is an uninteresting background for wildlife pictures. But for sheer numbers of game it compares with Serengeti in Tanzania or anywhere else.

At Etosha, figure on gemsbok and springbok, very large greater kudus, cheetahs (excellent for these), large lions, and elephants. Hides for photographers have been built beside some waterholes. Rest camps are located at opposite ends of Etosha Pan—at Okaukuejo and Namutoni. The latter is a Beau Geste type of fort built before World War I beside an oasis when that arid area was the northern frontier of the former German colony. One of my

most indelible of all African memories was of sleeping outdoors one moonlit night on the same parapet from which a handful of garrison troops defended against hundreds of screaming Ovambo attackers. Only on this night lions rather than hostile natives prowled and roared just outside the walls.

Summed up, Etosha is an ideal destination for a cameraman seeking to duplicate the vast game herds of eastern Africa in a country which is totally secure and where the human population remains relatively small. Safaris start at Windhoek, the capital, where cars with or without guide-drivers can be rented.

Of the other southern African nations, Zambia offers some photo-safari possibilities in the Luangwa Valley, which I have never seen. As this was written late in 1973, the political situation there was not too stable and three tourists had been shot by trigger-happy soldiers along the Zambezi River. A wildlife cameraman may feel more secure shooting elsewhere.

The cheetah of eastern and southern Africa is probably the fastest mammal on four feet, but in national parks is one of the easiest to photograph.

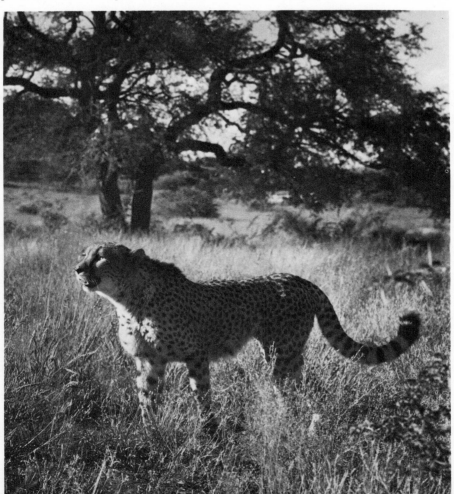

Nor have I visited the several national parks and game reserves of Angola, some of which are reported to be outstanding. Others are very remote, difficult to visit, without any nearby accommodations, and therefore not much is known about them. However, here is the only home of the giant sable antelope, and to film that animal alone might be worth an elaborate expedition.

At this writing also, there has been a good bit of insurgent and guerrilla activity in Mozambique, especially in the north and along some border areas. There is a new regime in Portugal and its colonial policy is yet to be tested. This is another game reserve which we have not been able to visit, but wildlife biologists we encountered in Rhodesia and South Africa consider it a very remarkable place, surely one of the best in southern Africa. Lions are particularly abundant, and it is an excellent site to photograph elephants. Accommodations in rest camps are said to be adequate. We hope visitation will be possible when the political situation is stable once again.

All things considered, southern Africa may be anyone's best bet for a photo safari now. Here African wildlife has the best long-range future.

19
Hawaii

For more than 100 miles beyond Waikiki Beach, Diamond Head, and the main neon-lit Hawaiian Islands of tourists stretches a necklace of lonely, widely separated islands which few know or have ever even heard about. Still these tiny bits of real estate totaling only 2,000 acres are among the most precious of America's public treasures. Possibly they are more intensively utilized by wildlife than any other islands on earth.

Variously known as the Leeward Islands, Northwest Islands, or simply the outer islands, all are included in America's most remote, most remarkable wildlife sanctuary—the Hawaiian Islands National Wildlife Refuge. Also within the refuge boundaries are 200,000 acres of shallow lagoons and some of the least disturbed, least exploited ocean reefs on earth. The only human occupancy inside the refuge, which is administered by the U.S. Fish & Wildlife Service, is a U.S. Coast Guard Loran station on one island—Tern—of French Frigate Shoals. The rest belongs to an estimated 100,000,000 birds and includes some of the most spectacular nesting colonies in the world. Many places have been described as paradises for wildlife photographers, but not many qualify as well as this distant, Polynesian part of America.

In all history, relatively few humans (let alone cameramen) have set foot on the islands, which are virtually waterless and not astride any busy shipping lanes. Some are atolls; some are the ocean-battered remains of ancient volcanic cones. The present wildlife manager tries to make an inspection tour and a wildlife census of the islands once each year. It is always a very hazardous,

uncertain undertaking, and he must depend on the Coast Guard, which has the only available facilities for traveling so far and putting landing parties safely ashore.

Early in September 1971, I was able to join the annual inspection aboard the U.S.C.G. Cutter *Buttonwood*, a buoy tender. Besides Refuge Manager Gene Kridler and me, the party included John Sincock, a biologist who specializes in studying endangered species; marine mammalogist Ken Norris; and a good bit of scientific equipment. Norris was interested in recording whatever sounds the rare Hawaiian monk seals use to communicate underwater. Captain Dave Smith and the *Buttonwood* crew referred to the four of us either as "the wildlife bunch" or "the bird guys."

By military jet from Hickam Field, Honolulu, it is a two-and-a-half-hour flight to Midway, a naval base now as well known for the huge nesting colony of gooney birds—Laysan and black-footed albatrosses—as for the crucial World War II naval encounter nearby. At Midway we boarded the *Buttonwood* and began the sluggish—11 knots—voyage back eastward along the chain of islands. Lisianski, a day's cruise away and 6 degrees east of the International Date Line, was the first destination.

With the *Buttonwood* anchored offshore in 10 fathoms, a 25-foot surfboat was lowered just after daybreak, loaded with equipment, and we began the 5-mile run through a maze of reefs toward the beach. But long before the craft touched sand, clouds of noddy and sooty terns flew out to meet us. Boobies and great frigates flew escort above them. Hundreds of ruddy turnstones waited and watched us at water's edge. Dozens of gray Hawaiian monk seals baked on the beaches in both directions from our wet landing.

Kridler's program was to hike the $3\frac{1}{4}$ miles completely around 382-acre Lisianski, counting the seals and green sea turtles, then live-capturing and tagging as many of both as we could catch. I was luckiest of the "bunch"; I had only to carry cameras, film, and a canteen. The others lugged capture gear and scales. Over the soft, powdery sand and in the brutal heat of autumn at 26 degrees north latitude, the hike around Lisianski seemed more like 35 miles than $3\frac{1}{2}$.

Altogether we counted 119 seals and affixed tags to the flippers of most of the pups and yearlings. Despite their lethargic appearance, the larger animals are too difficult and dangerous to handle; tagging must be confined to smaller ones. Although considered endangered, but carefully protected, now the Hawaiian

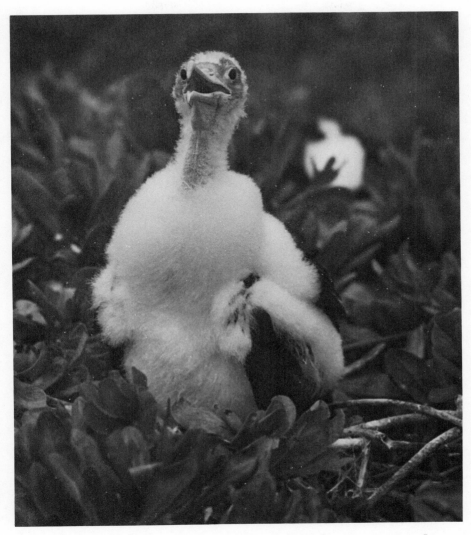

Young magnificent frigate bird makes preposterous pose for cameraman on Laysan Island, outer Hawaiians.

monk has much better prospects for survival than the other seals of tropical waters. The Mediterranean monk is nearly gone, and the Caribbean monk is almost certainly extinct. Kridler and crew also tagged four turtles here, one a 4-pounder. This created quite a mystery, because few this small are ever found on shore; all existing evidence suggests that the turtles do not come ashore until ready to breed or lay eggs. The largest tagged weighed 250 pounds and was mature. Our swim before the surfboat returned to Li-

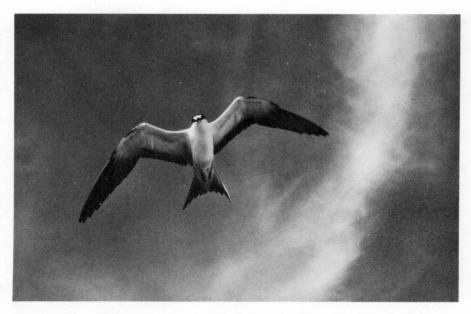

Sooty terns nest by millions on several of the outer Hawaiian Islands. A nesting colony may cover many areas.

sianski to retrieve us at dusk was the most refreshing I could ever recall. I didn't even take time to photograph the underwater marine life.

Overnight we cruised eastward again, and at dawn came into sight of Laysan. Because of the intricate, protective barrier reefs all around, Laysan is the easiest on which to land. A few hours after dragging anchor, the wildlife bunch was on shore with enough equipment to camp and be self-sufficient for a week while the *Buttonwood* abandoned us to conduct routine exercises elsewhere. We had to carry ashore enough supplies and fresh water to sustain us even if the *Buttonwood* was needed elsewhere and could not pick us up on schedule. By noon a comfortable two-tent camp was set up on the island's highest point—the crest of a dune about 40 feet above sea level. The *Buttonwood* vanished over the horizon. Then I began to photograph birds—and never so many in such a short time ever before.

In a career which has taken me to photograph wildlife on many lonely islands described in this book, no single place I've ever found has been so saturated with birds or so fascinating. Not even Kenya's Nakuru with its flamingoes matches it. Each year an estimated 9,000,000 to 10,000,000 birds of at least twenty-three different species use the 1,100 acres of Laysan to nest and rest. That

amounts to a density of 8,200 per acre, and although all are not on Laysan at the same time, it does mean that at times birds are nesting side by side and in three "layers." I photographed shearwaters and petrels nesting underground, terns and tropicbirds at ground level just above, and boobies, noddies, and frigates in the low shrubs just overhead.

I also spent a good part of the time photographing the rarest species of waterfowl on earth, the Laysan teal. It lives only here, where about 130 survive by skimming the brine flies from a landlocked lagoon, which is three times as salty as the surrounding ocean and is located in the center of the island. Several nights were spent in netting and tagging the teal, which is a nondescript chocolate-brown bird weighing $1\frac{1}{2}$ pounds or so. With the teal I shot a single pintail hen, which could only have been blown to this sanctuary, perhaps during migration from nesting grounds in Alaska, by a severe storm.

Around the teal lagoon were great numbers of wandering tattlers, ruddy turnstones, and whimbrels, all being restless migrants. Brown boobies posed patiently for pictures on our tent ridge pole, and great frigates fed their noisy, reptilian young a few feet away from short-focal-length lenses. Both species had no fear of us or our activities. Rare Laysan finches, also found nowhere else, shared the meals spread on our outdoor table.

During our visit, the most abundant birds on Laysan were wedge-tailed shearwaters, a bird which nests in burrows it excavates in soft coral sand. Large areas of the island are honeycombed with burrows spaced about 3 or 4 feet apart. When a wedge-tailed shearwater did not succeed in digging a burrow under our tent one night, it watched the curious figures inside making notes and cleaning cameras by yellow lantern light. All night, every night, we could listen to the strange, mournful chorus of thousands of Bonin Island petrels and Christmas Island shearwaters, which was alternately magnified and muted by the trade wind. Both of these species were difficult to photograph at all because they were at sea all day and returned only at dusk. By daybreak all were gone again.

Snorkeling and photographing the reefs of Laysan was as remarkable as the birdwatching. Here schools of neon-blue ulua, the abundant jacks of the central Pacific, plus lion fish, angel fish, Moorish idols, parrot fish, tangs, and several species of butterfly fish swam close to shore. But so did several large sharks, and for me at least, that fact tipped the balance back in favor of birding on dry land.

At the turn of the century, there were grave problems in this
paradise. Guano diggers, plume hunters, and the tragic introduc-
tion of European hares destroyed most of the vegetation and
completely eliminated three native species. Gone forever are the
flightless rail, the Laysan honeycreeper, and a millerbird. Barely in
time, President Theodore Roosevelt created the refuge by execu-
tive order. All exploitation was stopped, the hares were eventually
eliminated, and Laysan was gradually retrieved to something re-
sembling its primitive state.

In 1969, however, there were anxious moments when it was
learned that a Japanese longline fishing boat had crashed into the
island and by a series of violent storms was swept up onto the
beach. The fear was that this derelict would introduce brown rats
onto the island. These rodents have wiped out the birds on more
than one other island around the world. Luckily this craft was
clean. However, there remains the constant worry about in-
troducing strange, exotic plants onto the islands, and these are
eradicated whenever found during the annual inspection.

Two days sailing east of Laysan we came upon Gardner Pin-
nacles, the remnant of an extinct volcano covering only 40 acres. Its

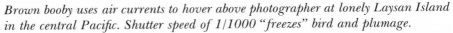

*Brown booby uses air currents to hover above photographer at lonely Laysan Island
in the central Pacific. Shutter speed of 1/1000 "freezes" bird and plumage.*

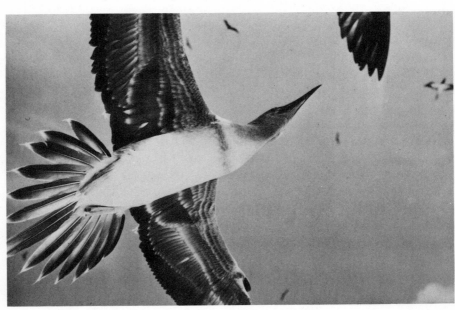

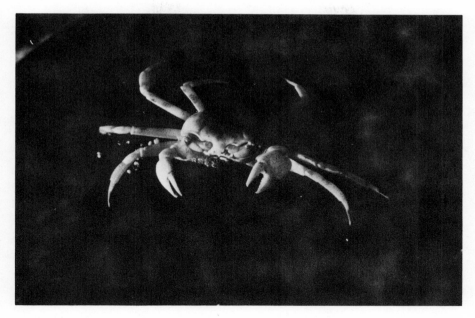

Ghost crab scurries across dark sand beach of Hawaiian islands.

white-frosted black peak juts about 180 feet above the sea, and it is the least important island in the chain for wildlife. Perhaps that is a lucky thing, because the rock is constantly lashed by wild breakers and such heavy swells that landing is never really wise. Very very few humans have ever been ashore on Gardner.

Because the ocean was extremely calm during most of our voyage—and even though he had nearly lost his life in a previous attempted landing—Kridler decided to try to go ashore. The technique was to run the nose of a rubber raft (rather than the rigid surfboat) up against an almost sheer cliff and hold it there. Then on the crest of a swell, Kridler leaped to a thin foothold and scrambled free up the wet rocky face. On the return he had to make a jump for the boat far below.

Because of time, we passed up visiting Pearl and Hermes Reef and instead landed next on French Frigate Shoals. While the *Buttonwood* crew went ashore at the Tern Island Loran installation for a picnic and the first cold beer in weeks, we made inspection beachheads on nearby South Island and Whale Skate Island of the same atoll. Besides the incredible amount of debris left to rust by the previous military occupants of the island, we found where forty-eight green sea turtles had recently made nests in the warm

sand; many of these were very close together, often as close as 5 feet. According to careful calculations, as many as 1,000 females nest here every year, and Kridler believes that French Frigate beaches are the major nesting site of green sea turtles left in North America and maybe anywhere on earth.

Turtles tagged at French Frigate have been captured by commercial fishermen at Hilo in the main Hawaiians, which is 600 miles away.

Except for Gardner Pinnacles, Necker, the next island in our voyage, is the most hazardous island in the refuge chain on which to land. The highest point of its 80 acres is about 280 feet above the sea, and after a dangerous landing it is reached by following a thin fissure upward in the face of a cliff. On the top is a crumbling stone parapet, now a convenient roost for boobies and frigates, but actually the remains of a Polynesian temple. Little is known today about the temple builders, exactly when they came or where they originated, but the most authoritative estimate is that the structure was abandoned (or the island last inhabited) between 700 and 800 years ago. I photographed what was left of the temple with sea birds perched on top of its now white-splashed surface.

On the high ridges of Necker we found the first Bulwar's petrels, grayback terns, and blue-gray noddies of the expedition. The last two, which were nesting on open ledges of rock or on bare gravel, are extremely beautiful but very uncommon. Nor were they nearly as easy to approach and photograph as a few fairy terns which had both eggs and young nearby. Several perched on my shoulders whenever I stood still long enough.

The easternmost island of the Hawaiian Islands National Refuge is Nihoa. Covering 156 acres, it is larger than either Gardner or Necker. But like them it is a brooding, dark volcanic monolith which pokes a single precipitous peak into the tropic sky. On our initial approach it seemed that any landing at all would be impossible, because the sheer smooth cliffs fall away directly to the Pacific and in many places are undercut or eroded into caves pounded by violent swells. But after completely encircling the island, we came upon the places where Kridler had landed before—a tiny gravel beach washed with a moderate surf, and a series of narrow volcanic rock shelves nearby. The decision was to try the latter place, since the ocean was relatively calm. We made the landing easily and almost without getting damp. I worried far more about getting photo gear than myself ashore because saltwater spray can have ruinous effect on camera mechanisms.

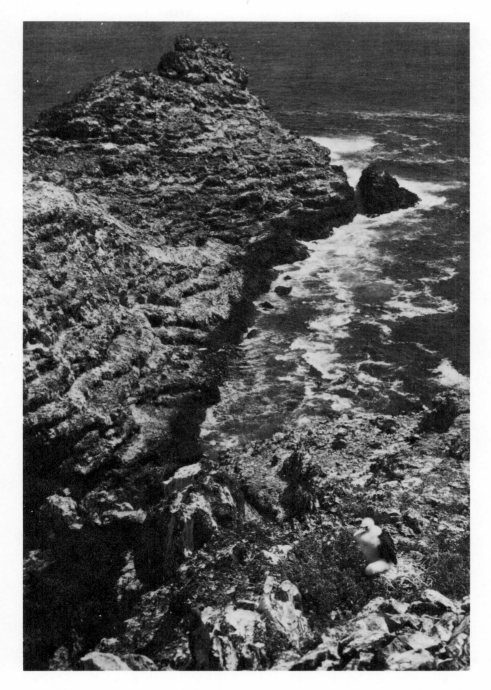

Few photographers have ever landed on Necker of the outer Hawaiian Islands, home of thousands of nesting seabirds.

In no way is Nihoa (which is an old Hawaiian word for "bird") a wildlife spectacle such as Lisianski or Laysan, perhaps only because it came after instead of before them on our trip. Still, it is the home of tens of thousands of sooty terns, noddy terns, redtail tropic birds, boobies, frigates, and petrels, each inhabiting, as elsewhere, a different niche in the environment. Nests of the terns and tropic birds were on the ground, usually under brush, but seldom intermingled.

In addition, we found the two endemic birds here which do not exist anywhere else — the Nihoa finch and the Nihoa millerbird. The first is abundant, in evidence everywhere, and very tame. There is no immediately visible difference between it and the Laysan finch, except that males seem to be paler yellow in color. But the millerbird, a species which was not even discovered until 1923, is entirely different. In fact, I could not find one until almost the end of the day as the rubber raft came out from the *Buttonwood* to pick us up. Then I spotted two, skulking close to the ground in dense and brittle vegetation. By nature they are very shy, compared to all other birds of the island, and there seems to be no reasonable explanation for it. I was able to make just one fast photograph of a Nihoa millerbird. But just seeing such a rare species is an extraordinary experience and seemed almost a fictional way to conclude an extraordinary trip.

In addition to the finch and millerbird, a rare palm, the loulu, is found only on Nihoa. About 800 trees survive there, midway between sea level and the island's crest, in two separate stands. Near these are remains of unnatural terracing; clear evidence that Polynesians at least tried to make a living here long ago. But with only a tiny seepage of fresh water, these could not have supported many humans for very long. Carved stone images and figures collected on the island are now on view in the Honolulu Museum.

From Nihoa we continued eastward, back to the Hawaiian Islands of tourists — where the most important birds are the "walking cranes" which are perched high atop the countless highrise hotels and condominiums under construction everywhere.

Thanks to that old pioneer conservationist Teddy Roosevelt, at least that northwestern part of the Hawaiian Islands has been saved for the wild birds. At present there is no way to evaluate the importance of the millions of birds to the ecology of the central Pacific Ocean. It must be immense, however, and it was my rare good fortune to visit them.

The outer Hawaiian Islands are obviously not easy to reach, and nothing less than a major expedition could put a cameraman ashore on any of that isolated real estate. Nor is there much likelihood that the islands ever will be accessible. However, there are opportunities to shoot many of the same birds on islets and rock piles adjacent to the main islands, and even just off the east shore of Oahu.

The matter of shooting land birds is a vastly different proposition. In his *Field Guide to the Western Birds,* Roger Tory Peterson writes that "the Hawaiian Islands have lost more endemic birds than any other area their size except the Mascarene Islands of the Indian Ocean, and have gained more exotics. There may be a sinister connection." What the famous ornithologist is saying is that bird photography (or in fact *any* wildlife photography) is not very productive on the *main* islands. Gone or nearly so are the colorful, once numerous honeycreepers, millerbirds, thrushes, and their exquisite allies which once occupied every environmental niche.

This isn't to state that a photographic safari to the Hawaiian Islands is not worthwhile. On all the major islands are scenes of great and unique beauty, sometimes bathed in bright sunlight and soon after shrouded in mist or light rain. There are lonely lava beaches and lush forests, cool waterfalls, and volcanic ridges where water becomes ice at night. There are also splendid national parks: Haleakala on Maui and Hawaii Volcanoes on Hawaii, the largest and southernmost island.

There are 30 miles of well-defined trails through the high landscapes of Haleakala, most of which is contained inside a now inactive volcanic crater. While hiking it is possible to see the endangered nene or Hawaiian goose, which long ago has forsaken the water (but still retains its webbed feet) for a home along Hawaii's cinder cones. Also characteristic of Haleakala is a rare plant, the silversword. Yuccalike, with silvery, saber leaves, the rare plant has vivid purple blooms and is always an exquisite photo subject.

Hawaii Volcanoes National Park is the result of lava gushing and spilling from active mountain volcanoes—Mauna Loa and Kilauea—over a luxuriant rain forest. Spectacular eruptions have occurred as recently as 1959, and probably more are to come. If measured from its base deep beneath the Pacific Ocean, Mauna Loa is higher than Mount Everest, and its scenery is no less remarkable. The best way to enjoy this park is also by hiking or riding the splendid trail system. New color pictures need to be taken around every bend.

20

Asia

One of Israel's best-known heroes of the Six-Day War in 1967 was Major General Avraham Yoffe. A naturalist as well as a colorful tank commander, Yoffe has spent the years since that conflict in setting up a system of nature reserves and national parks. In the long run this may prove to be a far greater, longer-lasting service to his country—to the world—than any military exploits.

After millennia of total neglect and armed warfare across the Holy Land, most of the native wild animals have been either wiped out altogether or driven to the edge of extinction. Yoffe's project has been to restore and restock these creatures wherever possible on 160 separate reserves totaling over 150,000 acres in a nation where all existing real estate is at great premium. The reserves are also figured to protect places of unusual natural beauty and of scenic or geologic interest, and where such native flora as the Cedars of Lebanon survives. Compared to other nature reserves around the world, most of these are pitifully small. But they are doubly valuable because they are the only such sanctuaries in the entire Middle East.

Some wildlife can be seen on all of these reserves, but two have special appeal for nature cameramen. One is Hai Bar South, 10,000 semi-arid acres just north of Eilat on the Gulf of Aqaba. Here range herds of Nubian ibex, scimitar-horned oryx, addax, and a few onagers, or wild asses. All of these are endangered species, having been long ago eliminated from most of their original ranges. Another reserve especially for big game and to be called Hai Bar North is planned for the Galilee Hills. There is some faint chance that Jordan may establish a reserve adjoining it.

Ein Gedi Reserve, 1,125 acres, contains the main oasis within the country. Here are clear, cool springs, waterfalls, limpid pools, and tropical vegetation which is dependent on water and thus nonexistent elsewhere in Israel. Wildlife easily filmed include Nubian ibex, hyrax, desert partridges, and Tristam's grackles. Mt. Meiron Reserve, 25,000 acres, is the largest in the country and includes the highest mountain. Flowering trees and plants will prove more interesting than wildlife to the visiting photographer. But look for the rare stone marten and for foxes and birds of prey anyway.

Still, there is something very sad about Israel's commendable attempt at wildlife conservation. As this is written, during Christmas of 1973, peace negotiations are convened in Geneva. No thought will be wasted there on wildlife or ecology by the politicians of both sides, and almost certainly some of the reserves will revert back to Syria and Egypt. This is not to argue the true ownership of the lands, but once out of Israel's more sympathetic jurisdiction, the reserves will no longer be reserves.

In many ways the status of wildlife in the Middle East today — and the attitude of most citizens there — is typical of all Asia from the Bosporus to Japan. A century ago the wildlife resources of this vast continent equaled or perhaps even exceeded those of any other continent. But during the brief period of the last half-century alone, it has plunged to almost nothing at all. In Asia one fact is most clearly, most terribly evident — that the abundance or lack of wildlife on the land is a reliable indicator of the earth's capacity to sustain human population. Humans cannot prosper where the environment for other creatures has been destroyed or allowed to deteriorate. All across Asia today the quality of human life is poorest and, deplorably, it shows no promise of improvement.

Consider, for example, what has happened to just two of the most magnificent animals which ever roamed the Asian continent. Seldom is the lion regarded as anything except an African cat, but the Asian subspecies once ranged from Greece and across Asia Minor all the way to northern India. The big cats were native (until the past century) to present-day Syria, Iraq, Jordan, Iran, Saudi Arabia, Afghanistan, Pakistan, and Israel. They are mentioned at least 150 times in the Bible. Today only about 140 Asian lions cling precariously to bare survival in the Gir Forest of western India.

Tigers have fared little better. These ranged in good numbers from Iran eastward across mainland Asia to Manchuria, China, Malaysia, and Indochina, and there were other populations on several Indonesian islands. Certain races are gone altogether, and the

best estimates are that a mere scattered 2,000–3,000 still exist on earth. That may not be enough to sustain them.

All this may be aside the subject of wildlife photo safaris, but it will certainly explain the scarcity of photo opportunities across this largest of all land masses. Perhaps the best course in Asia is to travel from west to east and to describe the best safari spots along the way.

Compared to other nations of Asia, Iran has a good wildlife conservation program more managed by scientists than politicians. Mohammed Reza Shah Pahlavi National Park of the Elburz Mountains in the northeast contains spectacular scenery and much wildlife, especially such big game as urials, Persian ibex, red deer, leopards, wild boars, Eurasian wolves, and bears. During one week's trip in 1970 I saw all of these, but was able only to photograph (with difficulty) the urials and ibex. Trophy gunning is also permitted in the park and although it isn't unjustified, it does make all the wildlife too nervous for the best photography. It is unfortunate that big game here does not have the same protection as it would, say, in Yellowstone or Serengeti. In a few years this park could develop into one of the top destinations of all for a photo safari.

All things considered, India has, or once had, Asia's greatest potential for wildlife photography; the original wildlife community was one of the richest and most varied on the globe. Herds of hoofed animals populated all open plains. From sea-level jungles and mangrove swamps to high in the Himalayas lived beautiful and unique creatures found nowhere else. There was a native antelope with four horns, for instance, and a rhino with only one.

Now, however, the Asian cheetah, pygmy hog, hispid hare, and pink-headed duck will never be filmed again; they're extinct. Nearly so are the red goral, the Nilghiri tahr, and the great Indian bustard. The long list of gravely endangered wildlife would include the dhole (or wild dog), barasinga (or swamp deer), brow-antlered deer, Indian onager, snow leopard, clouded leopard, Kashmir stag, one-horned rhino, markhor, chinkara (or Indian gazelle), blackbuck, buffaloes of pure wild strain, and gaur, as well as lions and tigers. Keep in mind that hunting alone has played little role in the decimation of any of these. Blame it instead on the expanding human population, the destruction of Indian forests, the disregard for national treasures, and other depletion of the land.

For the record, India does have a good many reserves. However, some are reserves in name only; there is no staff, no pa-

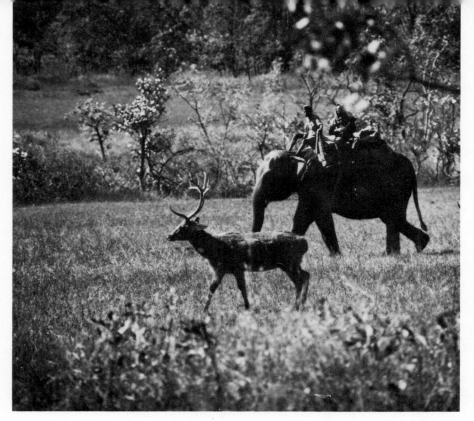

Cameraman on elephantback shoots a barasinga stag, one of the rarest of all deer, at Kanha.

trolling, and the practice of poaching proceeds unmolested. Too seldom are refuges maintained, and the wildlife lacks protection comparable to North American or African standards. In only a few places is serious, productive wildlife photography possible.

Of the Indian sanctuaries I have visited, Kanha National Park, 97 square miles in Madya Pradesh, is without question the best. The maidans, or open grassy areas, are undeniably beautiful, and on all the subcontinent, the wildlife is the most confiding. It is viewed either by Land Rover, from elephant back, or from blind or watchtower. Most of the wildlife seems least apprehensive of the riding elephants kept on hand for that purpose. Principal camera targets are barasingas, spotted (or axis) deer, sambars, blackbucks, and gaur. Present, but less easy to see, are a few tigers, leopards, hyenas, muntjacs (or barking deer), and sloth bears. There are two modest rest houses fully staffed near the best wildlife portions of the park. It can be reached by car from Nagpur.

Kaziranga Wildlife Sanctuary, 166 square miles of swamp in Assam on the south bank of the Brahmaputra River, is almost as worthwhile to visit as Kanha. It also is best viewed from atop a

trained riding elephant. Top target here is the one-horned rhino, and during a few days' visit, several should be encountered at close range. In 1970 I also saw pure-strain wild buffaloes, swamp and hog deer, and plenty of birds. But no tigers, or even a sign of them.

Corbett National Park, India's first, is reached by good road north of New Delhi to the Uttar Pradesh foothills of the Himalayas. It is an especially beautiful refuge, and the wooded valleys are memorable when the sal trees are in bloom. But I cannot recall another national park anywhere that the wildlife was so wild, so afraid of humans. Trying to film anything soon becomes exasperating, and a visitor can only guess that plenty of illegal hunting is the reason.

Manas Wildlife Sanctuary, also at the foot of the Himalayas, is best known for rhinos, but they are more shy than those at Kaziranga. Mudumalai Sanctuary in the thickly forested Nilghiri foothills is best known for wild elephants, as is adjacent Bandipur Sanctuary. Both are very hot and humid, and wildlife watching while driving over good roads which crisscross the refuges can be frustrating. There aren't that many animals to see.

The 500-square-mile Gir Wildlife Sanctuary in Gujarat, western India, is a forest under constant pressure from the dense

True wild buffaloes of Kaziranga Sanctuary, Assam, India. Elsewhere pure-strain buffs no longer exist.

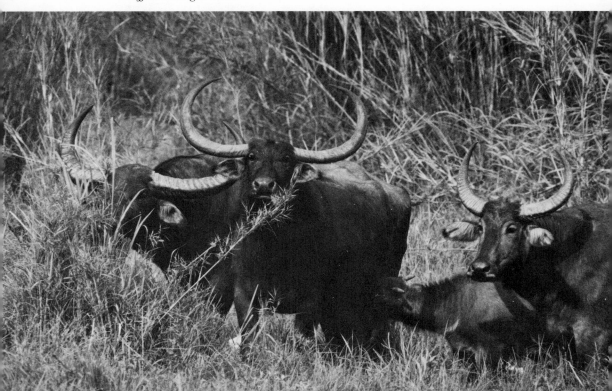

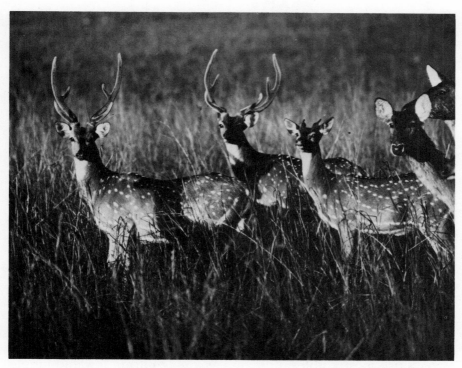

Chital stags in velvet at Kanha National Park. These may be the most beautiful deer in the world.

human population surrounding it. The forest is badly despoiled by unauthorized timber cutting. Poaching is common. In 1970 I found all wildlife to be difficult to see and nearly impossible to photograph. Lions were the single exception; they are daily baited to the vicinity of Sasan rest house by a staked-out domestic buffalo.

Tiny (11 square miles) much-publicized Keoladeo Ghana Wildlife Sanctuary in Rajasthan contains many nesting waterfowl and other waterbirds from July through September, when the shallow swampy depression is flooded and very hot. But cutting a lot of red tape, and baksheesh, is required for permission to get near enough to the main nesting sites for photography. At other times of the year it's not worth the effort.

Some other Indian national parks and refuges are usually listed in the many guides and brochures aimed at naturalist travelers and wildlife photographers. These are Chandraprabha, Jaldapara, Periyar, Ranganthittoo, Sariska, Shivpuri, Taroba, and

Vedanthangal. I would not return to any of those I have visited, and wouldn't recommend them to anyone else.

A good many "big-game shikars," "wildlife safari tours," and "nature tours" to India have been offered by various airlines and travel agencies. Far too many are only visits to ancient towns, temples, and the Taj Mahal, with a few wildlife reserves thrown in. Even concentrating on the best sanctuaries alone, a photographer must realize that he cannot possibly match (in pictures) any similar time spent in African parks. Also, travel inside India can be uncertain, subject to delays from airline and other domestic service strikes. It isn't unusual to be stranded or stalled in some town while a local official reluctantly tries to get things moving again. The best way to photograph India's wildlife at present is by one of the thirty-day late-fall to midwinter tours organized by Lindblad Travel. These also include visits to Nepal and Sikkim.

It is perfectly natural to think of Nepal only in terms of stupendous mountain landscapes and of Katmandu, the mysterious capital which is older than Rome. The tiny Himalayan kingdom does contain nine of the eleven highest peaks on earth and a good many others beyond 20,000 feet elevation. But surprising as it may seem, less than 100 airline miles from Everest or Annapurna, Nepal's two most visible landmarks, is a magnificent lowland jungle called Terai that is not too far above sea level.

More than 1,000 square miles of uncut timber survives intact here, and the Terai remains the largest virgin forest in Asia south of Siberia. Laced by clear cool streams which are headwaters of the Ganges, the jungle is bordered by vast swamps of the Rapti River where the grass grows taller than an elephant's back. Along with Manas and Kaziranga sanctuaries in India, it is a last refuge of the one-horned rhinos. But a wealth of other wildlife also is protected here.

In 1965 a vast chunk of the Terai was designated the Chitawan National Park, and today it rates among Asia's very best for photography, virtually all of it from the backs of riding elephants. Rhinos can be found, usually on every trip, in openings of the swamp. Photographers almost certainly will encounter spotted and hog deer, wild boars, and a great number of birds. Along the Rapti River are marsh crocodiles, gavials, and many waterfowl, including the striking ruddy shelducks. There is also the chance, though small, to see a tiger, leopard, or sloth bear when riding through the forest.

To photograph wildlife at Chitawan, I flew via an ancient

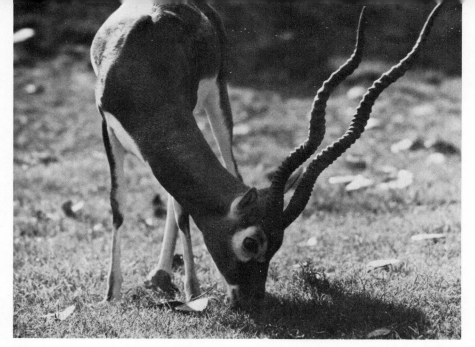

Once widespread over the Indian subcontinent, blackbuck is today restricted to Kanha National Park. Nowadays photographers will find more on the YO Ranch in west Texas.

Siberian ibex or wild goat lives in craggy high altitudes across central Asia.

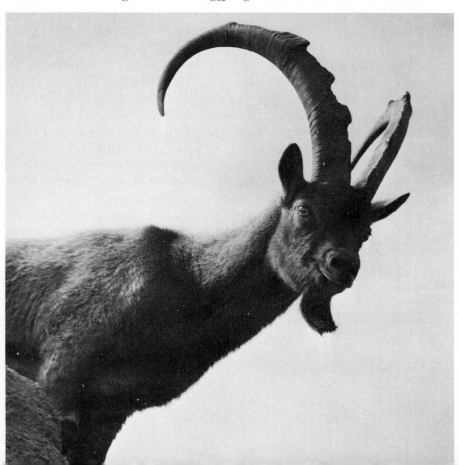

DC-3 from Katmandu to Meghauli "airport." It is a forty-minute hop with the main range of the Himalayas in view all the way. The airport is little more than a fairly level clearing on the edge of jungle. It has no terminal building, no landing lights, and not even a tattered windsock. Instead, elephants wait impatiently nearby to transport all arrivals the 8 miles to Tigertops. During that bumpy but eventful ride I saw several rhinos and many spotted deer.

Tigertops was modeled after Kenya's Treetops, being built at treetop level on mahogany stilts, with thatched roofs and rattan siding to blend well into the jungle environment. Illumination comes from vintage Coleman lanterns, and water in the taps is cold. But otherwise the accommodation has everything: no telephones, television, or radio, not even a modest power plant. A stone-walled thatched dining room is built around a large fireplace and bar. It is a cozy place to spend chilly evenings, surrounded by a fragrant sal forest and listening to the alien night sounds outside. Most of the time a bait of goat or buffalo is placed nearby to attract tigers. Late one evening during my visit, three — a large tigress with twin, almost full-grown cubs — appeared at the baited site. But with no more than flashlights to illuminate the scene, no pictures were possible.

The best time to visit Chitawan — or Nepal — is from mid-November through mid-March. Then the weather is clearest, coolest, and driest. From April onward, heavy rains may fall and vast areas of the Rapti bottomlands are likely to be flooded.

Khao Yai National Park is little known even inside Thailand, where it occupies 540,000 acres of beautiful mixed forest and savanna 130 miles northeast of Bangkok and near the Cambodian border. By some standards the scenery is not spectacular, mostly because the flora is so lush and dense. But there are waterfalls, many orchids, hiking trails, and a variety of wildlife not always easily photographed because it remains deep in forest shadows.

Wild elephants are the most conspicuous mammals at Khao Yai, and hornbills are the easiest to see of the numerous birds. Two species of gibbons cannot be missed. Gaur and sambar deer emerge after dark to feed on the lawns surrounding tourist cabins. Park rangers guide photographers on nighttime Land Rover drives, and sometimes it is possible to approach within flash range of large animals. A really serious cameraman can also test his skill in filming the huge flights of bats which occur around limestone caves every evening at dusk.

As elsewhere in Asia, there is little official interest in this

precious park. In fact, there are all sorts of plans to destroy it, such as a series of dams proposed for Thailand's "national defense." Also there is a bad problem of poaching both the wildlife and the valuable timber.

The present status of Burma's old, once excellent Pidaung Game Sanctuary is not known. Before World War II, machans placed in giant trees beside waterholes and salt licks were extraordinary places to view everything from black bears and bantengs to tigers, leopards, and elephants. There were also primeval forests of fig and teak where orchids grew profusely. Monkeys and waterfowl were especially abundant. Perhaps all is still the same or nearly so. Anyway, Burma is again encouraging tourists (after three decades of the opposite policy), and hopefully Pidaung Sanctuary will be restored to its original status.

For the time being, photographers or any other tourists can forget about Angkor National Park in Cambodia. The temples of

Markhor is fast disappearing from northern India hill country, where it inhabits inaccessible places.

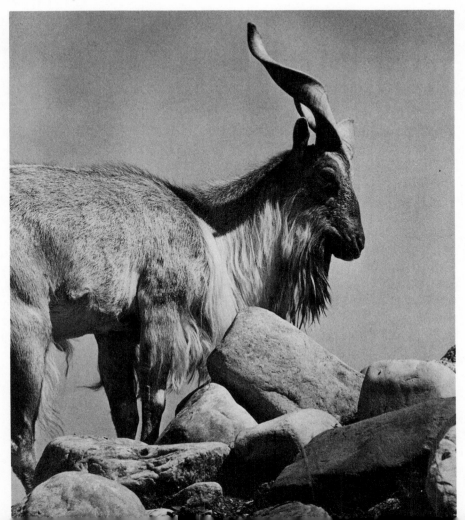

Swan goose is among largest migratory waterfowl of Asia.

the ancient Khmers are the main attraction. But sambar deer strolled through the ruins, leopards could occasionally be seen, and the bird life was rich and colorful before the Indochina fighting began. Now its status is unknown.

Large tracts of the dense, mountain-tropical forests included in Malaysia's Taman Negara National Park remain trackless and inaccessible. Some photography is possible by driving the loop trails, but probably the best bet is to travel the picturesque waterways by boat. It is possible to see Malayan tapirs, the extremely rare Sumatran rhino, gaur, binturong, and sloth bears, although seldom under the best conditions for photography. Malaysian Nature Tours are offered by Lindblad Travel of New York from mid-May through October, the driest months there, and these give the

best possible opportunity to view wildlife during a twenty-day safari. The tours also include Genung Loeser Mountains Nature Park in Indonesia.

Udjong Kulon Strict Nature Reserve of West Java, Indonesia, is one of the most important, least visited sanctuaries in tropical Asia. Near Krakatoa Volcano Island in the Sunda Strait, it is the final asylum for several mammals about to disappear from existence. Best known of these is the Javan rhino, rarest of the world's five species of rhinos. Udjong is also a last stronghold of the purely wild banteng and of the Javan tiger, which may already be extinct. A list of other rarities would include the dhole, the lesser mouse deer, the Malayan giant squirrel, and many species of monkeys. The reserve is reached by chartered motor vessel or a day's rough drive from Jakarta. Guides are available, but accommodations are not. We have not visited Udjong Kulon, but constantly hope for the opportunity.

Nor have we visited any of the national parks of the Philippines. Most are small and meant to protect isolated remnants of the once-magnificent virgin forests or such rare birds as the monkey-eating eagle (Mt. Apo National Park, Mindanao). According to the best information available, few of the parks are well protected and in fact do not meet the qualifications of national parks elsewhere.

Japan has twenty-three so-called national parks, some very beautiful, but few have managed to escape the massive intrusion of artificiality because of the dense human population of the islands. To be truthful, wildlife is nowhere really abundant in the Japanese islands, but rather exists in scattered small or token populations. A cameraman can waste much time here exploring on his own, except possibly on Hokkaido, northernmost of the islands. The Lindblad Nature Tours of Japan, which operate between May and October, offer about the best chance to concentrate as much wild-life viewing and photography in a single safari as is possible and at moderate expense. Japan is a very expensive place in which to travel.

21

The Indian Ocean

From time to time early in the eighteenth century, huge nuts which weighed as much as 60 pounds apiece were washed ashore onto the beaches of Ceylon and southern Asia. Their origin was unknown, and in India at least, it was believed that the nuts grew on coral trees somewhere on the bottom of the ocean. Because the gelatinous white "meat" was considered aphrodisiac, each nut was worth its weight in gold in the markets of Madras and Bombay. At least one coco-de-mer even found passage to Europe, where Grand Duke Rudolf of Hapsburg ate it and declared it the most powerful aphrodisiac of all.

But the mystery of origin, if not the aphrodisiac myth, was solved in 1768 when a French expedition led by Chevalier Marion Dufresne landed on a small, uninhabited island of the Indian Ocean. It was one of the Seychelles group, and Dufresne named it Praslin in honor of the French maritime minister. High on a mountainside he also found a forest of strange palms, some more than 100 feet tall and with fronds measuring to 40 feet long. The giant trees were laden with coco-de-mers, which are actually the largest seeds of any kind on earth. A year later, in 1769, Dufresne dumped a whole shipload of the nuts onto the Indian market and thereby destroyed their immense value forever.

Then as now, Praslin was far more than the world's only source of coco-de-mers. In many ways it conforms to the popular conception of a "South Sea Island." The Valée de Mai, where about 4,000 mature palms, some 800 years old, are concentrated, is exquisitely beautiful. In 1881, before his death defending Khar-

toum, General Charles "Chinese" Gordon visited Praslin and developed the theory that here indeed was the original Garden of Eden—the true birthplace of Adam and Eve.

For photographers, naturalists, and biologists, Praslin is Paradise Found. The 13-square-mile island contains several unique species of wildlife found nowhere else. One, the lesser vasa (or black) parrot, nests only in dead coco-de-mer trunks. The live palm is home for a strange yellow slug, for an endemic green snail, and a separate species of green gecko. This Garden of Eden even has its own serpent—a green boa which is similar to a South American species and which is the only large snake in all of the Seychelles.

Until recently, comparatively few travelers ever visited the Indian Ocean islands between Ceylon and Madagascar for any reason. Although first explored in 1609 by the British East India Company, and probably often visited by Arab traders before that, none of the Seychelles were inhabited until about 1777, when a few French settlers and their African slaves began to arrive. During the Napoleonic Wars there was some naval activity for control of the islands, but since then all, being 1,000 miles east of Mombasa and 1,750 miles southwest of Bombay, have been too remote and have in effect been forgotten.

Until 1969, travel to the Seychelles was costly, difficult, and time-consuming and meant chartering a boat. No air service or even sea passenger service existed. But because of the abundance of rare birds and the exotic species of fish and wildlife there, the MV *Lindblad Explorer,* a passenger vessel, finally began to make several expeditions each year. Although the last such visit was made in fall 1971, the islands were "opened up" to tourism. Now it is possible to fly to Mahé by jet and from there to make eighteen-day safari cruises on the 200-ton staysail schooner *Dwyn Wen* of all the Seychelles Islands. A comfortable, converted Norwegian coast guard cutter, *Christian Bugge,* carries passengers to all the forgotten islands of the Indian Ocean. Both are ideal for visiting and filming in the islands, and both are booked by Lindblad of New York.

The immensely scenic Seychelles lie in the tropical belt just south of the Equator. But since the islands are small, the climate is subject to maritime influences and is healthy. Temperatures vary between 75 and 85 degrees F.; Mahé rainfall averages about 90 inches per year at sea level. That figure is greater at higher altitudes of Mahé and less on outer drier islands of the archipelago. The coolest season is during the southeast monsoon, which begins toward the end of May and endures through September. Malaria

Fruit bats which resemble small winged foxes sleep days away, hanging in trees of many Indian Ocean islands. This one is in the Seychelles.

and yellow fever are unknown, and the Seychelles are outside the cyclonic belt. Even high winds are rare. Cruising among the islands is extremely pleasant. Beautiful beaches and birds are everywhere.

In addition, the people are pleasant, smiling. Miscegenation has always been so widespread that it is no longer possible to distinguish ethnic groups among the Seychellois. The common language is a soft French-creole. Some English is spoken, because the islands have been administered by the British for the last seventy years. The pace is leisurely, even languid and drowsy. In other words, here is a fresh new photogenic tourist destination.

However, the archipelago is not large, and nor is its capacity. On ninety-two granitic and coral islands there is a total land area of only 100 square miles (of which Mahé claims 55 square miles) spread over an ocean area of 150,000 square miles.

One of the first visitors to the Seychelles described Mahé in his journal as a "very good, refreshing place for wood, water, coker nutts, fish and fowle." This is still true, although of all the small islands of the western Indian Ocean, Mahé has been the most exploited by man, and the exploitation began with those first French settlers. For example, the giant indigenous tortoises were super-abundant before settlement, but unfortunately they also pro-

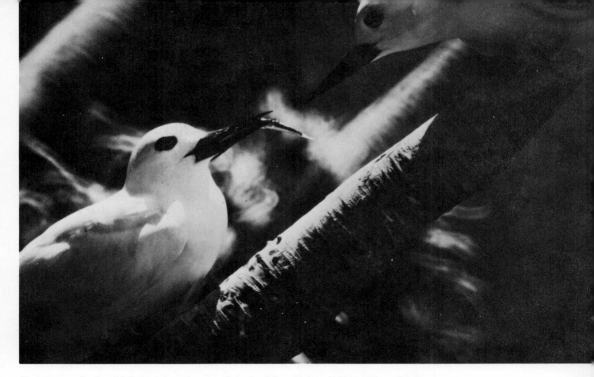

Fairy tern feeds chick its own size on Cousin Island, Seychelles. These birds are extremely tolerant of photographers here.

vided the perfect living meat supply for every ship which paused before passing by. The result was extinction of the tortoises.

Cutting the forests of Mahé has also eliminated a number of birds and reduced others to an endangered level. To fill their places, many foreign birds have been introduced, and as too often happens, these become a nuisance. The Indian mynah is a good example here. On the other hand, the Seychelles scops owl, long considered extinct, was recently seen on Mahé again. It was the first sighting in thirty-five years.

The other islands of the archipelago have fared far better than Mahé, although the continued existence of some rare fauna is most precarious. Five-square-mile La Digue Island is home for what may be the rarest land bird of all, the Seychelles paradise flycatcher, which was believed extinct until rediscovered fifteen years ago. Also unique to La Digue is a terrapin which lives in just one marsh palms are among the oldest and most primitive of all living plants.

La Digue has an interesting background. It was named for one and in small palms which resemble elongated pineapples. The of the two ships of Dufresne's expedition which discovered the coco-de-mers of Praslin. In 1792 it became a quarantine island for a French frigate, *La Minerve,* when smallpox broke out aboard.

Probably none of the seamen abandoned there survived, but still the fear of pox discouraged settlement for a long time thereafter. Today most of the 2,000 inhabitants are concentrated near a place called La Passe, which is the only safe landing spot for small craft.

For ornithologists and naturalists at least, 70-acre Cousin Island may be the crown jewel of the Seychelles, thanks to the far-sightedness of a previous owner, France Jumeau. Tens of thousands of sea birds use and nest on Cousin, mostly because Jumeau was able to keep cats, brown rats, barn owls, and any other predators from invading the island.

The common nesters of Cousin are fairy terns (very, very tame), two species of noddy terns, bridled terns, white-tailed tropic birds, and wedge-tailed shearwaters. But here also is the last surviving population (approximately fifty) of the Seychelles brush warbler, one of the last colonies of the red toq-toq (or Seychelles fody), and the purest remnant anywhere of the Seychelles turtledove. Elsewhere the dove has hybridized with a similar turtledove imported from Madagascar. In an enclosure on Cousin are twenty-two giant tortoises which have been on the island since anyone living today can remember. They are probably the last survivors of the Seychelles race, though they could have been introduced long ago from Aldabra.

To preserve the island forever as an international sanctuary, Cousin was purchased in 1968 by the International Council for Bird Preservation, with help from the World Wildlife Fund and the National Audubon Society. Today it can be explored via a system of trails which both encircle the island and wind over the summit of a 216-foot granite hill in the center. While hiking the trails late in 1971, Peggy and I watched a small endemic skink eat an egg fallen from a fairy-tern nest in a casuarina tree. One larger skink actually seeks out nests and eggs to eat. But the biologist-guide wisely made no move to eradicate this predator, because the skinks have evolved right along with the birds and each is a factor in the other's ecology.

Bird Island, northernmost of the Seychelles, is an atoll and another place of immense curiosity to ornithologists, since (according to a 1970 census) about 1,500,000 sea birds nest there. Most are sooty terns, but a complete list would also include noddies, fairies, crested terns, frigates, shearwaters, and tropic-birds. Most of the common land birds now present have been introduced from Madagascar and Malaysia, but the Seychelles sun-

bird can also be seen. So can a good many waders around Bird's perimeter, including whimbrels, turnstones, crab plovers, sand plovers, and sanderlings.

Today's jet visitors to the Seychelles can find much adventure in snorkeling and diving over the exquisite coral reefs which are part of the archipelago. But in places photography will be dull, because some reefs have already been denuded of a once-intoxicating variety of marine life by spearing and trapping. On reefs around Mahé it is difficult to spot a fish of any variety as large as one's hand, so complete has been the harvest for subsistence needs. But the reefs adjoining Cousin are now protected against spearing and shelling, and here it is an entirely different matter.

From the base of Mahé, cameramen can explore outward by boat beyond Praslin, Bird, and Cousin—on to Desroches, Remire, Poivre, D'Aros, African Banks, and other atolls of the Amirante Banks, even to French Glorioso Island, and on to incredible Aldabra.

African Banks is two low-lying, hot ovals of sand nowhere more than a few feet above sea level. But it is an outstanding seabird spectacle and likely to remain so because of the difficulty of getting ashore. It is uninhabited. Three-square-mile Desroches is part of the rim of a submerged atoll and not particularly attractive because it is devoted entirely to the production of copra. But at low tide, the vast reef on the exposed east side is suddenly uncovered. This leaves a honeycomb of isolated, waist-deep pools in which an extraordinary variety of reef fish are temporarily trapped. Perhaps nowhere is it possible for a snorkeler (even one without previous experience) to see so many Indian Ocean species so quickly in one confined area.

Circular, one-square-mile Glorioso Island is also likely to draw attention for the first time in its history. It is now populated only by four French meteorologists, and little is really known about the place, except that it is covered by more natural vegetation than most Indian Ocean islets of similar size. Fifty species of plants, although none endemic, were collected by a party of botanists in 1970.

One day in the same year, members of a *Lindblad Explorer* party believe that they discovered what may be three new species of birds: a brush warbler with pink legs, a new subspecies of fody (fodies are common in the Seychelles and elsewhere, all being red in color, but this Glorioso bird had a white breast), and an as yet

unidentified flycatcher. Also a small fast-flying quail has been seen near the Glorioso airstrip. Probably it was a lost or migrant coturnix from Asia.

Aldabra atoll, farthest west of the once-forgotten islands of the western Indian Ocean, must be ranked among the strangest, most inhospitable bits of real estate on earth. Until recently, for these reasons, it was largely ignored by humans. And for exactly the same reasons it is now attracting much attention.

Few ever even heard of Aldabra until about 1966, when the British government announced secret plans to build an airstrip and a military staging strip on the lonely atoll. But angry reaction and a worldwide conservation effort thwarted the plans, so that today it is mostly in the hands of the British Royal Society. The only settlement there now is a biology-research station staffed by twenty technicians.

The 60 square miles of Aldabra land area are really a crude necklace surrounding a shallow lagoon and broken by a few channels on the north and west sides. The peripheral reefs, and in places, the shoreline, have been eroded into "champignon" —mushroom—shapes of coral which is razor sharp. In turn the champignon is covered with a dense thicket of pemphis, which in places borders on being impenetrable. Elsewhere the scrub thicket is more open, but still difficult to hike through. An astounding 10 percent of all the 173 catalogued plant species are endemic to Aldabra.

Some other reasons make Aldabra absolutely distinctive. For one, it is the home of an estimated 100,000 giant tortoises. The only other large tortoises survive in the Galapagos, plus the few on Cousin. These of Aldabra live in the densest vegetation on the island and although numerous are never easy to see. Aldabra is the largest nesting ground in the entire Indian Ocean of both the green and hawksbill turtles. Laying occurs at night and usually from February through September, but I watched a large green female still depositing eggs after daybreak and in mid-October.

Distinct land birds of Aldabra include a drongo, a fody, a sunbird, a whiteye, a coucal, a kestrel, a blue pigeon, a nightjar, a turtle dove, an ibis, and most interesting of all, a flightless rail. Most of these exhibit little fear of visitors, and the rails are trusting enough to wander within a few feet of photographers. Great harm can be done to such unsophisticated birds by visitors who do not understand this behavior. Dimorphic egrets—some solid black, some all white—nest on the atoll. So do flamingoes and many of

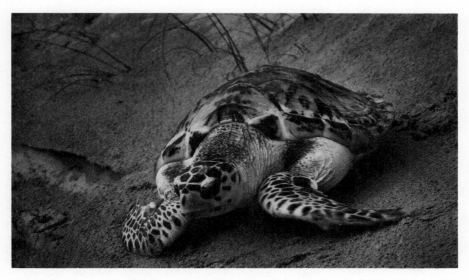

Hawksbill turtle, heavily hunted everywhere, may be seen and photographed when coming ashore on a few scattered and isolated beaches.

the common sea birds seen in the Seychelles. Recently a new species of brush warbler was discovered, but has since been observed only once.

Because it remains undiscovered and undisturbed, the underwater spectacle around Aldabra is even more remarkable than the land combination of rare birds and giant tortoises. Hovering over the coral heads is a rainbow procession of harlequin-colored fishes, some as bright as neon lights: Moorish idols; black, blue, and yellow angelfish; trigger fish; blue demoiselles; coral-eating parrotfish; sergeant-majors; morays; squirrelfish; wrasses; tangs; flutemouths; and a hundred others. Most are tame enough to stare back through a snorkel mask without fear. But any spearing could soon change that.

At the top of the Indian Ocean—north of the Seychelles and smaller forgotten islands—is a much larger island, different in every possible way: Ceylon (Sri Lanka). It is crowded and almost everywhere unpleasantly hot and humid. But there is much here to compensate. Most Ceylonese are serene and friendly, and the land is beautiful. In two national parks here—Wilpattu and Ruhunu—is the most productive wildlife photography I have managed to locate anywhere in all of Asia. More than anywhere else on the continent, national parks in Ceylon are regarded as national treasures.

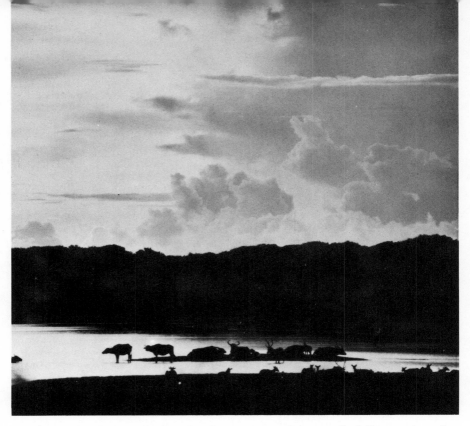

Humid daybreak on a Ceylon slough. Very soon the water bufalloes and sambar deer will retreat to dense jungles nearby.

I arrived in Colombo, Ceylon's coastal capital, during mid-February (middle of the driest season) and found little reason to linger around that dreary port city. By prearrangement I was met at the airport by Simon Gamage, a guide and driver of a rental car. Gamage was a handsome and engaging man of about fifty who spoke excellent English as well as Sinhalese and Tamil, the two native tongues. He had worked previously with several scientific expeditions and knew Ceylon's fauna and flora fairly well. Gamage was also the man who had supervised building of the bridge used in the movie *Bridge on the River Kwai,* filmed several years earlier not far from Colombo.

The drive from Colombo, around the densely populated southeast shore of the island, required nine and a half hours to reach a beach motel just outside Ruhunu. It was a hot, sweaty ordeal, but on arrival three elephants strolled past the lodging on the sand. Nearby, several sambar stags grazed on the coarse grass growing from golden dunes. It was a totally unexpected, but extraordinarily beautiful scene. I fell asleep soon after dark listening to sea birds and the thundering roar of the surf.

Early next morning, Gamage exchanged the compact car for a four-wheel-drive Land Rover and we pushed off into a mixture of dense scrub jungle with swamps bordered by grassy meadows. From the beginning I kept busy shooting faster than I could reload cameras. We found a surfeit of water buffaloes, sambar deer, wild boars, marsh crocodiles, and Ceylon monitors and spotted an occasional muntjac, or barking deer. Peafowl and jungle fowl (progenitors of all our domestic chickens) lurked at jungle's edge, only to slink away when we approached too near. Strangely, we found such birds of prey as the crested hawk eagle and serpent eagle to be very willing photo subjects.

The most interesting and impressive of all Ruhunu animals are the 300-odd tuskers which inhabit the 248-square-mile reserve. Gamage was very leery of the elephants from the beginning, and I soon learned why. Unlike their cousins in most African national parks, which have become tolerant of photographers, these rushed any car which came too close. Nor were the big animals bluffing; some charged straight out without giving any warning.

The week at Ruhunu ended far too quickly, and from there we headed northwestward over the central highlands, past the ancient Ceylonese capitals of Kandy and Anuradhapura, past Gal Oya where more wild elephants still live, to Wilpattu National Park, which is also on the coast. We arrived after dark. I attributed the

Ceylon monitors waltz in what is probably a mating rtiual. This island contains two of the finest wildlife sanctuaries in all Asia.

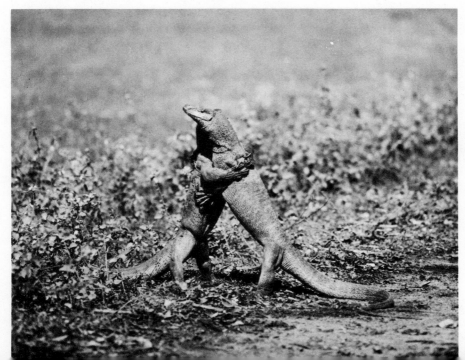

strange noises I heard all night to too much hot curry I'd eaten for late dinner. At daybreak a leopard coughed right outside my open bungalow window, and I suddenly realized that the cat, and not the curry alone, was responsible for the unsound slumber.

I've never seen a park or sanctuary exactly like Wilpattu. It contains nearly 400 square miles of virgin forest, classified as dry jungle, punctuated only by shallow ponds (here called wilus) which vary in size from 5 to say 80 acres. A strip of parklike grass or swampland borders each wilu, and beyond these strips is only unbroken jungle of palu, satinwood, kumbuk, dan, and ebony trees.

To accommodate visitors, the Ceylon Park Service has built rest houses near the park headquarters and bungalows beside six of the wilus. Gamage and I stayed at Kali Wilu. This was a spare but tidy structure which blended well into the environment and had just enough amenities (a flush toilet, a small gas refrigerator, but no electricity) to make jungle living very comfortable. No two bungalows are closer together than 4 miles. Each is staffed by a cook and housekeeper.

During the next week of busy photography, it was apparent that Wilpattu contained the greatest concentration of leopards on earth for an area of similar size. At least the spotted cats are more visible and more obliging for photographers here than anywhere else I've ever been. During many previous trips through leopard

Leopard of Wilpattu National Park. Here the beautiful spotted cats are tame enough for easy photography.

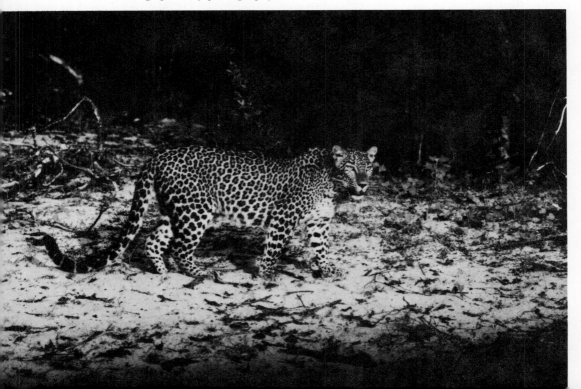

country of Africa and Asia, I'd considered myself lucky to have seen a total of a dozen. Here in just six days I photographed twice that many. One morning one of the leopards only sat motionless and stared at us through cold lime eyes from only 15 feet away. We saw another capture and drag away a small buffalo calf.

I emerged with one strong impression of leopards: the species (at least on Ceylon) is not nearly as solitary as generally believed. Besides one mating pair, we often saw two and three together. Chief park ranger Percy de Alwis stated that he has at times observed five and six in a party. De Alwis also reported that there has never been a single attack by leopards on humans in the park, despite the frequent close contacts there. Nor is Alwis aware of a man-eating leopard in Ceylon such as occurs in India and elsewhere.

Besides the leopards, we invariably found much other wildlife around the wilus. Waterfowl and shorebirds were always present. Marsh crocodiles sunbathed at water's edge. But by far the most conspicuous and elegant animals were the chital or spotted deer, which approached both at daybreak and at dusk to drink. These are surely the most beautiful deer on earth, and that is doubly true when their sleek coats are bathed in the orange light of a weak sun just before it dips below the crown of the jungle.

A final point is worth making here. My safari to the two parks cost only $425, or less than $30 per day. It included car rental, driver-guide, mileage, all meals, accommodations, park fees, and everything else except tips, liquor, and air fare to the island. However, an air ticket to almost any other destination in Africa or Asia can be arranged to also include a visit to Ceylon at little or no extra cost. Of course, this trip was made in early 1971 and a lot has happened to devalue the U.S. dollar since then. As elsewhere, prices in Ceylon will have increased. Nonetheless, here still is one of the best of all bargains I've ever discovered for a thrilling camera safari.

22

The Indo-Pacific and Australasia

From Telok Slawi Bay where we had anchored before daybreak and where whale sharks had cruised past on the surface, it is a two-and-a-half-hour hike from the coarse sand beach to the top of desolate Komodo Island. To ascend the first 1,000 feet or so the thin trail winds through a dense, dry, and sometimes rocky thicket. Here and there, sulfur-crested white cockatoos flushed at our approach, and once somebody had a glimpse of a rusa deer, a small island race of the sambar, slinking away. The final 500-foot climb over the crest and down the far side was through parklike stands of palmyra palms.

At the top I paused to shoot several photos of the strange inhospitable landscape with the Flores Sea below and far in the background. Peggy reflected that compared to the daily hike we take when at home in Jackson Hole, it hadn't been a hard climb at all. But even so early in the morning, the heat and humidity were terrible; we were thoroughly drenched with sweat. No winds blew to dry us; the day was perfectly still.

The day before, several Komodo Islanders had walked this same trail, leading a goat which they had staked beside a dried-up waterhole as bait. Their mission was to attract some of the dragons, for which Komodo and two tiny adjacent islands are the only known habitat on earth, so we could photograph them. Certain of the giant monitors have been conditioned to feed on this offering as the lions and leopards do around some African safari camps.

Even though we fully expected to see the dragons, we weren't exactly prepared for what we found. One dragon nearly 10 feet

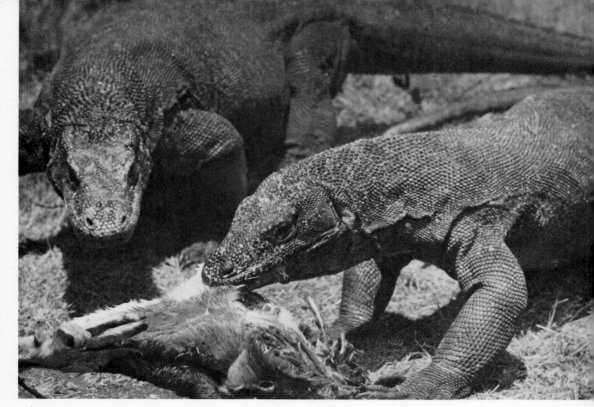

The monitor of Komodo dragon of Komodo Island, Indonesia, is the largest and probably the most impressive lizard on earth. Rare and restricted in range, it is nonetheless easy to photograph when baited to a given area.

long and probably weighing more than 150 pounds was tearing the bait apart, swallowing large chunks, hair, hooves, and all, while at the same time standing off another dragon nearly as large. Three others ranging downward in size to only 4 feet long, long forked tongues flicking out, waited nearby in the shadows of trees on which lavender orchids grew. None paid much attention at all to our approach. It might very well have been a scene out of prehistory, rather than atop a lonely tropical island of the Indonesian archipelago in late 1973. And here certainly is one of the most primitive, most fascinating subjects a wildlife photographer will ever encounter. It is also one of the most cooperative camera targets.

The Komodo dragon wasn't even discovered until 1912. Before that, only rumors of monsters said to be 20 feet long, to weigh over 500 pounds, and to eat men had filtered back to Java and Sumatra, which then were part of the Dutch East Indies. Of course the rumors were dismissed as fantasy or folklore until a Dutch official actually visited uninhabited Komodo, captured two of the dragons, and created a scientific sensation. Since then none has

ever been measured at more than 11½ feet. But even much smaller ones are powerful predators, fast afoot and perfectly capable of catching the deer, wild boars, or calves of wild buffaloes which also live on Komodo. In the past the dragons might also have caught a human intruder or two. Some of the present island inhabitants claim they still do.

Today the entire island is a dragon sanctuary, as it should be. The same isolation which so long prevented discovery of the reptiles has until recently made visiting Komodo at all very difficult. It is not a comfortable place to go and beyond the dragons has nothing to attract attention. Except to mount a major and costly expedition by sea, there was no practical way of getting there, until 1969, when the *Lindblad Explorer* was launched in Finland on the opposite side of the globe.

This unusual motor vessel is a one-class 92-passenger ship designed specifically to visit the least accessible parts of the world. It contains all of the latest icebreaking and ice-detecting equipment, which has made it possible to explore both the Antarctic and Arctic regions. The cruising range is 6,000 miles, and top speed exceeds 15 knots. The *Explorer* has taken travelers both farther south and farther north than any other passenger ship in history. By means of a small fleet of inflatable, almost capsize-proof, outboard-powered Zodiac landing craft, the *Explorer* has put passengers ashore where very few (and in many cases none) have ever been before. Almost no island on earth is now too lonely, too remote, or too lashed by wild seas to prevent a safe beachhead. Photographers have filmed some of the world's rarest and most fascinating wildlife while traveling aboard the 250-foot *Explorer,* which might be the most unusual ship afloat today.

During the summer of 1973, the *Explorer* made many cruises among the easternmost and least populated islands of Indonesia to New Guinea and return. Each of these put cameramen ashore at Komodo. Nearly all shot the baited dragons at close range. Then, beginning on November 1, 1973, Peggy and I joined an *Explorer* expedition planned to begin at Bali and for five weeks to island-hop eastward toward New Guinea and southward to northern Australia, around the Great Barrier Reef to terminate in New Zealand. It was really a wildlife safari by sea, and Komodo on November 3 was the second landing place. It will always remain among the most eerie, most unearthly places we've ever waded ashore in a lukewarm surf.

At least one large volume would be required to describe the

entire cruise in any detail. Here we will mention only highlights of special interest to nature photographers. Before Komodo we beached on Satonda, a small extinct volcano island in the center of which is a dark-green, algae-fringed crater lake. We did not find any of the crocodiles believed to lurk here, but did collect some of the landlocked fishes, not yet known to science. Beautiful butterflies flew everywhere. But most noteworthy about Satonda was snorkeling over the reefs—over exquisite sea gardens, to be more explicit—just offshore. For the first time I realized that the difficulty of reloading an underwater camera is very fortunate. Otherwise too much film could be burned up in too great haste.

On November 7 we explored among the Noes Lima—Five Islands (but really many more)—which are sharp crusts of upthrust coral north of Tanimbar Island in the Banda Sea, but which may not appear on any maps. Here reef and mangrove herons took wing ahead of the Zodiacs, and almost pure-white Torres Straits pigeons flushed in clouds from a few of the mushroom-shaped islets. Again there was nothing to match the underwater photography. Here the waters seemed to be infested with neon-blue starfish and giant clams, some almost as big as bushel baskets.

Next day we went ashore on 3-square-mile, uninhabited Enu, south of Kepulauan Aru. It is not an attractive island, the interior being almost impenetrable jungle, but in it I did find and film the nest of a scrub hen, or megapode. Although the bird itself is only chicken-size, the nest (which is a compacted compost pile of rotting vegetation) was shoulder-high and measured 15 feet in diameter! We also found, from the telltale tracks, that many turtles had laid eggs during the previous night on a sand beach which mangroves were beginning to colonize. But the big reptiles had returned to the oceans before our arrival.

We spent an uncomfortably hot day visiting two villages in Asmat, West Irian, the Indonesian portion of New Guinea. Here was no wildlife to photograph, except that the feathers of parrots and birds of paradise decorating the heads of nearly nude, painted, stone-age tribesmen who paddled out in dugout war canoes to meet the *Explorer*. Except that the influence of missionaries based at the villages was too evident, it was exciting to photograph the colorful people and their excellent carvings. It was also easy to believe that headhunting is still surreptitiously practiced hereabouts.

From Asmat we cruised southward to Darwin for refueling and resupply and to clear Australian immigration. Other pauses to

go ashore at an aboriginal resettlement station in Arnhemland and at Thursday Island, once a pearldiving center, were a waste of time for all impatient to shoot wildlife again, either above or underwater. But once around Cape Melville and the northern edge of the Great Barrier Reef, we were in business again.

While cruising past a necklace of unnamed islands just after daybreak, thousands of Torres Straits pigeons traded back and forth toward the Queensland coast. Suddenly also we were surrounded and trailed by seabirds which had been almost totally absent in Indonesian waters. At nine in the morning on November 16, we anchored off Pelican Island and rode the Zodiacs ashore to a bird photographer's paradise.

Roseate, black-naped, and lesser crested terns, little gray ternlets, noddies, and silver gulls were either already nesting or preparing to do so. Tight groups of thirty or forty of the crested terns flushed up from eggs laid in clusters on bare ground when a cameraman came too close, but all settled down again as he retreated to telephoto lens range. Not nearly so confiding were the fourteen Australian pelicans which flew out onto low tide flats and watched us from that distance. We concluded that Tern might have been a better name for the 20-acre island.

A few hours from Pelican we anchored again inside semicircular Rodda Reef to try snorkeling at the edge of the deep reef entrance. There the exquisite sea gardens of living coral fell away sharply from the clear shallows to a deep blue void, and it was then the most beautiful place I had ever ventured underwater. An absolutely astonishing number and variety of fishes swam along the edge of the coral canyon. There were large parrotfishes, wrasses, and groupers, one of the last being very dark and weighing perhaps 100 pounds. Small whitetip and blacktip sharks circulated below in somewhat deeper, dimmer water. One snorkeler saw the first close-up sea snakes of the trip, except for those passed when cruising through the Timor Sea.

Among the divers at Rodda were Rod and Valerie Taylor, Australian husband-and-wife motion-picture producers, who are probably the best of all underwater photographers. While reviewing the day at Rodda, they suggested the following tips—basic information, really—for cameramen planning to shoot underwater anywhere in the world.

Consistently successful picture taking depends on several factors which have no effect when above the sea. These are clarity of the water, the sun's angle, and distance. With experience and some experimentation, coping with these becomes second nature.

Underwater visibility — the distance a diver can distinguish an object such as a fish or coral formation — varies depending on the number of particles or sediment suspended in the water. Visibility decreases as camera-to-subject distance increases; in other words, the longer the distance, the more particles are in between. The lesson here is always to get as close as possible to the subject, no matter what the clarity of the water. Shooting at close range also preserves the natural color of the subject and improves both sharpness and contrast.

Optical distances above water do not correspond to true distances in water, since the refraction index in water differs from that in the air. This has the effect of increasing the focal length of any lens and narrowing the picture angle underwater by a ratio of four to three. For practical purposes that makes little difference, since both the cameraman and his lens see the same thing underwater. But when distances are actually measured, the distance scale should be preset at three-quarters the actual distance to compensate. In other words, to focus the lens on a fish actually 10 feet away, set the distance scale on the lens to $7\frac{1}{2}$ feet.

An exposure meter in a waterproof case is the best means to accurate exposures underwater. If such a meter is not available or practical to carry, the following will give at least satisfactory results. First measure the light above water. Use this exposure setting down to 3 feet below the surface. Then for each additional 3 feet of depth, open up an extra f/stop.

For best picture quality, try to shoot horizontally. As much as possible, avoid aiming the camera straight down. Since the light source will be behind the camera, illumination will be flat and contrast poor.

Light falls off rapidly as depth increases. For that reason, underwater flash may be necessary at depths beyond 20 feet, even in the clearest water, especially when using color film. But be sure to hold the flash unit as far away from the camera as possible, and close to the subject. Otherwise the solid suspended particles in the water will be brightly illuminated and appear in the picture or slide as out-of-focus white blotches.

The color red is rapidly absorbed underwater, and a common disappointment when shooting beneath the surface will be pictures with an overall greenish or bluish cast. To avoid this with all kinds of color films, use an amber filter over the lens.

Underwater photography is far too complex and variable a matter to be covered in this limited space in every detail. The best advice is to obtain a book which deals solely with that subject and

then to practice in the nearest local pool or swimming hole before beginning a long and expensive photo safari.

From Rodda we island-hopped southward, snorkeling, but having to pass up several scheduled stops because of great swells and very rough seas. November was normally the calmest period of all to visit the Great Barrier Reef, but the effects of a bad typhoon to the north were severely felt for several days. We especially regretted having to pass up Swain Reef and Lizard Island. But it was particularly pleasant to anchor in the relative shelter of Heron Island on the Tropic of Capricorn and just south of the Capricorn Channel.

Heron (like Lizard, Green, and many of the other Barrier Reef islands) is a national park. Although barely 40 acres in size and nowhere more than 11 feet above high tide, our pause here provided by far both the best bird shooting and the best underwater photography of the trip.

The reefs surrounding Heron are many times larger than the land, and since we arrived near low tide, we went snorkeling first near a necklace of bommies (coral upthrusts) at the edge of a boat channel into the Heron beach. Even the most experienced divers were astonished at the extraordinary scenes they found here underwater. Large batfish swam up to meet divers, and we saw large groupers lurking in the mouths of coral caves. Many fishes rushed to feed on bits of fish Valerie Taylor offered as bait. Over 500 species of reef fishes have been identified here, and often it seemed that dozens were in sight at once. Since I can accurately identify too few of the countless corals growing in the sea gardens beside Heron, I feel unequal to describe its unbelievable beauty.

Sometime in the future, we would like to return and spend a long time just diving there and getting acquainted. Incidentally, there are modest bungalow accommodations on the island, which is reached by either boat or helicopter from Gladstone, 45 miles away on the Australian mainland. Shallower parts of the reef inshore can be explored on foot—without snorkeling or diving—for an hour or so during very low tides.

Heron Island itself is completely canopied by pisonia trees and its sandy surface undermined with burrows. As many as two dozen lesser noddy terns may nest in each pisonia, and the underground "apartments" belong to muttonbirds, or wedge-tailed shearwaters. The latter are seldom seen during daytime, but the noddies show little concern even when cameras are poked to within a foot or two of their nests.

Other birds also live or nest on Heron, including both white and dark-gray color forms of the reef heron. Banded landrails race about beneath the understory and are reminiscent of American roadrunners. A few are tame enough to be lured into camera range with bits of biscuits. Shorebirds, silver gulls, and oyster-catchers patrol the same sand strips where many sea turtles come ashore during spring nights to nest. Here is one of the few places in the world where the huge reptiles are completely protected and where it is easy to flash-photograph after dark during the Australian springtime.

Early on November 22 in the northern Tasman Sea, we sighted what appeared to be a large vessel on the horizon. But soon we realized it was the hulk of the 15,000-ton *Runic*, a refrigerator and passenger vessel which had crashed into Middleton Reef in 1958. There it remained, ghostly and rusting, a terrible surf tearing wider and wider a gaping hole in the stern.

In spite of heavy swells we spent most of the day snorkeling around Middleton, or more specifically around the several fish-infested wrecks very visible there. Besides the *Runic*, we found the more recent carcasses of two Japanese trawlers and two unidentified sailing ships, one of which probably was an old American whaler. Among the incalculable numbers of smaller rainbow fishes common to reefs of the South Pacific, huge manta rays glided near the Middleton wrecks, and occasionally sharks put in a brief appearance. It would have been the underwater experience of a lifetime to explore Middleton Reef in calm waters, but on this trip it wasn't to be.

The sea was still wild, and a cold rain fell next morning just after dawn as we passed Ball's Pyramid, an eerie pinnacle only 3/4 acre at the base, but towering 1,800 feet into the mists. Many birds swirled around it. An hour later we came into the shelter of the tiny Admiralty Islands and then to Lord Howe Island. On arrival, however, we could see very little of Lord Howe except the precipitous green cliffs of the north shore, the base of which was pounded by an angry white surf. A gray overcast spilled over the island's main volcanic peaks.

Many of the world's islands have been described as perfect paradises—as the ideal places to escape. Probably 10-square-mile Lord Howe deserves it more than any other anywhere.

Consider the following. Over 500 miles from Sydney and twice that from Auckland, it is wonderfully remote and connected to Sydney only by once-a-week flying-boat service. The landscape is

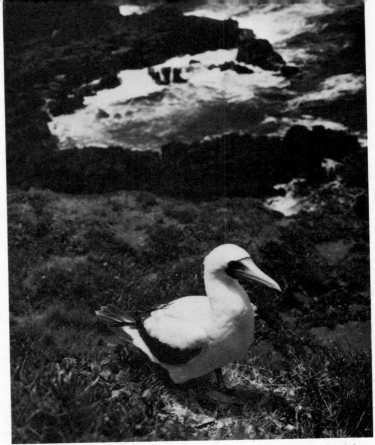

Surf scouring a rocky headland on Norfolk Island is the backdrop for a masked booby, a seabird species which nests here.

Lord Howe Island in southern Pacific is excellent example of island paradise with spectacular seascapes all around.

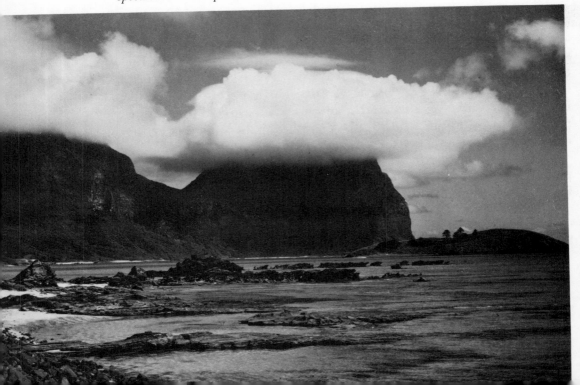

semitropical and in places breathtakingly beautiful, from soft sand beaches to the rain forests almost 3,000 feet directly above. The year-round weather is warm, but is far more temperate and dry than other "South Seas islands," where the heat can be oppressive. The human population is still small, and Lord Howe harbors no stinging insects, no venomous snakes or spiders. Surrounding it are the southernmost coral reefs on earth. They are also among the most lovely, with very tame fishes, several of which, such as the Lord Howe butterfly fish and Lord Howe anemone fish, exist in no other place. Wildlife photographers have the choice between going underwater or photographing the nesting colonies of wide-awake birds (noddies) and masked boobies near Ned's Beach.

From Lord Howe Island, where the weather had suddenly changed in our favor immediately after landing, the *Lindblad Explorer* paused at Norfolk Island before the final run to Auckland. Once Norfolk, with its forests of giant cone-shaped Norfolk pines, its spectacular seascapes and colonies of nesting sea birds, must at least have rivaled Lord Howe for peace and immense natural beauty. But today it seems dominated by a growing free-port in-dustry, too many noisy motorbikes, and tourist hotels. Most worth-while spot is a small nature preserve containing a remnant of virgin forest, some magnificent ocean views, flocks of introduced scarlet rosellas, and a rookery for masked boobies, which are rather tame.

From Bali to Auckland, where this sea safari ended, we had visited a good many places a wildlife photographer could see in no other practical way. I hope the pictures with this chapter will illus-trate that point.

In conclusion, I should point out that much potential for nature photography undoubtedly exists in Australia and New Zealand. Both countries have many national parks, wildlife sanc-tuaries, and other places of unusual natural beauty. But unfortu-nately we have not had the chance to travel in these countries and cannot describe them from firsthand experience.

23

Antarctica

On a clear crisp morning in January 1973, Peggy and I were among the boatload of travelers in red down jackets who established a beachhead on a lonely, uninhabited black shore where jets of steam and sulfur hissed from the sand. Water's edge was warm enough for swimming and in a few areas almost scalding to the touch. Crunching inland over coarse, soft footing, we soon came upon a scene of great destruction. Twisted, blackened girders and crumpled corrugated roofing were all that remained of a small settlement. Farther down the beach a complex of machinery and boilers rusted in the sunlight. Dark, precipitous slopes punctuated with fumaroles loomed in the background.

Altogether the scene might have been on a strange planet of science fiction or the inferno of a grade B horror movie. But actually this was Antarctica—or rather one tiny part of this coldest continent which until recently few humans knew or had ever seen, Deception Island. An almost circular volcano of the south Shetland Islands, Deception was named by an early sealer whose tiny ship was desperately in need of shelter from the stormy waters which threatened to swallow it. He had almost circumnavigated the island without finding a harbor before suddenly coming upon the only channel which gave access to a deep-water basin inside the volcano.

On most modern charts this entrance is called Neptune's Bellows, but it has also been known as Hell's Gates, Dragon's Mouth, and some unprintable names. Now during the middle of an Antarctic summer, the MS *Lindblad Explorer* had cruised to the anchorage inside of Deception. But instead of a small party of

302